150 BEST ALL NEW HOUSE IDEAS

150 BEST ALL NEW HOUSE IDEAS

FRANCESC ZAMORA MOLA

HARPER
DESIGN
An Imprint of HarperCollinsPublishers

First published in 2022 by
Harper Design
An Imprint of *HarperCollins*Publishers
195 Broadway
New York, NY 10007
Tel.: (212) 207-7000
Fax: (855) 746-6023
harperdesign@harpercollins.com
www.hc.com

Distributed throughout the world by
*HarperCollins*Publishers
195 Broadway
New York, NY 10007

Editorial coordinator: Claudia Martínez Alonso
Art director: Mireia Casanovas Soley
Editor and texts: Francesc Zamora Mola
Layout: Cristina Simó Perales

ISBN 978-0-06-321924-3

Library of Congress Control Number: 2021062946

Printed in Thailand
First printing, 2022

CONTENTS

INTRODUCTION

Large expanses of glass that let in abundant sunlight, bright open-plan living areas encouraging social interaction and fluid circulation, indoor-outdoor connection, and an architecture that incorporates sustainable practices, minimizing the environmental impact and maximizing energy efficiency; these features add to a series of site-specific factors—the climate, morphology of the site, and historic context—demonstrating that home design must be contextual in order to work. All the homes included in the book spotlight these design components, all expressed in a wide variety of compelling designs located in the United States (for the most part), Canada, Australia, and India. Functionally, they focus on comfort and flexible layouts that adapt to different situations and encourage social interaction.

Perhaps the most defining feature of contemporary homes is their openness. They establish a living environment that embraces the views and textural qualities—the topography, the vegetation, and other buildings—offered by their location. This strategy drives internal planning decisions—generally providing a flexible living environment—and resultant building form. Transparency is an effective means to achieve this openness. Not only does transparency open interior spaces to light and air, but it also allows a perception of depth, revealing views and the layering of spaces as one moves through a house. These qualities ultimately contribute to a rich spatial experience. Moreover, transparency is an integral part of an architectural language, providing a sense of lightness and contrast with the more opaque materials, but most importantly, allowing a connection with the exterior.

What we see standing at a window or doorstep is more than just the mere outdoor environment. It is a series of physical and non-physical elements such as a tree grove or a lake, a steep terrain offering valley views beyond. These elements become referential landmarks for a house design to exploit. Therefore, the connection with the outdoors is a critical design feature to create a sense of place. Architecture and home design build on these environmental elements expressed through the building orientation, the arrangement of rooms, and the creation of built outdoor spaces. This design strategy is further enhanced by the material selection, one that echoes the immediate surroundings. When all these elements work together harmoniously, the result enhances the inviting and comfortable feeling.

When dealing with the natural environment, architects and designers have learned that it is best not to tame nature but rather coexist with it, building contextually, working with the constraints and benefits inherent to the natural habitat. In the book, we'll find buildings that adapt to the natural slope of the site. Others take advantage of a clearing in the woods to minimize tree cutting and the impact on the natural environment. In an urban environment, the importance for house design to take into account the sense of place is just as critical. Urban residences engage with the street and the neighboring houses. Privacy and space efficiency are issues that architects and designers understand as challenges presenting the opportunity for creative solutions.

In connection with the historic context of a place, new buildings can interpret vernacular architecture while integrating elements of sustainability using local resources and technology. By doing so, these new buildings contribute to the preservation of cultural identity.

Grove House in Bridgehampton, New York, by Roger Ferris + Partners, Black and Tan House in Rogersville, Missouri, by Dake Wells Architecture, and Thaynes Canyon Residence in Park City, Utah, by Sparano + Mooney Architecture are some examples of this reference to the historic context of a place. Coincidentally, these three buildings recall the simple agricultural forms of their regions. By referencing these buildings, the design of contemporary domestic architecture spotlights the timeless character of these old buildings.

The relationship between the history of the location and the way the site is used helps new buildings root themselves in the place and the local tradition. The result is the creation of meaningful architecture, one that fits in a chosen location, the *genius loci*, commonly known as the spirit of the place.

House designs that have a harmonious relationship with nature elevate awareness of the site's qualities into everyday experience. In rural settings, open and bright interiors connected with the outdoors bring us closer to nature. In urban locations, homes engage with the street and the neighborhood. Taking into account the *genius loci* makes the design process a compelling and remarkable analysis mechanism. The resulting built work derives from a particular place and its uniqueness.

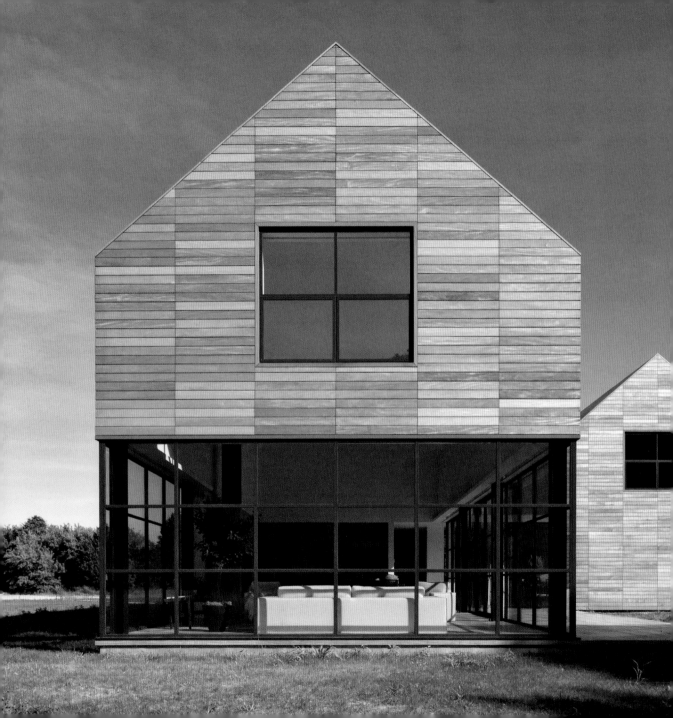

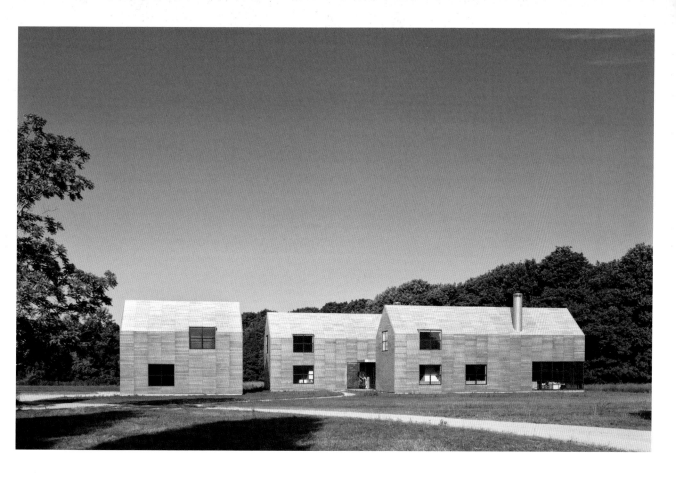

Situated along a natural ravine and protected wetlands, the residence was designed as an immersive yet modern retreat. It consists of three simple gable-shaped volumes, creating a dialogue between the natural grasslands and the built environment. The objective was to create a single-family residence with a distinctive shared living area, private bedrooms, and an art studio, while optimizing functionality and taking advantage of the breathtaking views. A contemporary interpretation of a common New England building form, each volume is shrouded in horizontal wood slats, which seamlessly wrap all wall and roof surfaces. While the project is a simplified version of a common building form, it strives for warm comfort through material selection and acute attention to detail.

Grove House

5,700 sq ft

Bridgehampton, New York, United States

Roger Ferris + Partners

© Mark Seelen, Paúl Rivera

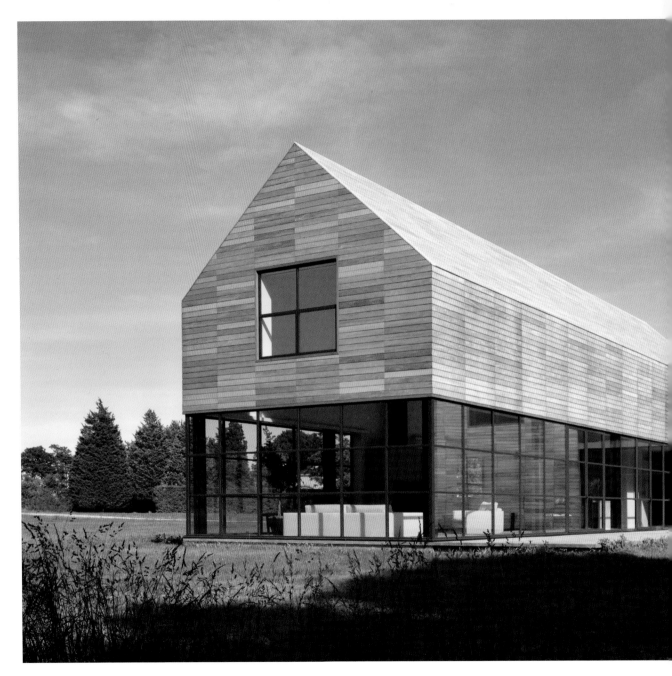

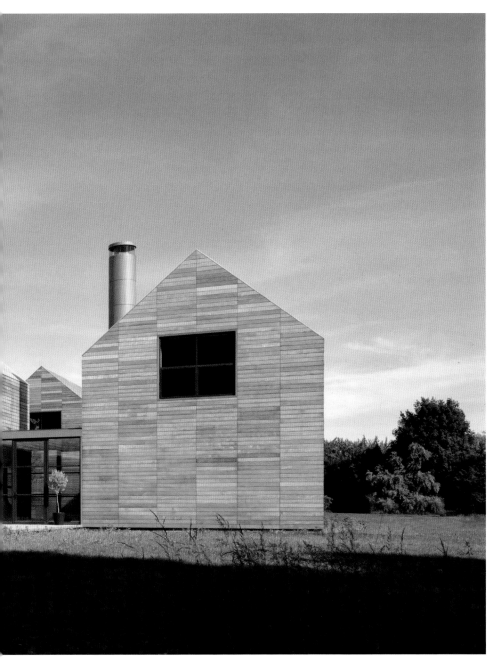

Two of the volumes are delicately connected and sectioned off by a glass breezeway, one housing the public living spaces, the other accommodating the private quarters of the home. A third volume stands alone, housing an artist studio on the second floor, overlooking the rural landscape on which the home is set.

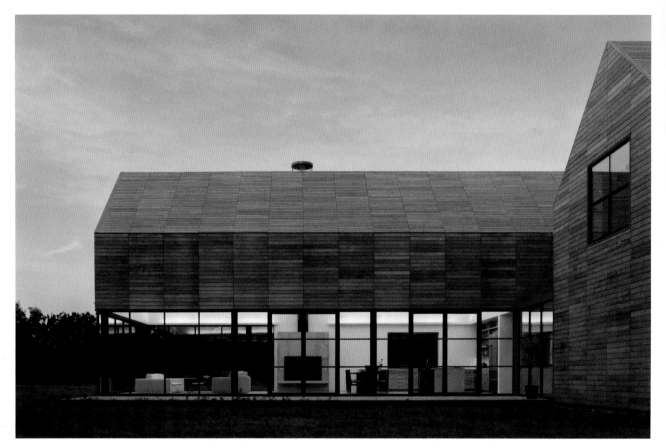

001

The placement of the building on the site responds to the challenge of adhering to environmental regulations, while orienting the volumes to maximize views.

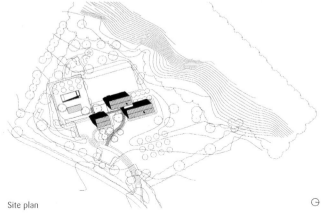

Site plan

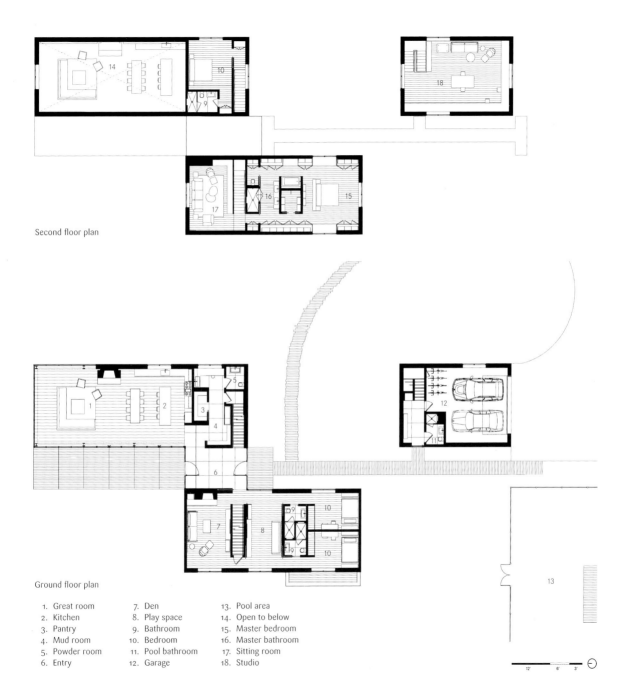

Second floor plan

Ground floor plan

1. Great room
2. Kitchen
3. Pantry
4. Mud room
5. Powder room
6. Entry

7. Den
8. Play space
9. Bathroom
10. Bedroom
11. Pool bathroom
12. Garage

13. Pool area
14. Open to below
15. Master bedroom
16. Master bathroom
17. Sitting room
18. Studio

12' 6' 3'

Grove House 13

Brazilian ash clads wall and roof surfaces, offering a uniform look. In contrast, the ground floor of the building with the open kitchen and living room is fully glazed, connected with the outdoors. Above this transparent volume, the second floor appears to be floating.

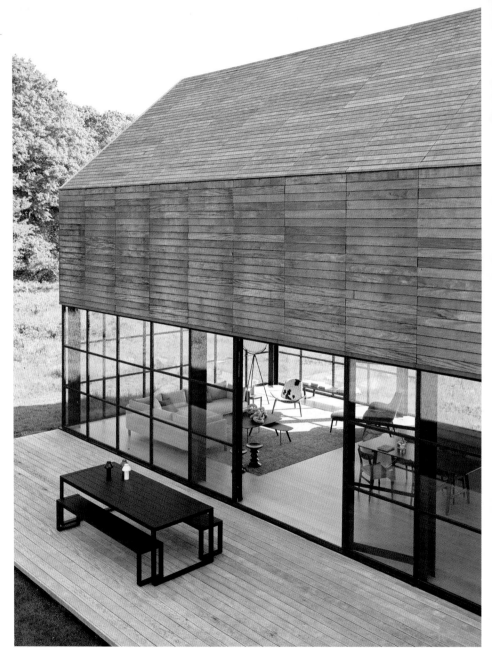

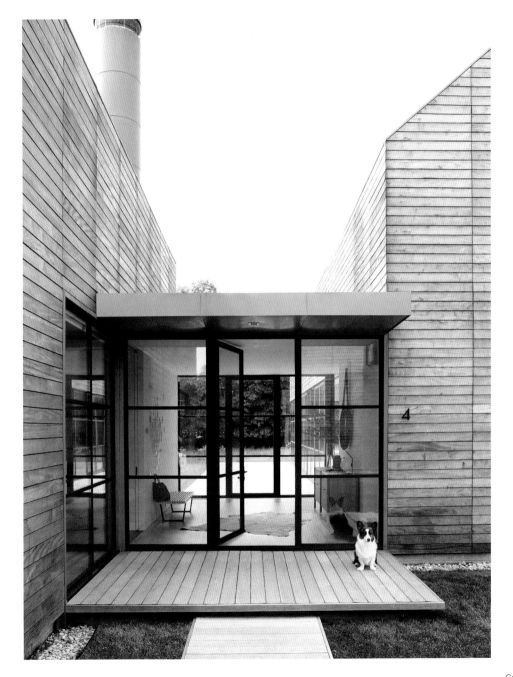

003

Planes of glass provide both a
visual and physical connection to
the natural surrounding landscape,
allowing natural light to flood the
interior, while motorized shades are
utilized to control natural light and
provide privacy.

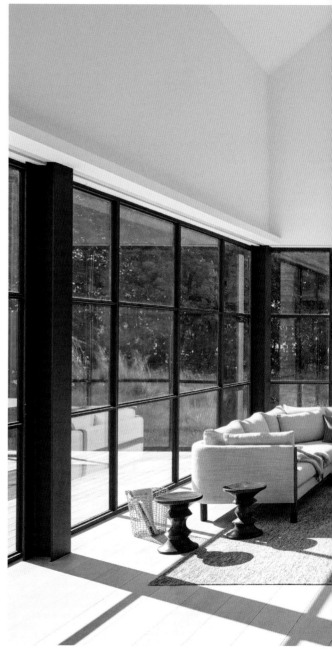

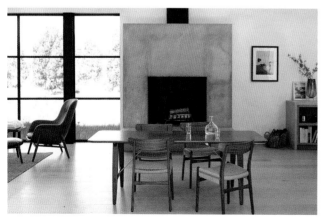

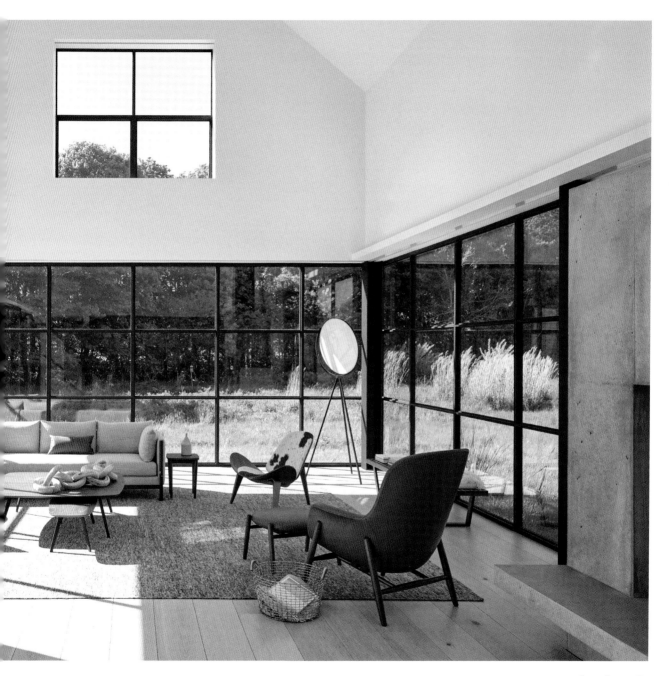

004

The lighting in the master bedroom spotlights the distinct form of the gable-roofed buildings, a nod to the typical structures found in the area.

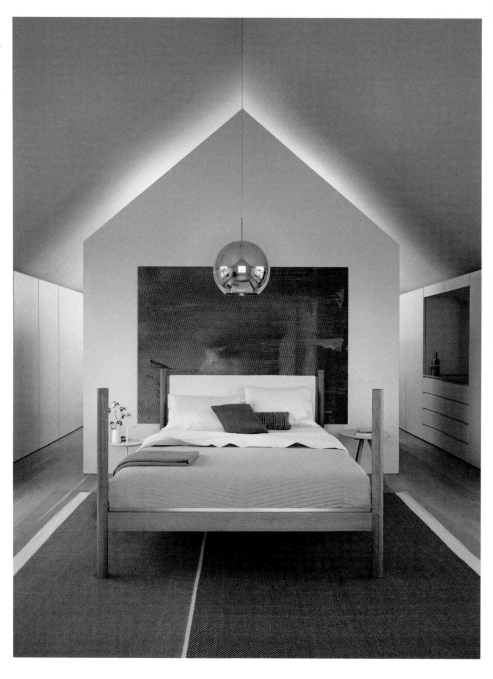

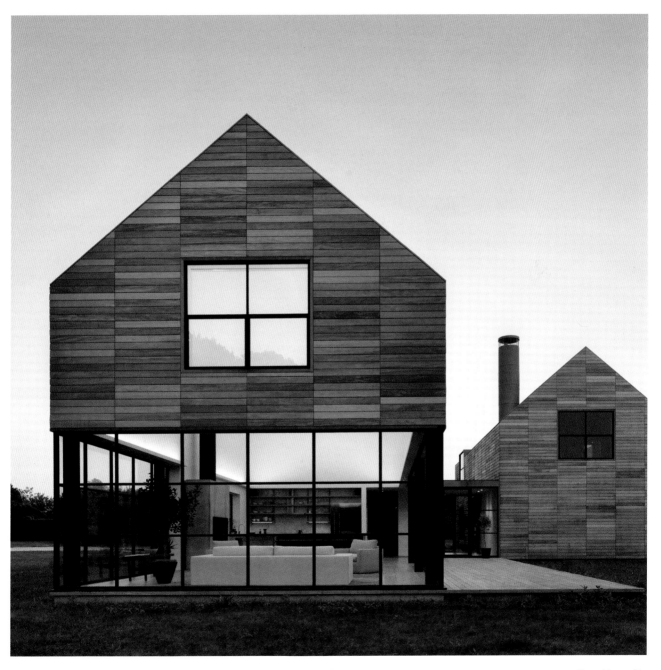

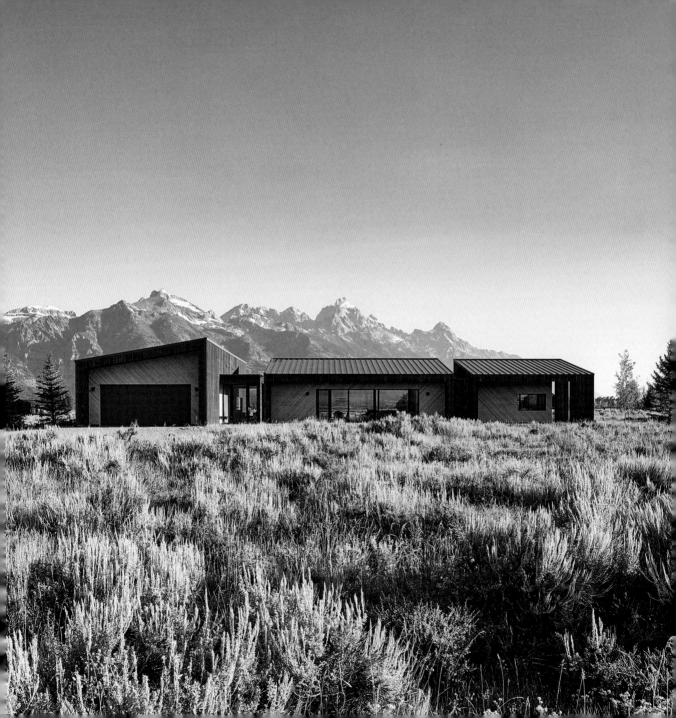

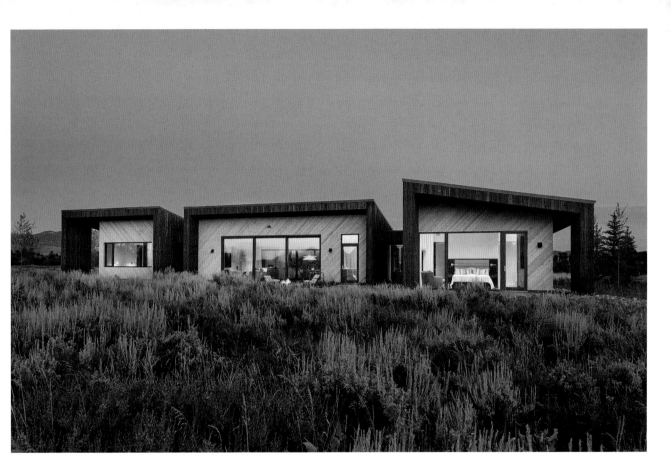

kt814 architecture took into account the timeless beauty of the Grand Tetons when designing this passive house-inspired home. A series of three connected pavilions clad in Douglas fir and cedar compose the architecture on the two-and-a-half-acre parcel with sustainability, low maintenance costs, privacy, and unobstructed views as priorities. The homeowners are a retired couple. After living in a mobile home for ten years, they sought to build a house close to their grandchildren and to allow for easy aging-in-place by incorporating universal design. One of the challenges in the design was to position the home in a way that would block the surrounding houses in the area, providing privacy and in return, offering long unobstructed views.

House of Fir

3,200 sq ft

Jackson Hole, Wyoming,
United States

kt814 architecture

© David Agnello

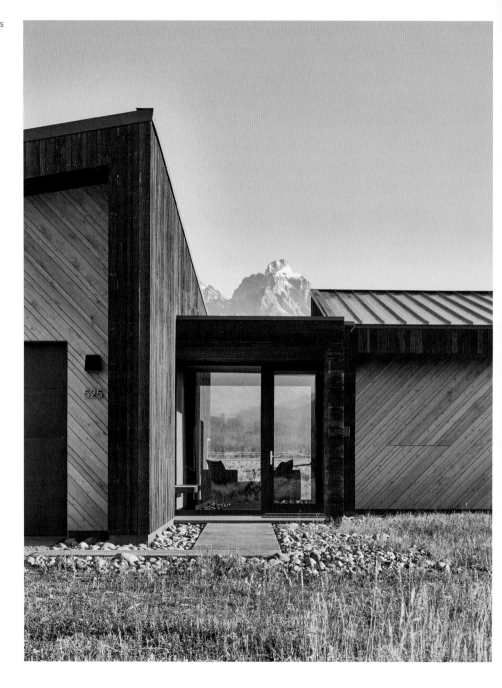

The glass entryway deliberately draws attention to the magnificent Teton Range beyond.

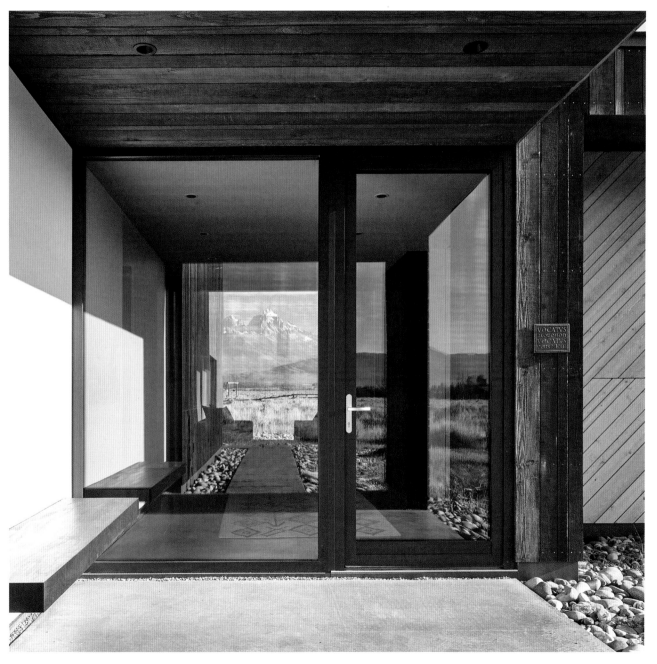

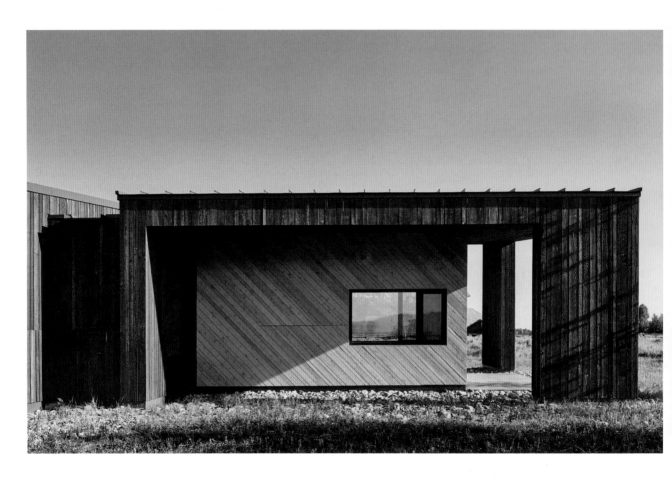

The rich dark-brown vertical Douglas fir exterior siding, from Montana Timber Products, melds into the native woody sage-brush tones and harmonizes with a lighter cedar in intermittent horizontal bands around the house.

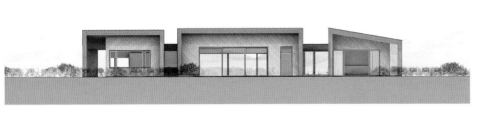

North elevation

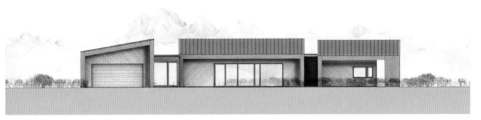

South elevation

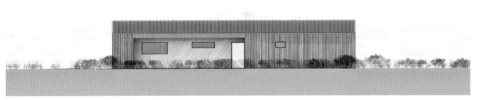

West elevation

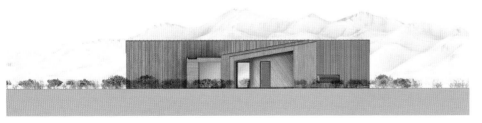

East elevation

005

The winged exterior walls block the houses to the north, while as one travels through the hallway, the main circulation of the home, it purposefully hides all the houses to the east and west.

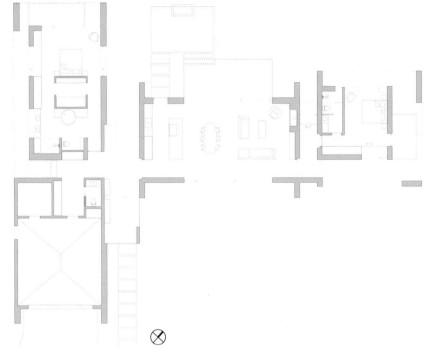

Floor plan

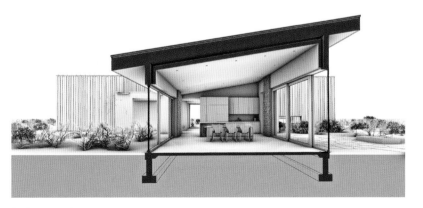

Section perspective

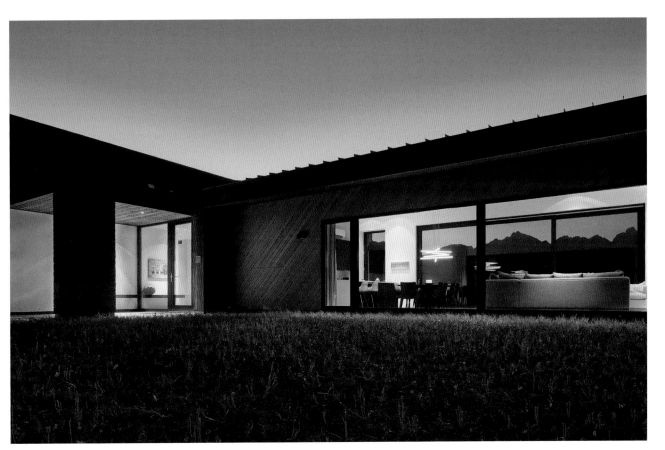

006

The strategically positioned southern-facing windows with the four-foot overhang receive winter gains, yet keep the building's thermal mass in the shade in the summertime.

The interior finishes echo the home's exterior architecture, making it seem even more spacious. Cabinet doors, a custom built-in desk in the office, and a bench in the entryway are fabricated from a mixture of walnut, mimicking the same hue as the facade's Douglas fir.

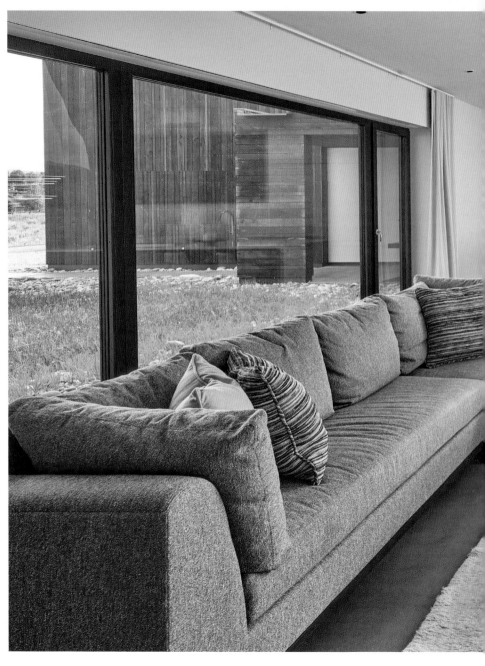

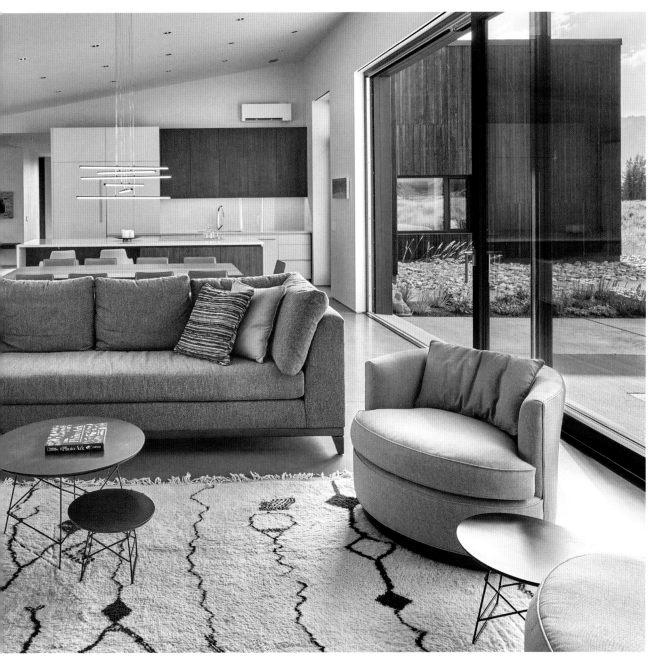

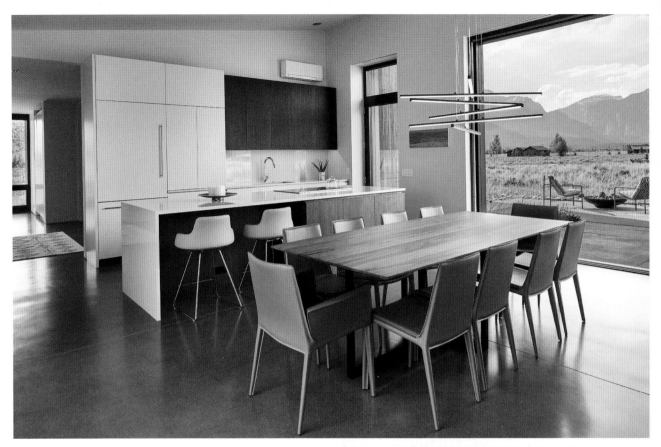

008

Just off the kitchen, clever "window walls" of Zola Windows surround the living room and direct one's gaze to the panoramas unfolding beyond while retaining an intimate connection with the natural sagebrush landscape.

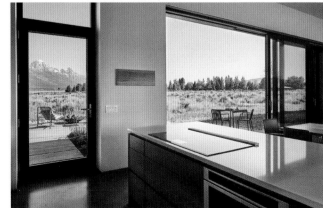

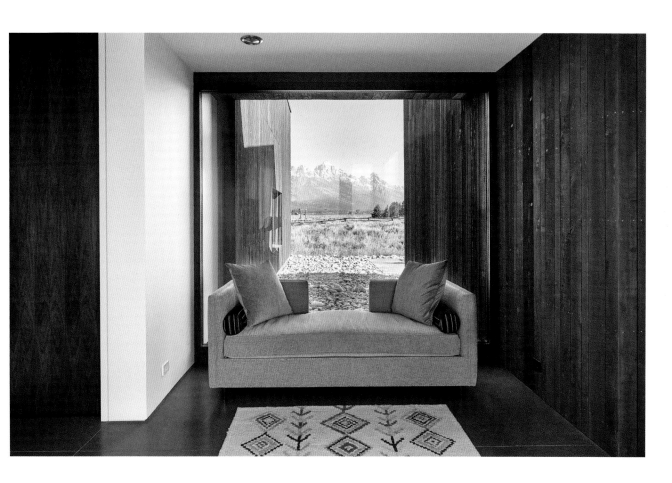

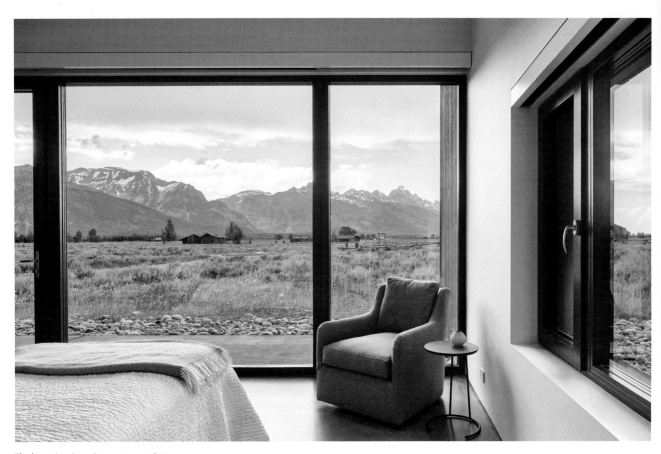

The house's orientation creates a private
pocket of space for the master wing with
views of Sleeping Indian Mountain.

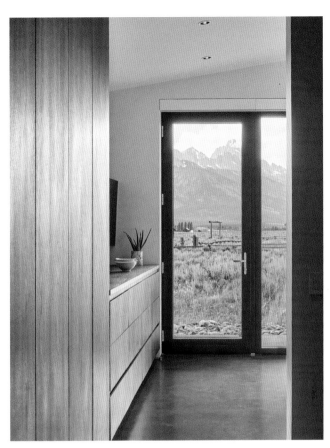
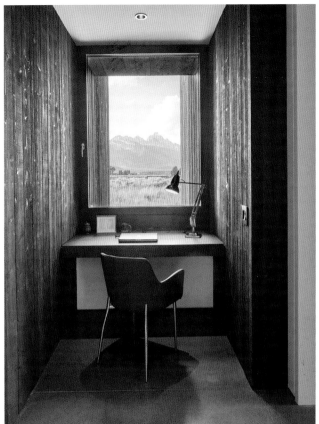

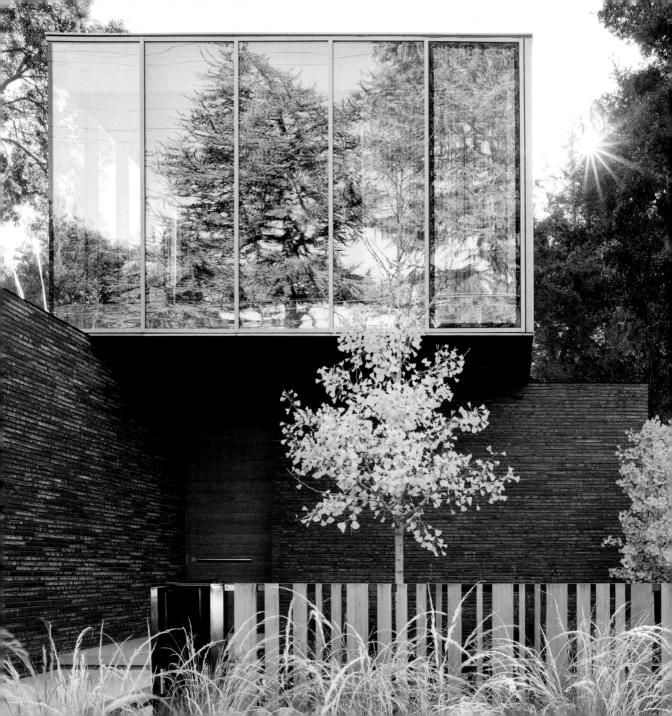

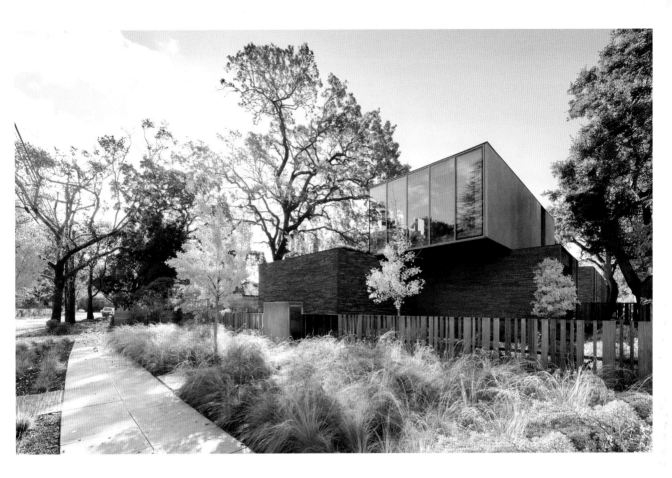

Designed for a young couple, the 5,000-square-foot home and 1,700-square-foot back house sit on a flat 21,000-square-foot lot in a 1920s Palo Alto neighborhood. The architecture is a study in strong, simple composition and is museum-like with its highly refined materiality and emphasis on craft. The ground floor volumes are wrapped in an elongated hand-fired brick from Denmark, emphasizing the horizontality of the architecture that lies solidly on the land. In contrast to the grounded brick volumes, the second floor is clad in stainless steel panels and oversized aluminum-framed windows. The lightness and openness of the second floor is nestled among the oak-tree canopies of the site. The massing defines solid and void, capturing the natural light and connecting the indoors with the landscape, which integrates California native plant species, grasses, and trees.

Waverley

6,700 sq ft

Palo Alto, California, United States

Ehrlich Yanai Rhee Chaney Architects

© Matthew Millman

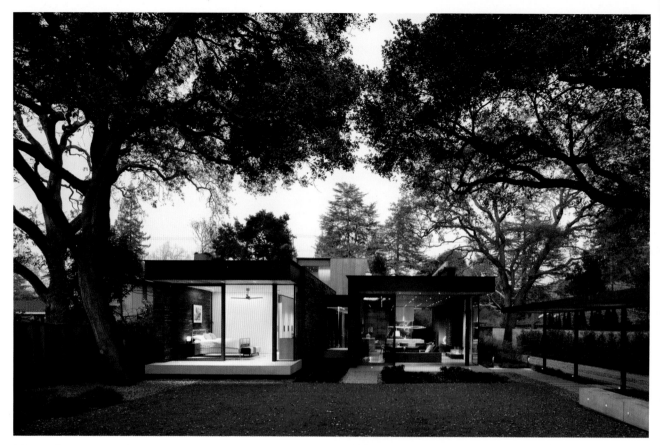

A freestanding structure set deep back into the site is a zen-like fitness/yoga studio and a guesthouse with a kitchenette. This dramatic stone mass opens up in the center to give the impression of exercising outdoors.

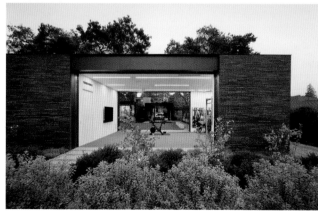

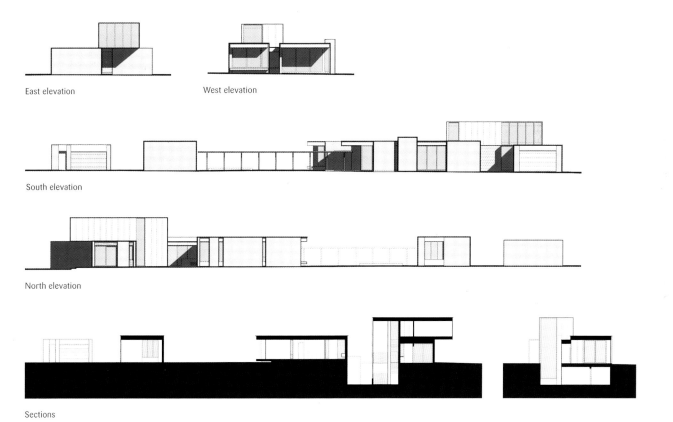

East elevation

West elevation

South elevation

North elevation

Sections

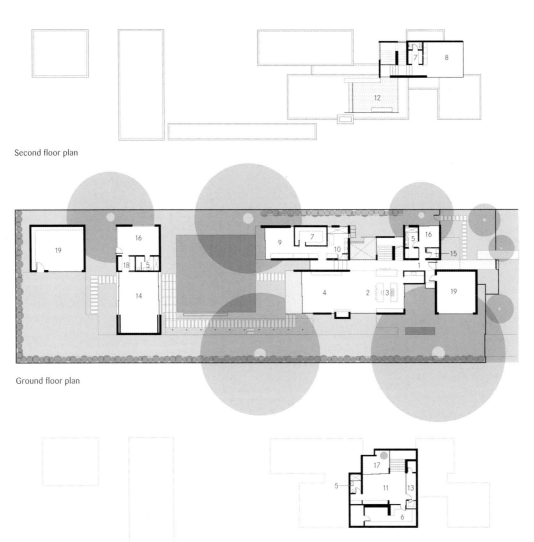

Second floor plan

Ground floor plan

Basement plan

1. Entrance
2. Dining area
3. Kitchen
4. Living area
5. Bathroom
6. Laundry room/utilities
7. Walk-in closet
8. Study
9. Primary bedroom
10. Primary bathroom
11. Wine tasting lounge
12. Deck
13. Wine cellar
14. Gym
15. Powder room
16. Guest bedroom
17. Zen garden
18. Kitchenette
19. Garage

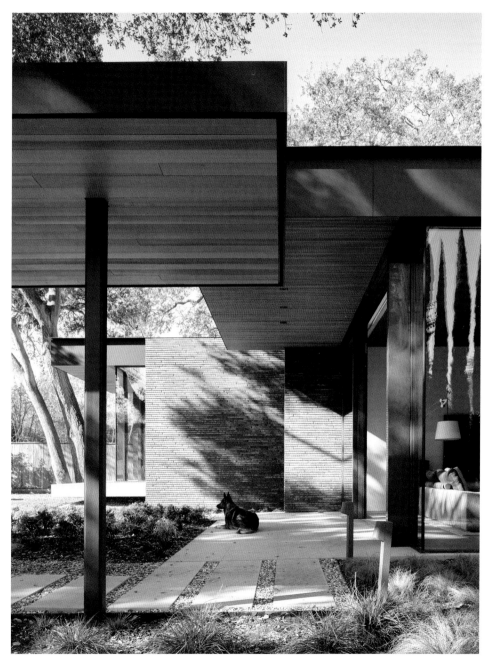

Bronze-trimmed ceiling planes slide between the brick masses and floor-to-ceiling glazed openings.

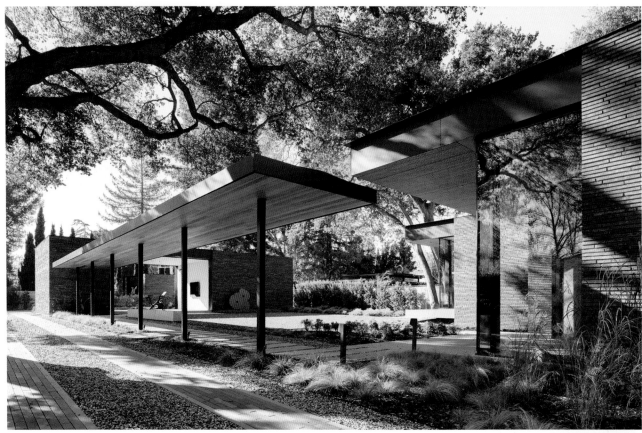

A bronze anodized aluminum and steel
canopy connects the main house with the
gym and guest bedroom while framing
the backyard.

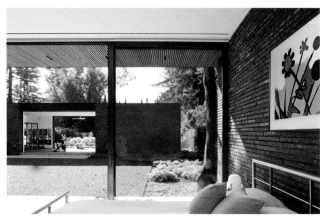

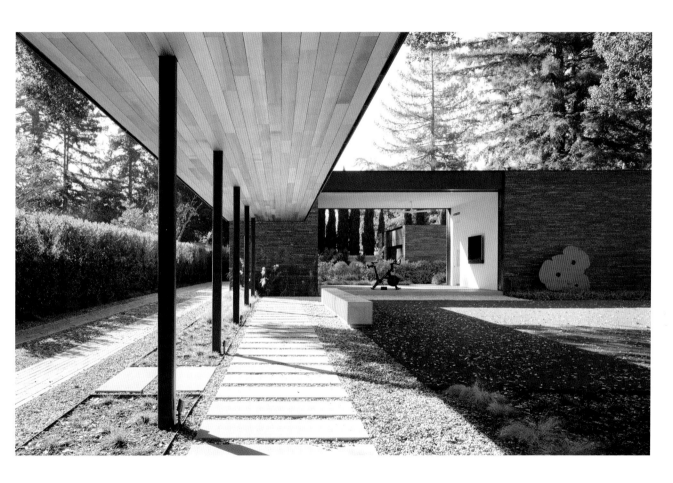

Visual alignments create a sense of order and influence spatial perception by providing connection and reference.

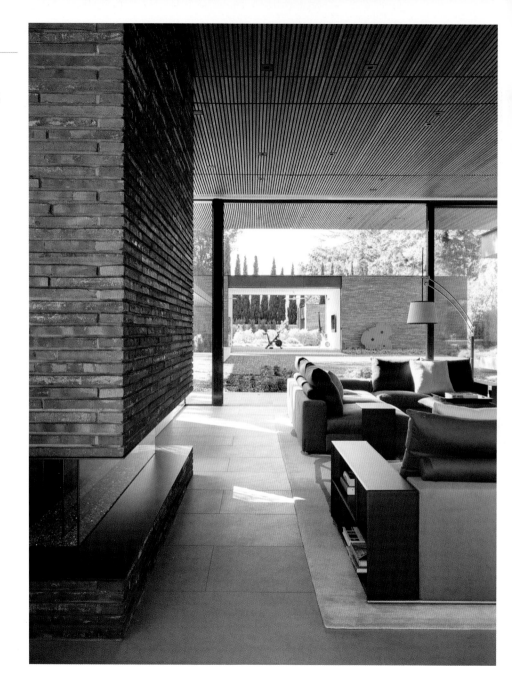

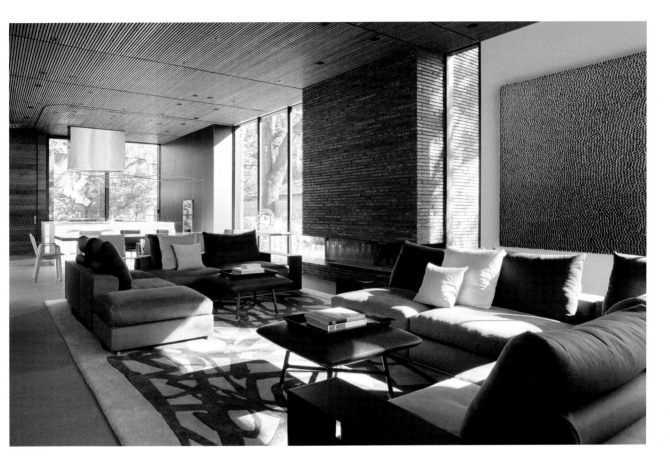

010

An open-plan living space abandons the formal dining and living room and the kitchen as a separate room in the house in favor of a large, flexible space, ideal for entertaining.

011

Interior spaces focus on high-quality materials and unique craftsmanship. An example is the custom-designed steel mesh screen that wraps the kitchen, separating it from the more public "guest hosting" adjacent areas.

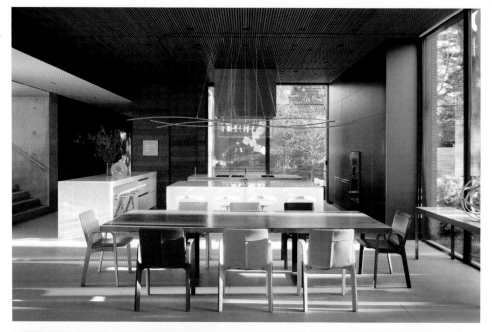

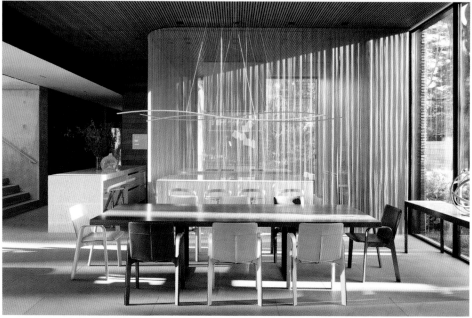

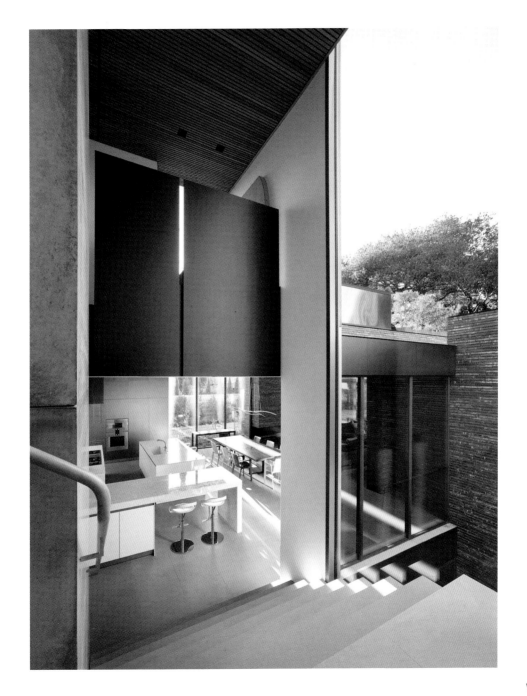

012

A thirty-feet-by-ten-feet continuous glass pane runs alongside the grand stairwell of floating stone steps, connecting the three levels of the house. This dramatic moment in the sequence of progressing through the house minimizes the indoor-outdoor boundary.

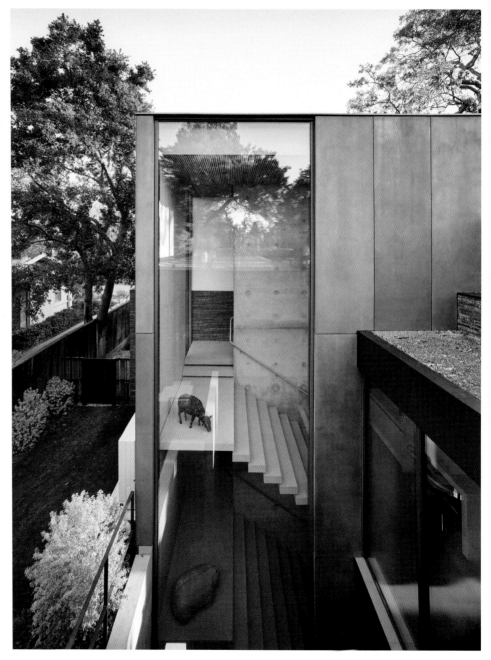

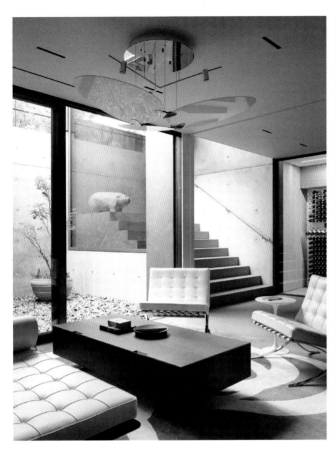

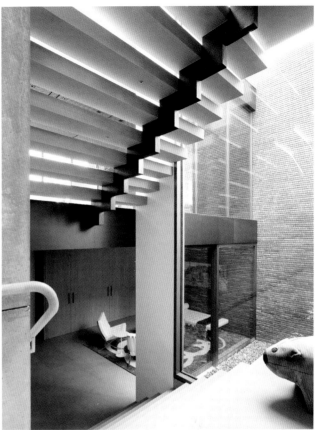

At the basement level, a wine cellar and tasting room open to a sunken landscaped courtyard.

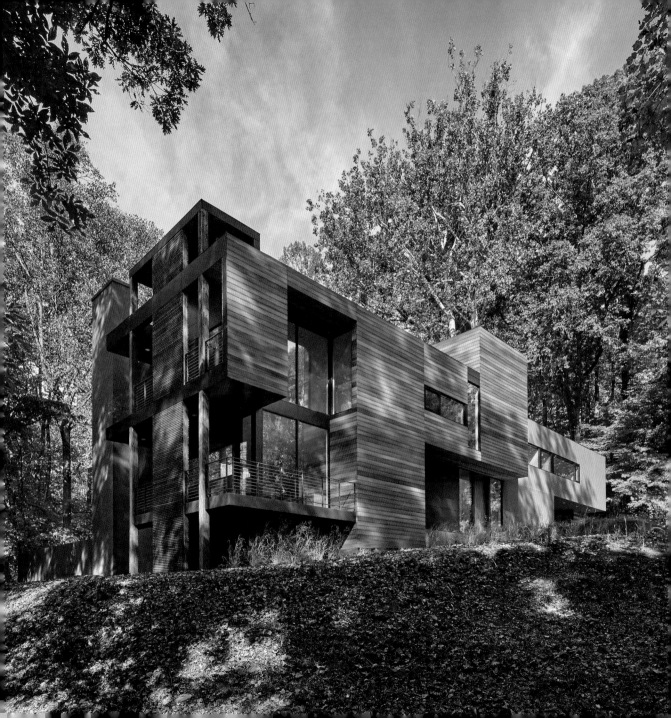

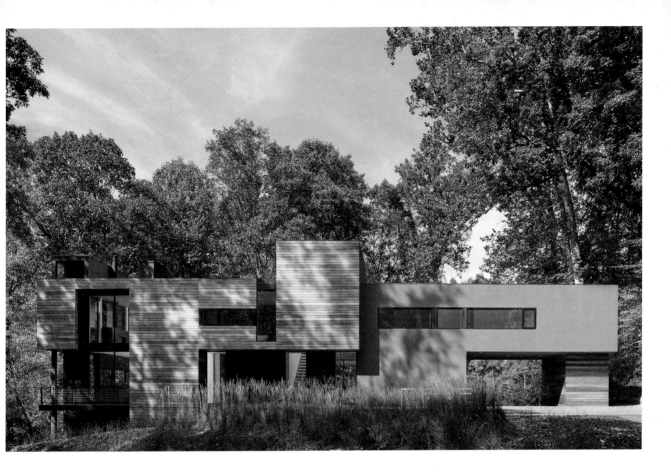

This house is positioned along the ridge of the sloping site and oriented toward the Potomac River. A composition of spaces along the ridge and existing clearing provides a large lawn with minimal site intrusion and preserves site trees. A modern design sensibly coexisting with the natural environment. Glazing provides views into the wooded landscape toward the river and animates the house with light. Intersecting spaces ensure light penetration at all times of day and year. This open and light-filled home features energy-efficient strategies including forest-managed thermally modified wood (non-toxic and durable), solar-sensitive shades, efficient HVAC, and natural ventilation.

Mohican Hills House

4,670 sq ft

Glen Echo, Maryland, United States

Robert M. Gurney Architect

© Anice Hoachlander

The house was positioned to respond to the site's particularities. Its generous glazing on the south side connects the indoors with the Potomac River and the expansive lawn on the south-facing slope.

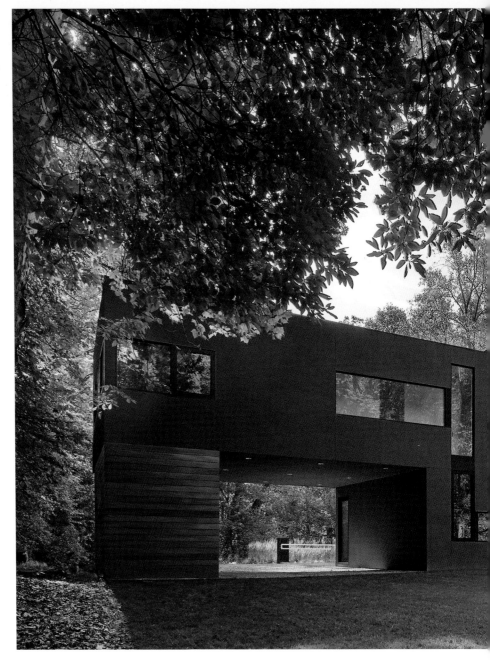

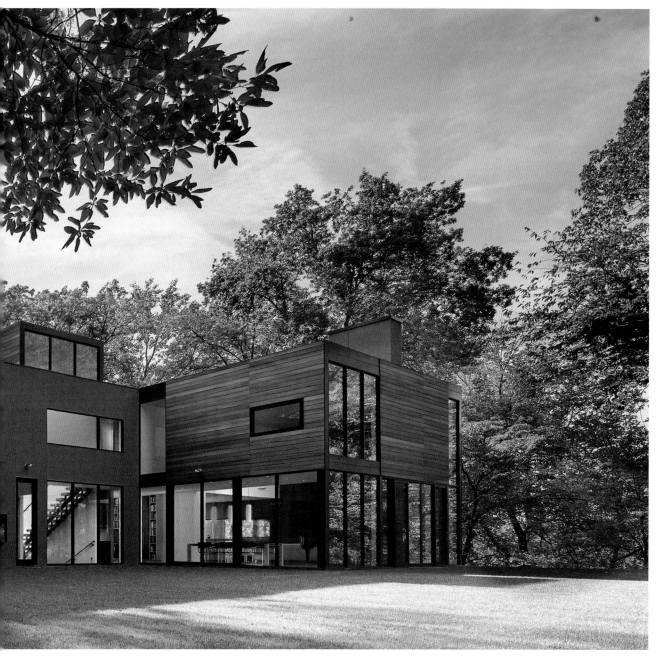

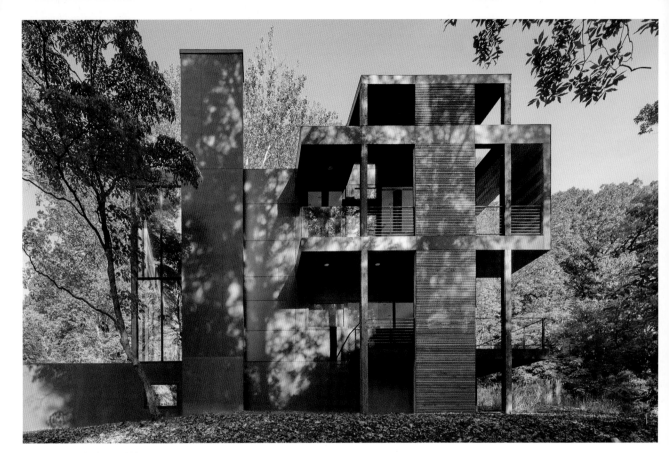

Horizontal wood siding and blue-gray
metal cladding create a balanced massing
composition while expressing the different
interior functions: the wood-clad volumes
enclose the public areas; the metal-clad
ones contain the private spaces.

The house sensibly sits atop a sloping ridge, minimizing its environmental impact and maximizing views.

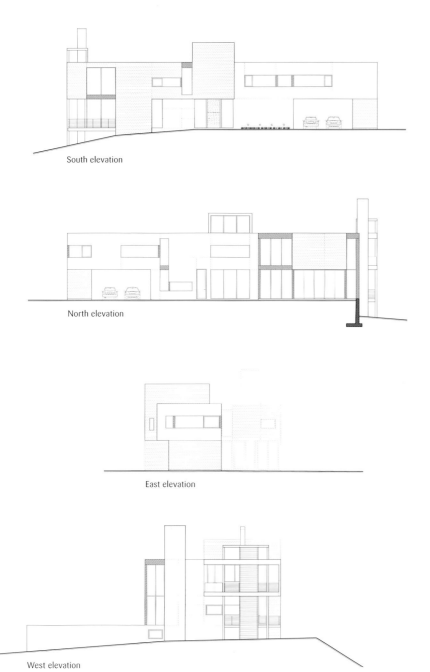

South elevation

North elevation

East elevation

West elevation

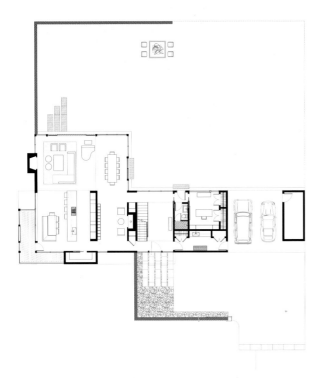

Ground floor plan

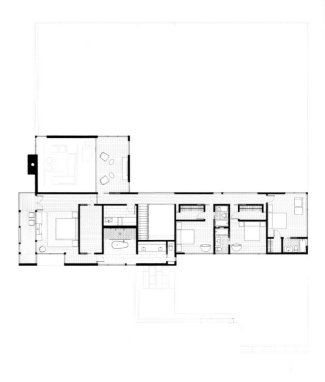

Second floor plan

013

An open plan ensures that light reaches deep into the house at all times of the day. A high ceiling further enhances the bright and airy atmosphere.

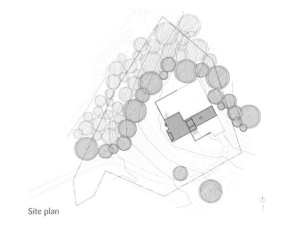

Site plan

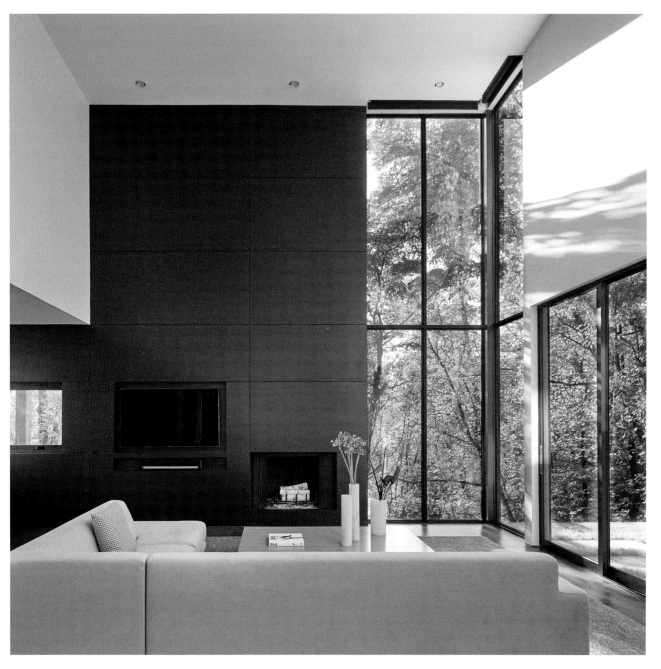

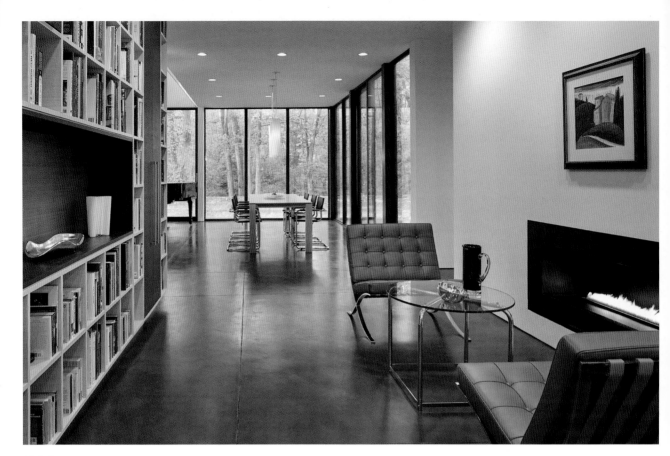

014

The design of the house minimizes
its environmental impact with
sustainable strategies, including
a concrete slab on the main floor
that provides passive solar energy
assistance and is stained dark to
increase solar gain and storage.

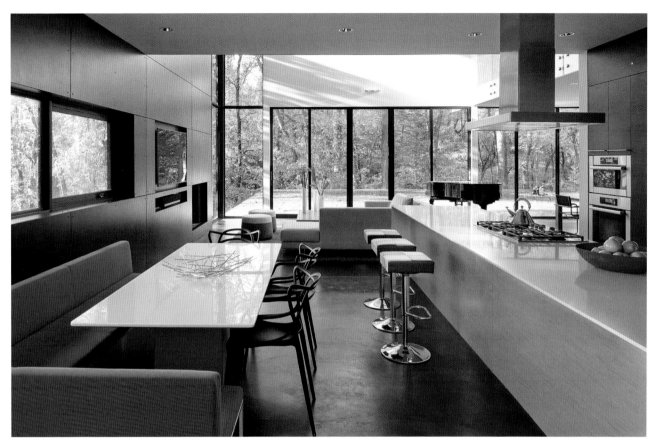

015

Other energy-efficient design features include operable windows and doors that provide natural ventilation and access to the outdoors.

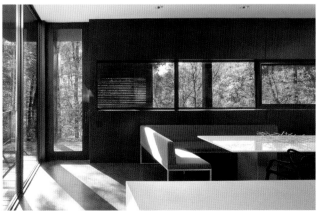

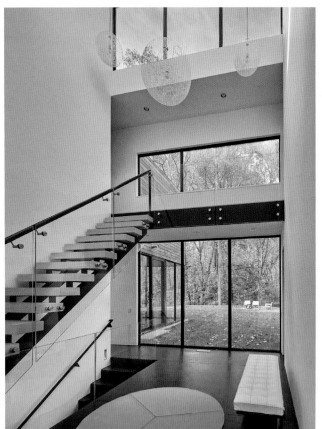
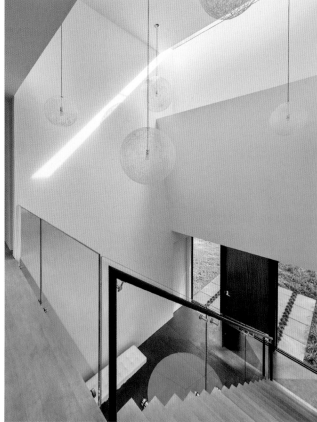

016

The minimalist aesthetic of the house interior plays well with the forested backdrop, enhancing a sense of calmness and desirable isolation.

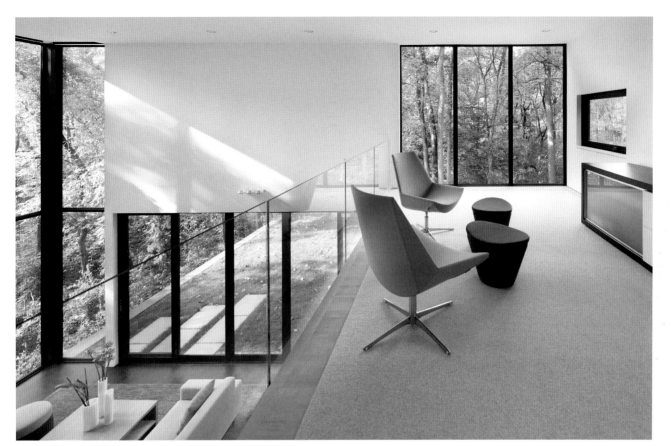

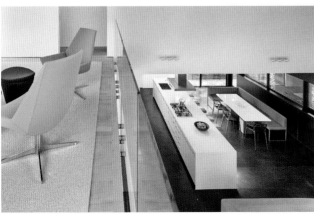

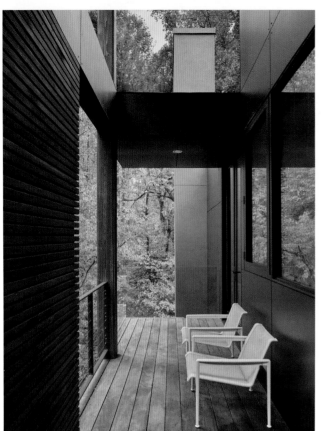
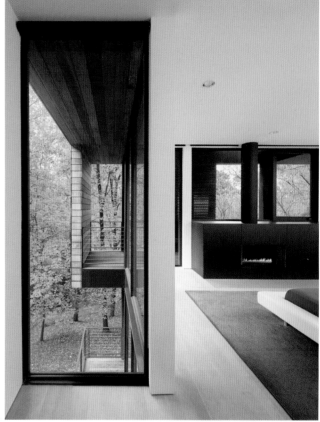

017

The succession and alignment of
spaces create a dynamic sequence
of indoor and outdoor views.
This design strategy contributes
to the integration of the natural
surroundings into the house.

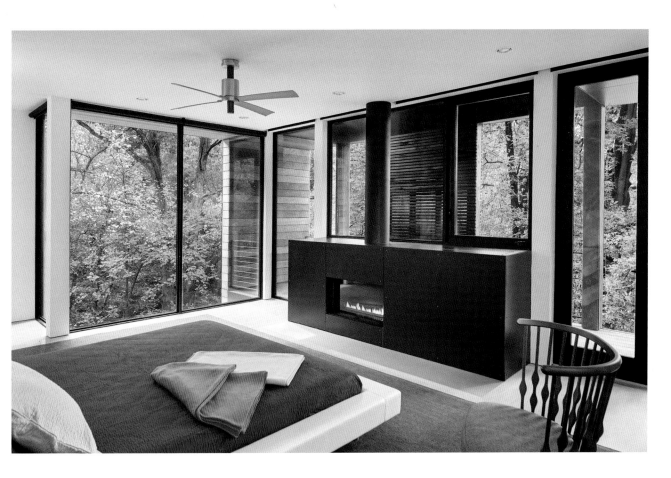

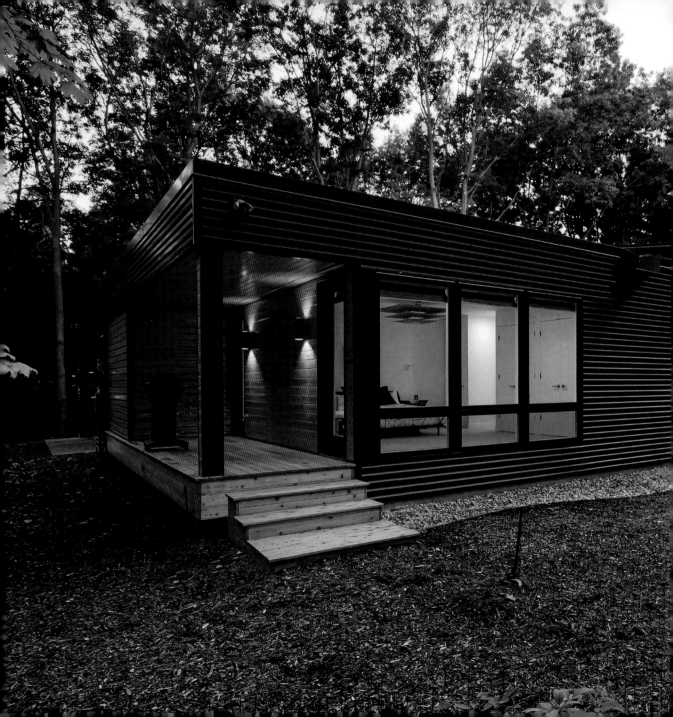

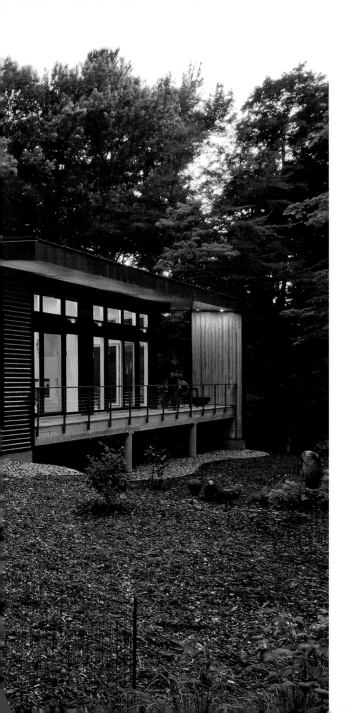

Bridge House

4,000 sq ft

Fennville, Michigan, United States

HAUS | Architecture for Modern Lifestyles; Marika Designs (Interior Design); TR Builders (Builder)

© HAUS | Architecture for Modern Lifestyles

Bridge House was initially designed as a vacation home for a couple of neuropsychology and therapy professionals who ultimately decided the area would be an excellent location for their next phase of life. Located south of Douglas and Saugatuck, the region has a rich history and culture rooted in the natural environment and art. The acquired land and the adjacent Pier Cove Valley were formerly owned in the late 1800s by the Chicago landscape architect O.C. Simonds, who introduced many unusual plant species to the area; it is now a protected nature and wildlife sanctuary. It was important to the owners that the design captured views while being sympathetic to the natural condition by limiting the environmental impact and treading lightly on the land. The owners were also inspired by the rolling topography and the coloration of the trees.

The natural preserve affords walking paths, natural habitat, and beautiful year-long views directly from the project site, a natural canvas to become immersed in an experience of nature and art.

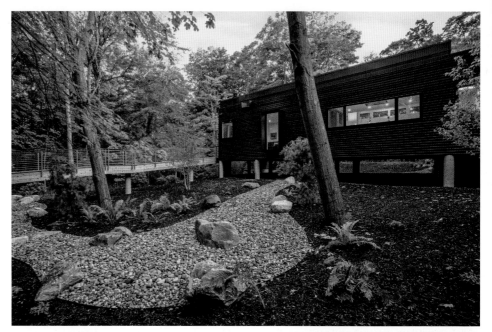

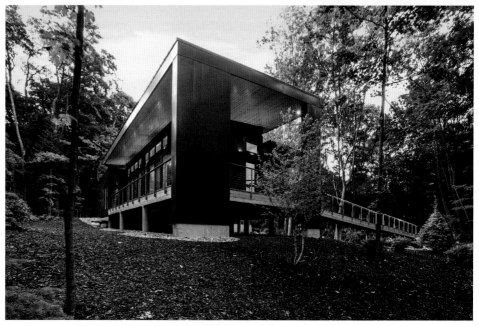

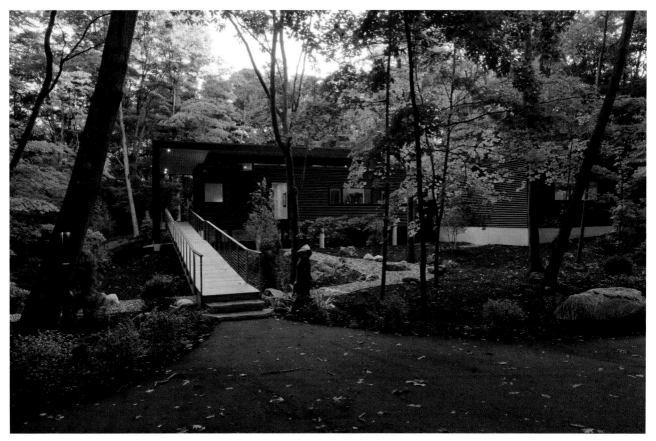

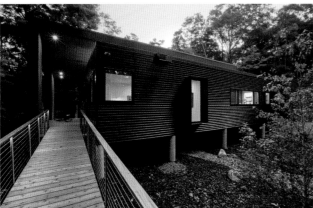

The house is accessed by way of an elevated entry bridge, inspiring visions of nearby jetties, past and present.

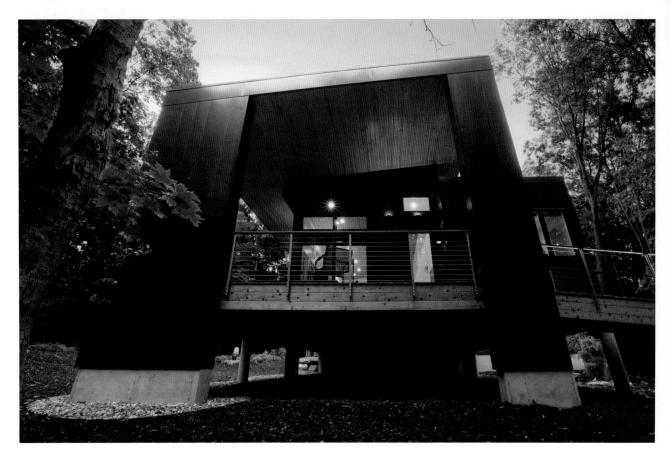

018

An elevated ceiling plane turns downward to become sheltering fin walls anchoring the west porch literally and figuratively while providing some protection from prevailing lake-originated gusts from the west.

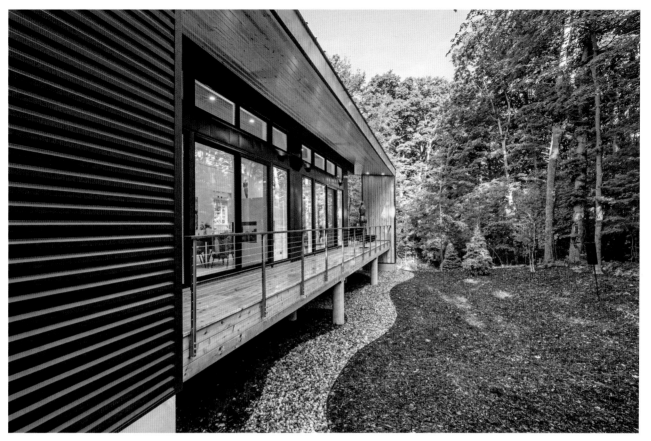

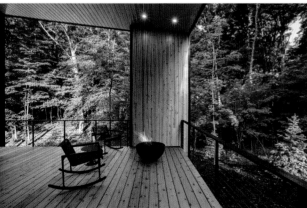

The dark bronze and black exterior cladding was directly inspired by the black walnut tree, whose bark varies from mid-gray to dark brown. The natural cedar decks blend with the pine fin walls and soffits, natural elements contrasting with the darker shell.

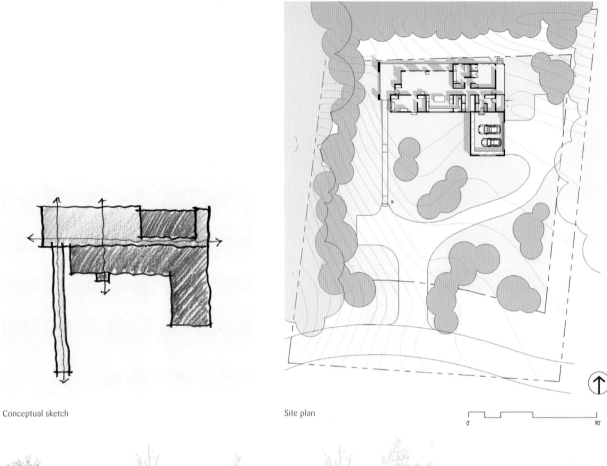

Conceptual sketch

Site plan

0' 90'

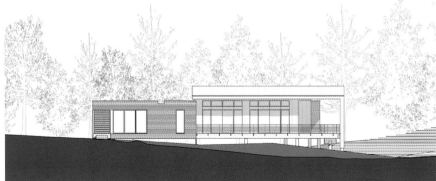

Elevation

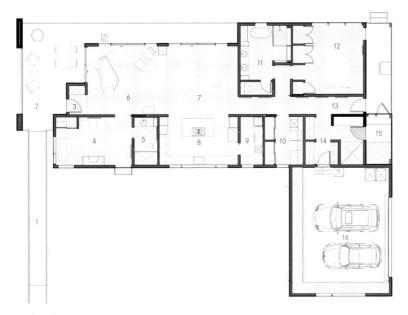

The west end of the house is elevated on pilotis above the natural terrain, while the east end is anchored to the ground. The living spaces are positioned on an east-west axis with views to the north and passive solar exposure to the south via clerestories.

Floor plan

1. Entry bridge
2. Porch
3. Entry
4. Guest/office
5. Bathroom
6. Living room
7. Dining area
8. Kitchen
9. Pantry
10. Laundry room
11. Master spa
12. Master bedroom
13. Hall/gallery
14. Mudroom
15. Dog run
16. Garage

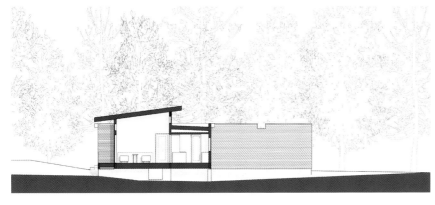

Section

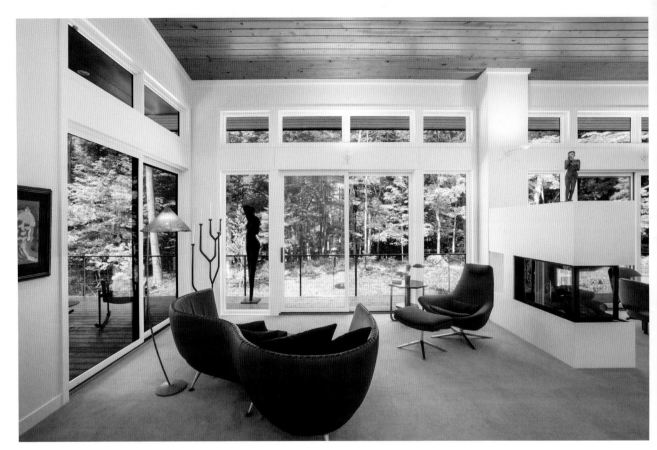

The design focuses paths on views of nature, inside and out, while also accommodating art and artifacts, classic furniture, and lighting.

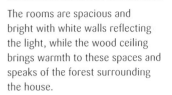

The rooms are spacious and bright with white walls reflecting the light, while the wood ceiling brings warmth to these spaces and speaks of the forest surrounding the house.

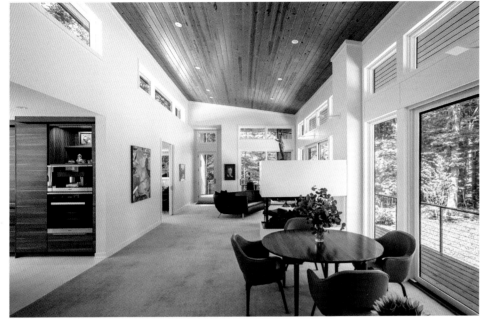

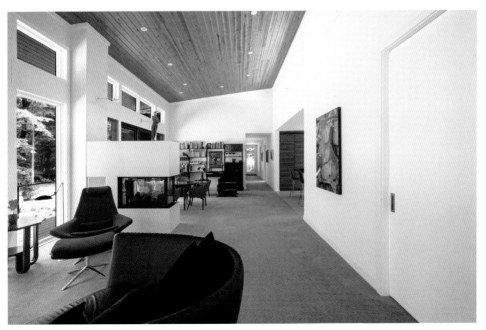

020

The kitchen island adds an ethereal touch to the room, reflecting the light from the windows above a three-bay sink. Its lightweight appearance contrasts with that of the full-height dark wood cabinets.

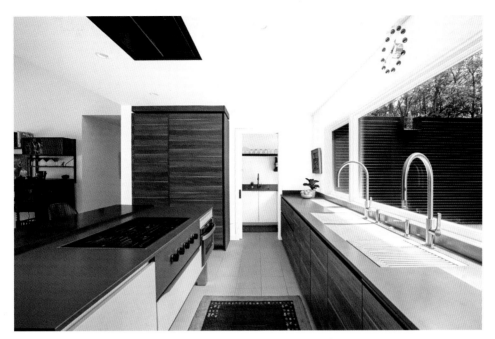

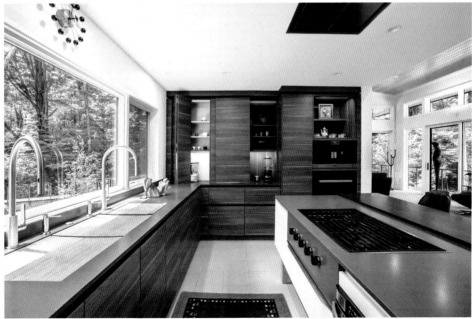

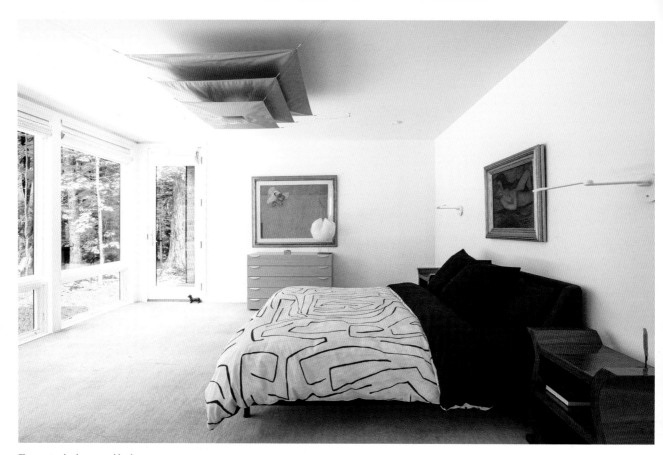

The master bedroom and bathroom are simply furnished and fitted so as not to compete with the views of the surrounding woods.

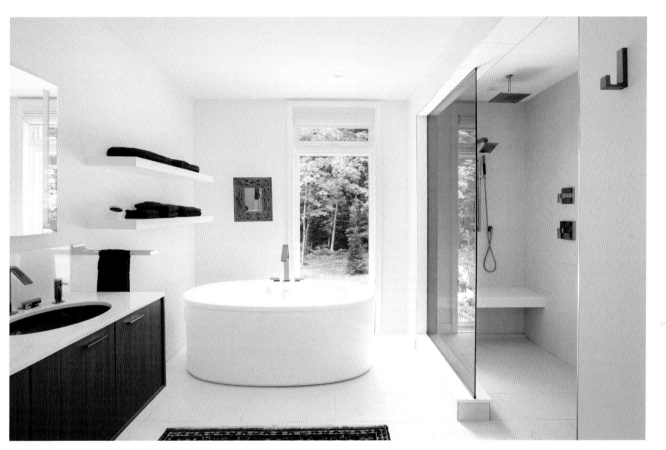

021

The clean look of the bathroom harmonizes with the greenery outside, creating a serene and soothing atmosphere, a place where one would want to spend time soaking in the tub.

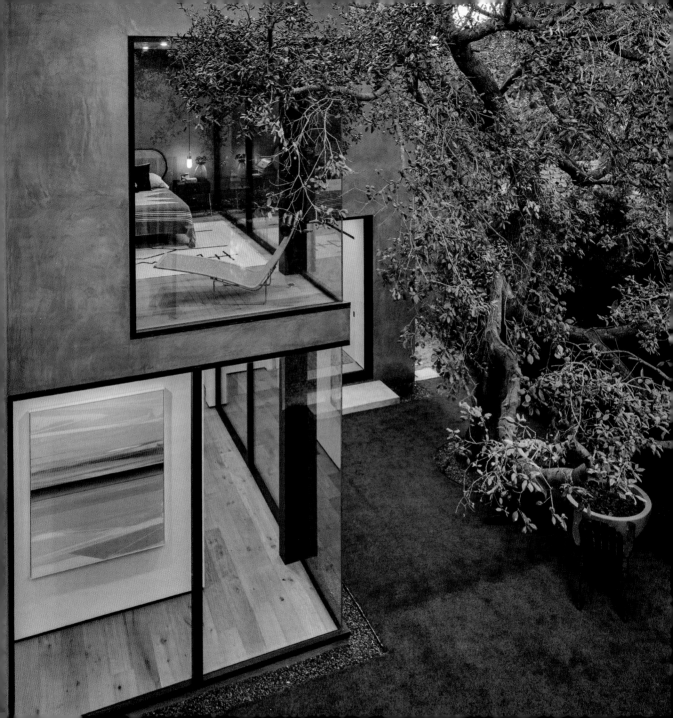

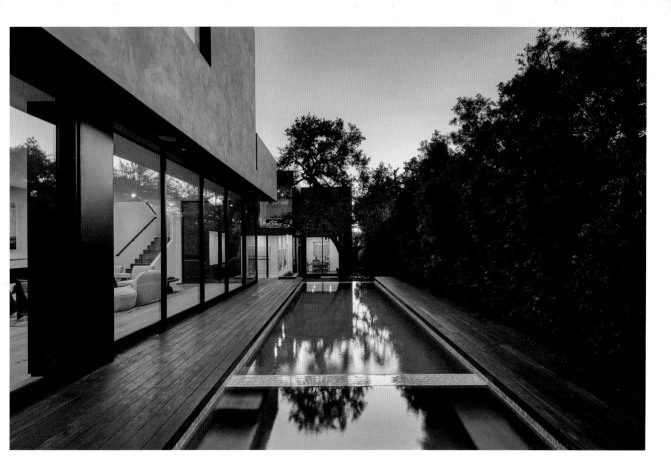

The story of this house begins with a tree: a one-hundred-year-old oak anchoring the back third of the lot. Hsu McCullough was inspired by its twisting, broad canopy to design the new home with both interior and exterior spaces opening to its glory. Once inside, it is clear the intent was to create a private oasis: a courtyard house tethered to an existing majestic oak tree sitting at the lower portion of the property with a swimming pool, wood deck, and tall landscape edges. The spaces were carefully positioned to naturally follow the descending grade of the property while maintaining an outward gaze to the outdoor living space. The owners can see other rooms beyond and at different floor elevations due to the C-shape house footprint.

Grand View Oak Residence

5,200 sq ft

Los Angeles, California, United States

Hsu McCullough

© Dan Arnold, Tim Hirschmann

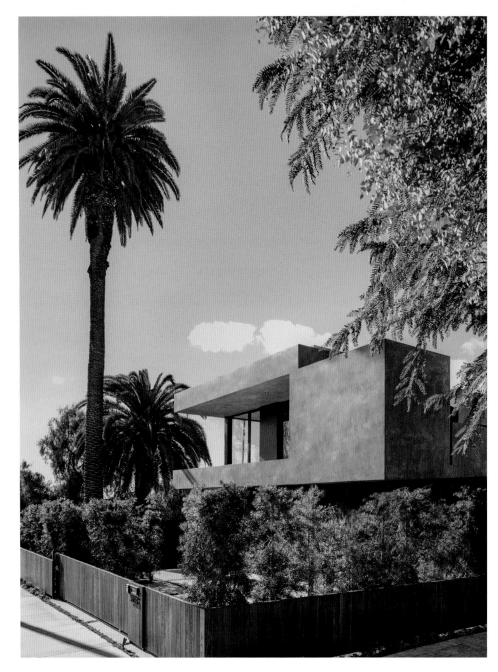

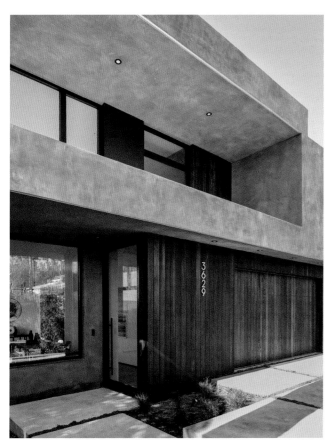

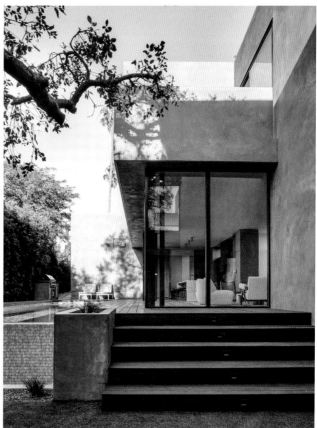

From the street, a simple facade highlights smooth stucco with a deeply carved recess combined with walnut-hued ash vertical wood siding that disguises a descending hillside property and elongated home beyond.

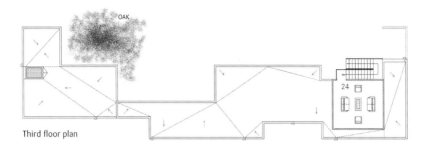

Third floor plan

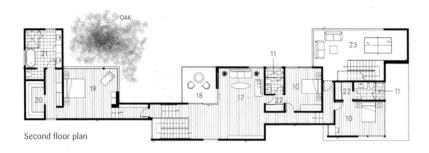

Second floor plan

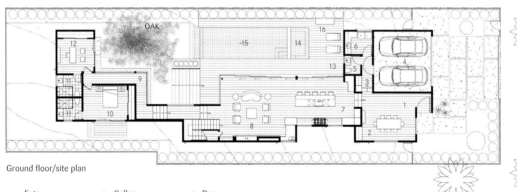

Ground floor/site plan

1. Entry	9. Gallery	17. Den
2. Dining room	10. Bedroom	18. Patio
3. Mudroom	11. Bathroom	19. Master bedroom
4. Garage	12. Study	20. Master closet
5. Powder room	13. Deck	21. Master bathroom
6. Laundry room	14. Spa	22. Closet
7. Kitchen	15. Pool	23. Patio deck
8. Family room	16. BBQ area	24. Roof deck

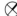

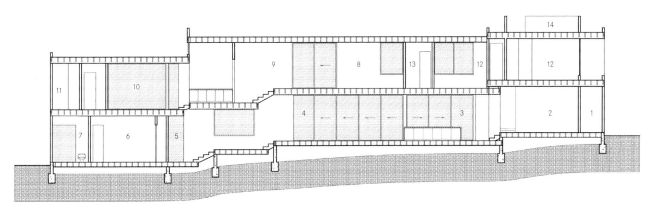

Section

1. Entry
2. Dining room
3. Kitchen
4. Family room
5. Gallery
6. Bedroom
7. Bathroom
8. Den
9. Patio
10. Master bedroom
11. Master closet
12. Bedroom
13. Closet
14. Roof deck

022

There are several interior floor level changes along the entire length of the house—created by placing short flights of stairs in key positions—treating the occupants to novel apertures as they move through the house.

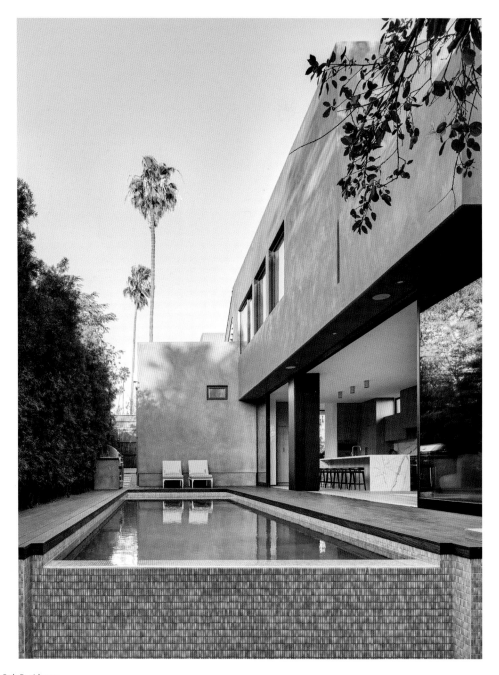

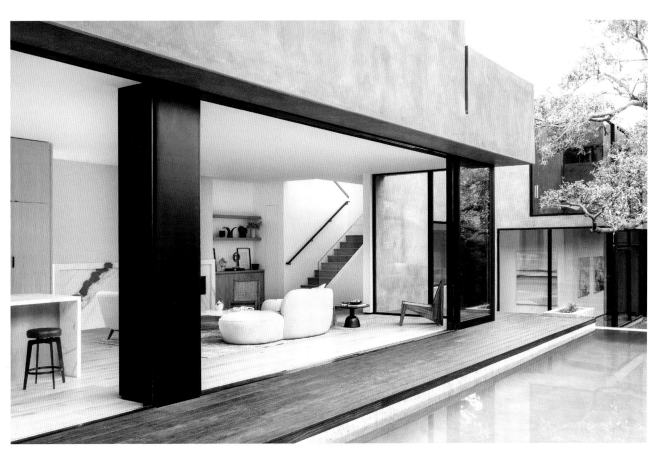

023

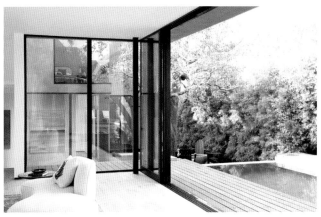

A wood deck matching the exterior wood siding wraps the pool and provides space for an outdoor kitchen/BBQ area. This deck is also connected to the kitchen and living room by a long run of multislide glass doors, blurring the threshold of the interior and exterior while offering fantastic natural light.

Transparency is a prominent design element of the house, enhancing the perception of spatial depth and revealing layered spaces and materials.

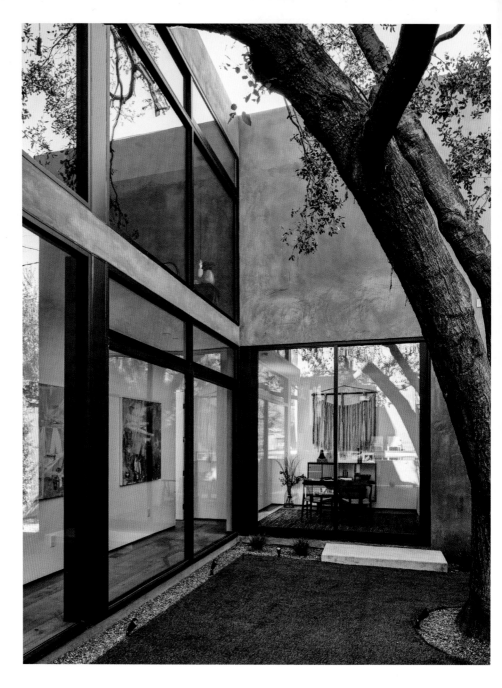

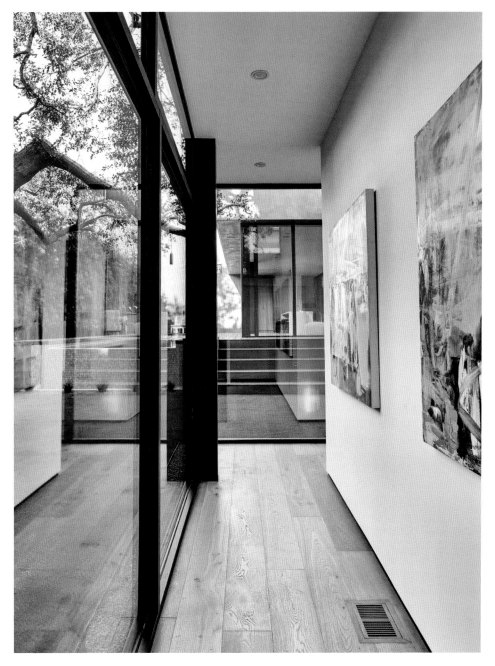

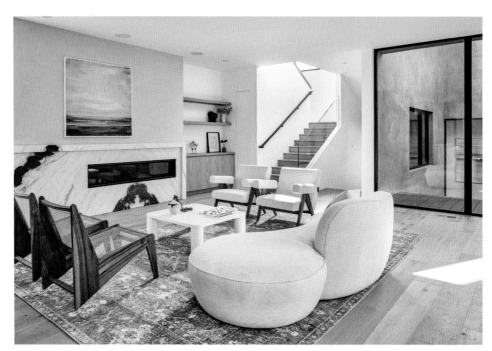

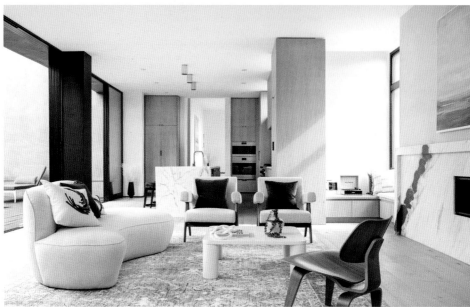

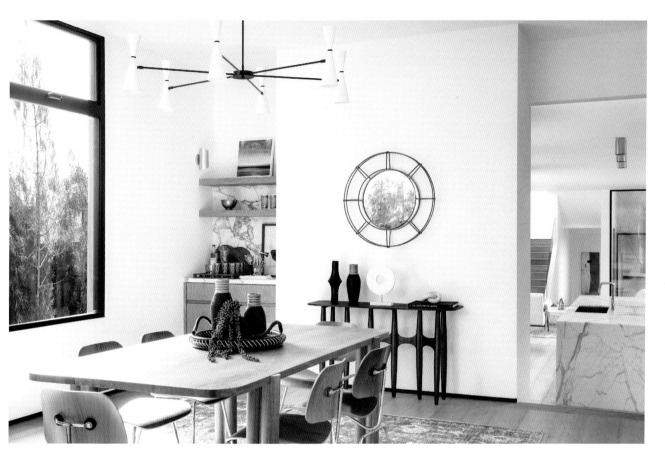

024

The configuration of the spaces encourages fluid circulation and allows for long sightlines that spotlight the spatial qualities of the house.

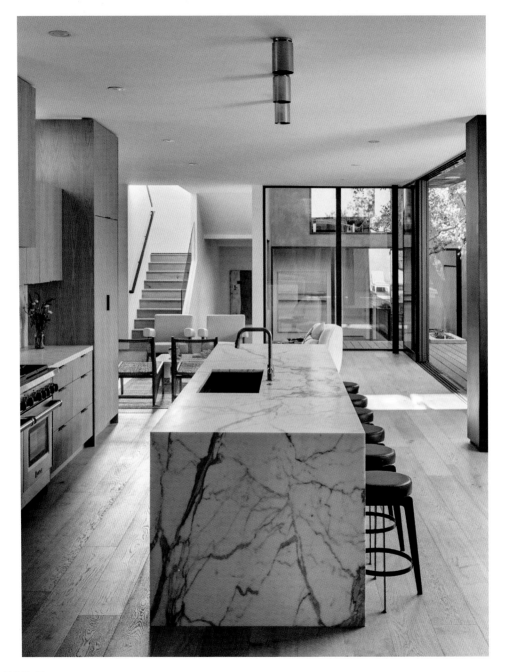

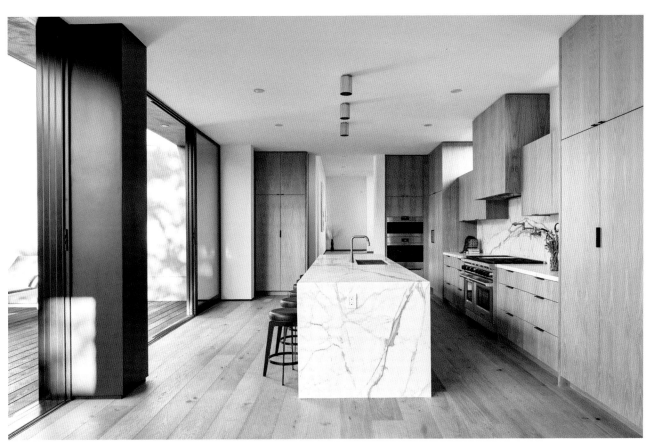

025

The kitchen in white oak and Calacatta marble opens up to the pool deck. It is conceived as a social area where family and friends can gather around the island or step out to the deck.

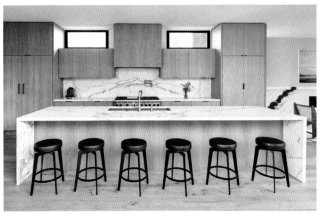

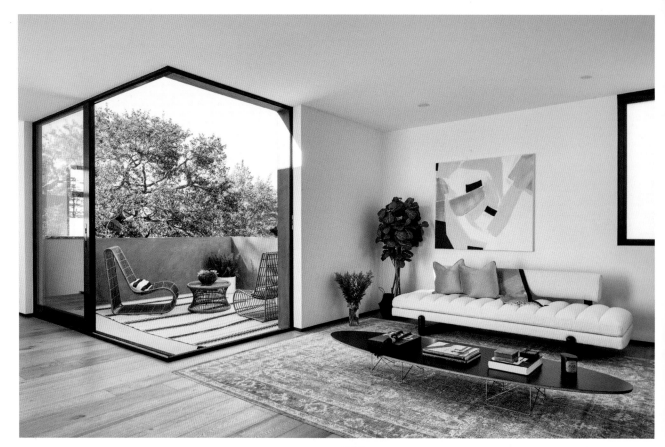

026

The various decks at different levels offer opportunities for diverse activities, from entertaining to lounging, yoga practice, and Ping-Pong tournaments.

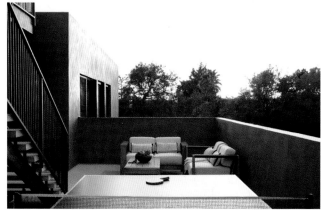

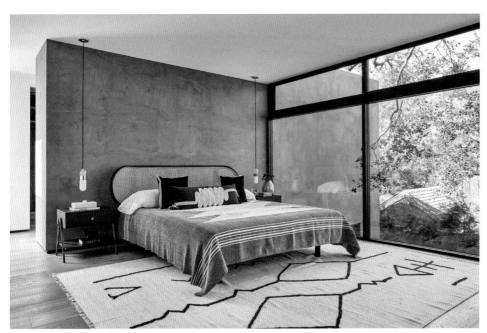

Hsu McCullough designed the primary bedroom with floor-to-ceiling glass extending the oak tree canopy into the room. To amplify the drama, a corner fireplace clad in "Nero Marquina" book-matched marble frames glimpses of the swimming pool and deck below.

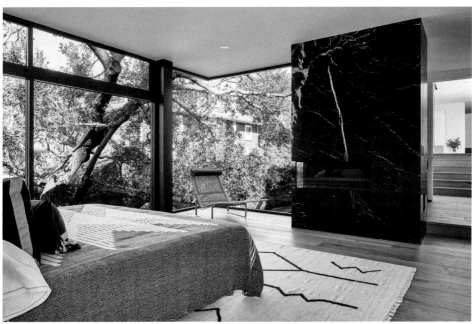

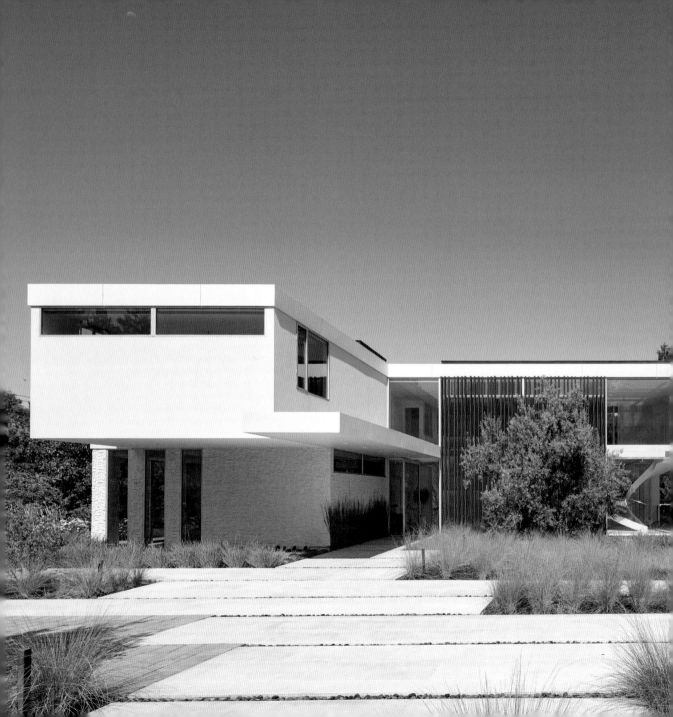

Atherton Residence

Main house: 8,819 sq ft
Pool house: 526 sq ft
Garage: 730 sq ft

Atherton, California,
United States

Mark English Architects

© Bruce Damonte

The Atherton House is a family compound for a professional
couple in the tech industry and their two teenage children. After
living in Singapore, then Hong Kong, and building homes there,
they looked forward to continuing their search for a new place
to start a life and set down roots. The site is located on a flat,
one-acre lot. The neighboring lots are of a similar size and are
filled with mature planting and gardens. The brief was to create
a house that would comfortably accommodate the busy lives of
each of the family members, as well as provide opportunities for
wonder and awe. Views on the site are internal. The main design
goal was to create an indoor-outdoor home that embraced the
benign California climate.

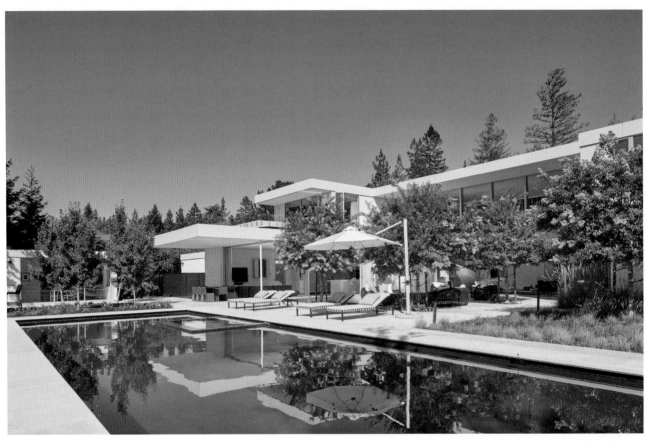

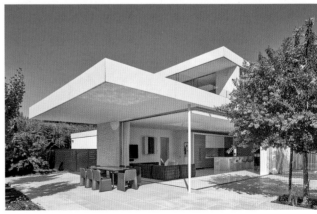

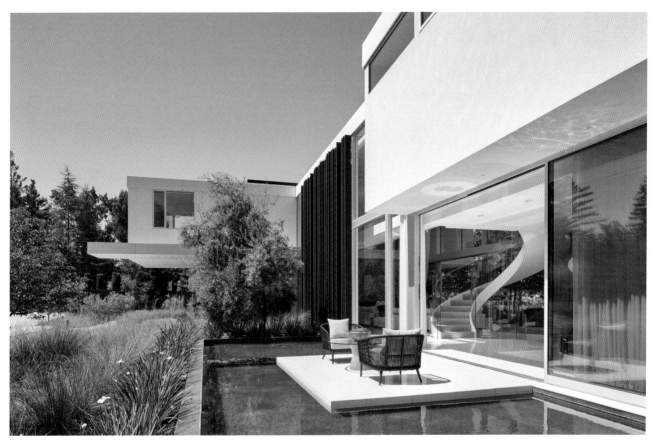

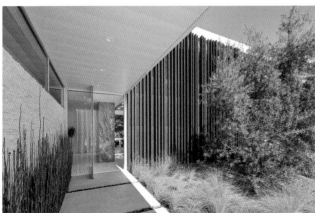

The front (east) wall is the all-important receiving place for guests and family alike. There, the interplay between yin and yang, weathering steel, and the mature olive tree empower the entrance. Most other materials are white and pure.

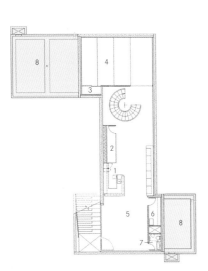

Basement floor plan

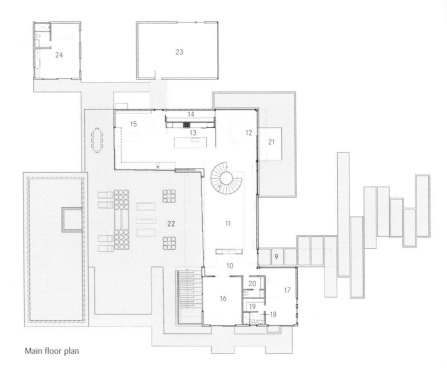

Main floor plan

The building was conceived as a classic H plan with two wings attached by a double-height entertaining space. The H shape allows for the mass of the building to embrace alcoves of the yard. These alcoves create different types of exterior spaces that can provide shelter from the prevailing winds and privacy.

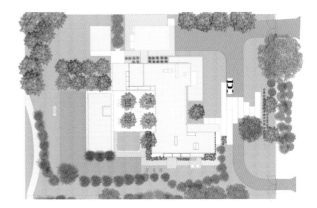

Site plan

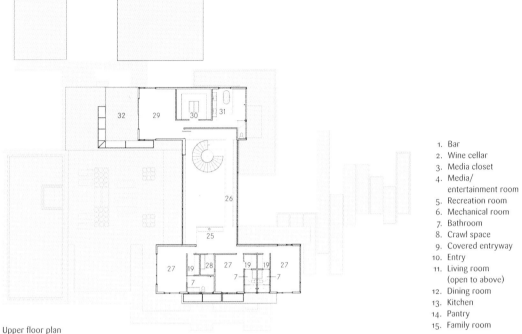

Upper floor plan

1. Bar
2. Wine cellar
3. Media closet
4. Media/
 entertainment room
5. Recreation room
6. Mechanical room
7. Bathroom
8. Crawl space
9. Covered entryway
10. Entry
11. Living room
 (open to above)
12. Dining room
13. Kitchen
14. Pantry
15. Family room
16. Library/study
17. Guest bedroom
18. Guest bathroom
19. Walk-in closet
20. Powder room
21. Deck
22. Courtyard (to pool)
23. Garage
24. Pool house
25. Study
26. Walkway
27. Bedroom
28. Laundry room
29. Master bedroom
30. Master closet
31. Master bathroom
32. Terrace

027

The two wings of the home provide a sense of enclosure and privacy along the side property lines. The yard alcoves that this shape generates allow for a variety of outdoor spaces with their specific function and character ranging from public to private.

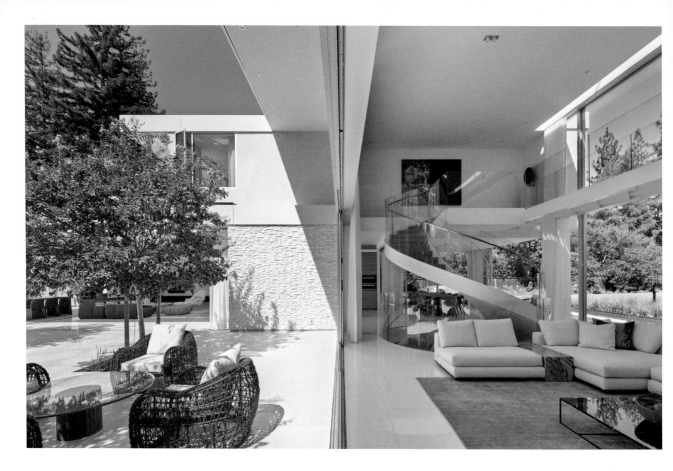

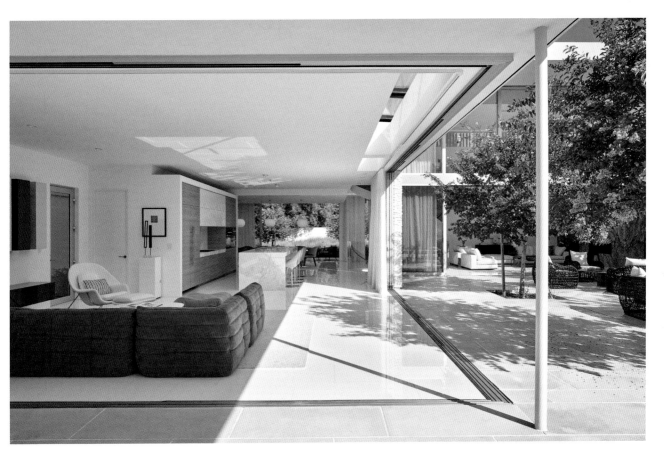

028

Pocket sliding glass doors on the main floor dissolve the boundary between inside and outside. A subtle difference in texture and color in the flooring and the pavement further reinforces the continuity from interior to exterior spaces.

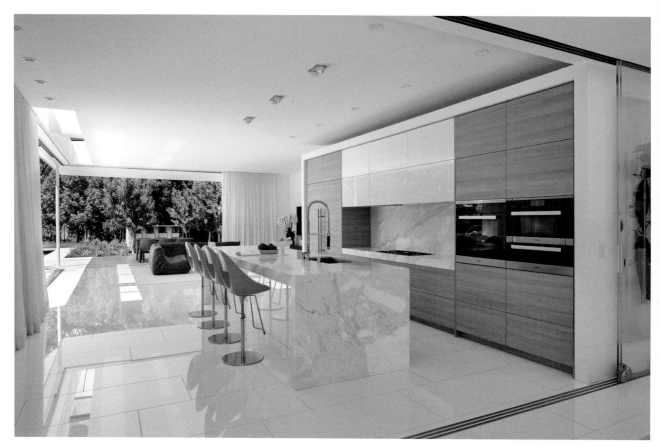

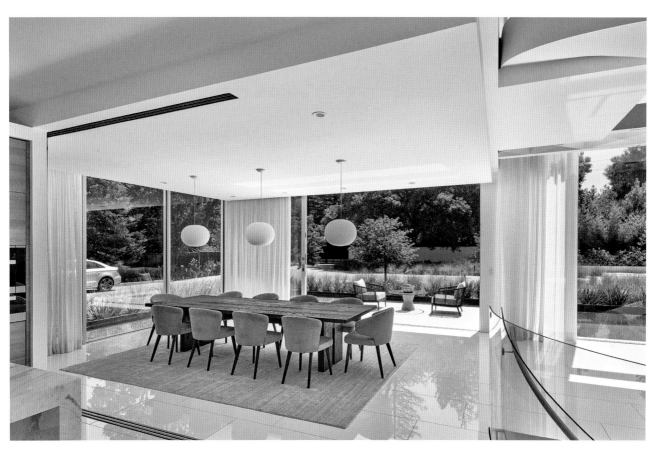

029

The abundance of glass gives the dining room a pavilion-like atmosphere and minimizes the indoor-outdoor separation.

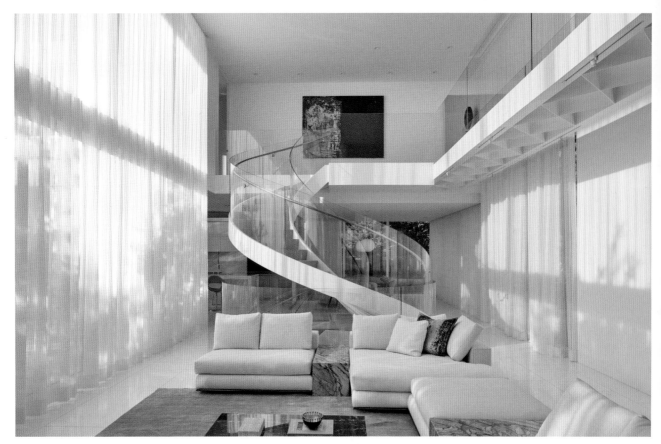

Connecting the wings is a double-height living space meant to be comfortable, delightful, and awe-inspiring. A custom fabricated two-story glass and steel spiral staircase connects the upper level to the main floor and down to the basement's lounge below.

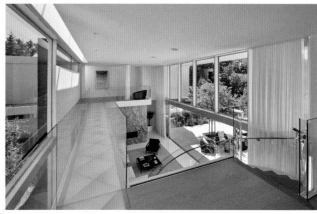

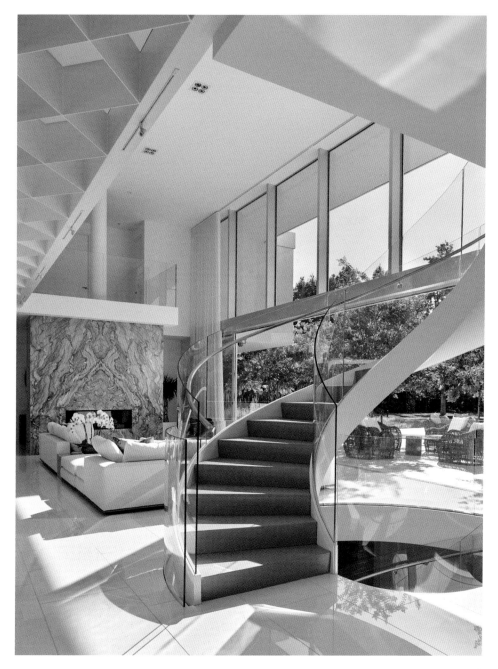

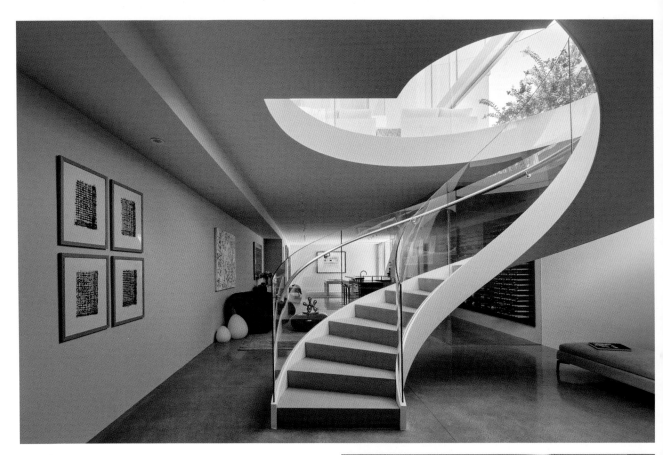

030

Staircases can add character to spaces. Their form, materiality, and positioning can transform an otherwise nondescript, plain staircase into a conspicuous feature that highlights the architectural language of an overall house design.

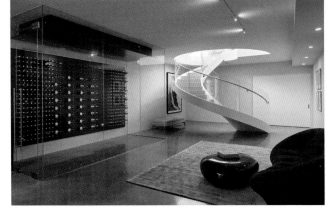

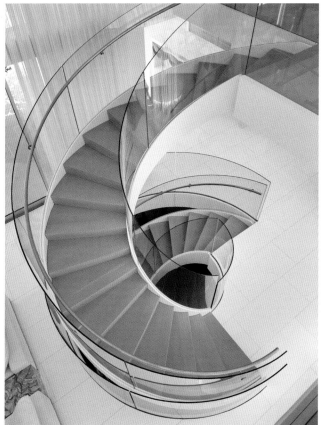

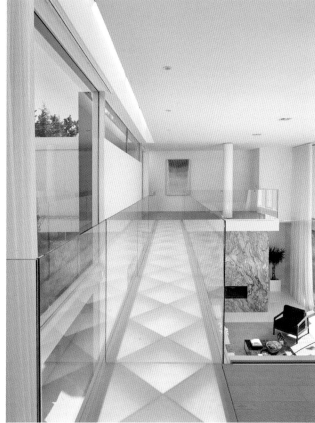

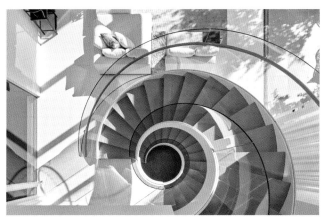

An acrylic and steel bridge starts at the staircase landing and flies forty feet to the children's bedroom wing. People going about their day moving through the stair and bridge become both observed and observers.

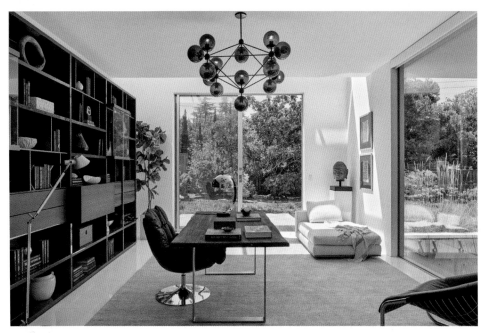

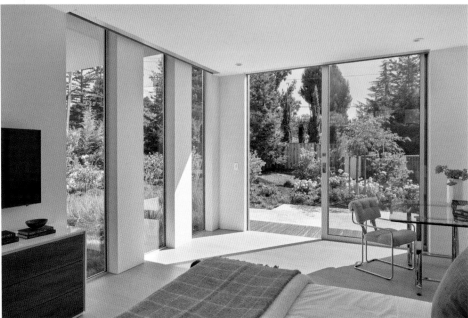

Like the spiral staircase, circular skylights invoke the yin and yang. This philosophical reference is a recurring theme used in the design, including the interplay between the mature olive tree and the weathering steel as interconnected opposite forces.

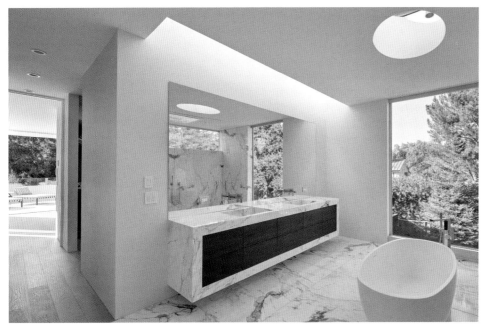

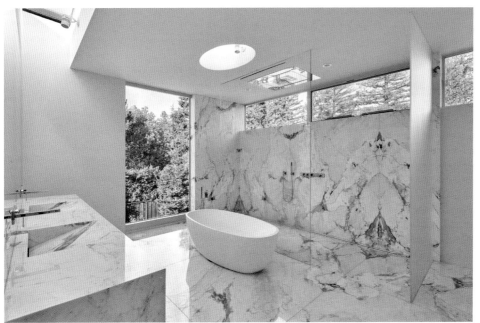

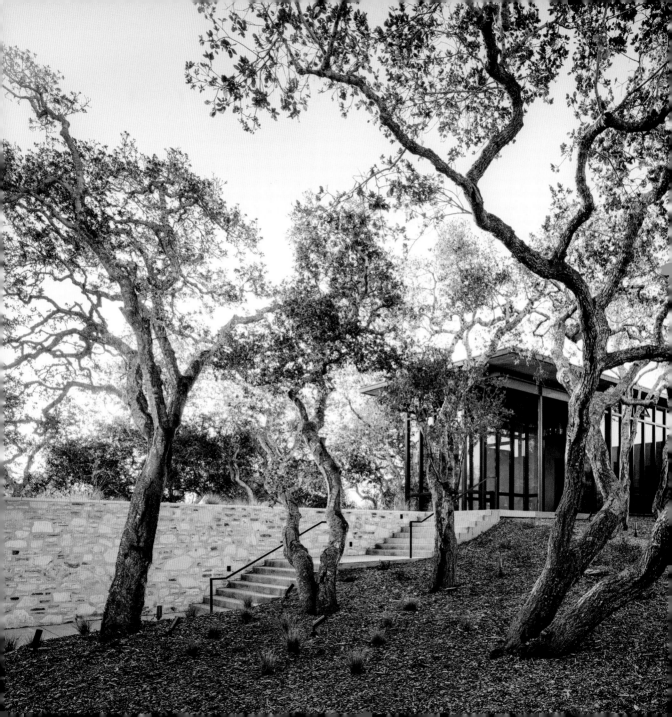

Tehama 1

Main house: 3,521 sq ft
Guesthouse: 600 sq ft

Carmel Valley, California,
United States

Studio Schicketanz

© Joe Fletcher Photography

Studio Schicketanz organized the design of this house around
a central cleared knoll, prioritizing outdoor space with a deep
exploration for the ways a structure can merge with a specific
ecology. The architects chose to abandon an existing driveway in
favor of keeping the knoll as open space for a courtyard garden.
Textured stone walls give rise to controlled cement steps leading
to a crisply modernist structure. Detailed geometric framing and a
cantilevered roof create a shaded trellis that wraps the structure.
Light is at play everywhere, from the dappled light that hits the
stone walls to the reflection of the majestic neighboring tree
along the house's expansive glass facade. The result is a uniquely
vernacular modern architecture.

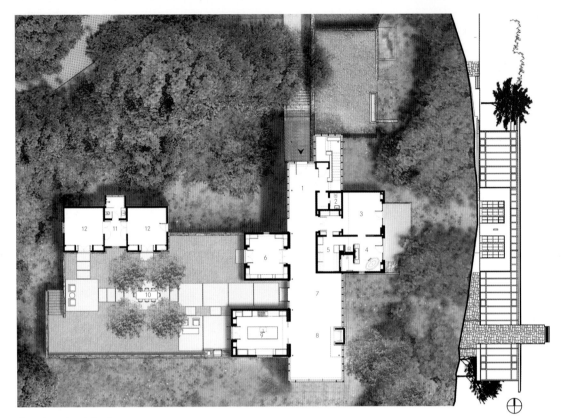

Floor plan and east elevation

1. Entry
2. Powder room
3. Master bedroom
4. Master bathroom
5. Master closet
6. Library
7. Dining area
8. Living room
9. Kitchen
10. Patio
11. Guest hall
12. Guest room

The garage was built underground with a green roof and shielded by a stone wall. This wall leads up to the guest entry and transitions into the base for the home above.

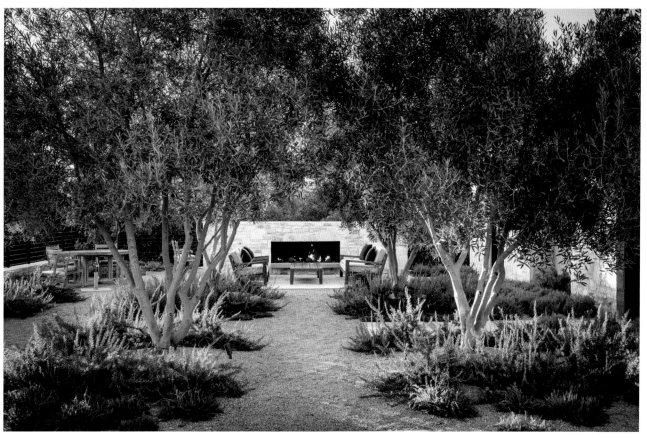

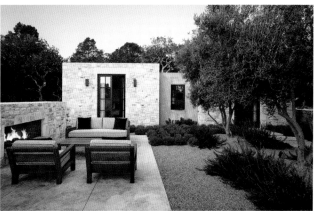

Two stone cubes house guest rooms and frame the courtyard garden to the north. Beyond the courtyard walls, the landscape was left natural.

The house is organized into a fourteen-foot-high rectangular glass and wood structure running north-south at the forest's edge. This "public space" of the home relates to the surrounding nature and spectacular views. The more solid plaster cubes penetrate the glass and offer intimate spaces for retreat.

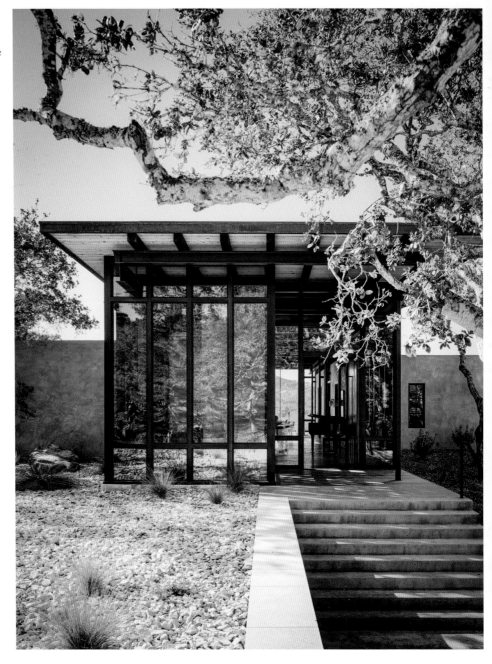

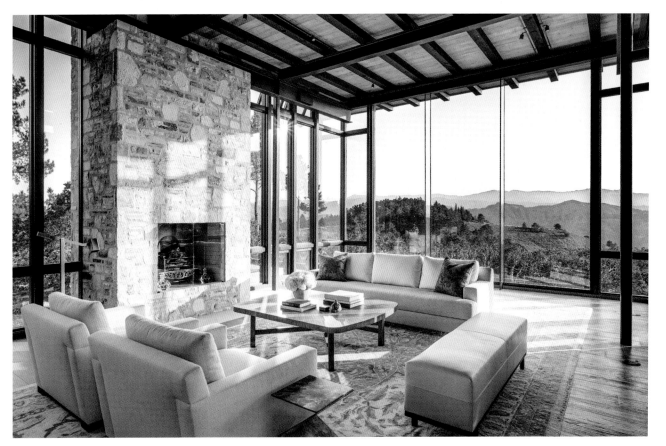

032

The floor-to-ceiling windows enhance the open character of a space even more so when juxtaposed with a massive stone fireplace. Over this great room, the ceiling seems to hover above it.

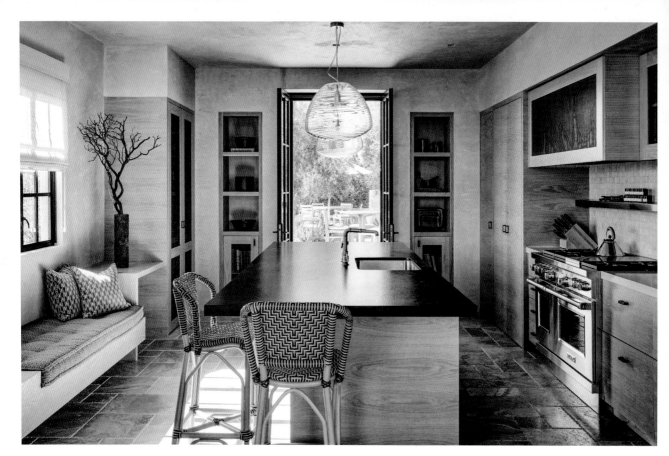

033

Built-ins are space-efficient home design features. Their design can adapt to any aesthetic, achieving a clean and seamless look.

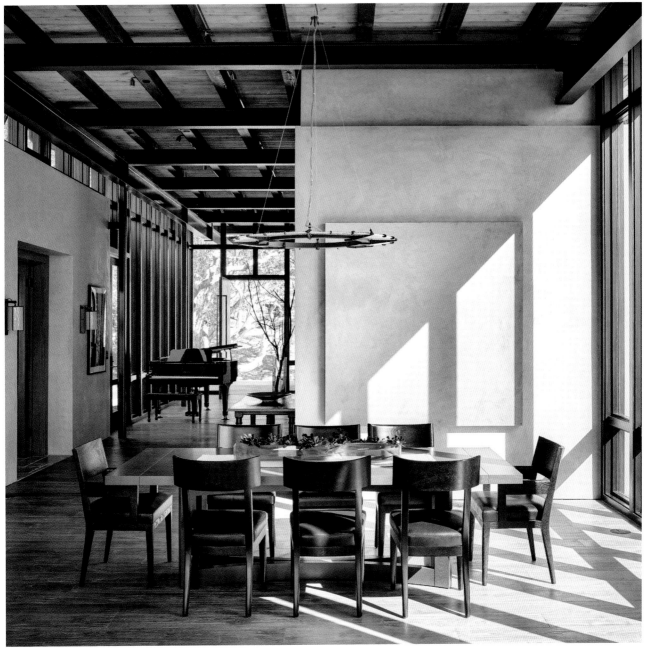

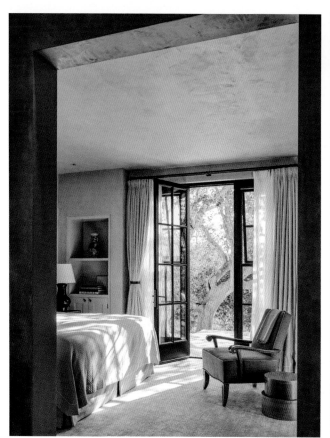
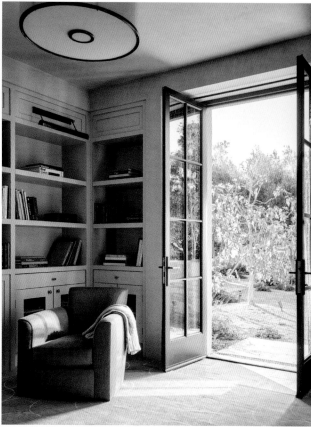

034

French doors are known for adding charm and symmetry to traditional homes. In this context, their elegance complements the warm, relaxed, and comfortable feel of the guesthouse's rustic chic decor.

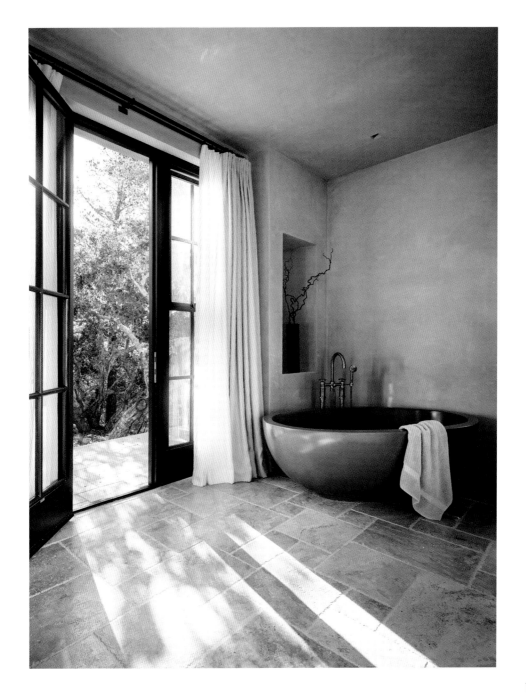

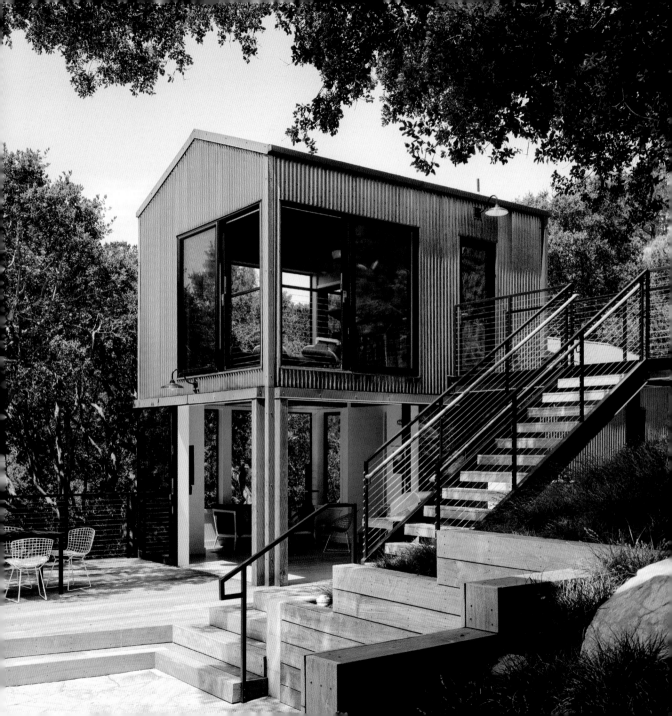

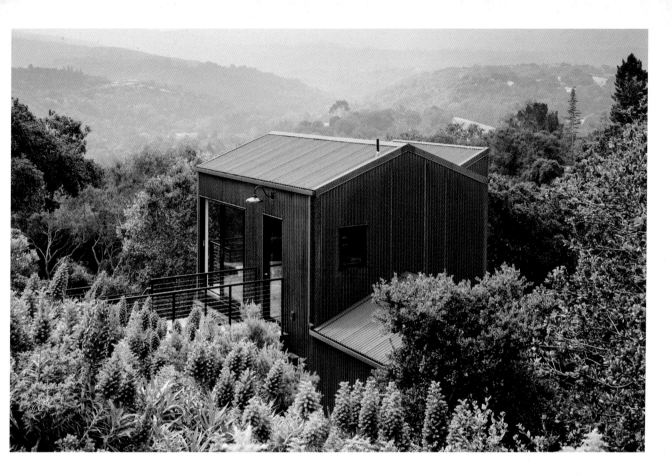

This home for a couple starting a family pulls elements from its woodland surroundings, which allow it to blend into the landscape. The owners purchased the existing home taken by its mid-century charm and its incredible views. The exterior is finished with burnt cedar siding and stucco, creating an earthy tone, while the interior features significant design moves, including the addition of large floor-to-ceiling windows and a wraparound balcony off of the dining room, taking in the landscape and abundant natural light. For Malcolm Davis, it was an incredible opportunity to work with clients who share his deep appreciation and love for the California landscape and the lifestyle that it allows.

Portola Valley Residence

House: 3,671 sq ft
Guesthouse: 747 sq ft

Portola Valley, California, United States

Malcolm Davis Architecture

© Joe Fletcher Photography

South elevation

Lower level floor plan

Upper level floor plan

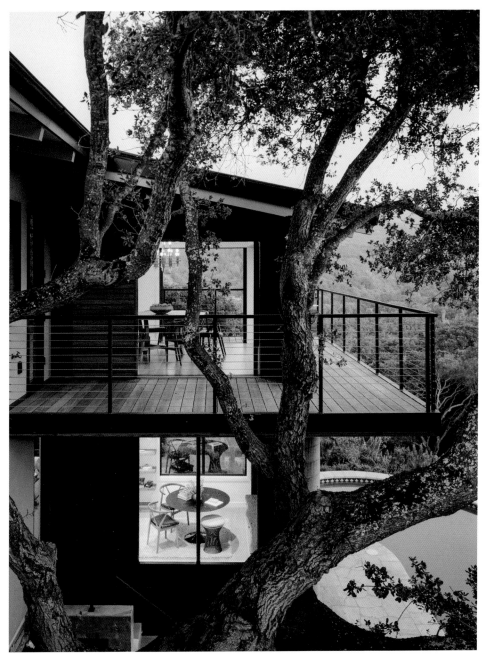

The house was originally designed around an existing oak tree. While its upper level was already sited nicely for the views, Malcolm Davis Architecture dropped the floor at the lower level to take advantage of the natural sloping site. This allowed for the creation of a spacious media room and guest suite on the lower level that connects directly to the outdoor swimming pool.

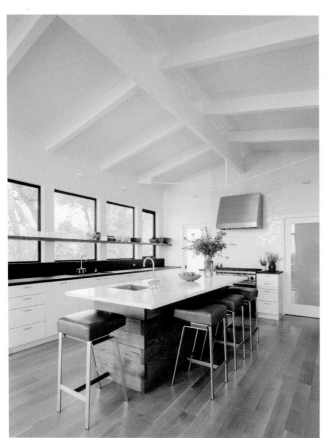
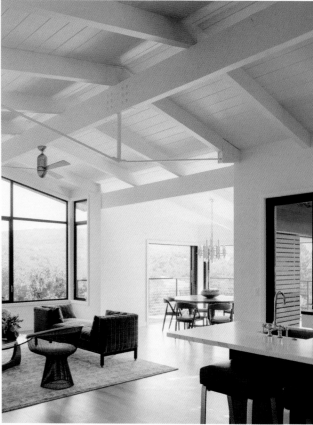

035

The central kitchen, which is the heart of the home, was enlarged through the removal of existing posts that were then replaced with tension rods and trusses, creating a spacious area perfect for hosting family and friends.

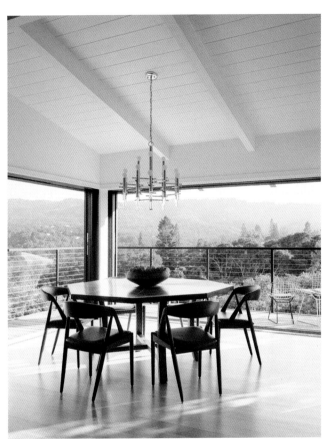
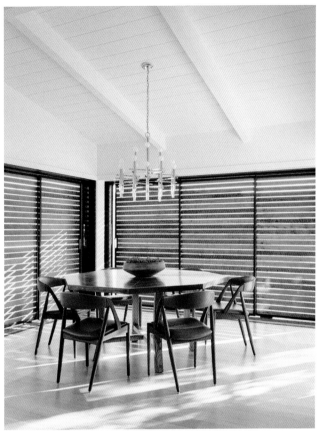

036

Wrapped with a new balcony, the dining room has custom sliding glass panels, wood and steel shutters, and retractable screens on three sides. This one space now allows for multiple dining experiences—the homeowners can dine inside a glass box, a shuttered pavilion, or a screened-in porch.

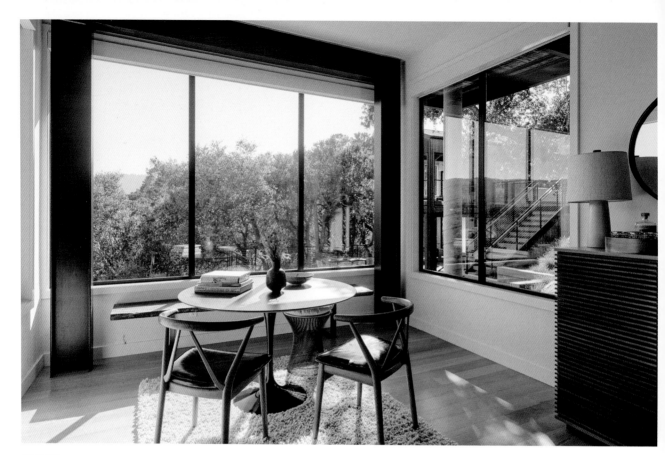

037

Dropping the floor in the lower level media room enhances the feeling of spaciousness in the room with taller ceilings and increased natural light.

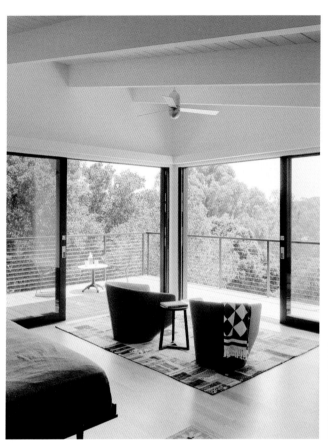

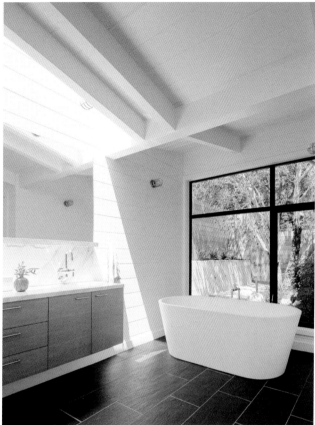

038

Every room in the house is connected with the outdoors. While the master bedroom takes in long valley views above the tree canopy, the master bathroom overlooks a private patio.

The detached guest suite and studio building on the west side of the original property is a renovation and addition to an existing pool house. Clad in corrugated metal siding, it mimics the natural tones of the surrounding landscape.

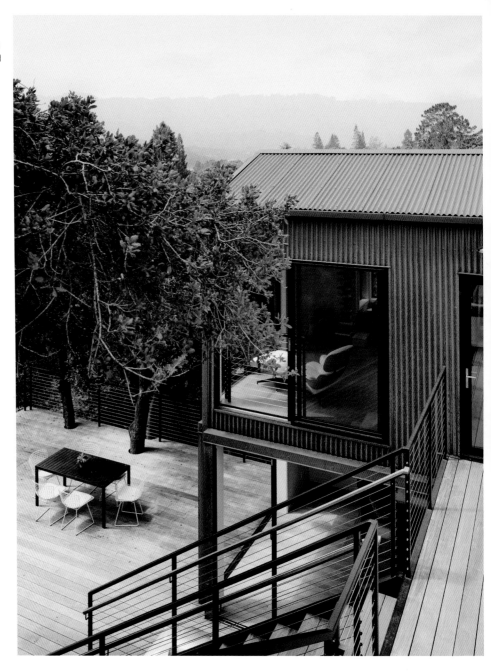

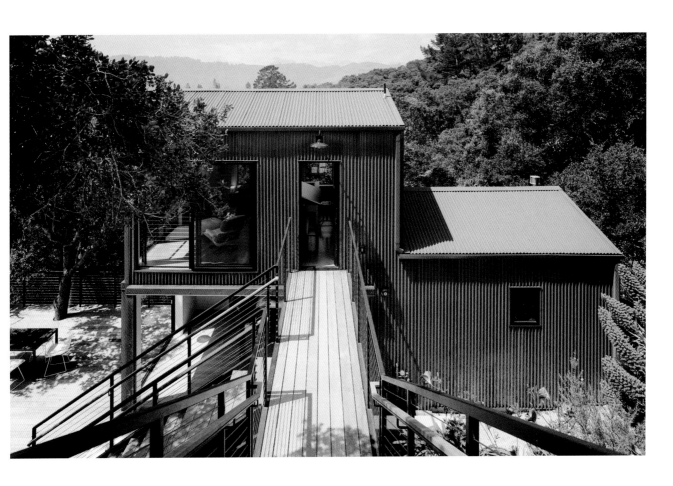

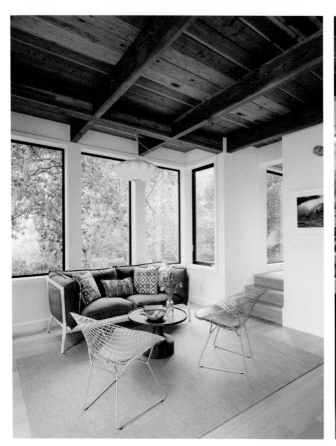
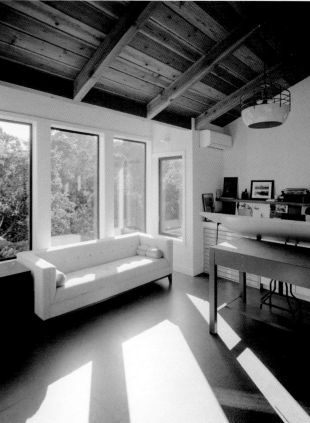

The art studio on the top floor of the new structure takes in the long views above the tree canopy. The room is flooded with natural light. Below is the guest suite connected to a sitting area with direct access to the outdoor pool.

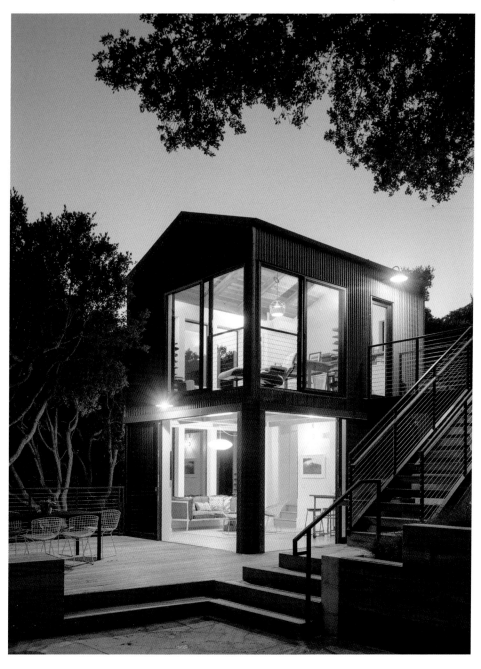

The design for the Portola Valley Residence conveys an earthy, modern California vibe, exemplifying Malcolm Davis Architecture's sophisticated yet seemingly effortless style.

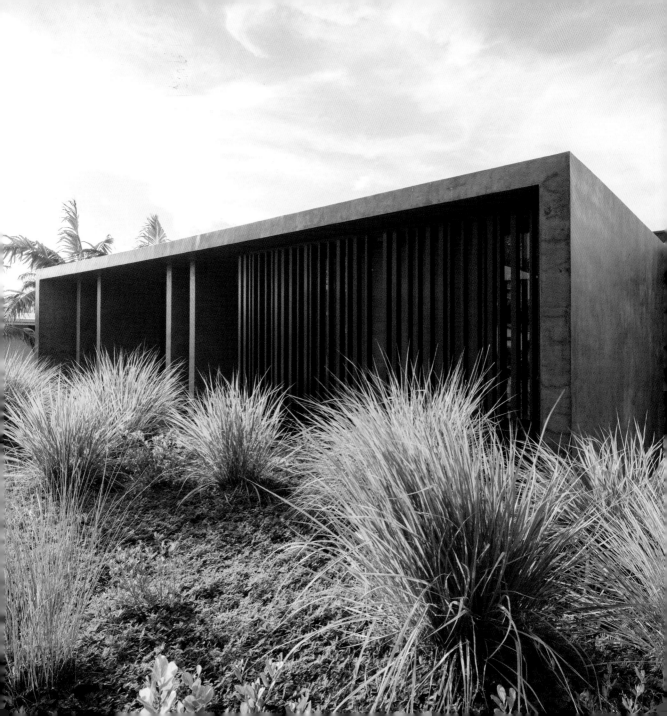

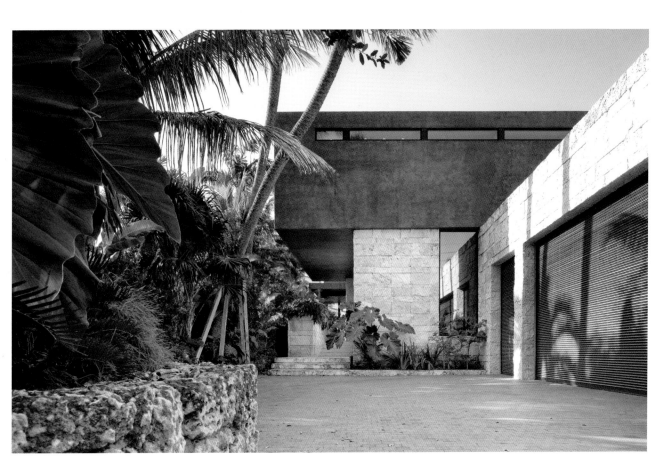

This residence is a sophisticated take on the "tropical modern" aesthetic. Situated on an island lot with privatized and protected views of the water, the site and climatic considerations resulted in a design that provides breezes and ample sunlight for the outside living areas. Transparency and privacy are carefully balanced. With its understated shape, form, and size, the property's facade is pronounced by its depth, but minimal in its grandeur. The one-story structure's massing facing the street is minimized while offering an intriguing yet inviting appearance. Deep overhangs, highly detailed louvered panels, and careful detailing using a smooth fly-ash concrete finish define this Miami Beach home and add to its unique symmetrical design.

Sunset One Residence

4,700 sq ft

Miami Beach, Florida, United States

Strang Design (Architecture) and Tatiana Moreira, StyleHaus Design (Interior Design)

© Robin Hill, Claudio Manzoni

Elevations

039

Good design brings together all the features for effective function and aesthetics. This house features a series of vertical fins that provide shade, privacy, and structural roles while also creating a sense of well-being.

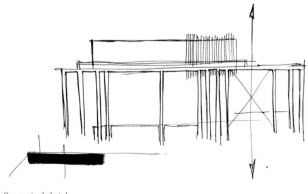

Conceptual sketch

The design was guided by the particularities of the site, including orientation to control solar exposure and maximize views while preserving privacy. It also incorporates local materials, such as natural stone, following sustainable practices.

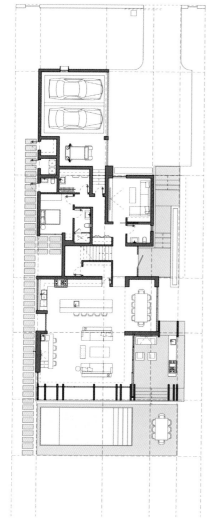

Lower level floor plan

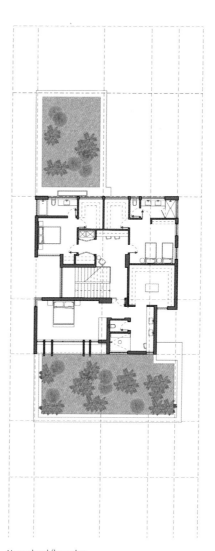

Upper level floor plan

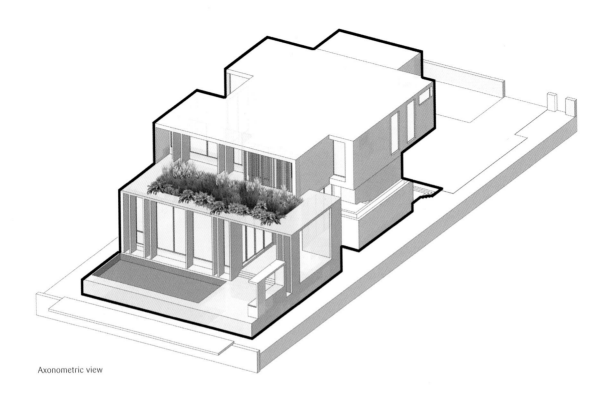

Axonometric view

The second floor is set back for privacy.
This setback is then turned into a lush
terrace, creating a sense of well-being.

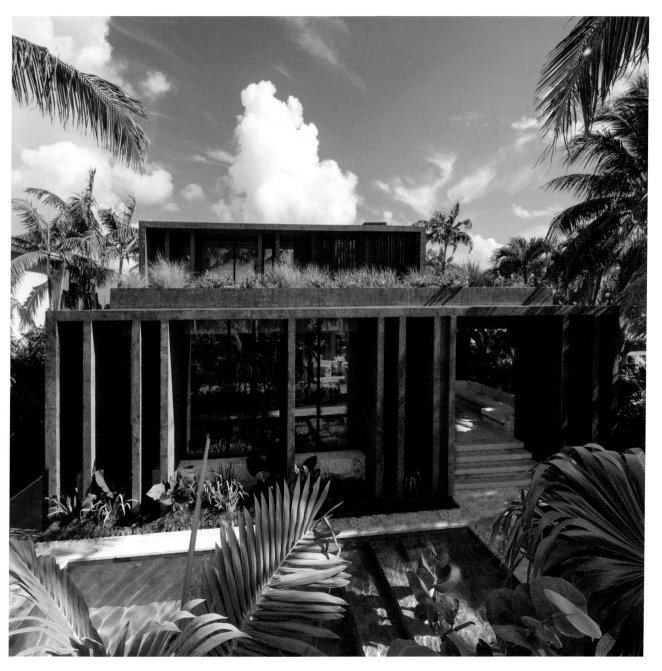

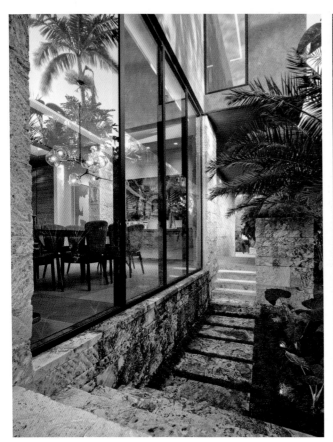
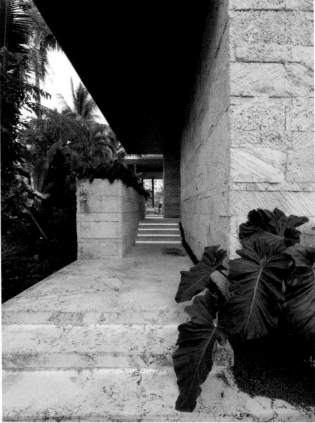

041

Following biophilic principles, the design of the house fuses architecture and lush landscape design, allowing every interior space to be visually connected to the outdoors. It also highlights axes that cross the house, offering glimpses of the water.

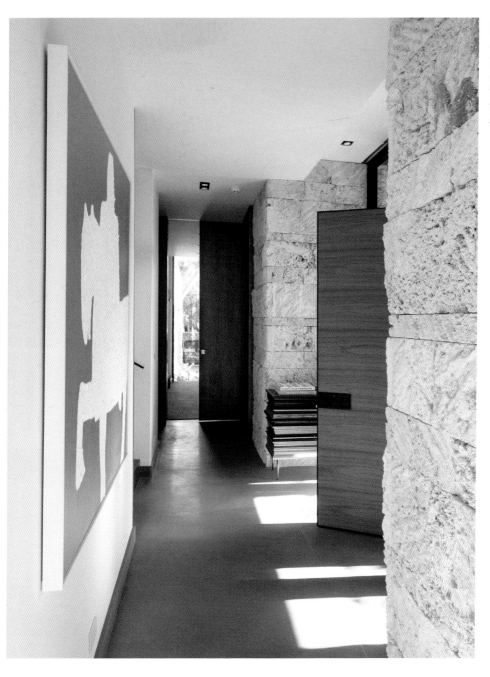

The dark micro cement adds
contrast and dramatic edge amid
the prominence of the landscape,
while the stone walls add texture
and visual appeal.

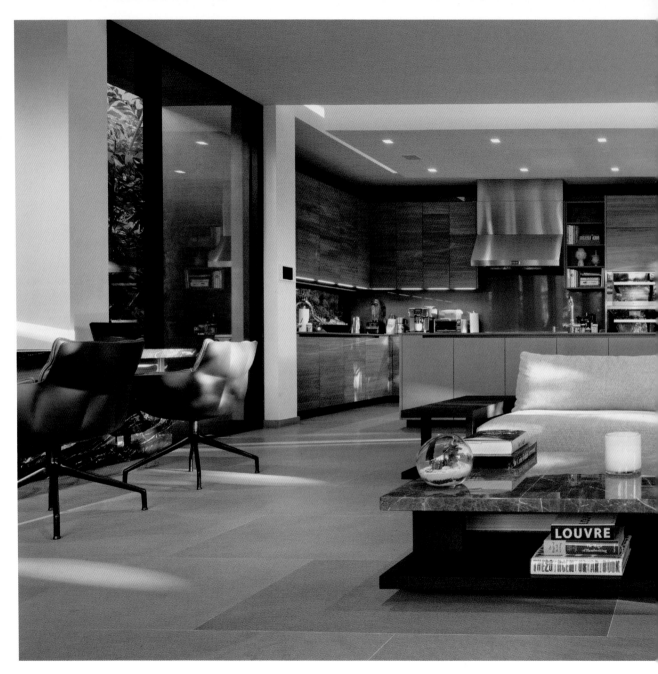

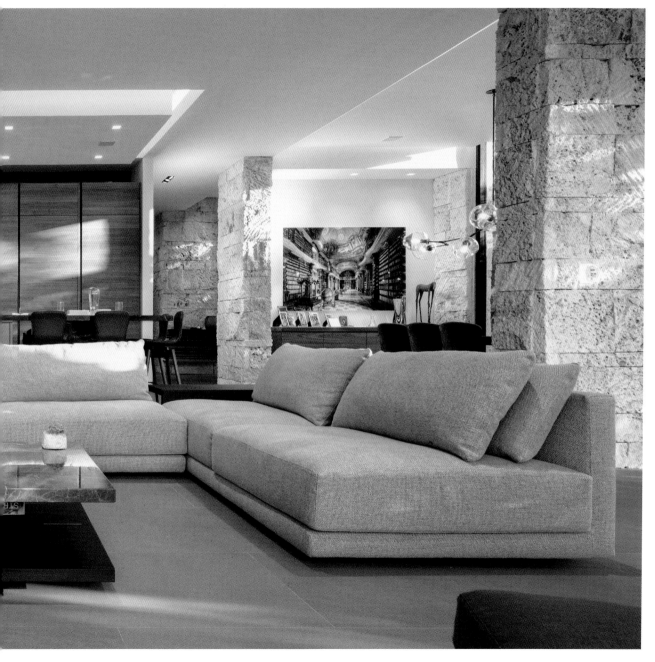

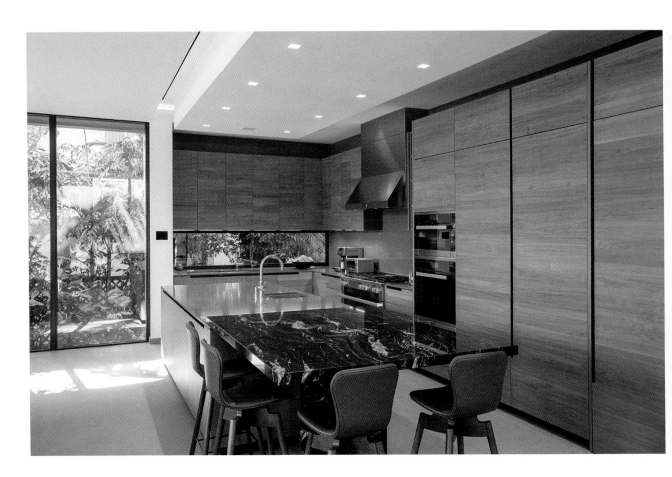

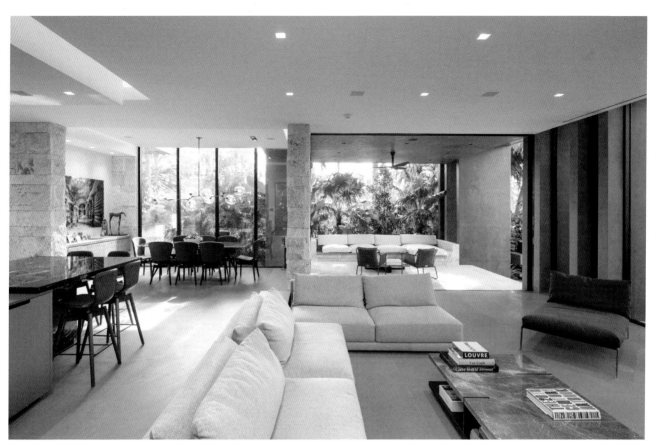

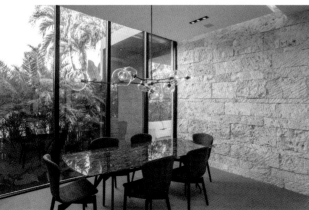

The kitchen, living, and bar areas are combined into one large public space that flows onto a covered terrace overlooking the pool. The dining room, on the other hand, has its own unique view of the lush landscape surrounding the home.

043

Large windows invite greenery inside, enriching the spatial qualities of the interior spaces and positively influencing the homeowners' well-being.

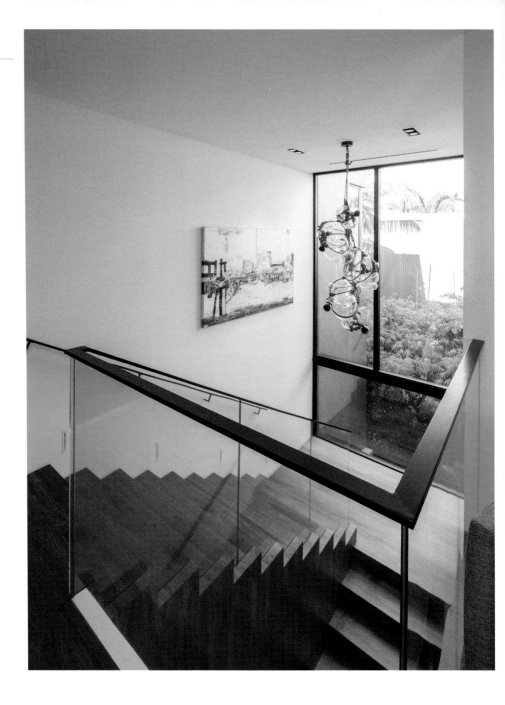

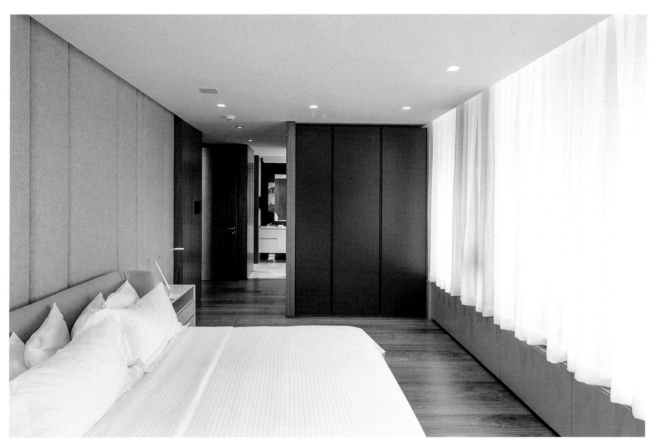

044

The use of light colors, a restrained material selection, and generous room proportions create cool and airy interiors. These design features counteract the tropical climate of the region.

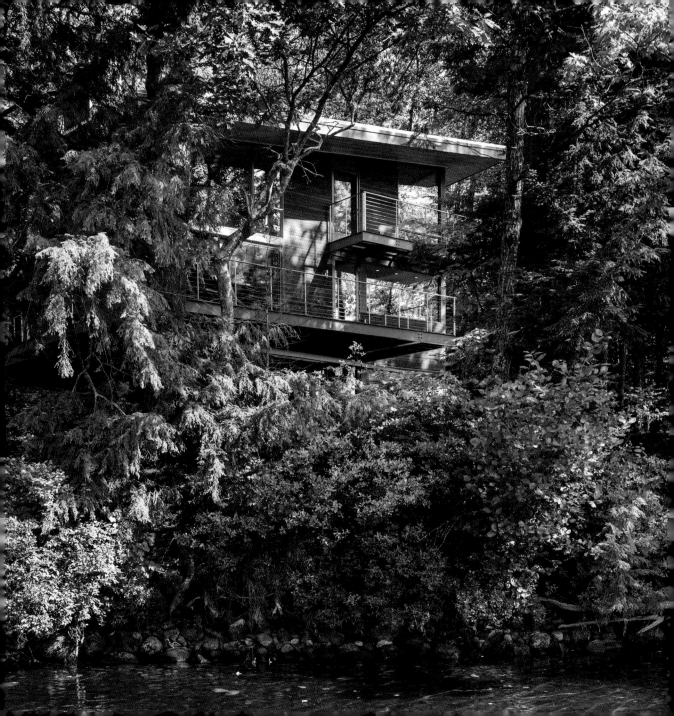

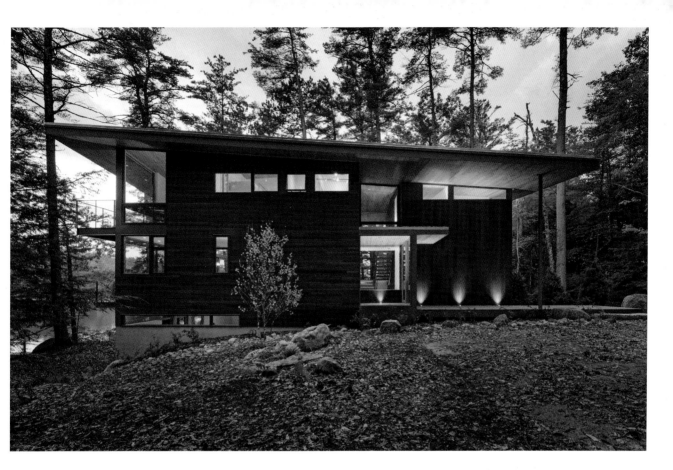

The cabin is nestled in a beech-hemlock forest on Squam Lake with a veil of trees and vegetation separating them. Instead of opening views to the lake, the project takes advantage of this natural veil to create a different experience: one of water, sky, and sunlight reflecting off the lake, filtering through the trees and into the cabin. The clients desired a lake retreat for their family of four and their guests, a lake retreat with an emphasis on indoor-outdoor living. The body and senses are engaged throughout the cabin and site in a narrative about one's time and place on this lakeside idyll, providing a tranquil respite from a plugged-in city life.

Lakeside Cabin

4,200 sq ft

Squam Lake, New Hampshire, United States

Murdough Design Architects

© Chuck Choi
Architectural Photography

The design is a modern interpretation of
a traditional cabin: a simple but dynamic
wood-clad box and sheltering roof with
ample connection to the outdoors.

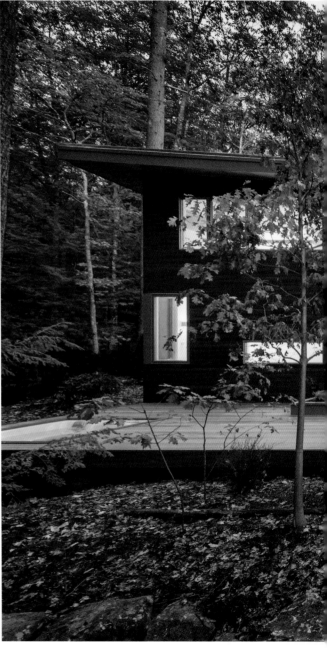

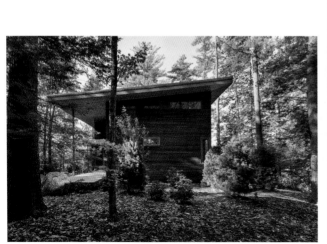

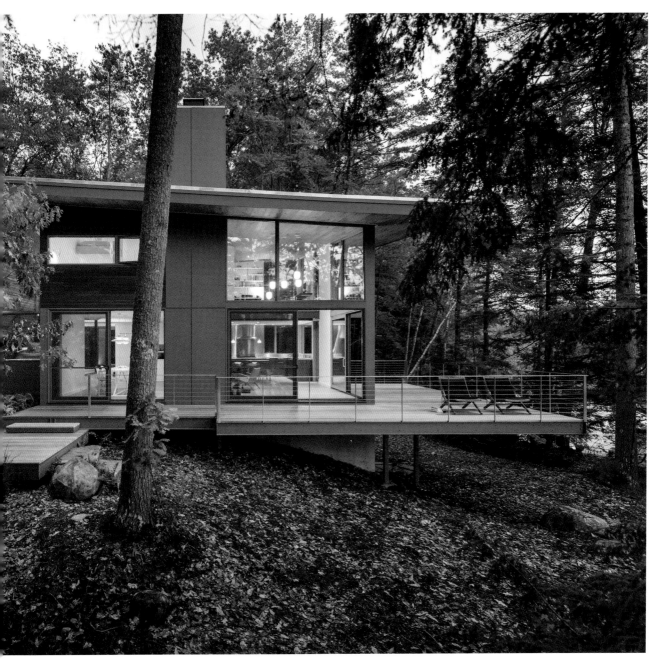

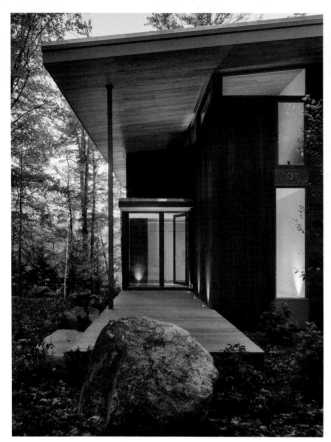

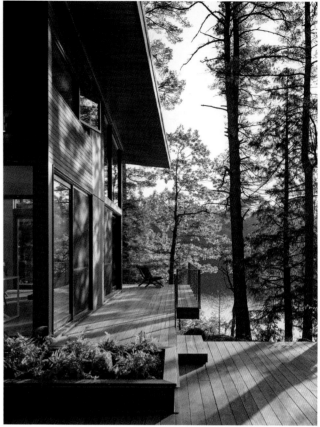

Perched on a hillside overlooking the lake and seemingly circumventing the tall trees, the cabin is sensitive to the site. With materials that echo the natural surroundings, it is designed to offer the full cabin experience.

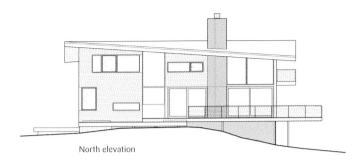

North elevation

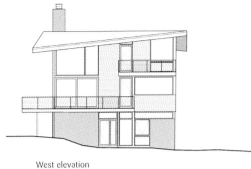

West elevation

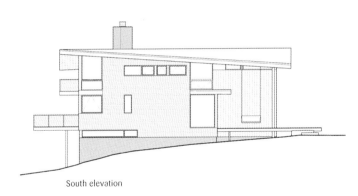

South elevation

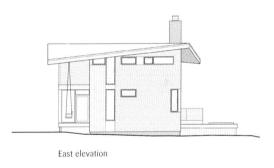

East elevation

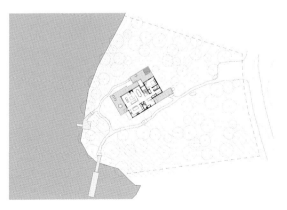

Site plan

A framework of expanding and sheltering spaces is choreographed in a sequence of episodes to ground and amplify the relationships and connections between the building and the landscape.

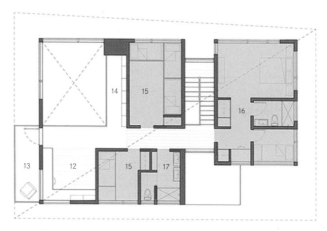

Second floor plan

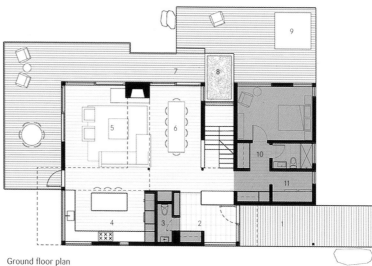

Ground floor plan

1. Entry deck
2. Entry/mudroom
3. Powder room
4. Kitchen
5. Living area
6. Dining area
7. Deck
8. Fern planter
9. Hot tub
10. Guest suite
11. Laundry room
12. Study
13. Balcony
14. Catwalk
15. Bunk room
16. Master suite
17. Kids' bathroom

Fine materials and finishes combine with elegant detailing to create a comfortable, bright, and airy home. The atmosphere is relaxed, yielding to the beauty of the site.

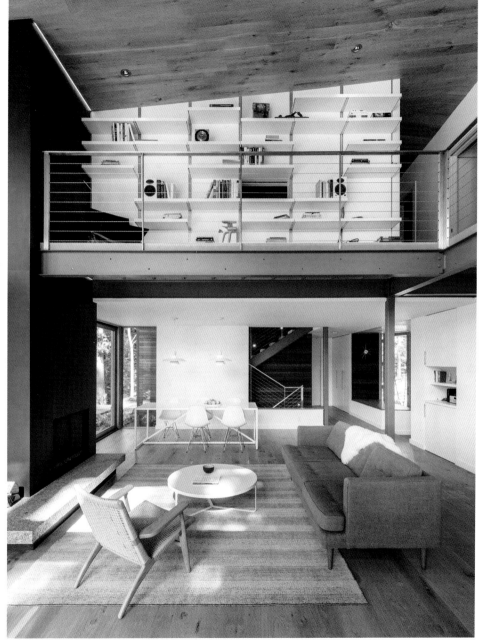

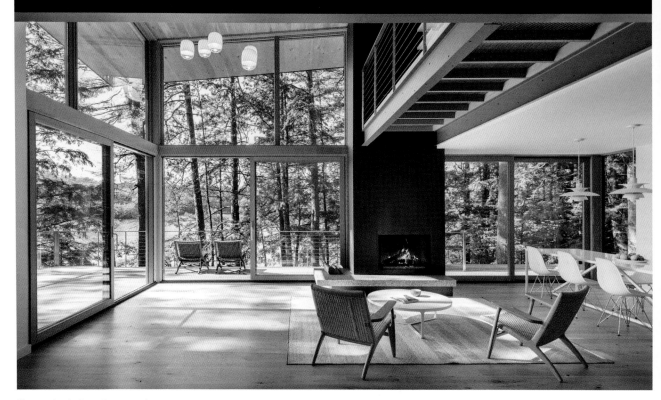

The exterior deck reaches toward
the treed canopy, as well as into the
interior living room.

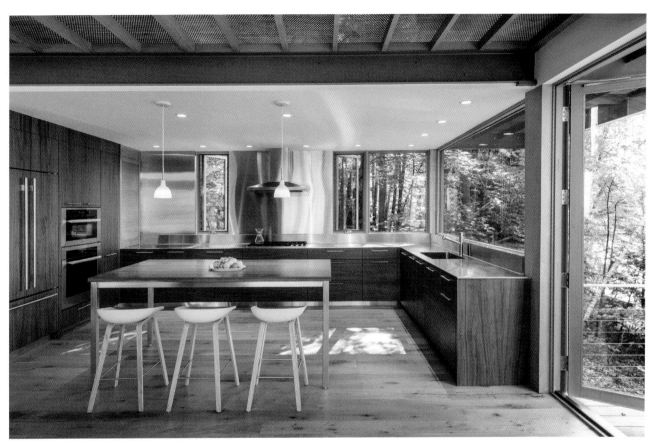

046

The spatial expansion and contraction under the shed roof and between/within loose volumes provide a dynamic and interiorized landscape that speaks to the natural one.

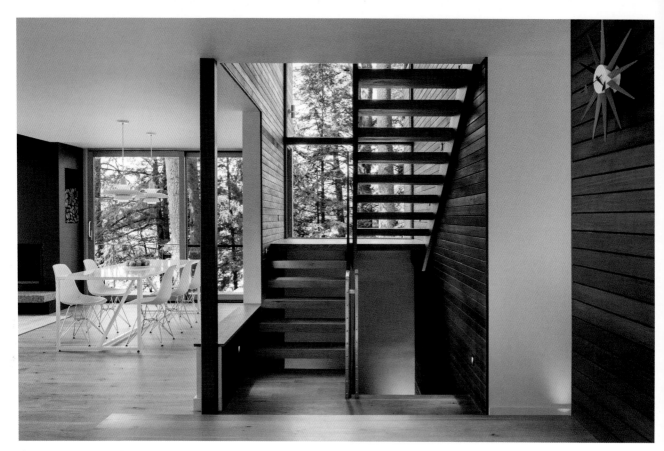

The open riser stair extends vertically in a chasm that engages a stand of towering pines beyond.

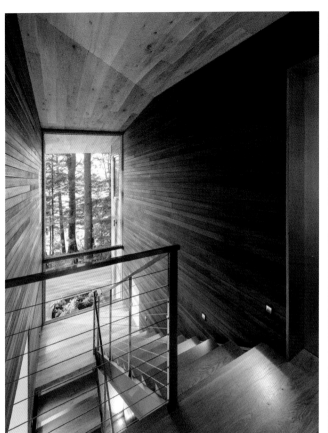
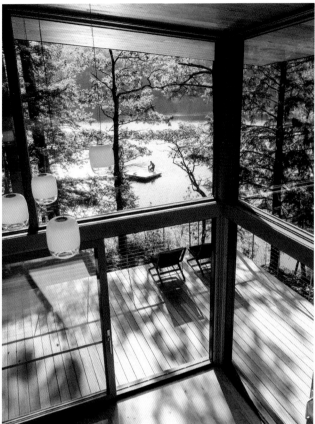

047

Moving through the cabin, multiple experiences of one's place in the site are framed, unfolded, and revealed.

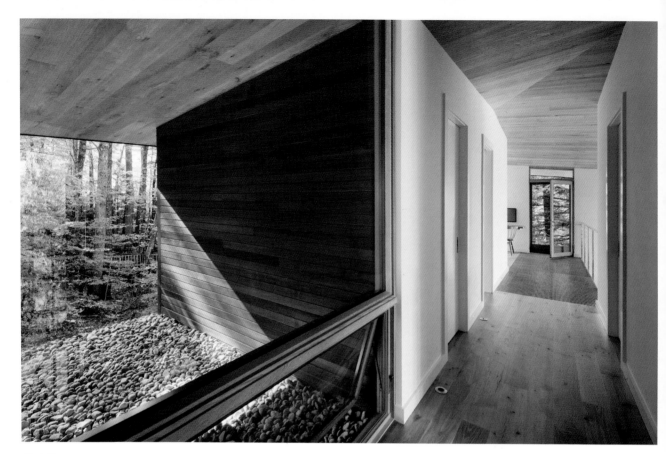

048

Materials and clean detailing
support varied readings of interior
and exterior conditions. Glazed
fields and frames suggest different
relationships to the forest, trees,
lake, and sun beyond.

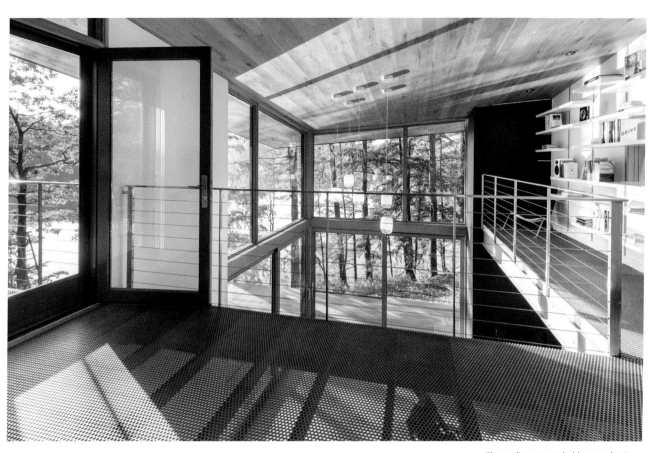

The roof's pressure holds a comforting space, cocoon-like—especially in the bedrooms—but gives way in the upper hall as the floor changes to perforated steel and opens to the living area and lake below.

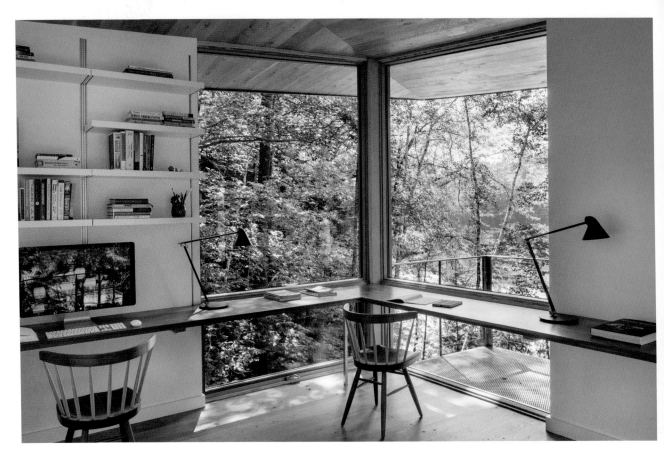

049

Views at tree canopy level give the
impression of being in a treehouse,
enhancing the nature experience.

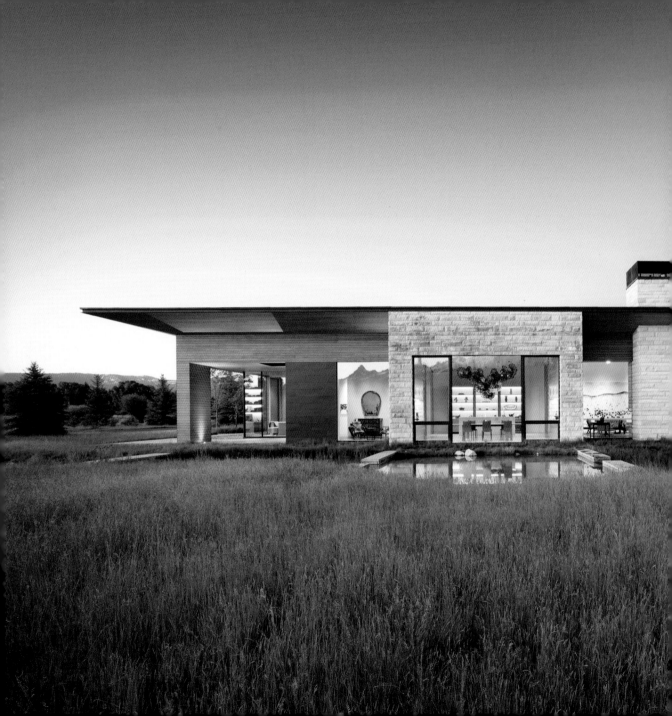

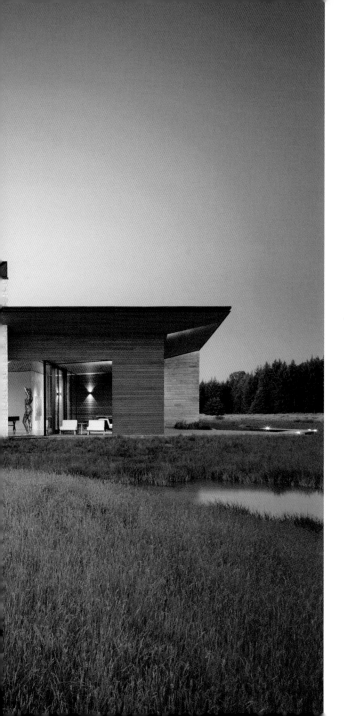

Lefty Ranch

Main house: 7,100 sq ft
Guesthouse: 850 sq ft

Jackson, Wyoming,
United States

CLB Architects

© Matthew Millman,
Gibeon Photography

Lefty Ranch is located on the historic bed of Wyoming's Snake River on a thirty-five-acre property with remnant corrals and outbuildings ranging across it. A stand of mature pine trees form the western boundary of the property, which has a large pond that reflects the surrounding views of the Teton and Gros Ventre mountain ranges. The main building is inspired by the regional vernacular expressed in "loafing sheds," traditional agrarian structures used for shielding livestock from the elements. The home's simple form is abstracted, with deeply carved overhangs that create shelter and signal entry points. The main house is clad in limestone, each stone face chiseled to create depth and texture.

The calm waters of a pond reflect the house and the mountains beyond, adding to the picturesque setting through the day and the seasons.

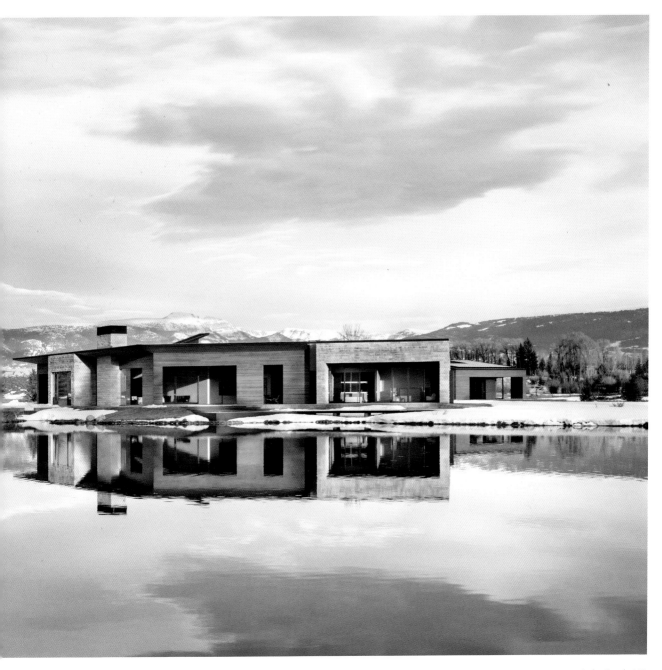

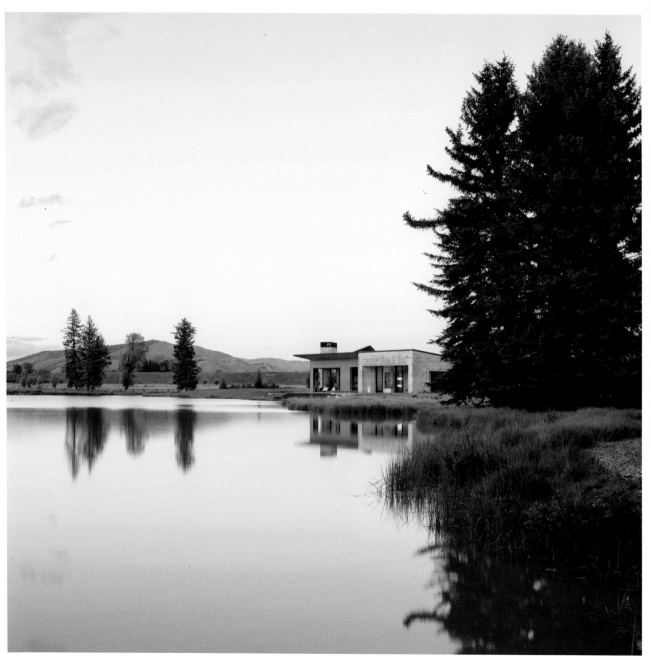

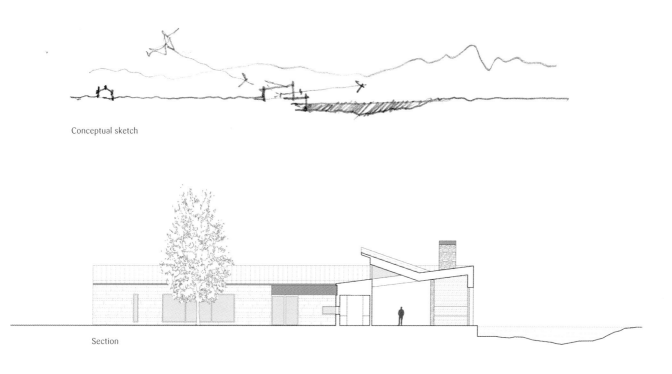

Conceptual sketch

Section

Traditional agrarian structures inspired the design of the house.

050

From its massing to its materiality, the history and morphological context of the site were deliberately considered while designing the house.

The main house is contained under a
single shed roof, its shape articulated to
define a south-facing interior courtyard
where an ornamental maple tree serves
as a focal point.

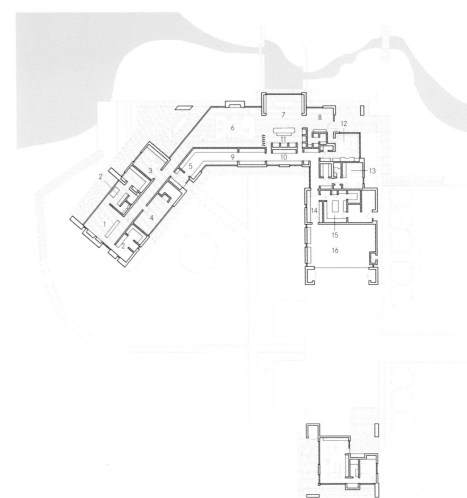

Floor plan

1. Primary bedroom
2. Bathroom
3. Lounge
4. Exercise room
5. Laundry room
6. Living room
7. Dining room
8. Entry

9. Pantry/food prep
10. Butler's kitchen
11. Kitchen
12. Office
13. Staff living quarters
14. Mudroom
15. Shipping/receiving
16. Garage

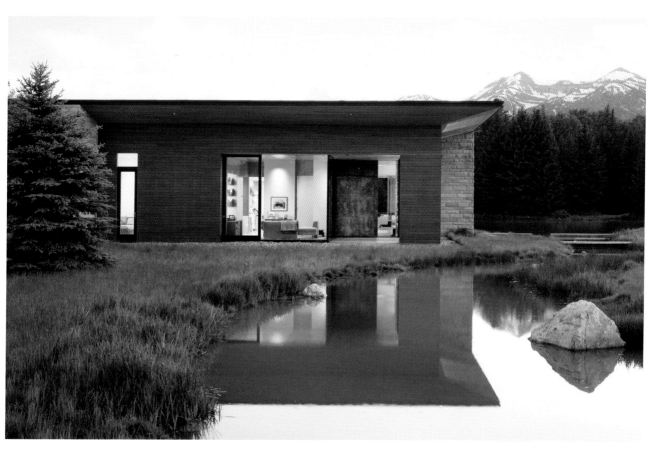

Programmatically, the house is arranged with public rooms, entertainment areas, and outdoor spaces connecting to the pond and oriented to capture the most expansive views.

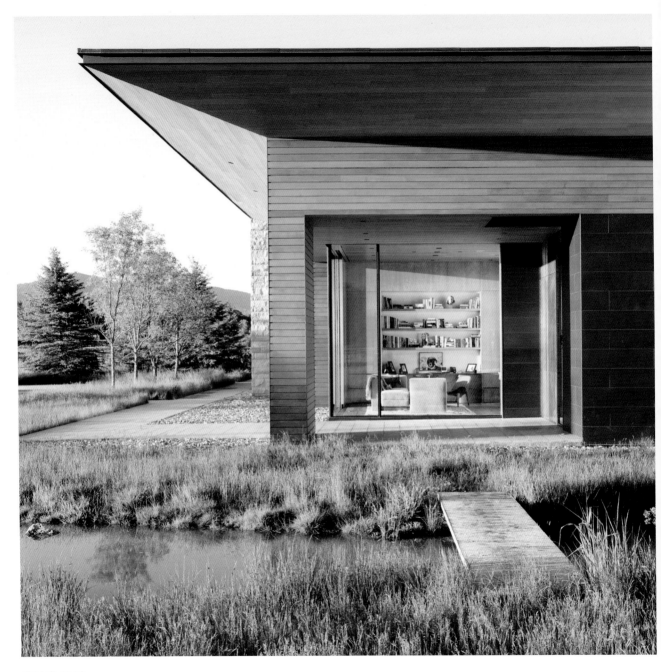

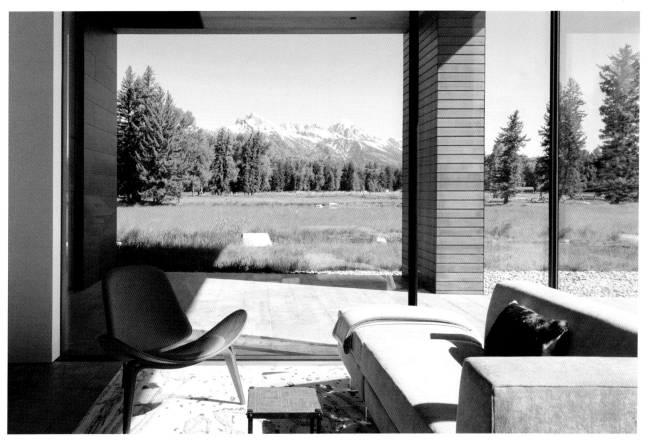

051

The design of this idyllic place goes beyond an architectural scope of work. It addresses the spectacular natural surroundings, making them part of the house. It all starts with a sense of arrival across a footbridge over the pond.

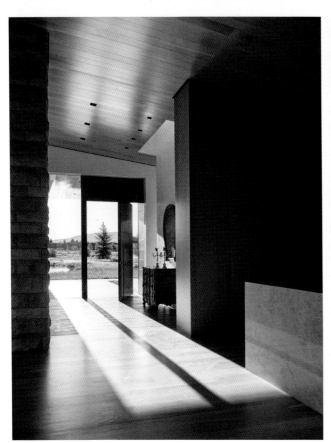
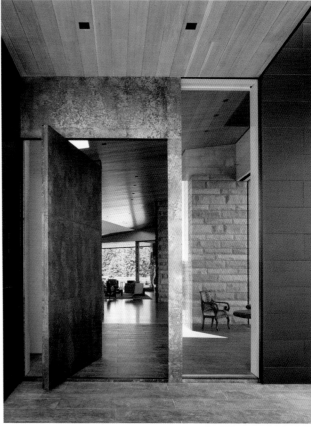

052

A reductive interior palette features
ceilings and floors of white oak
and locally quarried limestone. This
material selection speaks of the
landscape that surrounds the house.

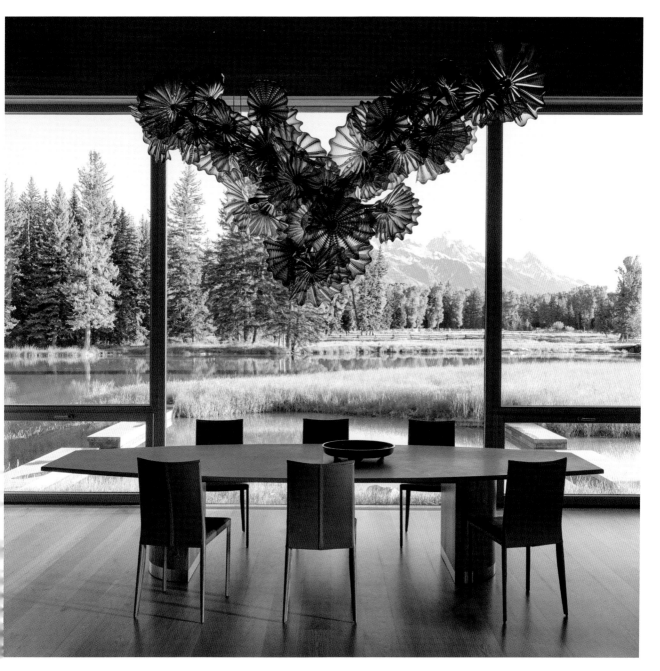

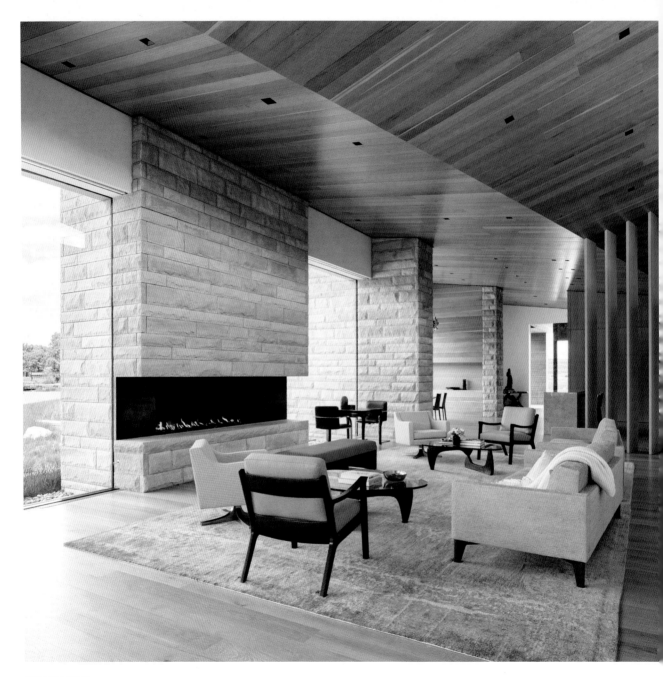

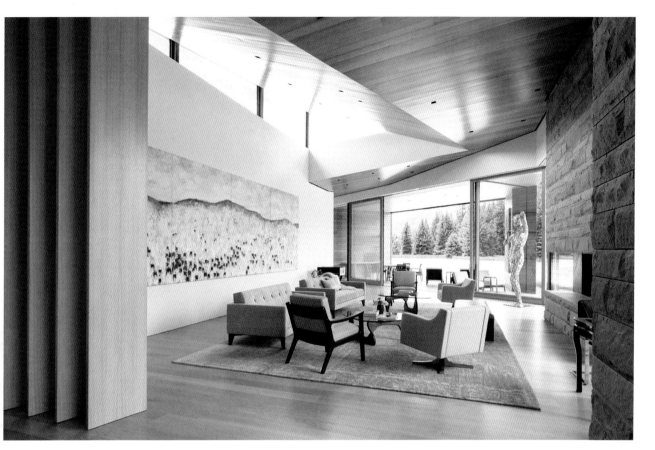

053

Deliberately placed glazing serves to admit light and frame views. In the living room, an aperture in the sloping ceiling is oriented to draw southern light, which traces the room during daylight hours.

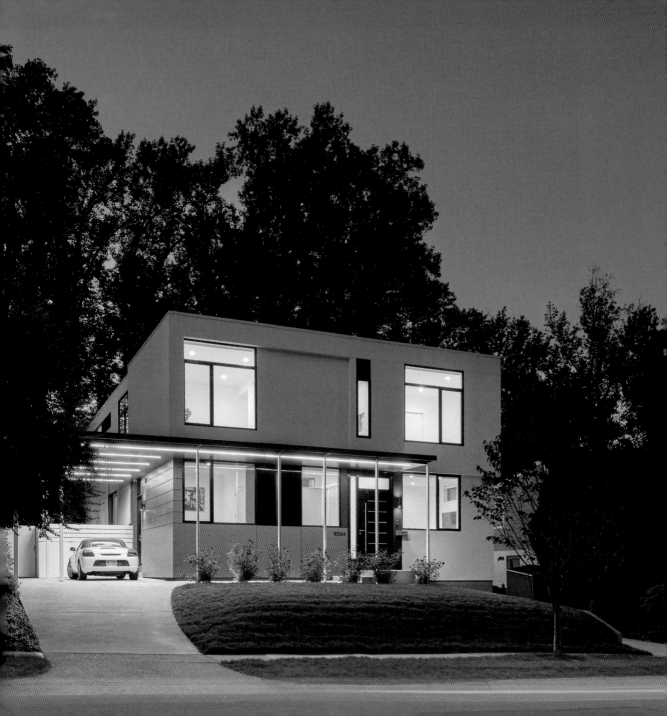

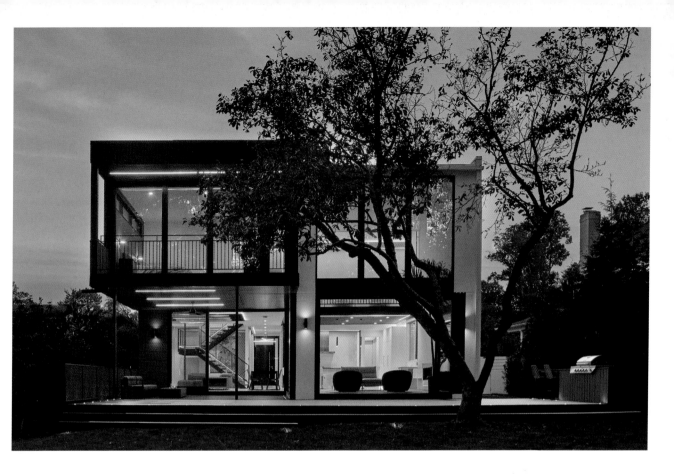

A young couple, in anticipation of starting a family, desired a new home that reflected their cultural backgrounds. He is Spanish and was drawn to black and white minimalism. She is Mexican and wanted splashes of color in a modern home. Their existing house was small and dark and did not take advantage of the views of the green parkway running behind. The design solution included razing the existing house, preserving the basement to limit excavation, and building an efficient two-story home. It was important to the owners to maintain the scale of the changing neighborhood, so from the street, the new house is a white stucco-clad residence that does not overwhelm its modest neighbors. The rear opens up with large windows on every level to the park beyond.

Casa Blanco

4,200 sq ft

Silver Spring, Maryland,
United States

KUBE Architecture (Architect)
RessaBuilt (Contractor)

© Anice Hoachlander

Warmth is added through the use of composite panels on the front elevation, wrapping the entry canopy and the underside of the carport. White stucco and red-orange panels continue the front material palette onto the rear.

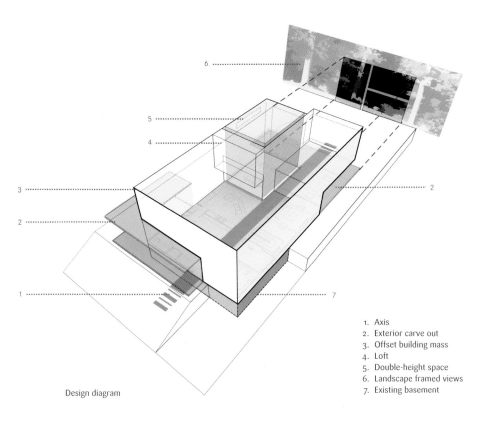

Design diagram

1. Axis
2. Exterior carve out
3. Offset building mass
4. Loft
5. Double-height space
6. Landscape framed views
7. Existing basement

Section

Site plan

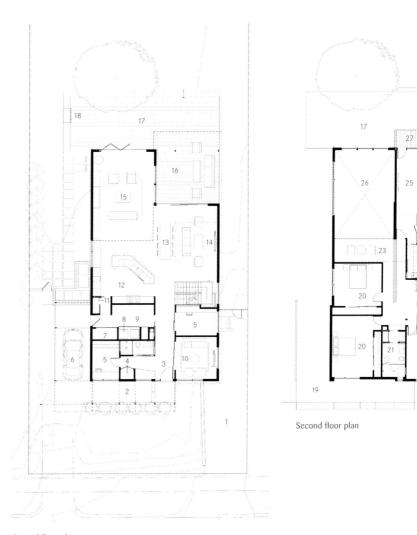

Ground floor plan

Second floor plan

1. Driveway
2. Front walkway
3. Entry
4. Coat closet
5. Office
6. Carport
7. Storage
8. Laundry closet
9. Mudroom
10. Front living room
11. Pantry
12. Kitchen
13. Dining area
14. TV lounge
15. Family room
16. Covered deck
17. Deck
18. BBQ area
19. Canopy below
20. Bedroom
21. Bathroom
22. Master bathroom
23. Sitting area
24. Walk-in closet
25. Master bedroom
26. Open to below
27. Deck below

The bright red-orange house front makes for an inviting entry and stylish first impression, an introduction for what is to be expected inside.

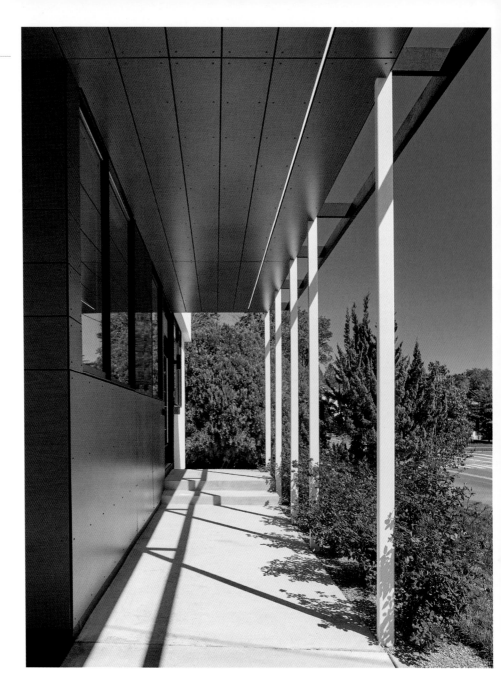

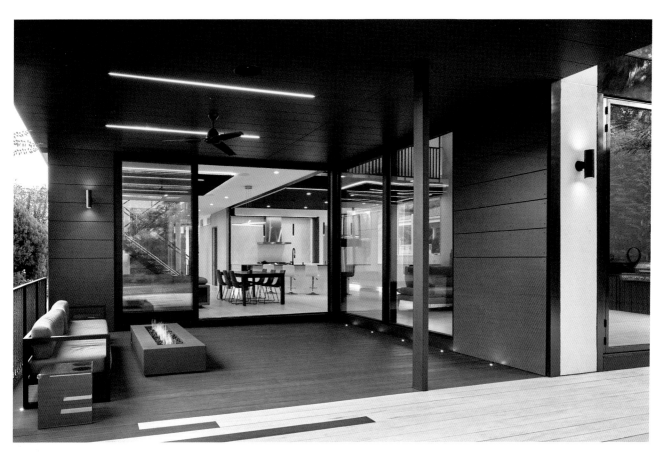

055

The deck spans the rear facade, creating a sitting area under the overhang of the master bedroom above.

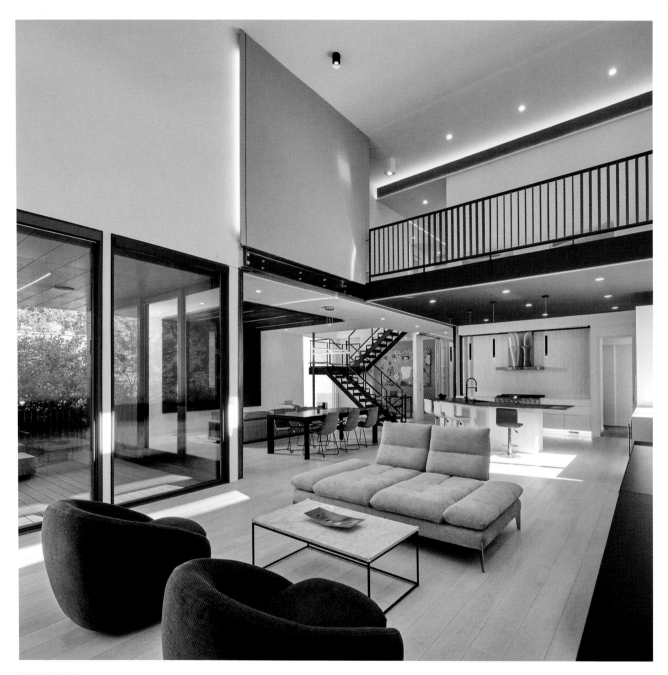

A double-height living space is a feature of the design, opening to wooded views and abundant natural light. The kitchen and TV lounge are adjacent to the living space on the main level, and a loft overlooks the space from above, with private rooms (bedrooms/bathrooms) completing the rest of the upper level.

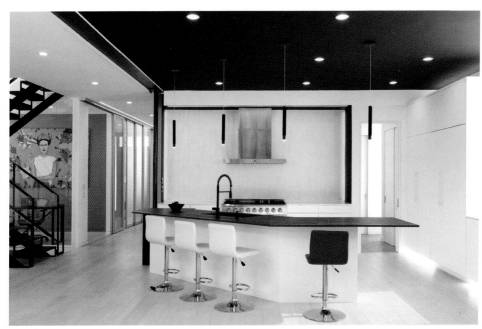

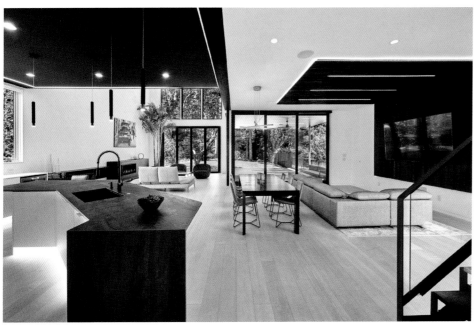

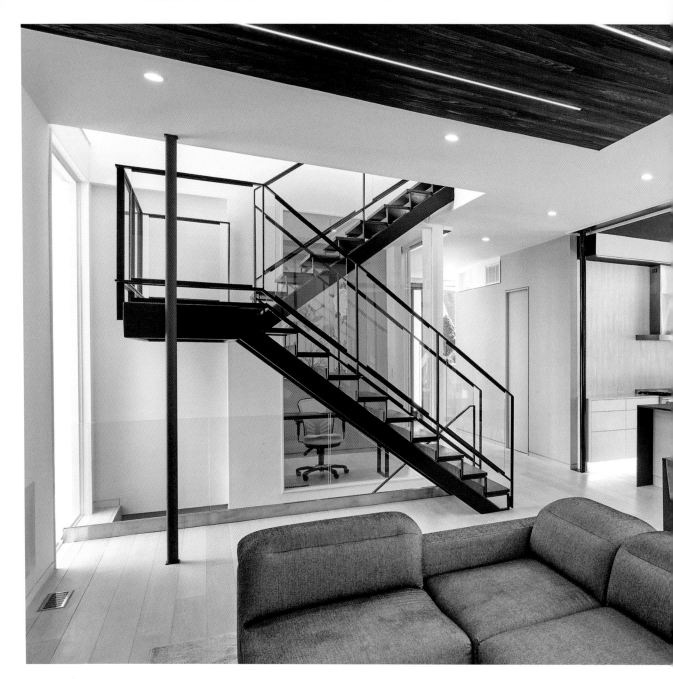

A dropped ceiling painted black sets apart the white cabinets of the kitchen area, while color LED lights flank the white, tiled backsplash. In the adjacent TV lounge, a charred wood plane hovers overhead, adding warmth and a distinct appeal.

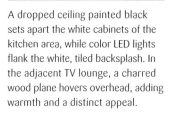

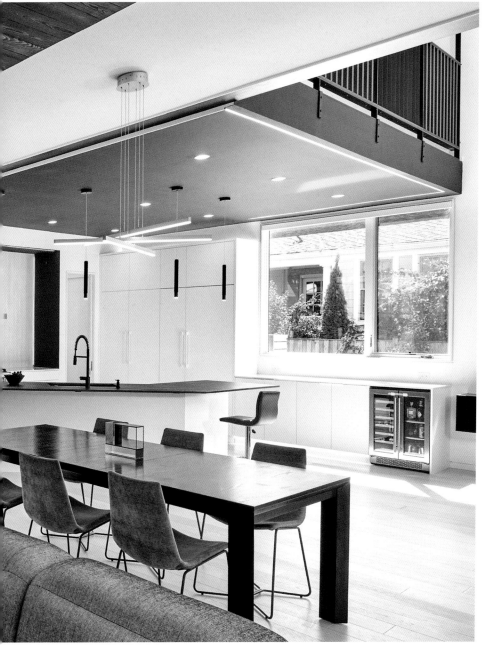

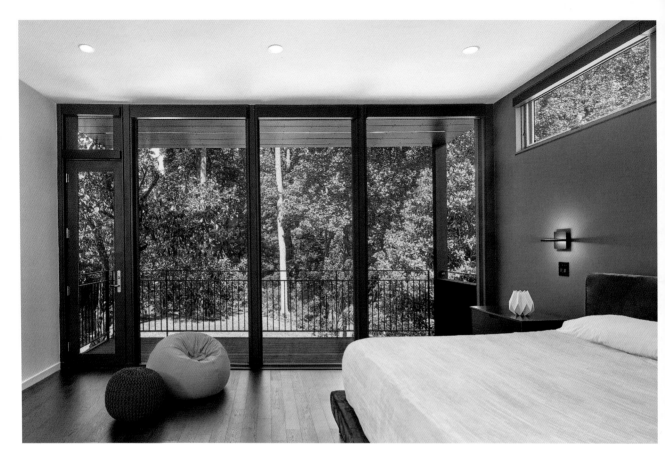

057

The use of bright colors on surfaces
and furnishings complements an
architecture of clean lines and a
reduction of design to essential
forms. In turn, the design highlights
spatial experience, light, and
outside views.

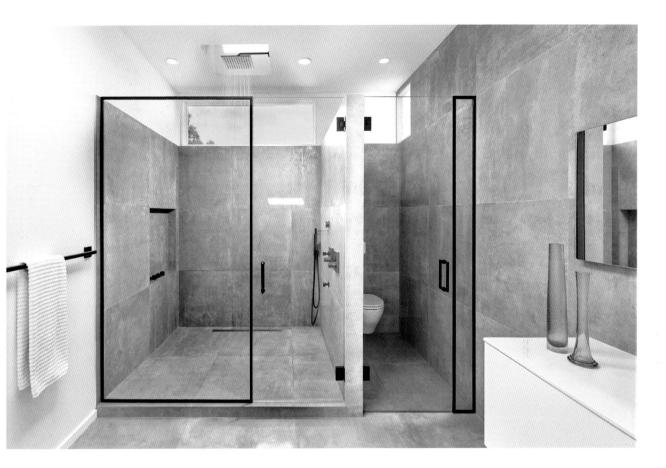

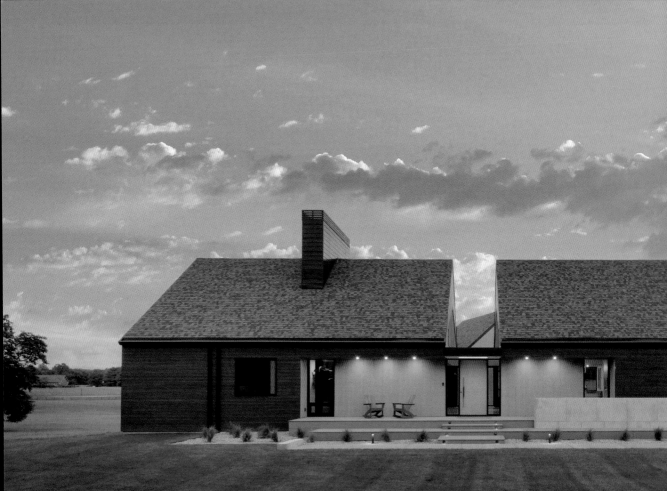

Black and Tan House

8,462 sq ft

Rogersville, Missouri,
United States

Dake Wells Architecture

© Architectural Imageworks

Located on four acres of rolling hills in a suburban development, this single-family home draws on the conventional construction methods of its neighboring houses but focuses on reductive material use and detailing to elevate the living experience. The program is arranged as four gabled forms enclosing a small courtyard with a pool. Sited at the high point of a former hayfield, the house recalls the simple agricultural forms of the region. The house follows a rigorous order that serves to layer spaces and establish framed views through the house, allowing family members to see each other inside and out. The architecture responds to its context, blending into the style of the surrounding neighborhood while balancing the owner's desire for a contemporary aesthetic with comforting warmth.

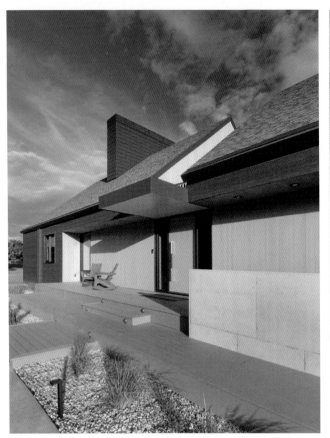

Sited in a suburban development atop a
former hayfield, the house intentionally
recalls the agricultural forms of the
region but is executed with finely crafted
details that belie its conventional origins.

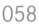

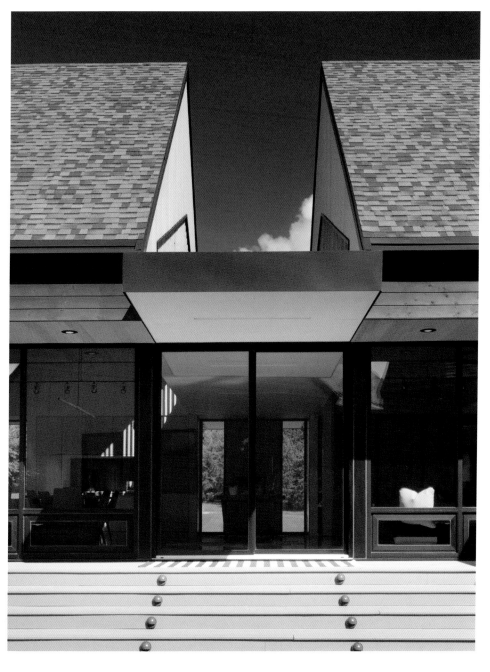

Construction costs were held in check by using a lower-grade, knotty cedar siding for the majority of the skin and staining it a dark charcoal color to hide its imperfections. A higher-grade, select vertical cedar is used at the recessed entry and vertical "slices" through the gabled forms, adding a level of refinement to the public spaces.

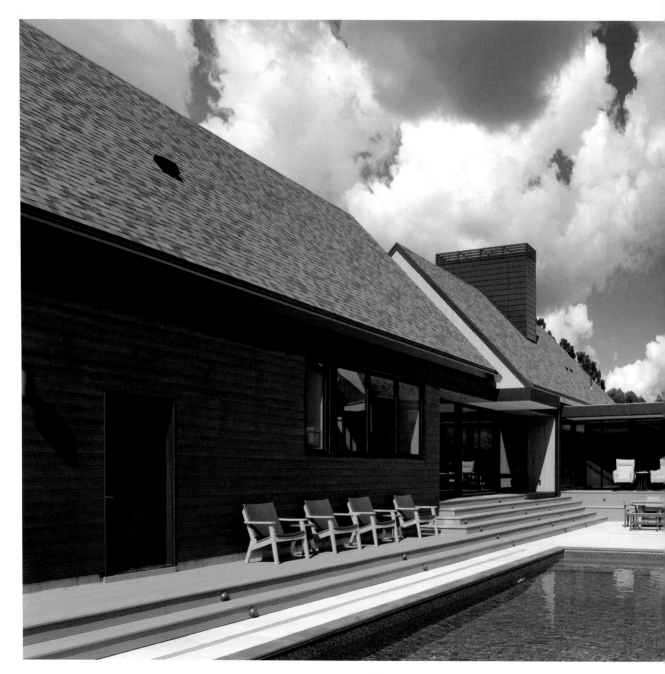

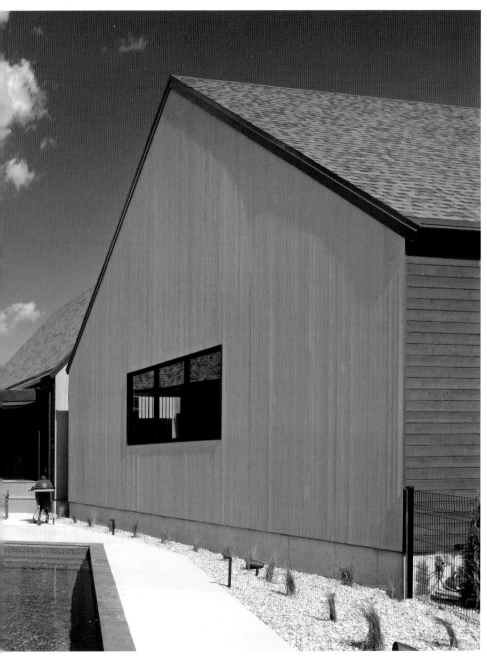

The program is expressed as a series of four gabled volumes gathered around a courtyard swimming pool, defining a private outdoor space. The two-toned skin of each form expresses their division from the original while also linking them together as if they were one.

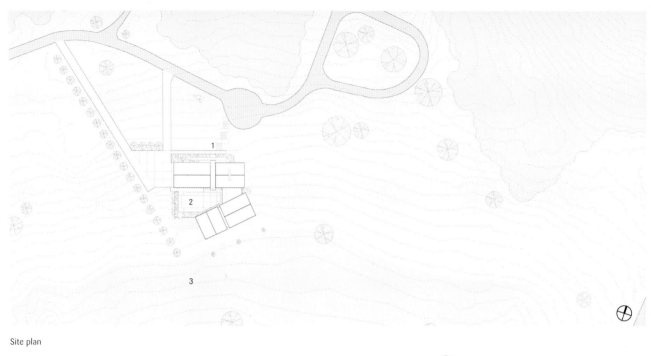

Site plan

1. Entry
2. Pool
3. Flood plain

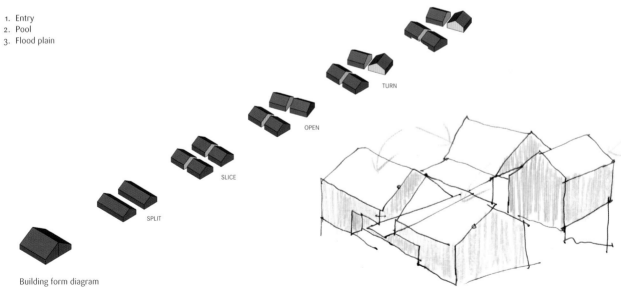

Building form diagram

SPLIT

SLICE

OPEN

TURN

Siding diagram sketch

Basement floor plan

1. Entry
2. Dining room
3. Living room
4. Master suite
5. Laundry room
6. Bedroom
7. Game room
8. Garage
9. Playroom
10. Entertainment room
11. Guest suite
12. Storage

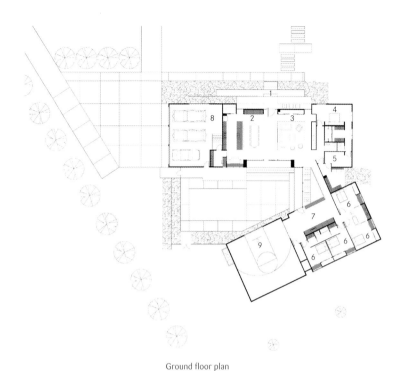

Ground floor plan

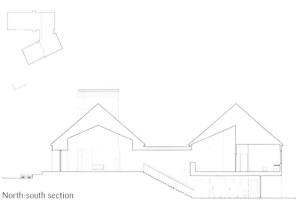

North-south section

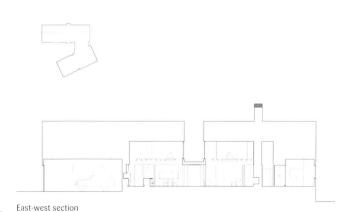

East-west section

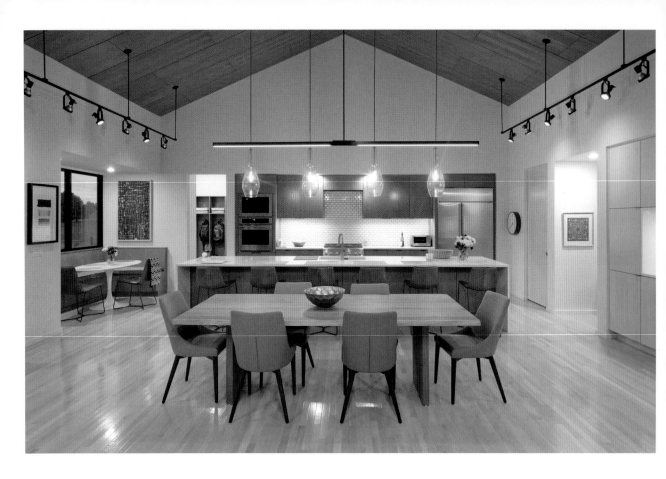

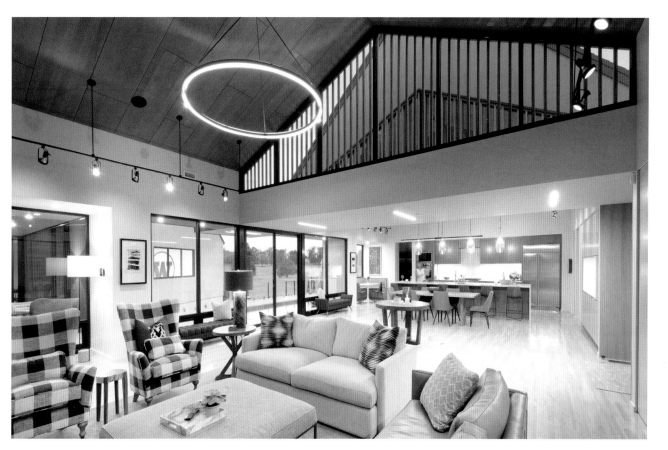

059

The section created by the sliced gable admits ample daylight through clerestory windows.

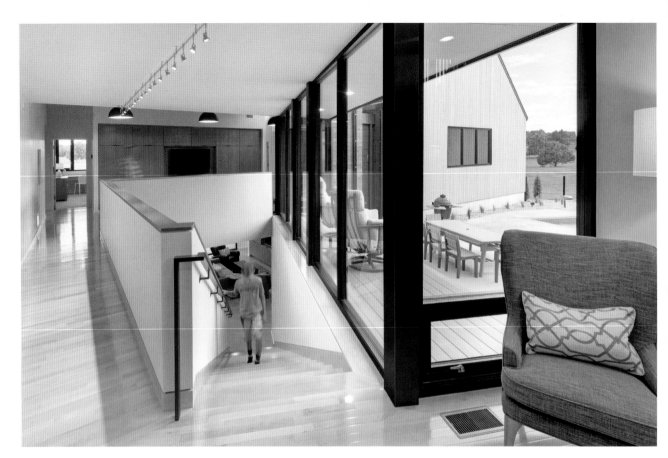

060

A staircase occupies the "knuckle" between the gabled forms and is used to filter daylight into the deepest recess of the lower level.

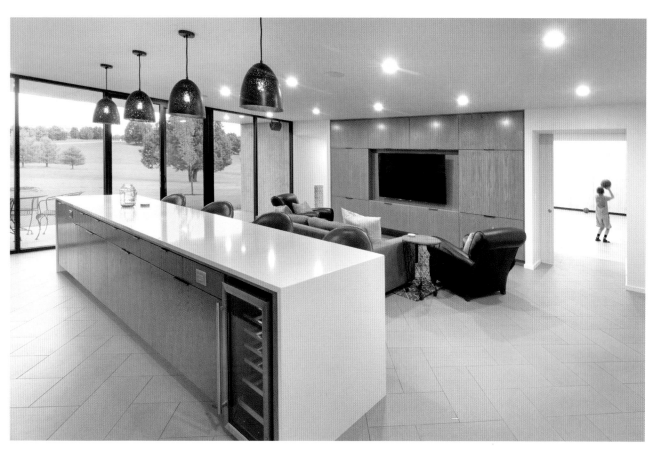

061

The lower level spills outside and provides ample space for gatherings.

The house is more transparent surrounding the courtyard pool, strengthening its connection to the outdoors. The cascading deck—facing south and west—provides places for lounging in the sun at midday and frames sunset views.

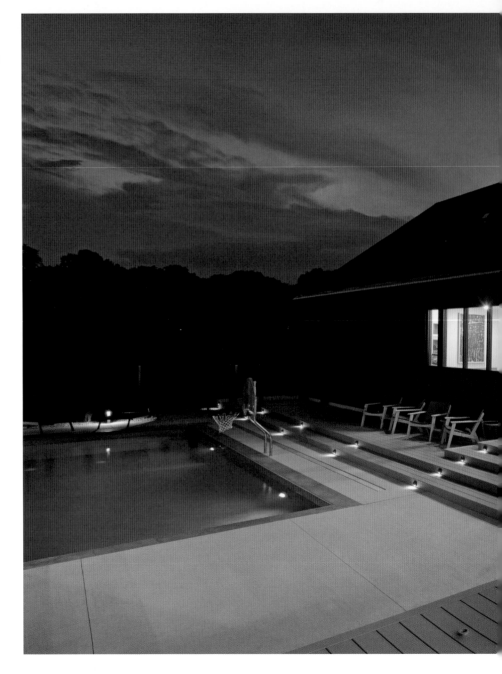

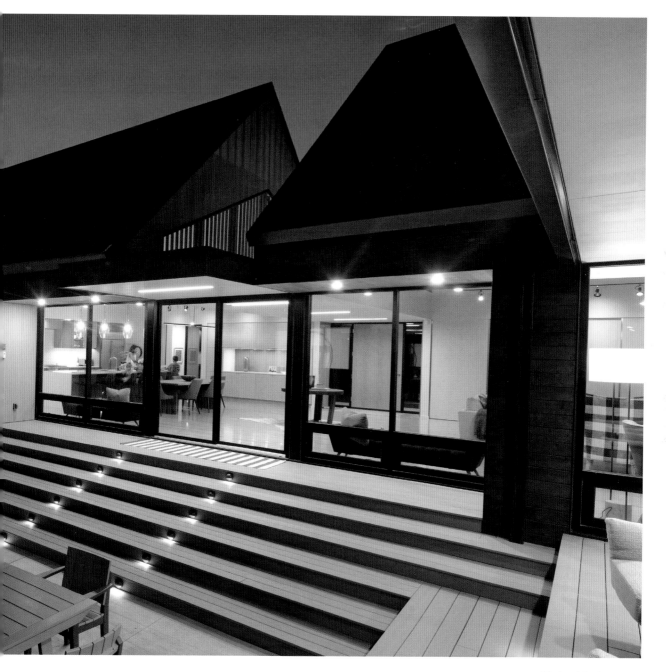

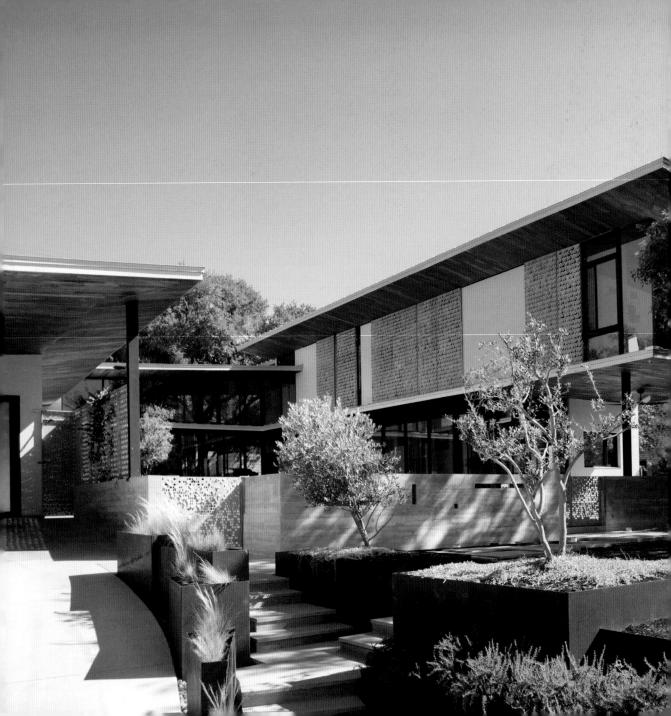

Casa de Sombra

5,000 sq ft

Austin, Texas, United States

Bade Stageberg Cox

© Tim Bade, Whit Preston

This house for a family of seven explores the integration of indoor and outdoor living in response to the high temperatures and rainfall of Austin. The house opens toward a pool court encircled by permeable rooms. Large windows and sliding doors provide cross-ventilation and connect the double-height living room to outdoor rooms, front courtyard, and backyard. In using sensuous materials—the red-brown of mesquite and cool smoothness of ground concrete floors, exposed steel columns and cantilevered steel beams, sanded aluminum, board-form concrete, and weathering steel—an ecology of materials is formed that will patina over time and endure in a desert climate.

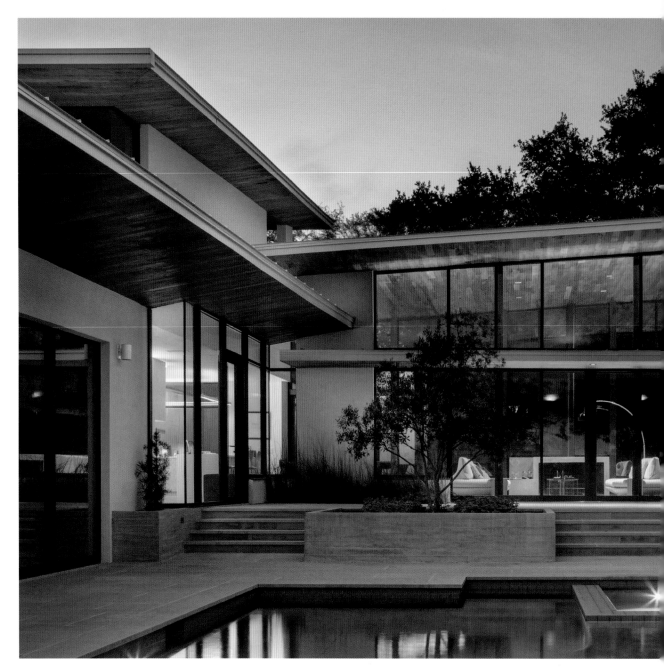

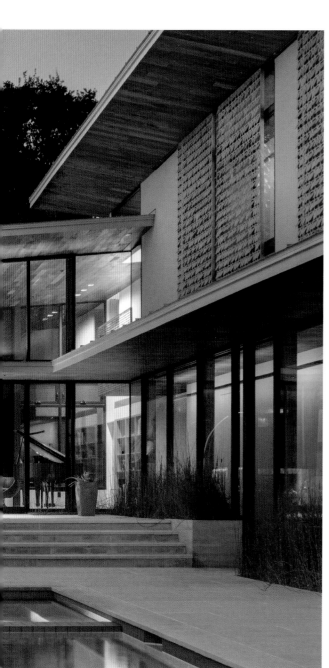

The central courtyard is conceived as a communal exterior space, sheltered from unwanted views and prevailing winds.

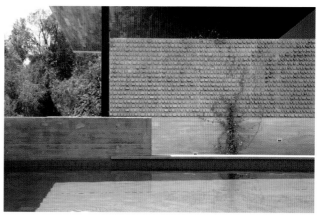

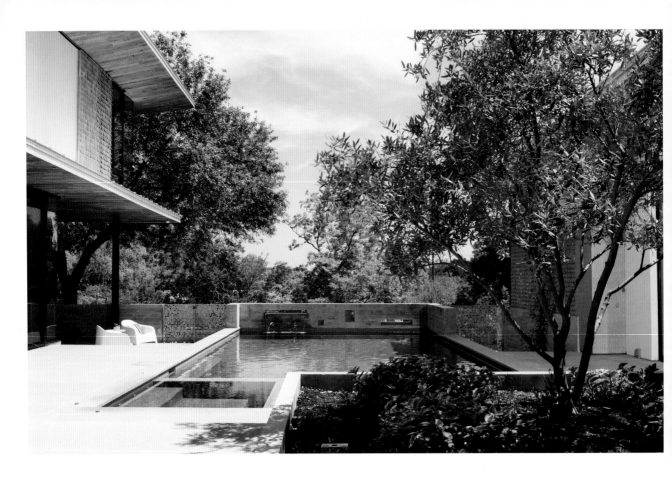

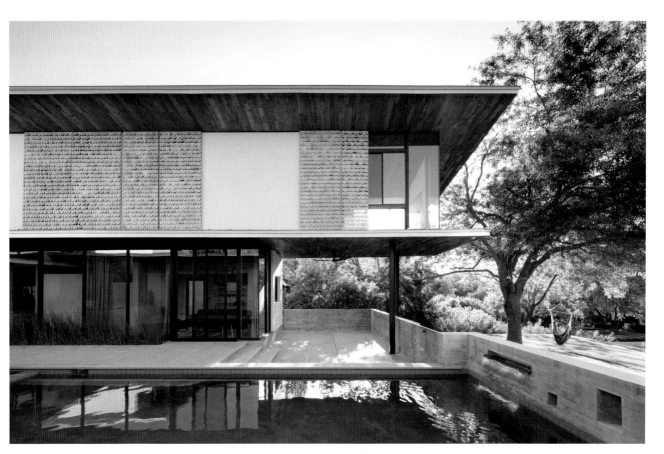

063

Extended roof planes, calibrated using sun-tracking computational modeling, minimize solar heat gain in the summer and allow passive heating in winter.

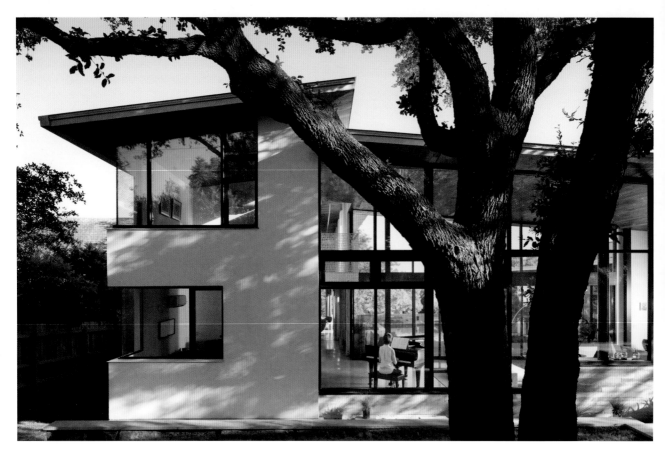

The constrained site is eight feet above
the street, affording the house privacy
and views over the neighboring houses
to downtown Austin. Mature ash and
live oak trees provide vital shading.

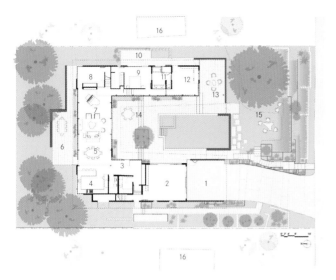

Ground floor plan

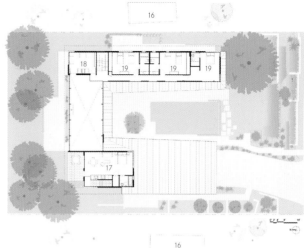

Second floor plan

1. Carport
2. Garage/studio
3. Entry
4. Kitchen
5. Dining area
6. Dining patio
7. Living area
8. Media room
9. Master bedroom
10. Outdoor shower/patio
11. Bathroom
12. Library/study
13. Master patio
14. Pool court
15. Front yard terrace
16. Neighboring house
17. Guest apartment
18. Study
19. Bedroom

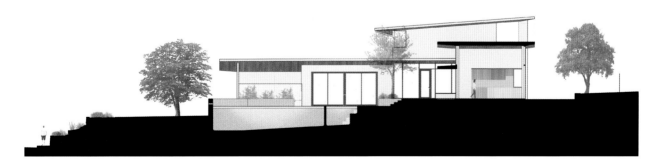

Section through court

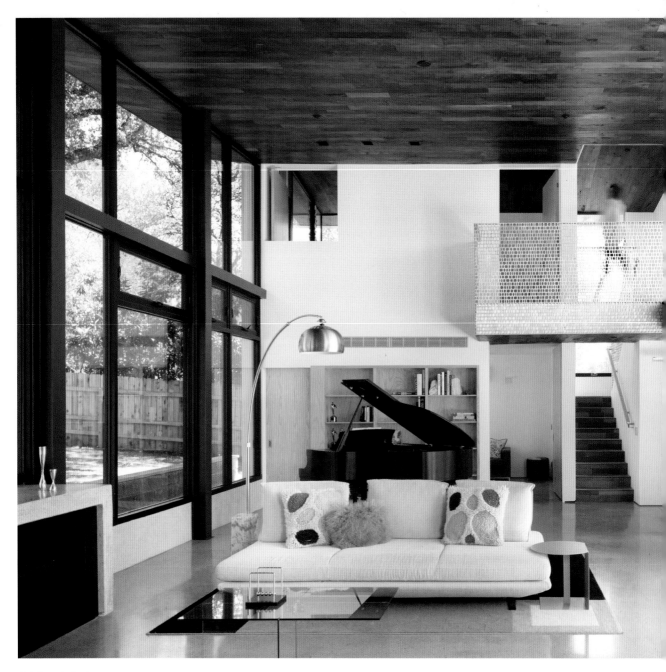

Openings on the wall of the second floor establish a dialogue between the two levels of the house, encouraging interaction among the occupants.

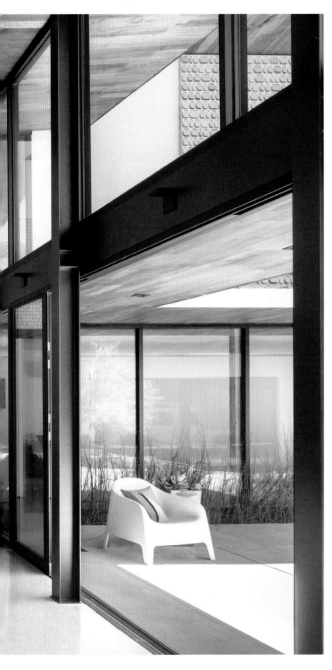

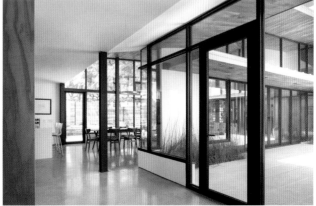

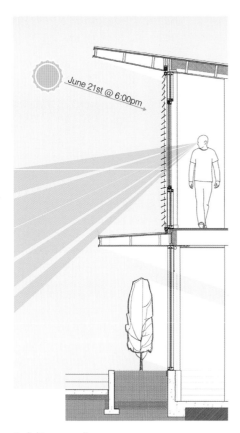

Sunlight exposure diagram

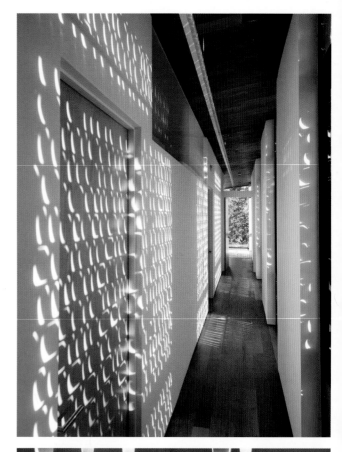

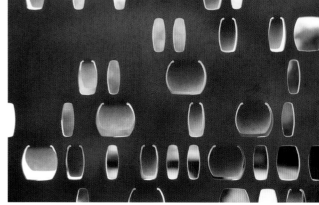

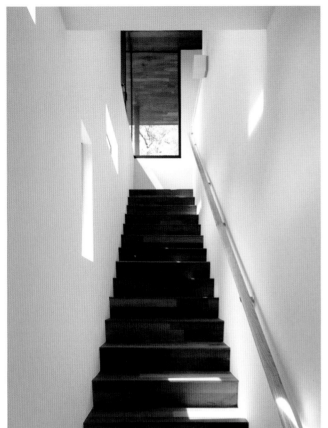

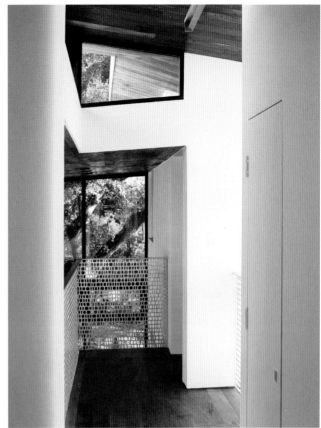

065

Custom-made movable shutters with moon-shaped cutouts let dappled light in to animate the interiors and allow the owners to control sunlight and ventilation.

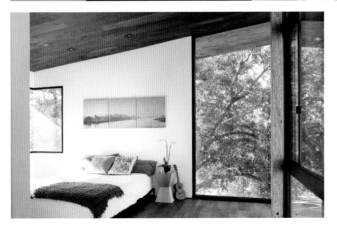

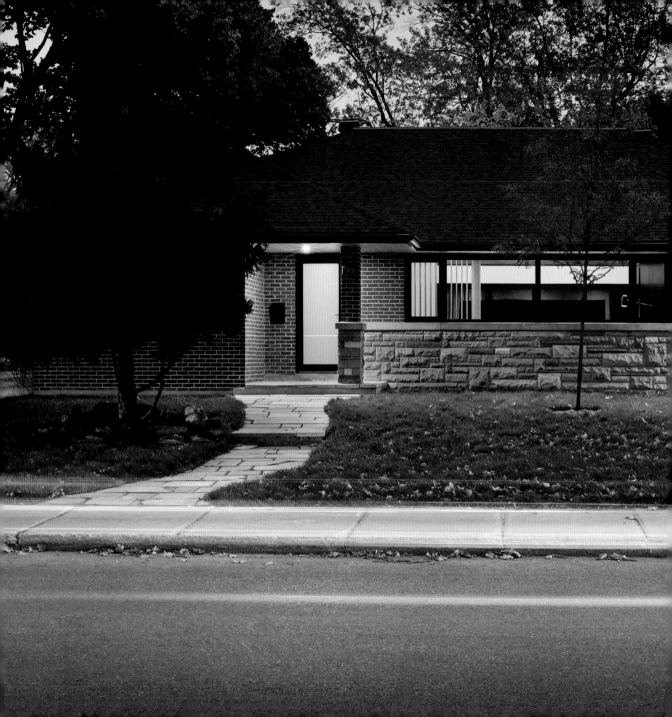

Pearl House

2,128 sq ft

Montreal, Quebec, Canada

MXMA Architecture & Design

© Annie Faffard

Pearl House was born from a strong and simple concept: as a design element, a house must be a place of sanctuary. To achieve this, the architect imagined the house for a Korean couple with two young children as a single box containing an original bungalow and the new primary suite. Then, he removed a portion of this box to create an inner courtyard, a protected place that highlights a large maple tree in the middle of the garden. The couple fell in love with the bungalow on a large corner lot, surrounded by mature trees. Although the interior decor needed a face-lift, the house, inspired by the modernist movement of the 1960s, featured clean lines and compelling architectural elements: ideal conditions to implement a project full of family appeal. It also satisfied the couple's desire to move into a home with well-balanced living spaces, and ample outdoors, where their children could play.

A large maple tree located in the heart of the garden became central to the design of the new house and an architectural element in its own right, honored for its ecological, aesthetic, and social benefits. Also, three new trees were planted, reducing the heat island effect.

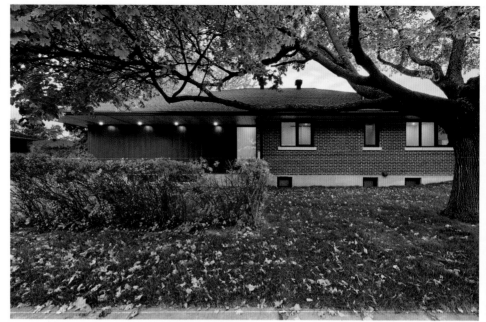

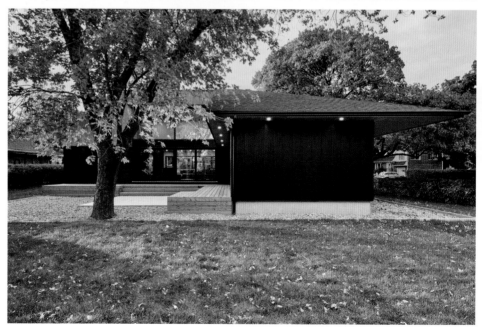

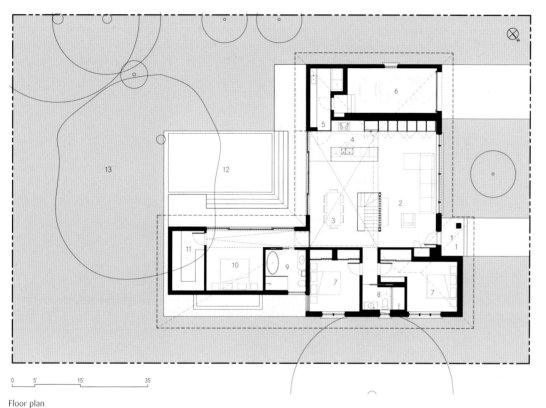

1. Entry
2. Living area
3. Dining area
4. Kitchen
5. Laundry room
6. Garage
7. Bedroom
8. Bathroom
9. Master bathroom
10. Master bedroom
11. Master closet
12. Courtyard
13. Maple tree

Floor plan

0 5' 15' 35'

The client wanted to open up the interior spaces so that his family could gather in a vast unobstructed room, expand the house to include a primary suite, and transform the backyard into an exterior extension of the living spaces.

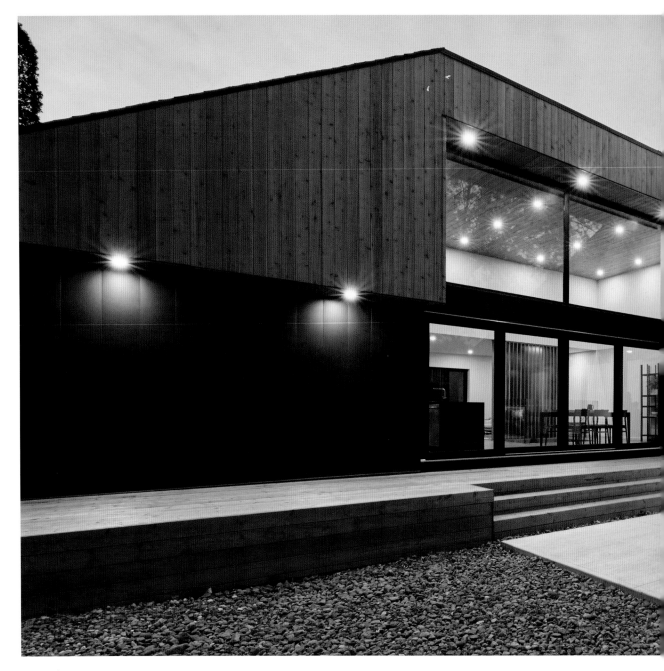

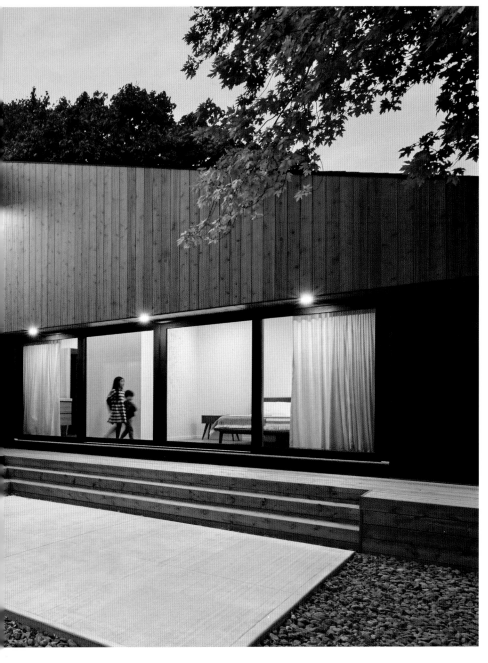

Special emphasis was given to the use of certified wood and metal to create durable and environmentally friendly exterior cladding.

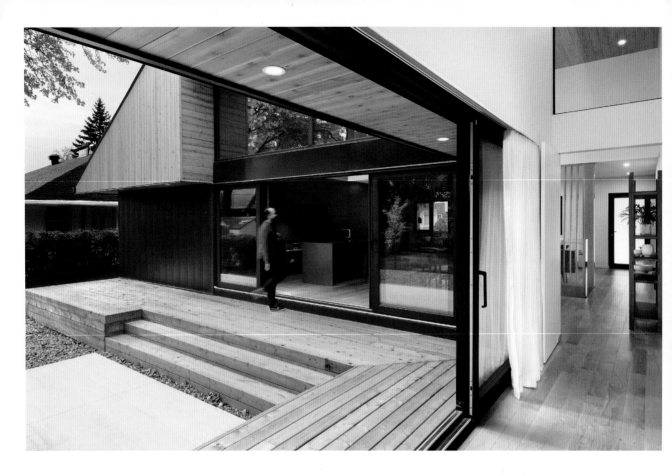

068

High-performance glazed windows were placed on the southern-facing side of the building to brighten the living spaces and capture solar thermal energy naturally, following sustainability principles.

With its style, materials, spatial organization, and variable energy strategies, Pearl House is the very definition of environmentally friendly architecture, greatly enhancing the quality of life of the family who dreamed of living in contact with nature.

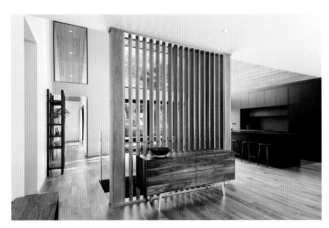

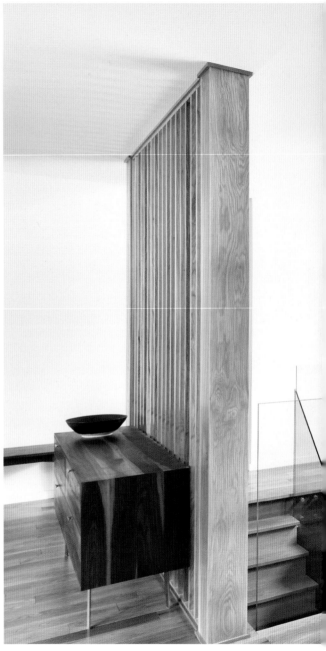

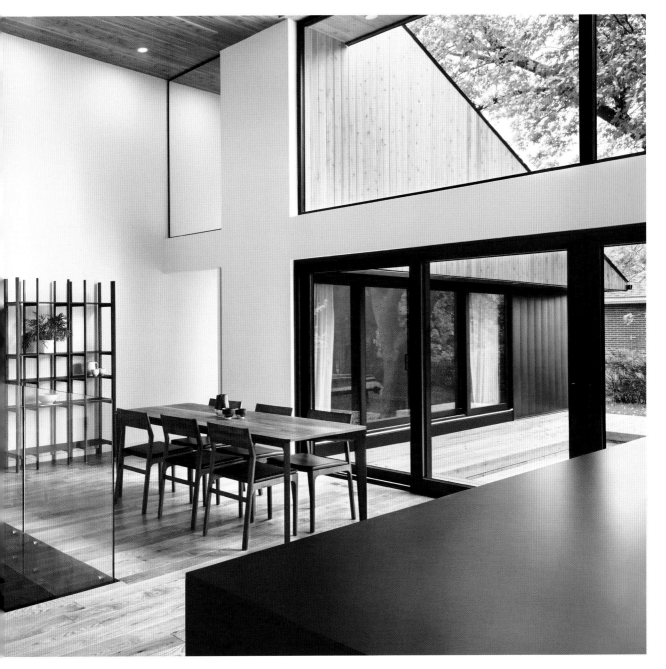

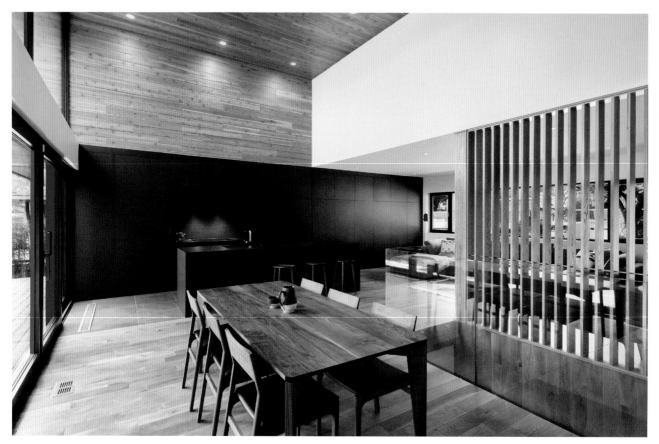

The dark kitchen furniture also stands in stark contrast to the bright white oak floors and the abundant light of the interior spaces.

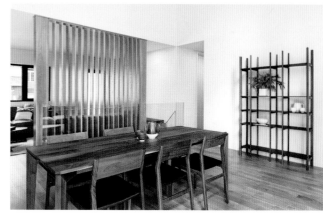

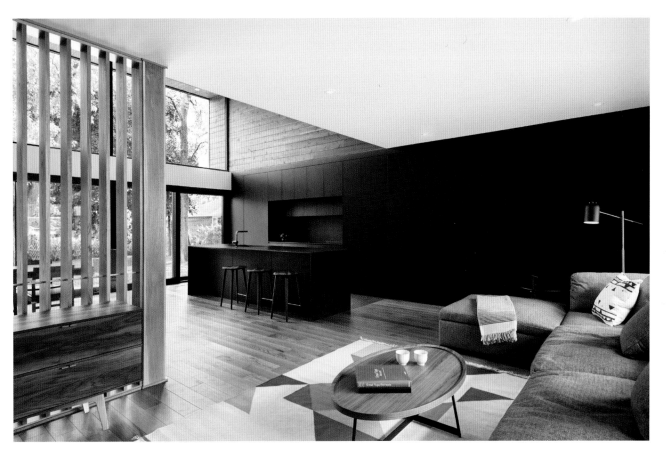

069

Generous storage is provided to meet the family's daily needs. It is hidden behind large doors and integrated into the interior architecture to create a functional place with a minimalist aesthetic.

Drawing inspiration from materials, colors, and textures, the Pearl House kitchen is a warm space, open to the whole family, and perfectly integrated into the overall concept of the home. Its matte black cabinets and countertops harmonize with the window frames and add a sophisticated touch.

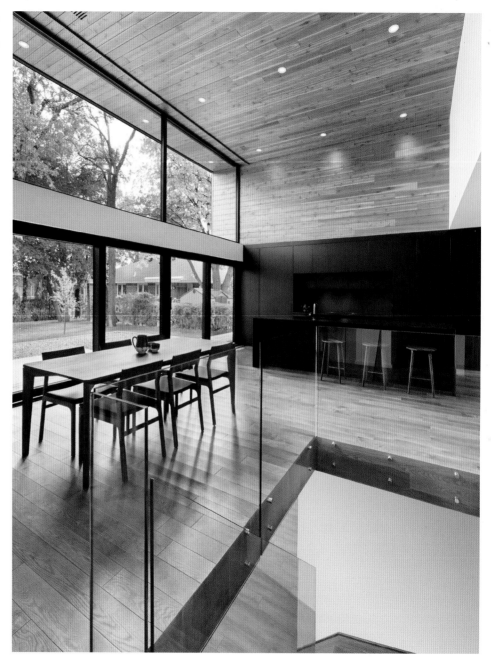

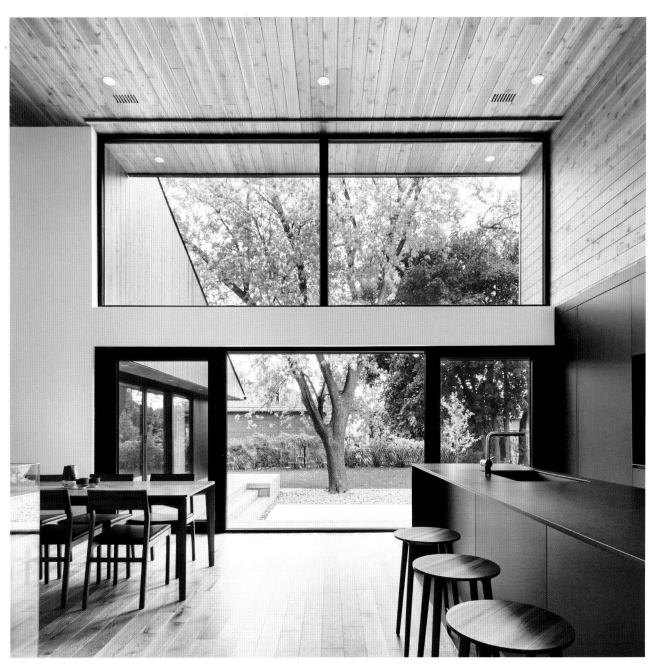

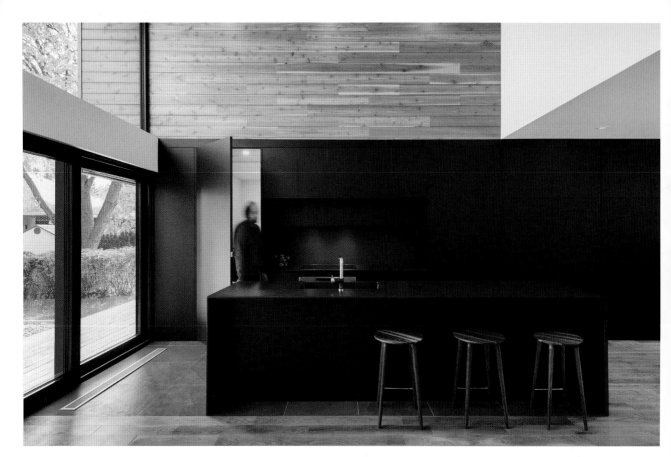

070

The black metal shell wraps around
the body of the house and then folds
inward to become the wall-length
black cabinets of this sophisticated
kitchen. This innovative gesture
reinforces the idea of indoor-outdoor
architectural continuity.

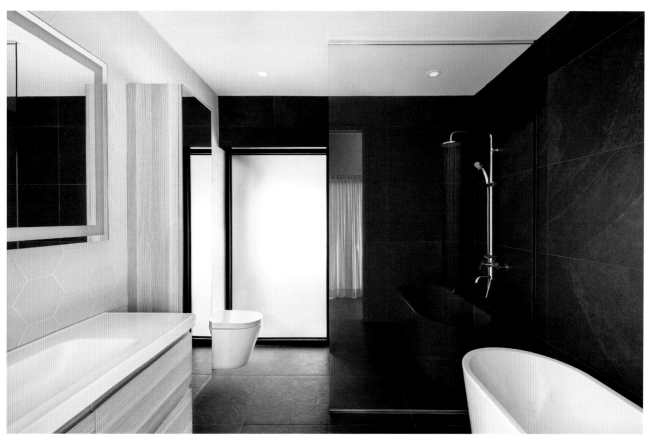

The color black represents both mastery and a cycle of human existence in Korean culture. It is expressed on the bathroom's walls and floor in stark contrast with the white surfaces.

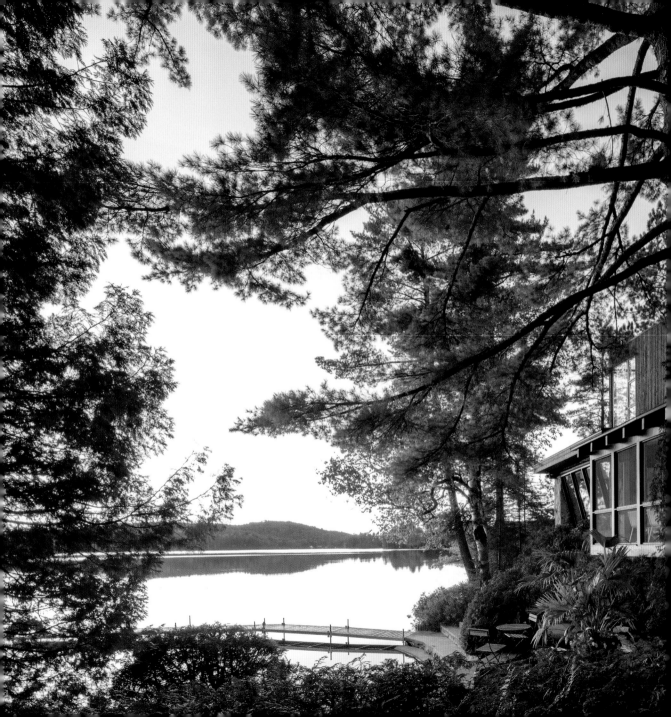

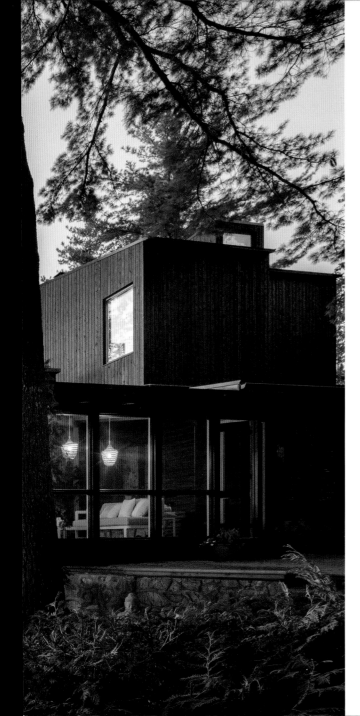

Cottage on the Point

2,700 sq ft

Lanaudière, Quebec, Canada

Paul Bernier Architecte

© Raphaël Thibodeau

The clients owned this cottage, which has been in the family for forty years. It is anchored on a rocky point jutting out into the lake. The project to be carried out was to completely renovate this cottage and expand it to turn it into an open, fluid, and bright space that takes advantage of the beautiful views of the lake. The proximity to the shore led the architects to expand vertically rather than horizontally, except for a screened porch added at ground level. The project contraposes the original cottage's rustic character—stone, log, and deep overhangs—with that of the addition, clean and monolithic but with colors that echo those of the cottage. The added story has exceptional lake views and illuminates the once dark ground floor through a tall opening at the staircase, taking in views of the tall trees and sky.

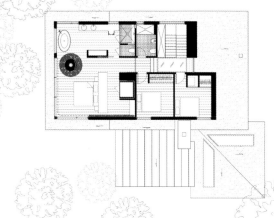

Second floor plan

Roof plan

Ground floor plan

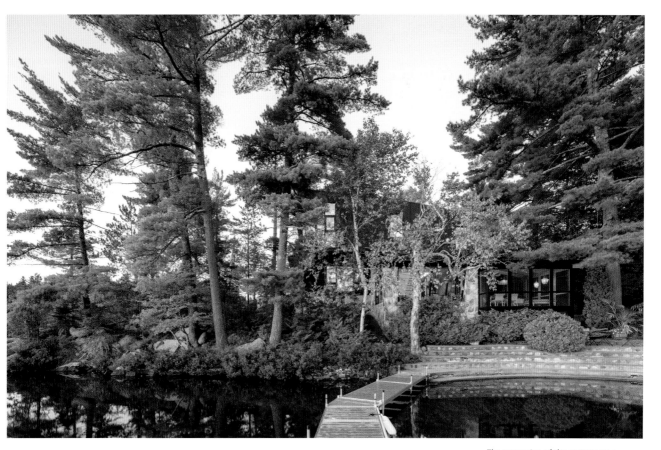

The expansion of the cottage was limited by its proximity to the lake's shore. Mindful of this site limitation, the design extends the cottage vertically rather than horizontally.

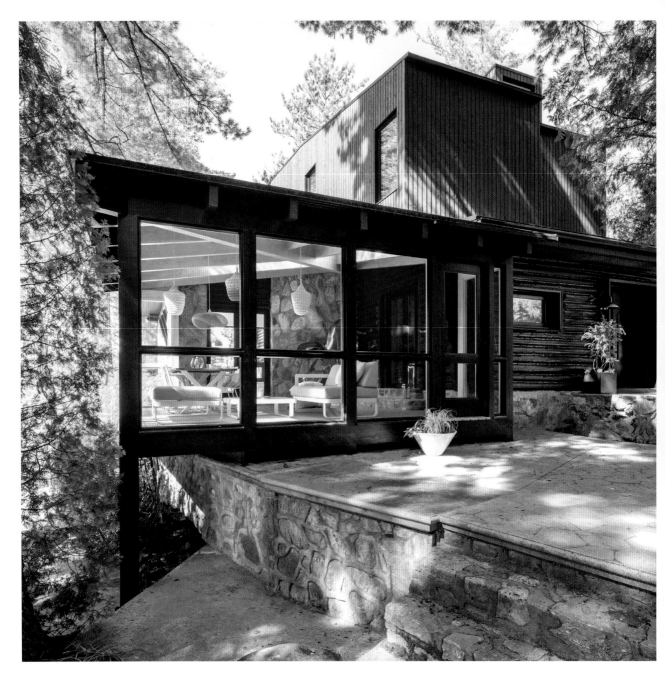

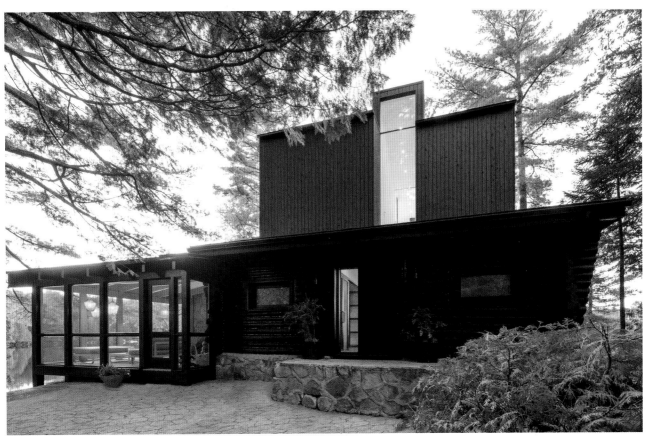

Contrast and continuity were crucial criteria that informed the design, ensuring a cohesive outcome respectful of the original structure.

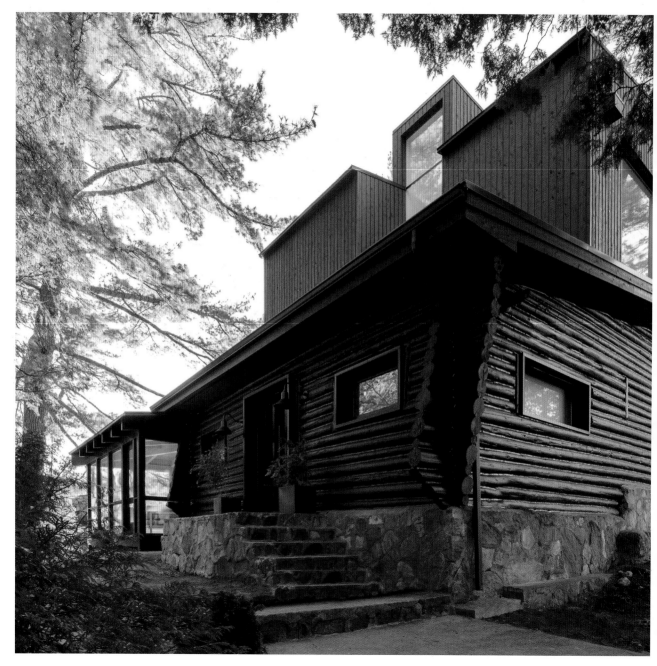

The old cabin is made of logs
and sits on a stone foundation.
This stone base, anchored on the
rock cap from which the site is
made, integrates the cabin into its
natural environment, following a
sustainable design approach.

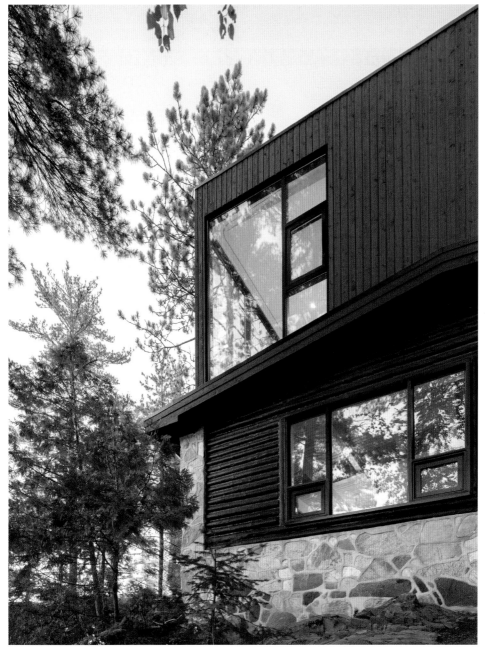

The new screened porch is fitted with
two skylights, offering a protected place
to enjoy the outdoors.

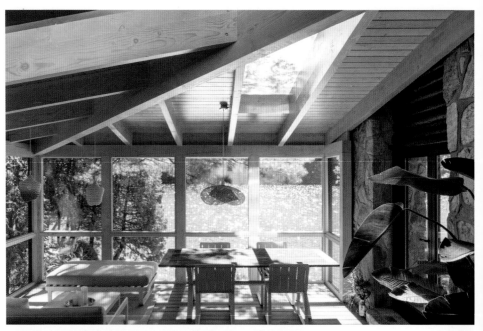

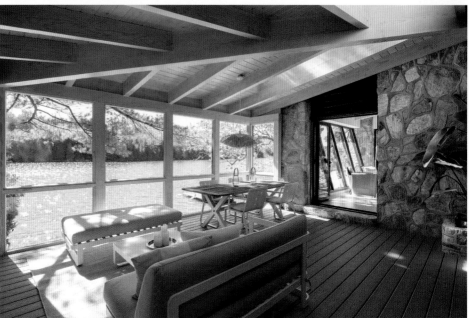

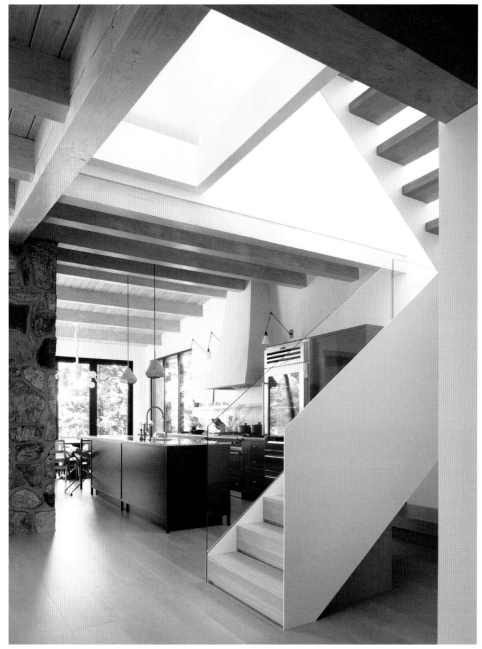

The white surfaces of the staircase reflect the light from the skylight above and transform this double-height architectural element into a light source that brightens the lower floor.

Stone and solid wood highlight the colors of the surrounding nature, while white surfaces maximize the light and provide a neutral backdrop for the natural materials.

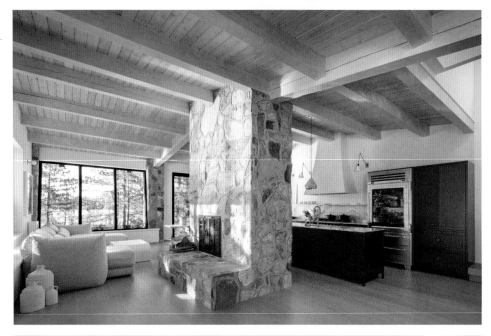

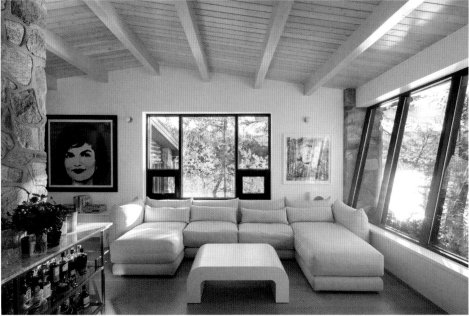

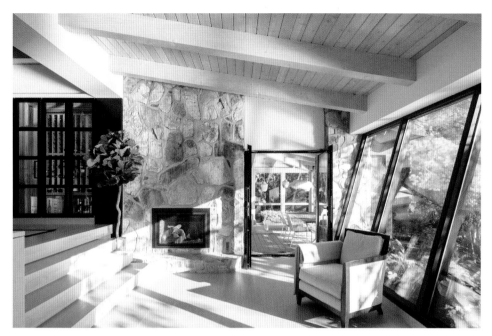

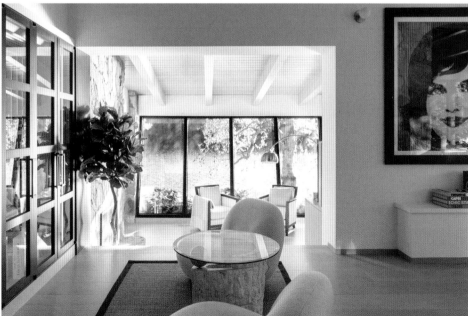

Inside, this coexistence of styles and periods is also present. The beautiful, old, massive stone fireplace has been restored and is now visible on all sides, right in the center of the space. The new staircase is light and minimalistic.

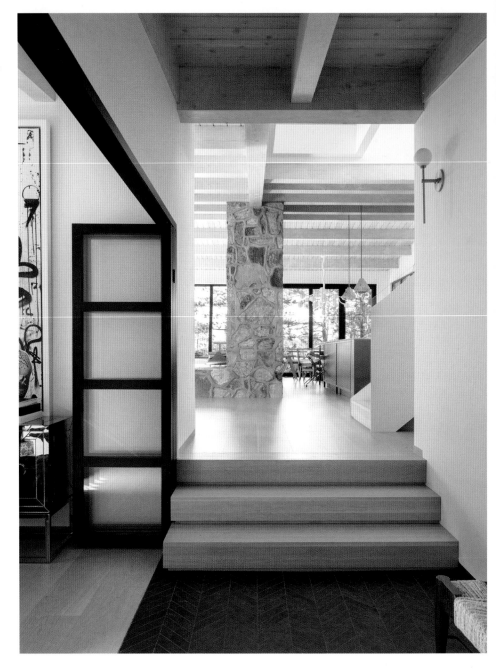

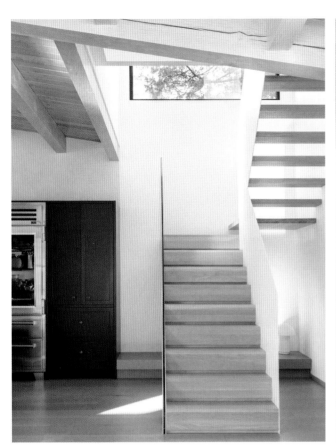
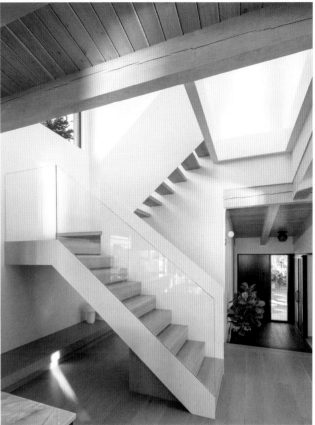

073

An abundance of natural light is high on the wish list of many homeowners. The addition to the original cottage serves to brighten the ground floor through a large vertical opening on the east side. Also, a large window at the top of the stairs acts as a skylight and offers a view of the sky.

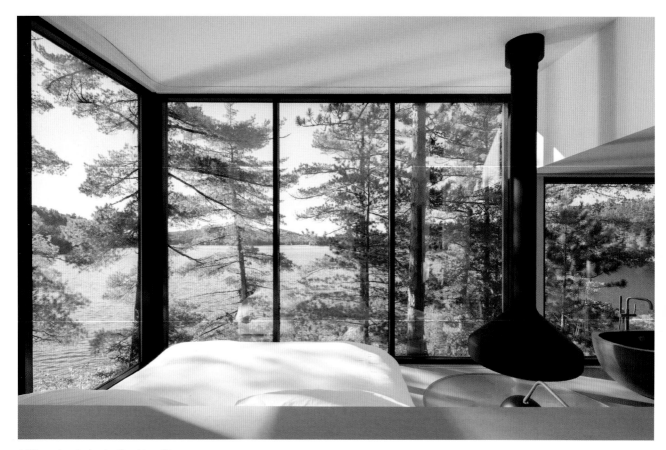

Adding a story had a significant benefit that the clients and the architect could see during the design process when they climbed onto the roof of the old cottage. This second story is an observation post with breathtaking views of the point, the lake, and the towering pines.

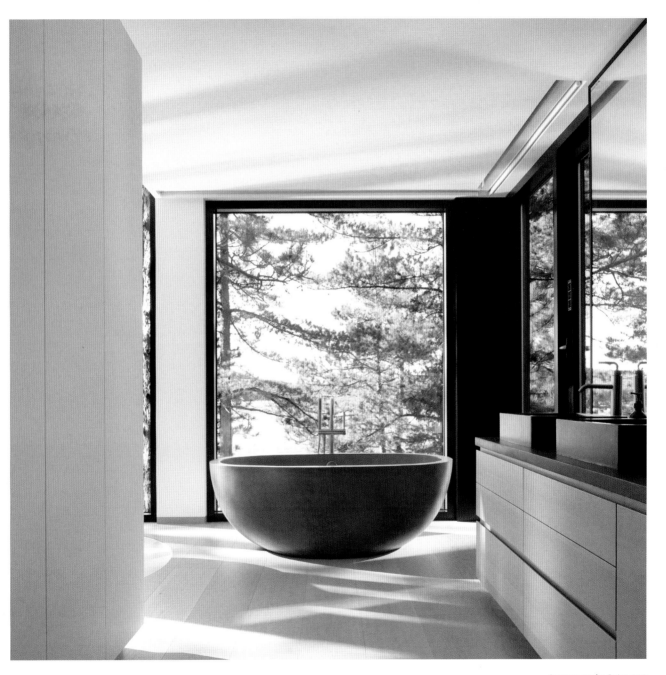

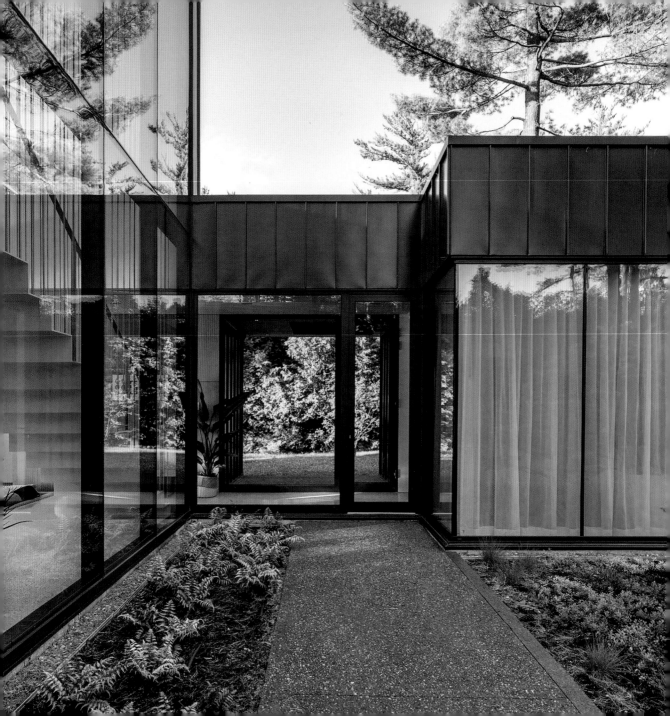

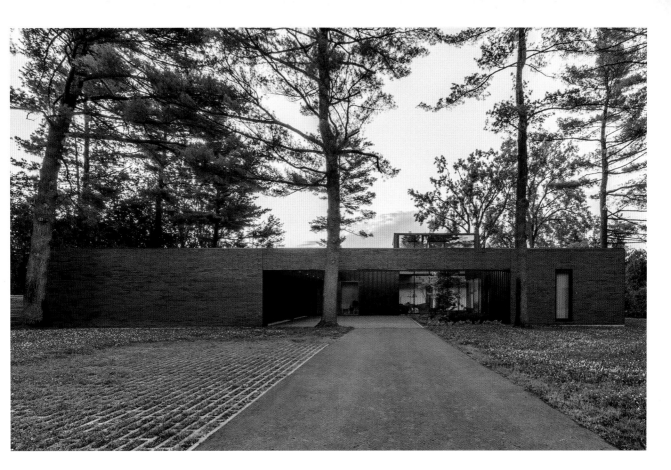

Built on the banks of a river, this single-family home revisits the domestic architecture of the 1950s in North America. Its design, however, adapts to contemporary living standards and the Canadian landscape. The house, which stands along a row of tall, mature pines, allows the natural vegetation to become an integral part of the project. Most existing trees were preserved, and views toward the water were optimized. The house is straightforward, both in form and materials, with clay brick walls as the predominant material. Other materials such as wood, stone, and brass combine with a palette of natural colors to better integrate the house with its surrounding landscape.

The Isle Residence

6,243 sq ft
Montreal, Quebec, Canada

Chevalier Morales

© Adrien Williams

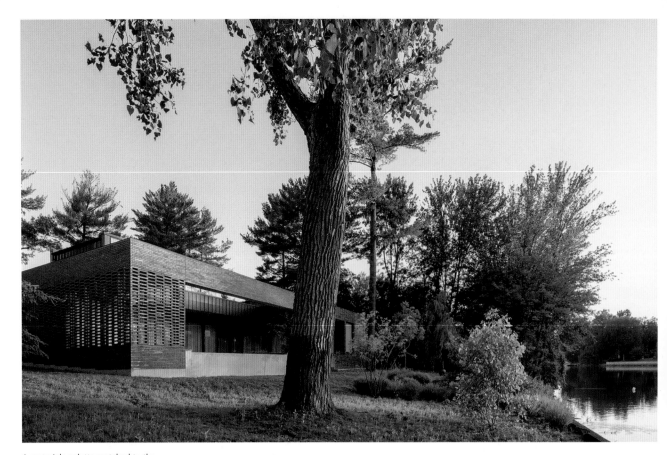

A materials palette matched to the
color of the natural trees' bark makes it
possible to integrate the new tone-on-
tone construction into its surroundings.

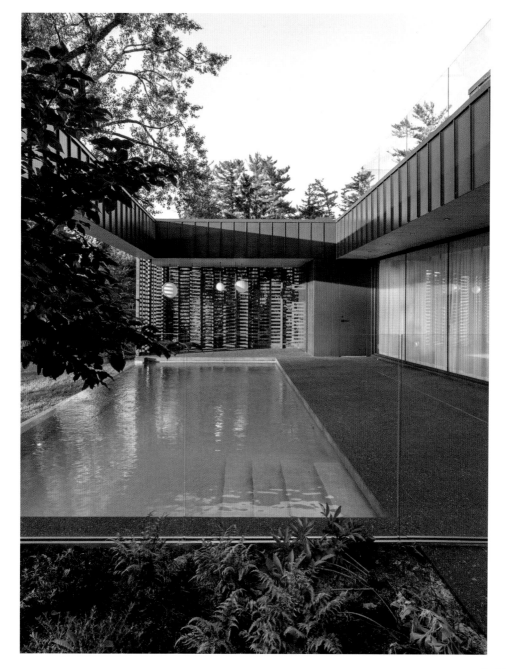

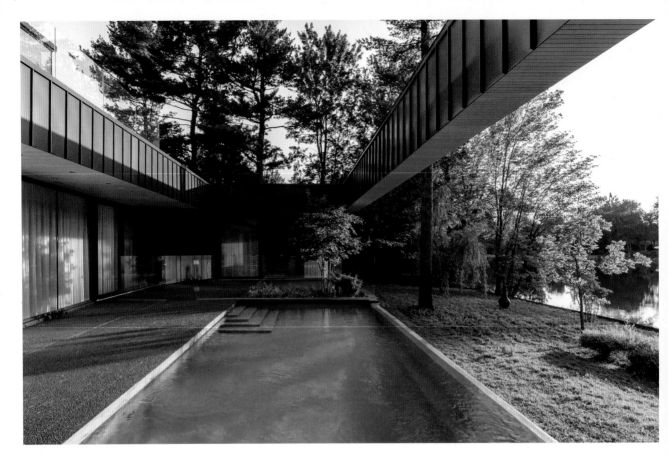

074

Architecture is influenced by a location's specific particularities, like its climate, topography, and site features such as water bodies, trees, plants, or outcroppings.

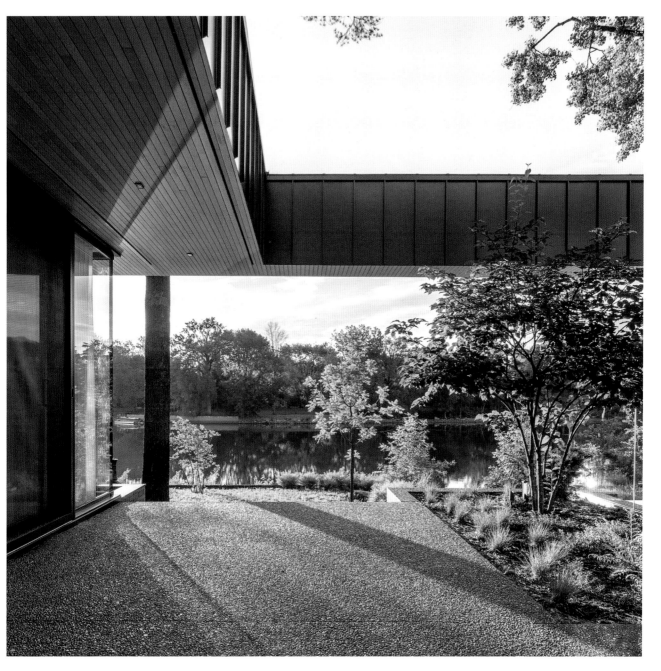

The horizontality of the building is only interrupted by the mezzanine box rising above the ground floor's roof. The roof has been partially landscaped, offering a private natural domain above the existing scenery.

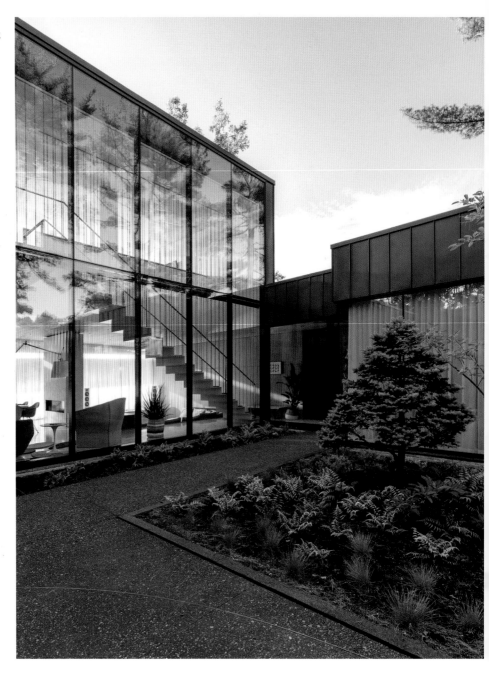

100' × 100'
The natural configuration of the site offers a clear area of 100 feet by 100 feet bathed in delicate natural light and topped by the canopy of tall white pines.

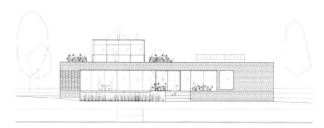

Rear elevation

Interior courtyards
The insertion of interior courtyards into the initial 100-foot-by-100-foot square—a result of the particularities of the site—defines the interior geometry of the house and acts as a buffer space with the exterior open.

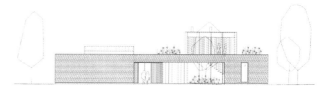

Front elevation

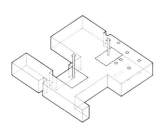

Artificial landscape
The play of topography on the floor and the ceiling and numerous skylights generate an artificial landscape that enriches the spatial experience of the house.

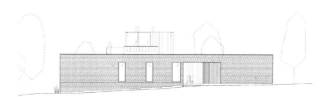

Bedroom side elevation

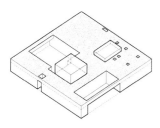

Roof
Closing all sides of the interior courtyards at roof level emphasizes the square and generates introversion.

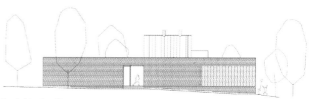

Pool side elevation

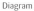

Diagram

Cross section

Street-river section

1. Garage
2. Living room
3. Pool
4. Mezzanine
5. Terrace
6. Bedroom
7. Family room
8. Kitchen
9. Dining room
10. Living room
11. Cellar
12. Green roof
13. Garden

075

Existing landscape features can inform architectural design. In this case, the river is integrated into the house design by creating public spaces that address it through panoramic floor-to-ceiling windows.

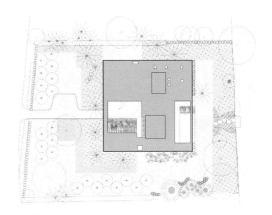

Site plan

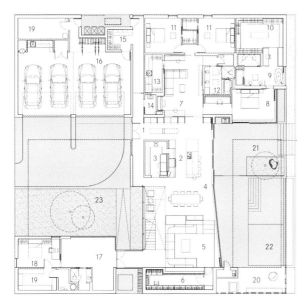

Ground floor plan

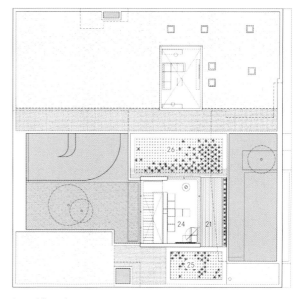

Second floor plan

1. Entry hall
2. Kitchen
3. Pantry
4. Dining room
5. Living room
6. Cellar
7. Family room
8. Master bedroom
9. Master bathroom
10. Walk-in closet
11. Bedroom
12. Bathroom
13. Laundry room
14. Washroom
15. Closet
16. Garage
17. Gymnasium
18. Guest room/office
19. Mechanical room
20. Porch
21. Terrace
22. Pool
23. Interior courtyard
24. Mezzanine
25. Garden
26. Green roof

Two rectangular courtyards address the question of privacy versus openings, crucial in the 1950s. The courtyards help organize the geometry of interior spaces while also integrating the backyard and the swimming pool.

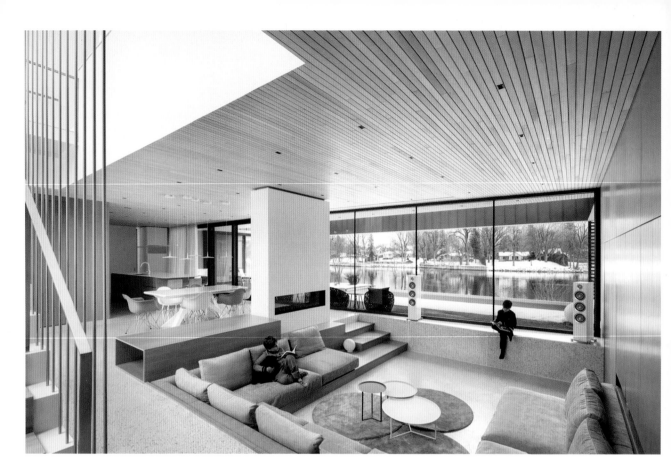

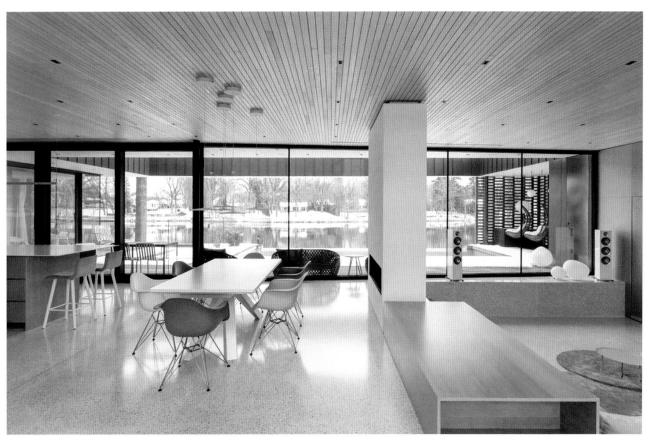

A panoramic window on the front facade creates a visual flow through to the river while accentuating the design's pavilion-like feel.

The floors' and ceilings' geometry, integrated wooden furniture, sunken seating area, and masonry cladding revisit key architectural elements of modernism in a contemporary way.

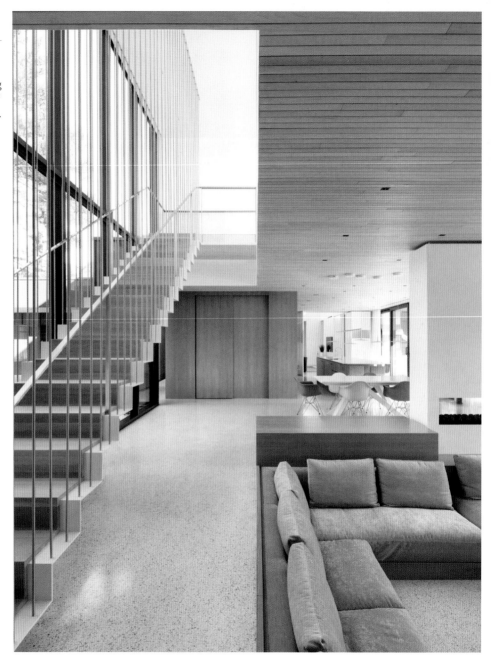

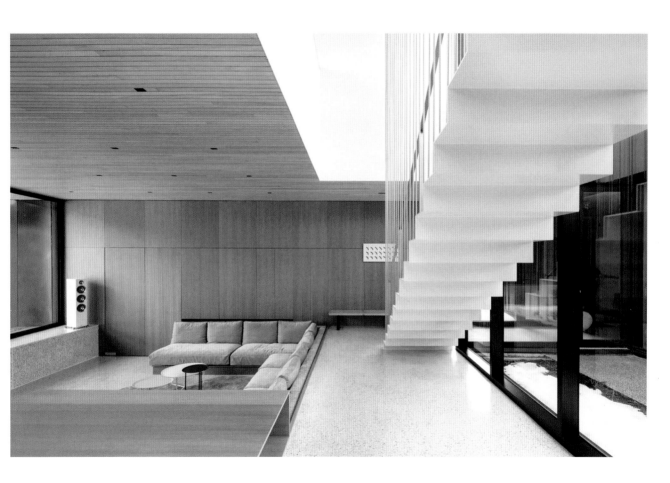

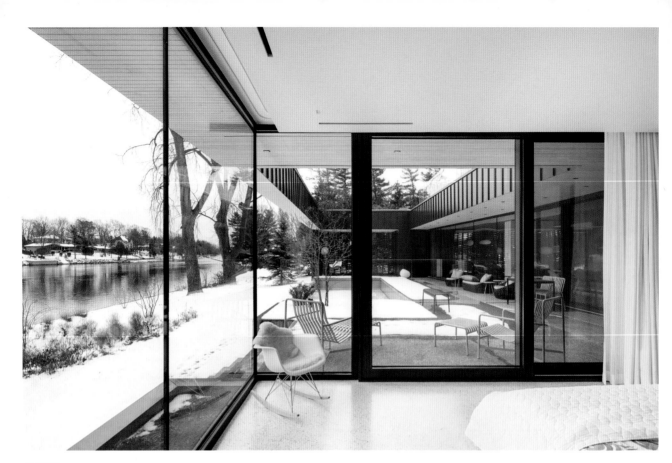

077

The design intent to give the house
a pavilion-like feel reaches its peak
in the master bedroom with its
corner position and two all-glass
exterior walls.

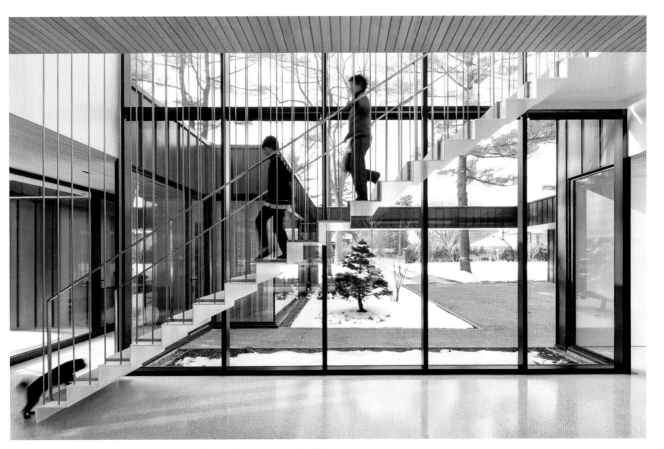

078

A minimalistic staircase with a brass guardrail gives access to the mezzanine level, an open space with a suspended steel fireplace—another reference to mid-century architecture—affording unbeatable river views.

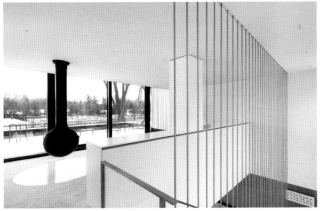

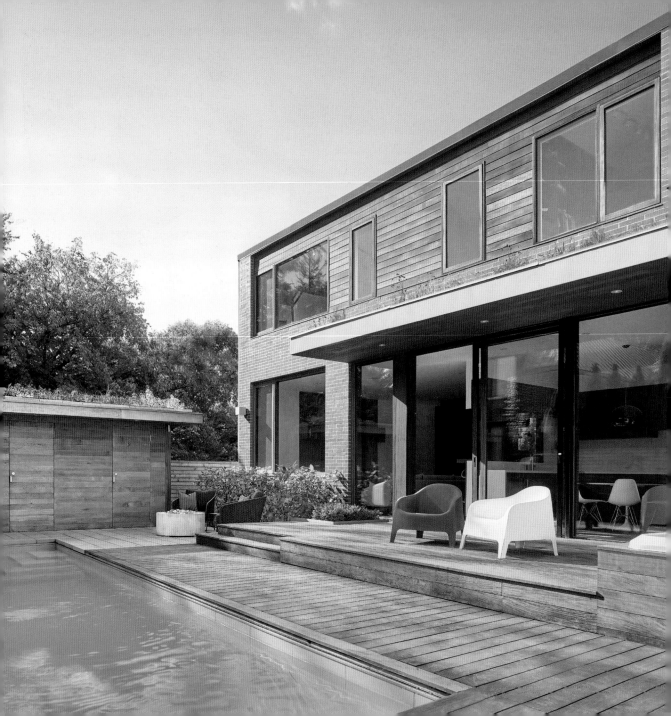

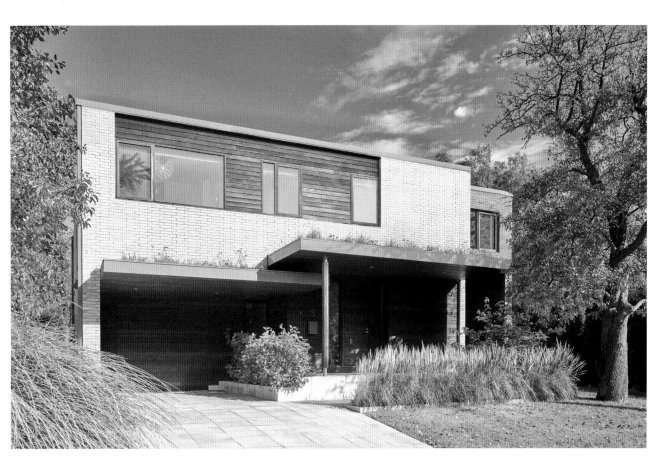

Garden Circle House is a four-bedroom home that responds to the client's desire for a sustainable home inspired by nature, connected to the outdoors, and awash in daylight. The Dubbeldam team drew upon biophilic design strategies, which can be described as a conscious effort to link the built environment to the natural world through various sensory experiences, including sight, sound, touch, and smell. The house is imbued with wellness features, including a palette of natural materials, lush landscaping, and water features that offer both visual and auditory effects to enhance a sense of calmness. It also uses spatial strategies to maximize natural light and visually connect to the outdoors through ample fenestration and elevated vantage points. Views of the house are primarily oriented to the rear yard, while green space is maximized through multiple green roofs.

Garden Circle House

3,200 sq ft
Toronto, Ontario, Canada

**Dubbeldam
Architecture + Design**

© Scott Norsworthy

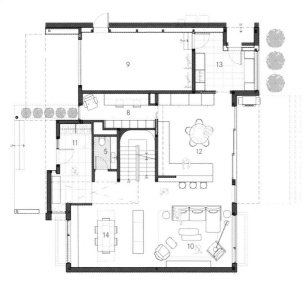

Ground floor plan

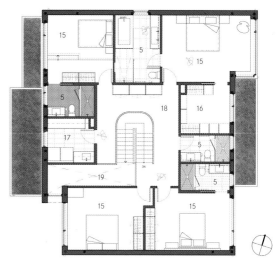

Second floor plan

1. Recreational room
2. Gym
3. Storage room
4. Utility/
 storage room
5. Bathroom
6. Sauna
7. Cold storage
8. Study/pantry
9. Garage
10. Family room
11. Entry foyer
12. Kitchen
13. Mudroom
14. Dining room
15. Bedroom
16. Walk-in closet
17. Laundry room
18. Hallway
19. Open to below

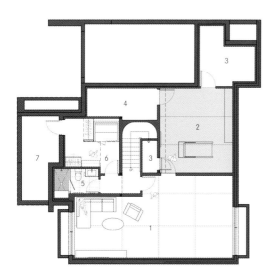

Basement floor plan

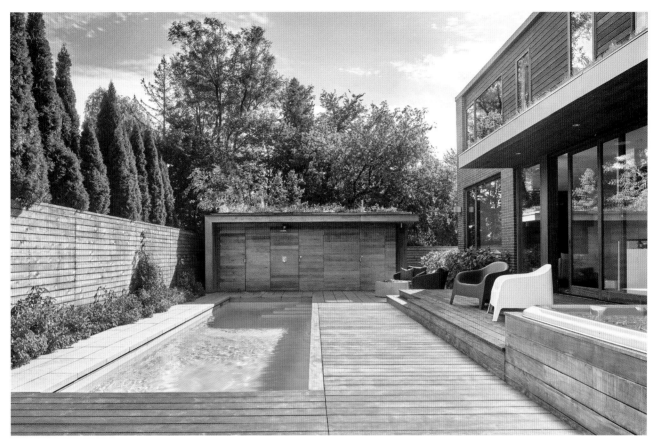

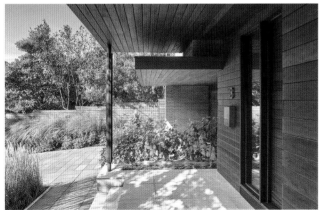

079

The presence and sound of water features, such as the pool and hot tub in the backyard, promote relaxation and contribute to the creation of cooling breezes.

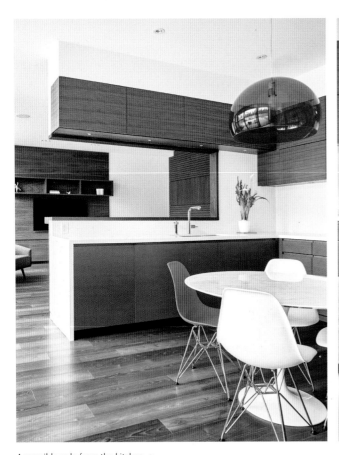
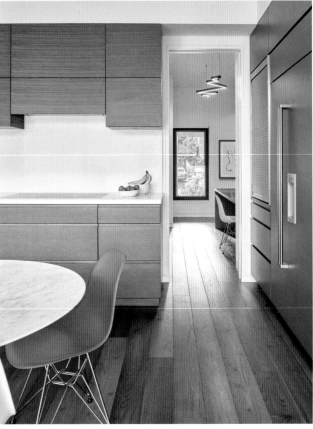

Accessible only from the kitchen, a
hidden pantry doubles as a small study,
which offers a curated view to the
exterior and a place for focus away
from the communal areas.

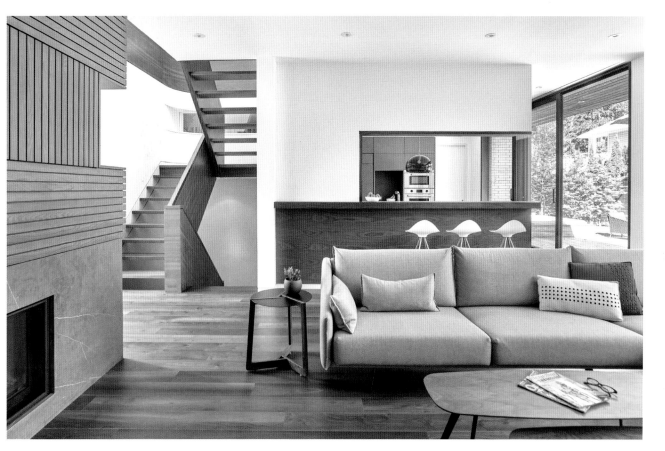

080

Wall openings and millwork provide spatial definition in an open plan while allowing visual connection between interior spaces and the exterior.

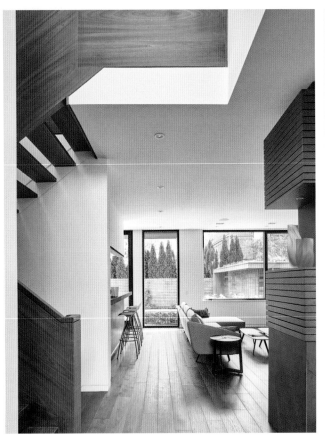
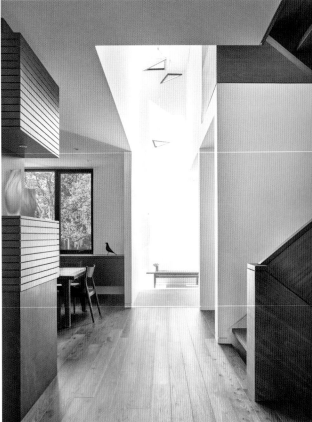

Visual connectivity to the outdoors is incorporated in every part of the house. From the entry, a direct view to the backyard is visible through a tall, narrow window.

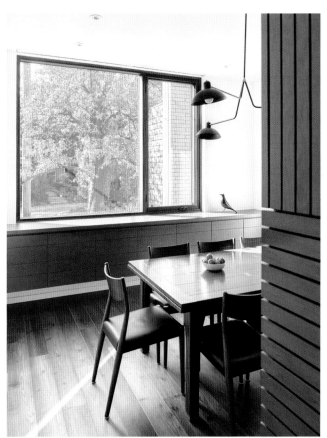

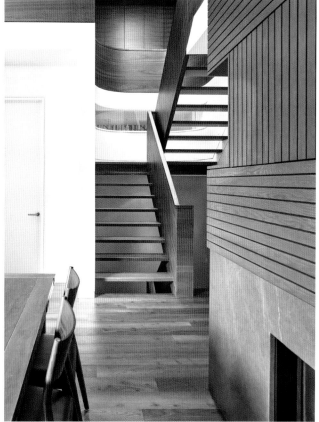

081

Clad in subtly veined gray limestone and gray-stained white oak slats, a free-standing cabinet with a double-sided fireplace and hidden storage divides the living and dining areas.

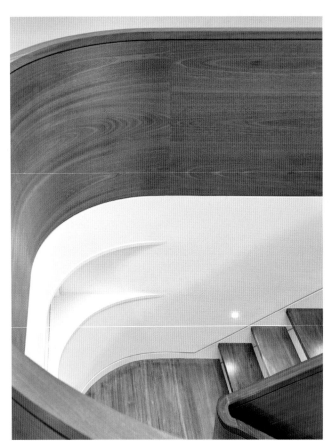

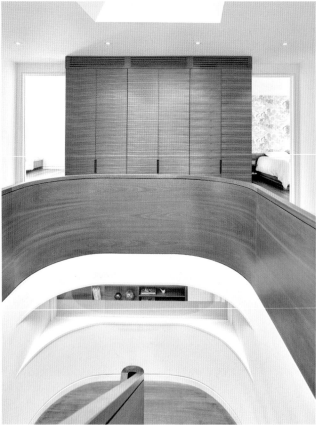

082

A curved staircase creates an
opportunity for a pause on the
landing, where a horizontal window
offers glimpses into the hidden
ground-floor study and pantry.
Its organic design encourages a
continuous flow that brings to mind
the circulation ramp at the New York
Guggenheim Museum.

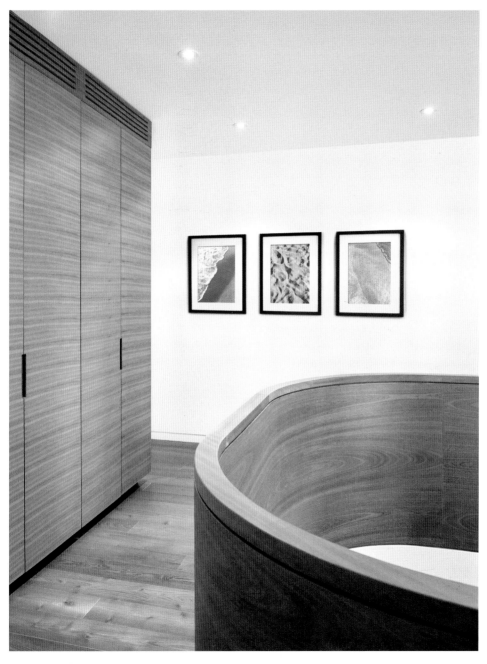

The staircase is a focal point of the house interior. It is crafted of solid mahogany and has open risers and a curved balustrade, which emulates natural organic forms, inviting the hand to run along its sculptural contours.

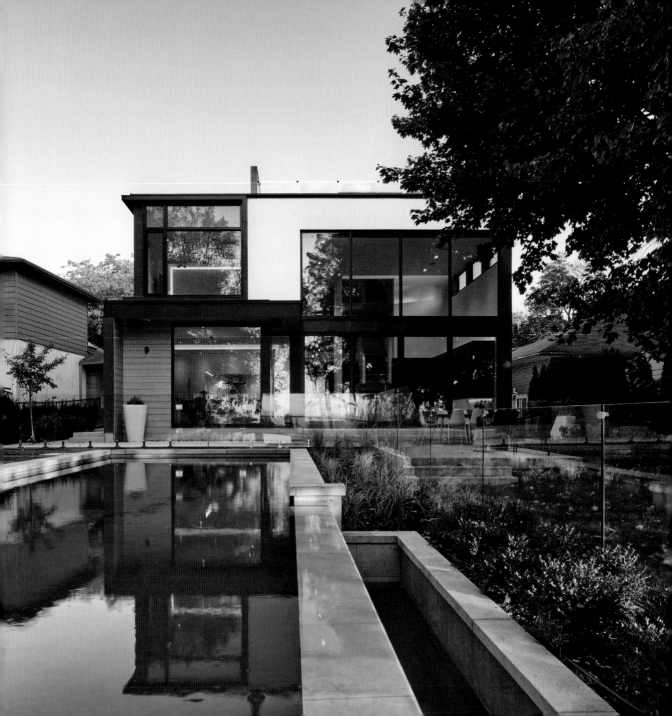

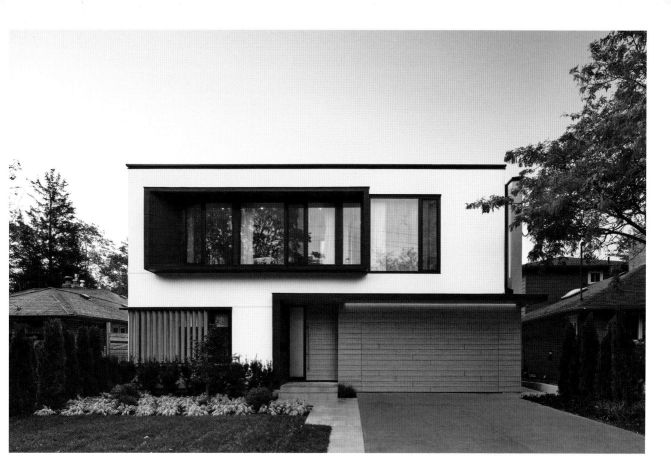

A young professional couple approached Taylor Smyth to design a new residence, impressed by one of their other contemporary houses in the vicinity, winner of the People's Choice Award for the Ontario Association of Architects Design Excellence Awards ("House on the Bluffs"). Both sites feature breathtaking views over Lake Ontario. Maximizing the views of the lake and embracing the landscape were guiding design inspirations. The house is focused on a two-story great room, skylit along one side and fully glazed at the back, with large sliding doors that open out to the backyard and swimming pool. Exterior materials, including white stucco walls, black metal accent panels, and oak-look phenolic panels (Trespa), were chosen for their no-maintenance composition, an important consideration in Ontario's widely fluctuating summer and winter climate.

Fishleigh Drive Residence

4,300 sq ft
Scarborough, Ontario, Canada

Taylor Smyth Architects
© Doublespace Photography Inc.

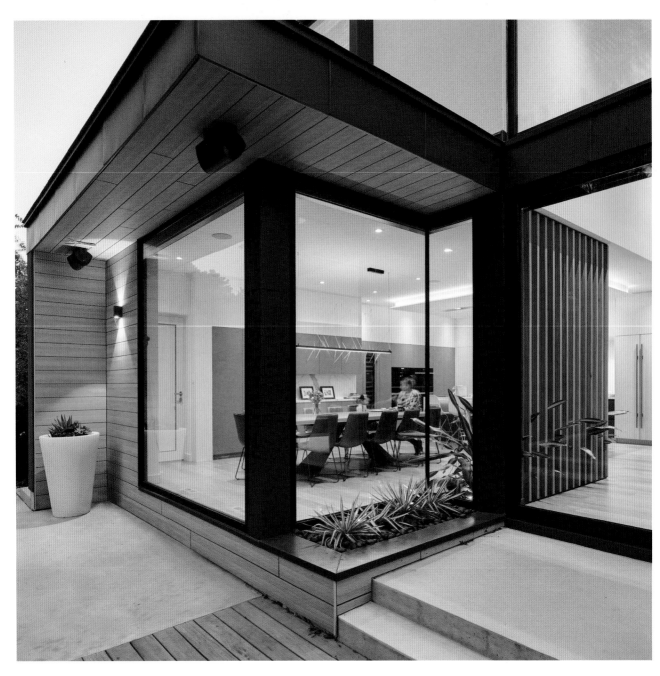

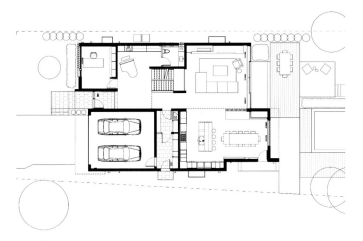

Ground floor plan

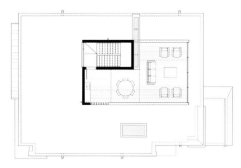

Terrace level floor plan

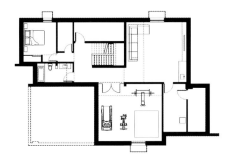

Lower level floor plan

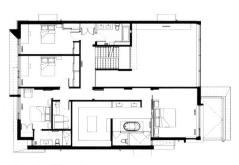

Upper level floor plan

Site plan

083

Embracing the natural environment and maximizing views are paramount during a house design process.

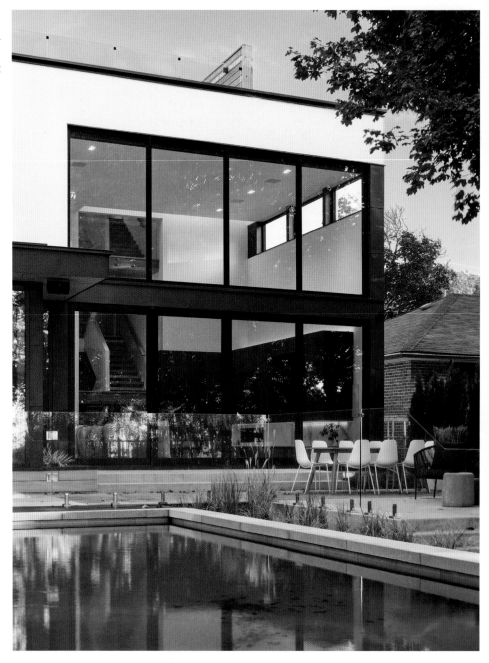

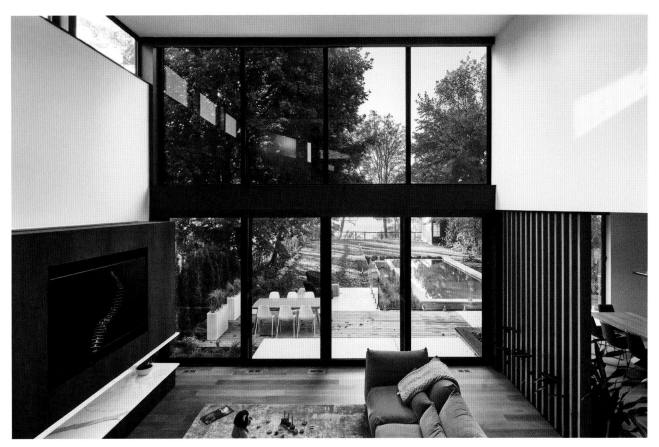

The highlight of the design is a double-height living area with a glazed wall offering views and access to the backyard. The house is topped by a terrace level offering longer views.

An exterior planter extends inside along a vertical screen of oak slats, separating the great room from the dining room. This design solution preserves spatial continuity.

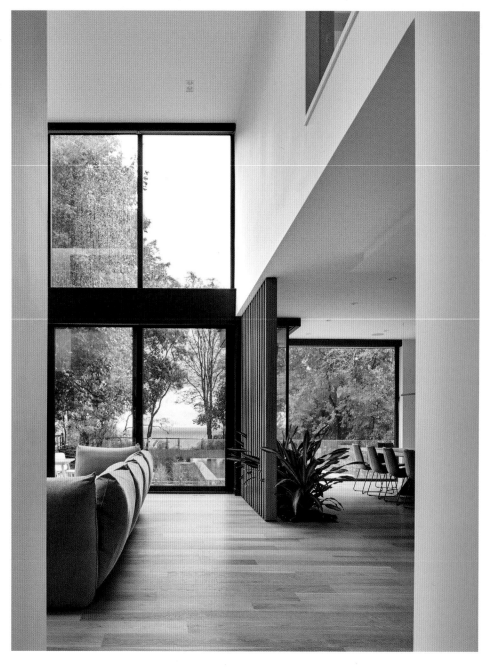

The material palette inside features light oak floors throughout, with accents of both white and black large-scale porcelain reproducing the rich patterns of Statuary marble.

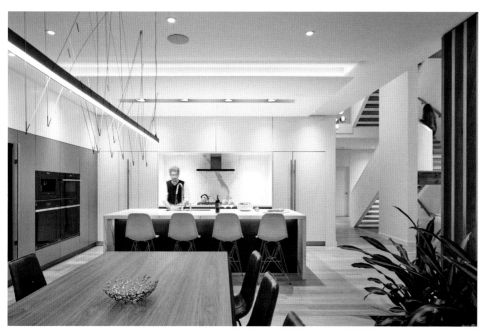

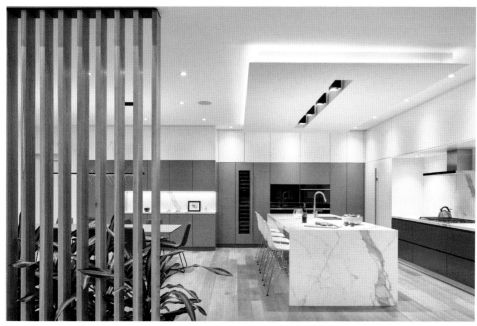

An open staircase winds through the center of the house up to the third-floor roof terrace, where the owners can enjoy spectacular views of the lake above the tree canopy.

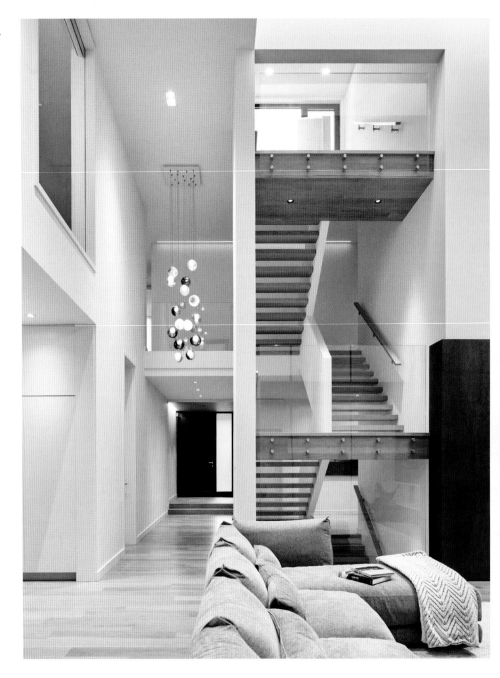

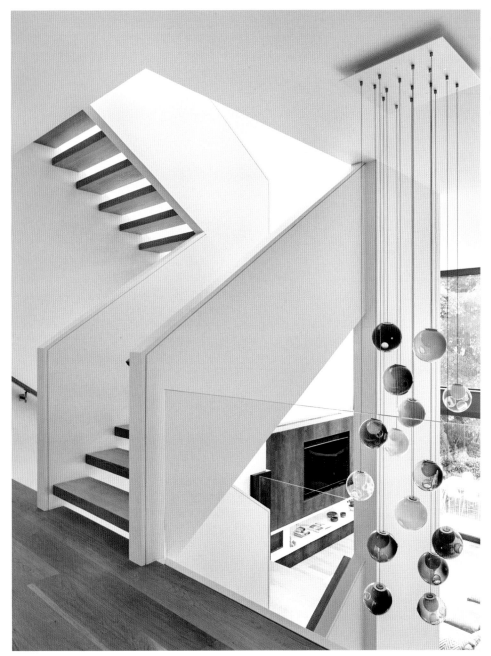

Feature staircases can transform spaces into extraordinary places. Form and material are the key design elements to achieve an eye-catching effect.

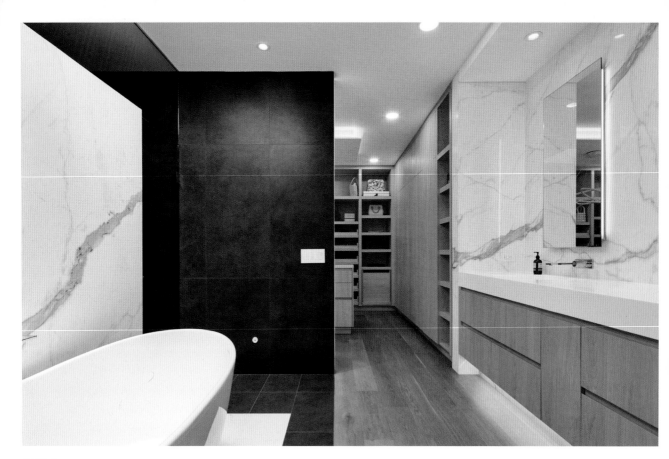

086

The master bedroom features a
spacious and luxurious en suite
bathroom and walk-in closet,
where white and black porcelain
slabs are combined to create a
dramatic contrast. Wood flooring
and cabinetry add warmth. The
result is a serene space that
evokes a spa-like atmosphere.

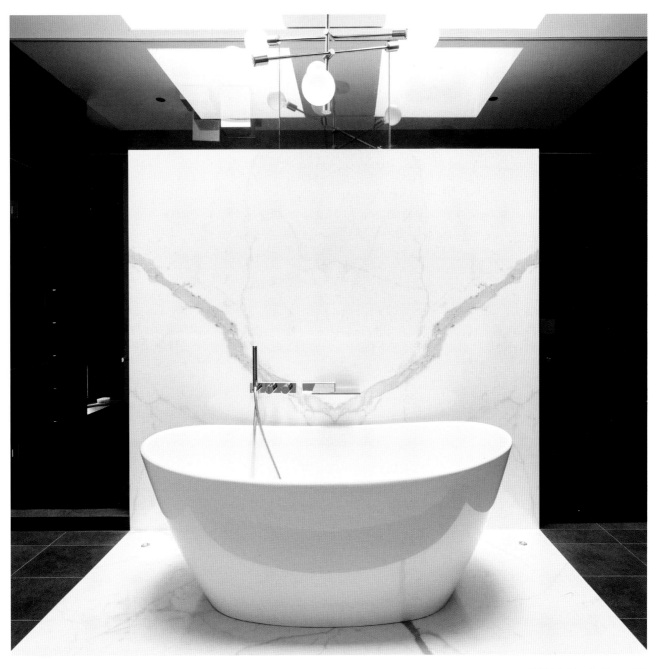

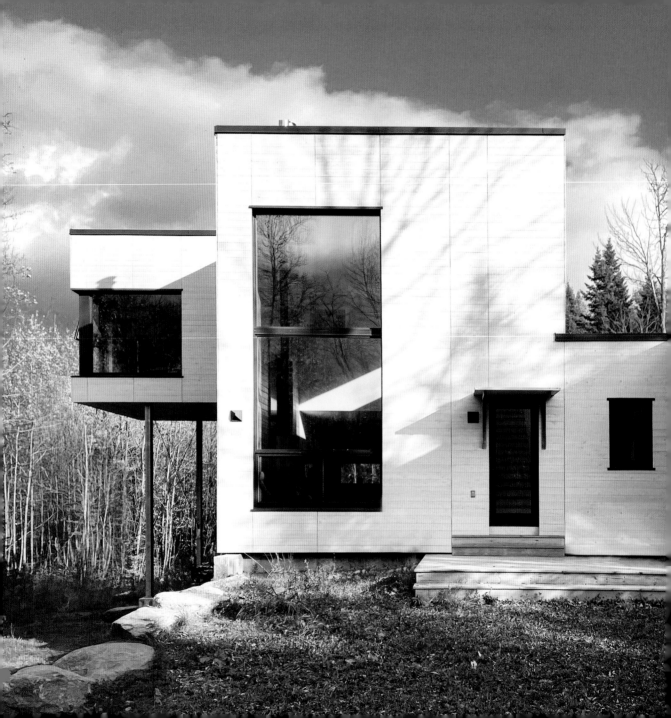

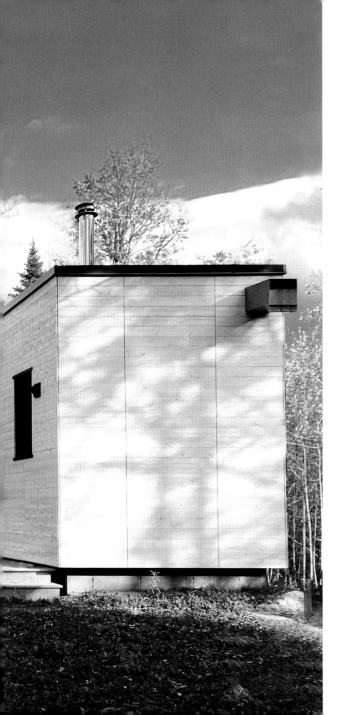

Bear Box House

1,900 sq ft

Middlesex, Vermont,
United States

Stonorov Workshop Architects

© Storonov Workshop Architects

The Vermont Bear Box House is a new high-efficiency, volumetric, single-family house designed for integration with site relationships as the primary design concept. Programmatic ideas, matched to plain forms, create intimate outdoor spaces separated from surrounding wilderness through adjacency and elevation. Beauty and delight were design goals and are realized through the rich circulation from dirt road, to a tree-lined driveway, to the house, through the materiality and through the detailing. Bear Box House provides a prime example of how a project may be realized with dynamic spaces while maintaining a minimal footprint and adhering to sustainable concepts. The resulting building amplifies the landscape through great respect for the site and careful consideration of constraints, which inspired the design.

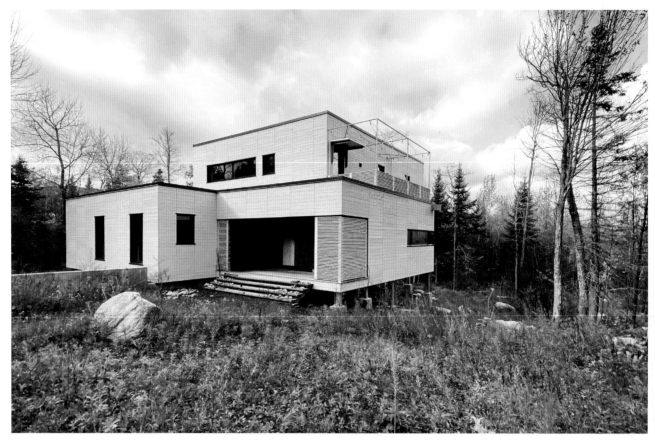

The Bear Box House has a dual relationship to the site. The southern entry is grounded on the earth with a concrete landscape wall that leads the entry sequence. The northern portion of the house sits lightly on the land, allowing the existing ecosystem to flow beneath it.

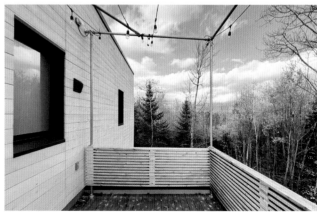

North elevation

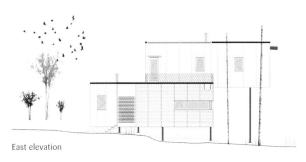

East elevation

South elevation

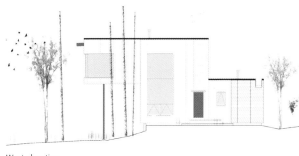

West elevation

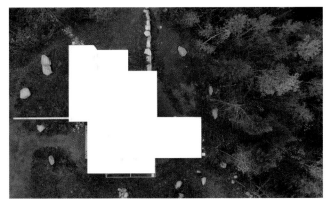

Aerial view with house footprint (© Nicholas Ames)

Restoring the original landscape of large boulders, ferns, moss, and native grasses was of the utmost importance. Only native plant species have been replanted, with the goal of having the house feel like it is fully integrated into the existing landscape.

087

At under 2,000 square feet, designing for the economy of need has been a driving principle of the Bear Box House. Spaces are designed to be as small as possible while providing nourishing comfort.

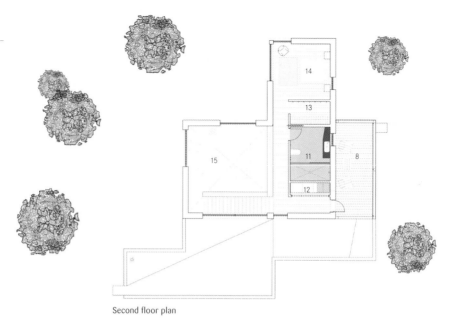

Second floor plan

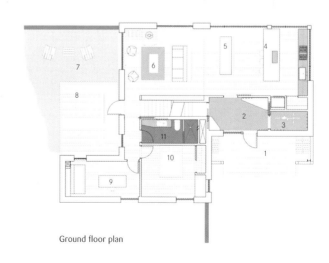

Ground floor plan

1. Covered deck
2. Entry
3. Bike storage
4. Kitchen
5. Dining area
6. Living area
7. Fenced stonescape
8. Deck
9. Office
10. Bedroom
11. Bathroom
12. Laundry room
13. Master closet
14. Master bedroom
15. Open to below

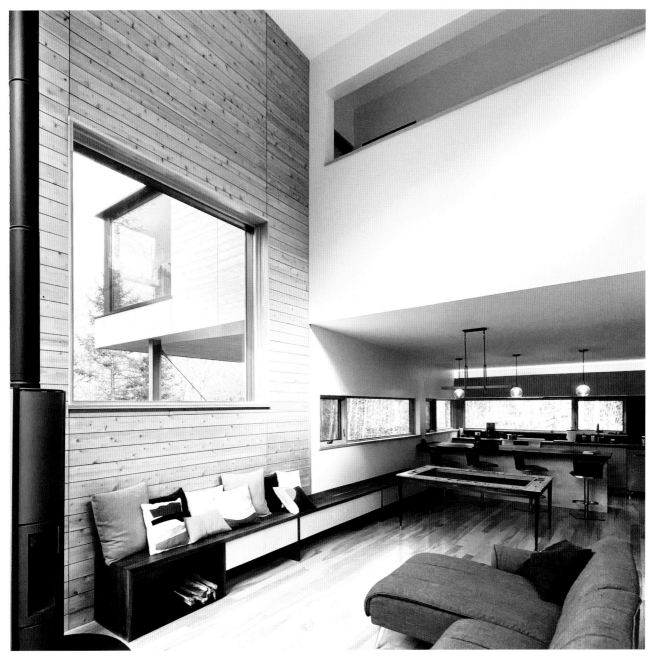

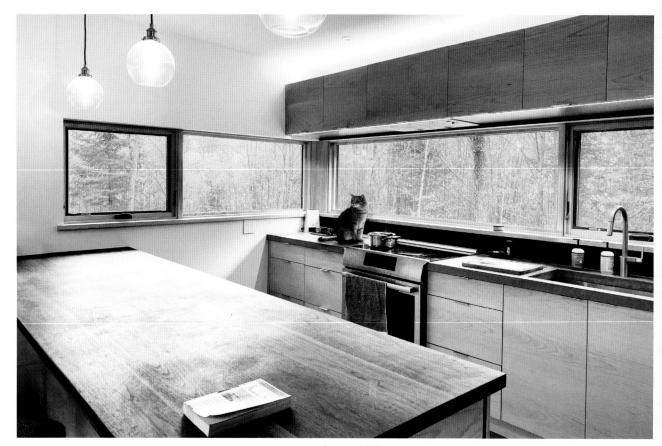

The kitchen windows frame panoramic
views of the immediate treed landscape.

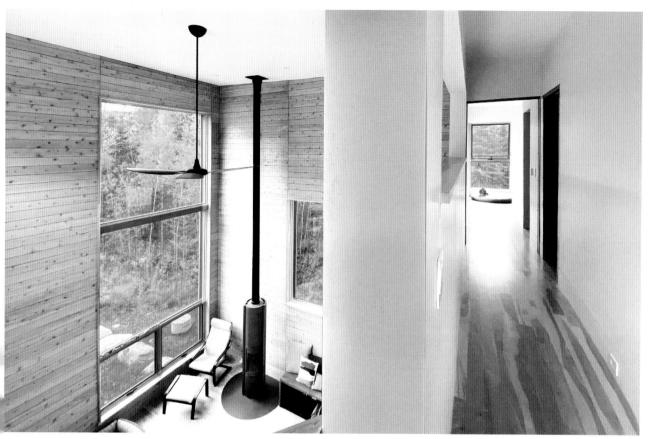

088

One large, double-height space provides dynamic relationships between the upper and lower floors.

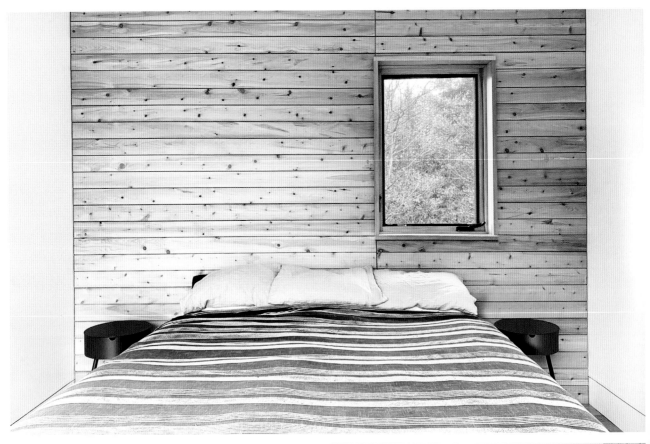

The house embraces interior space
while simultaneously connecting to
the landscape beyond.

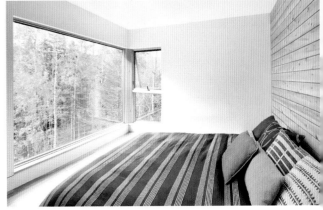

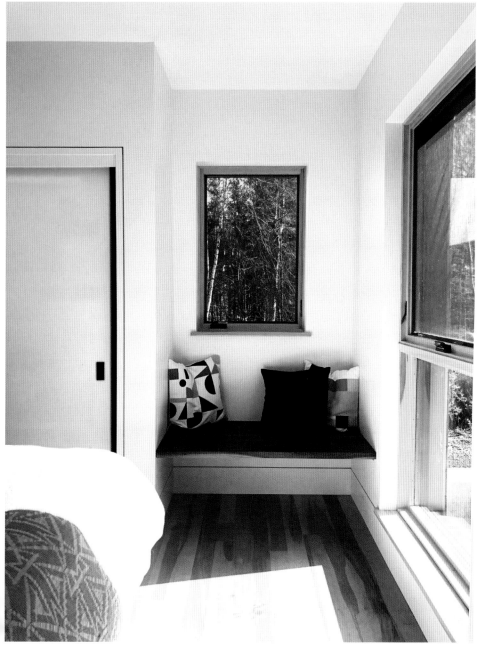

When dealing with small spaces, clever ideas can make a world of difference. Every corner can be put to good use for space efficiency, maximizing functionality without renouncing comfort.

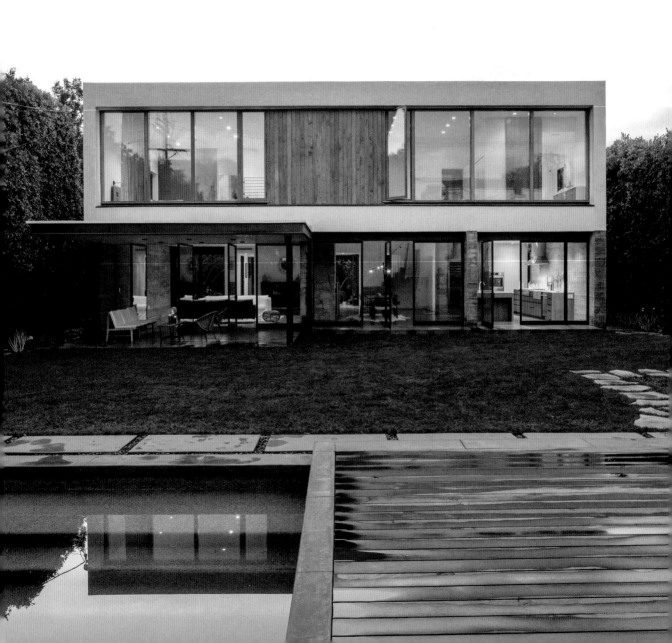

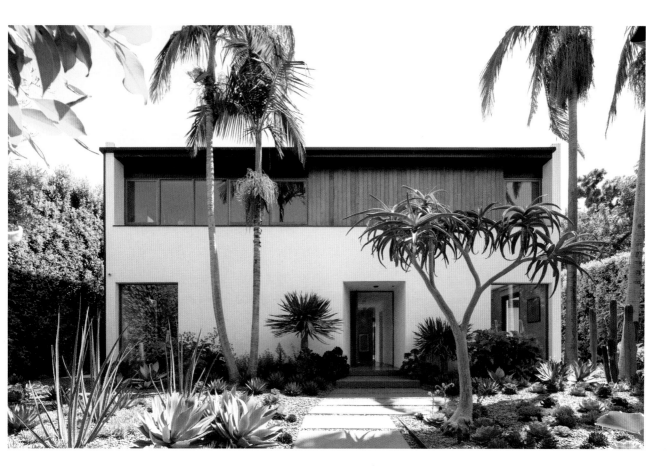

Tucked within a massive ring of *Ficus nitida* in a densely populated Hollywood neighborhood, the Hedge House exploits the privacy afforded by this unique and mature landscaping element. The thirty-year-old hedge played a significant role in the decision to purchase the property. Its presence along the site edges offers a high degree of privacy but also the opportunity to reconsider conventionally visible public spaces—front and side yards—as private garden space. The design of the house is organized around two architectural gestures: a multistory central lightwell that draws daylight deep into the middle of the house and open contiguous living spaces that directly connect to the garden.

Hedge House

4,200 sq ft

Los Angeles, California, United States

JacobsChang Architecture

© Michael Wells

090

From orientation to window and skylight placement, maximizing natural lighting is a sustainable design strategy that will reflect on energy costs.

Exploded axonometric

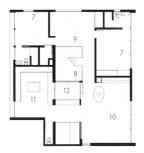

Second floor plan

1. Entry
2. Dining room
3. Kitchen
4. Living room
5. Outdoor patio
6. Office
7. Bedroom
8. Stair hall
9. Media room
10. Master bedroom
11. Dressing room
12. Outdoor courtyard

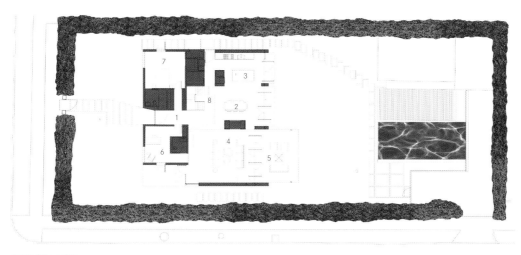

Ground floor plan

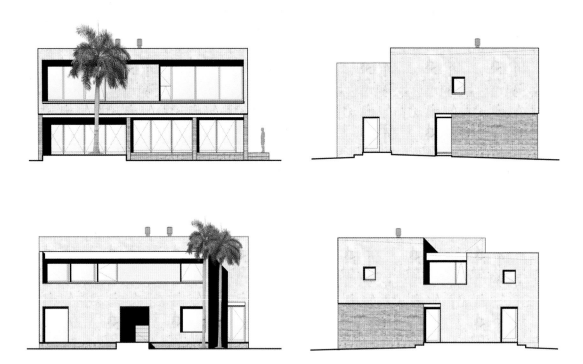

Elevations

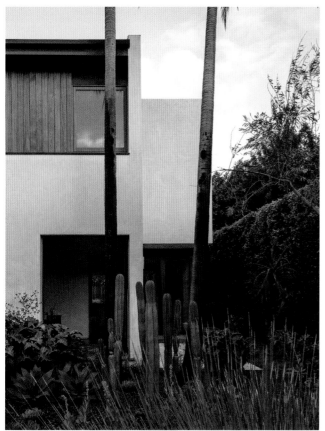

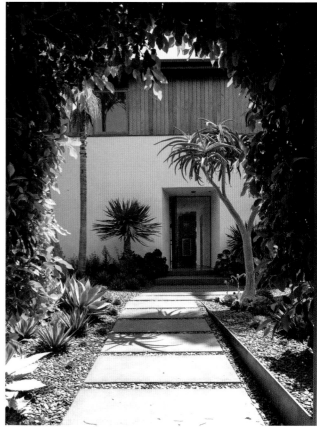

The ficus hedge establishes a continual reference from within the house. At the ground level, this green wall brackets the space of the gardens and provides an uninterrupted backdrop. From the upper level, the hedge is topped out at the height of the window sills, allowing longer views beyond the property.

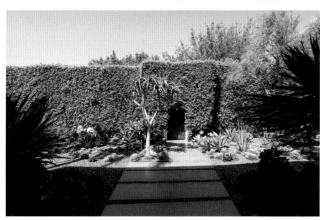

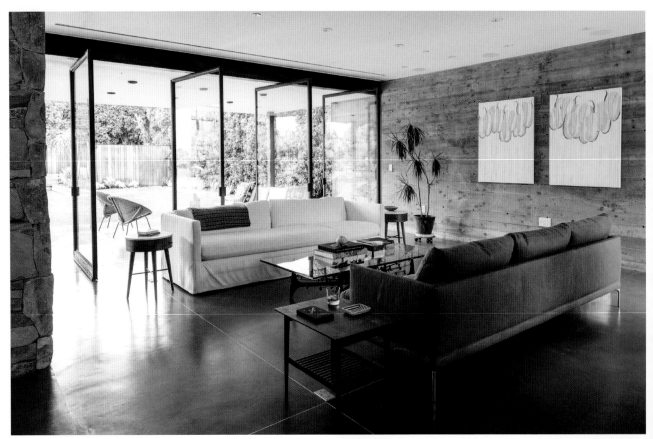

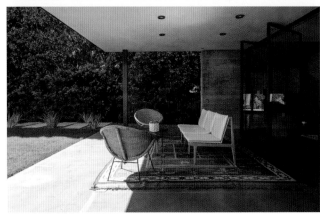

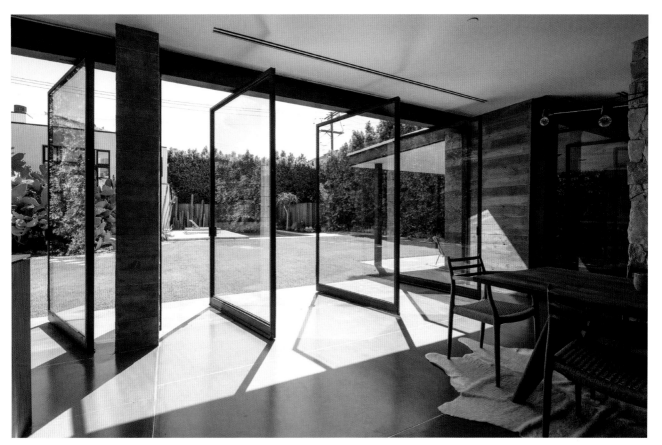

091

Large steel pivot doors infill the concrete walls. With no frames, pivot doors offer uninterrupted views while adding greatly to the aesthetic of a room.

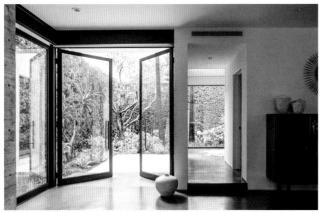

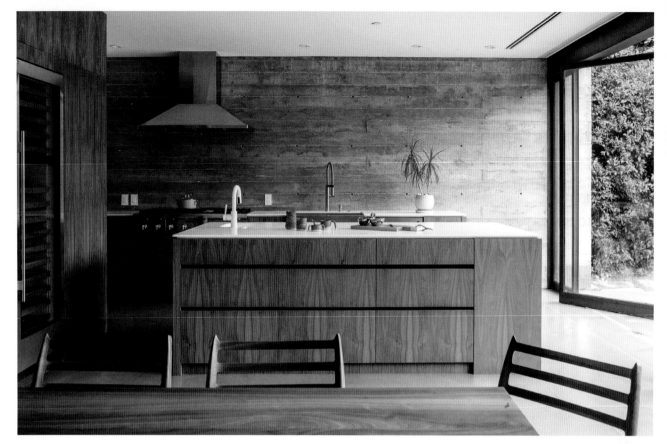

Stucco and cedar are the primary materials and delineate the smaller private spaces of the home. Board-form concrete piers complement the restrained material selection. These piers "lift" the stucco volume to produce a porous connection between the open living spaces, the garden, and the pool.

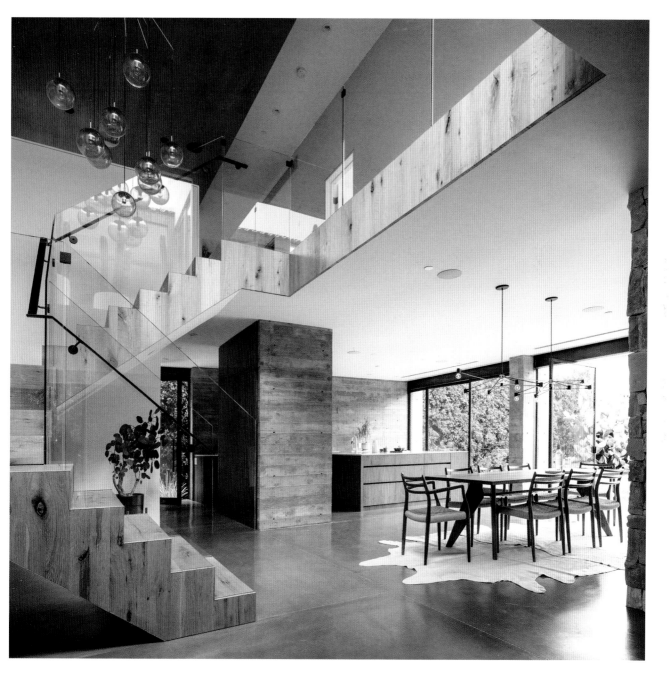

092

The interior spaces of the house are designed around a two-story volume with a bold wood and glass staircase, a central design statement that in turn creates an extraordinary space.

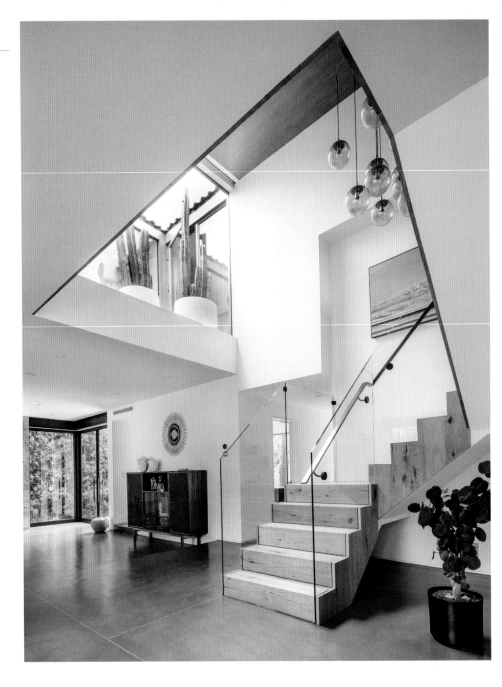

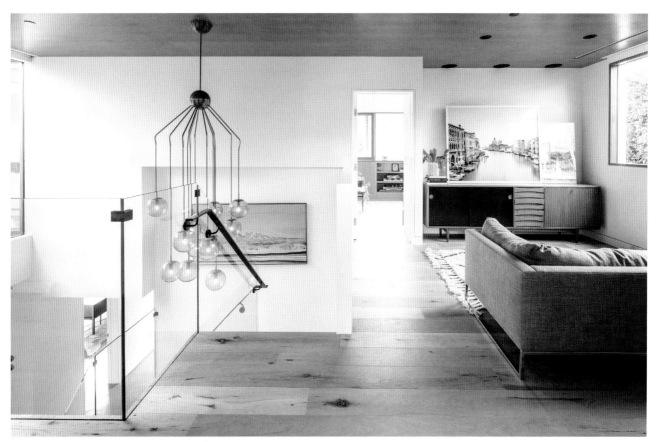

093

Climbers and dense shrubs can provide year-round screening for privacy while providing a relaxed and inspiring backdrop that encourages retreat and concentration.

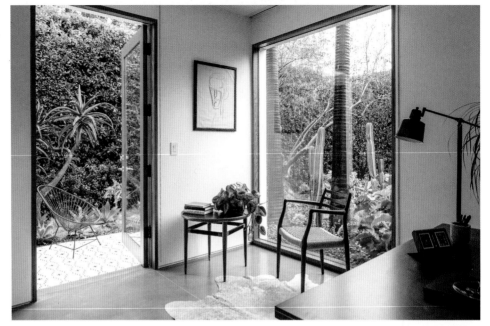

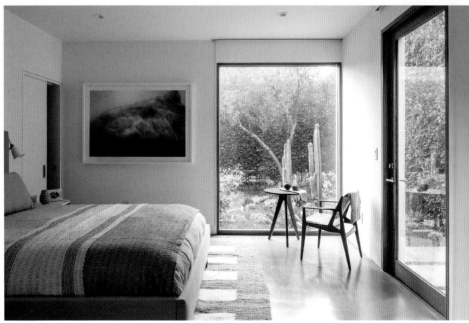

Interior courtyards are private oases that can allow greenery inside. As semi-outdoor spaces, they add to the spatial experience, establishing a diversity of indoor-outdoor relationships.

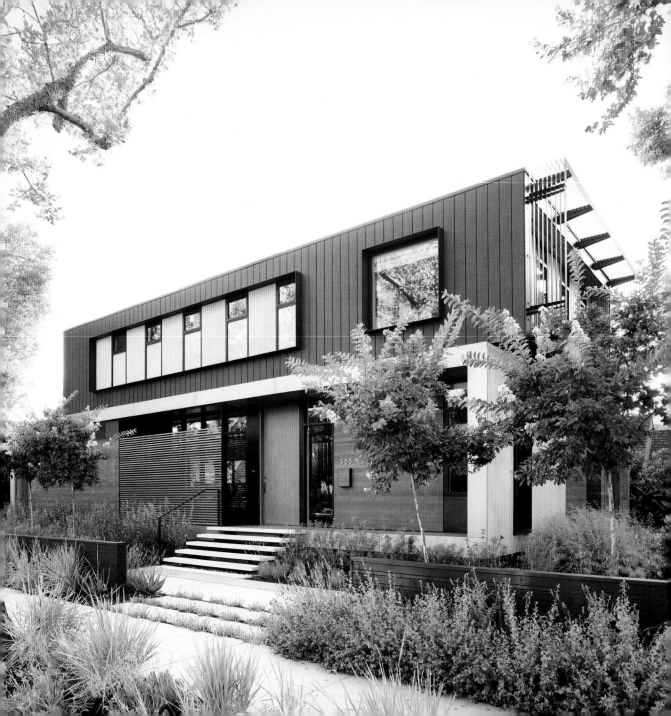

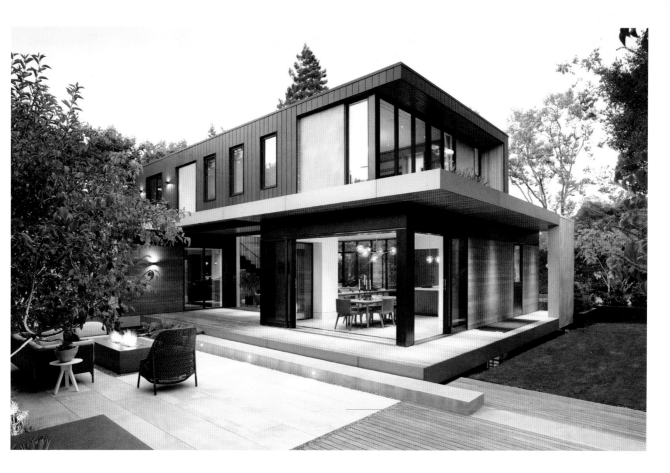

A young couple approached Studio VARA to design a new ground-up residence for their busy family of five on a prominent yet small corner lot in Old Palo Alto. Studio VARA created a small, flexible home with a generous program and a limited allowable footprint, weaving the architecture, interiors, furnishings, and landscape into a seamless, integrated whole. The house was conceived as a Rubik's Cube of tightly interlocking spaces that expand outward into a landscape of intimate yet generous outdoor rooms. Inside, sumptuous materials and sophisticated detailing make the home feel large and luxurious.

Palo Alto Residence

4,531 sq ft
Palo Alto, California,
United States

Studio VARA

© Matthew Millman Photography

095

Floor-to-ceiling glass walls allow the outdoors and daylight to penetrate the house and maximize sightlines to achieve a feeling of spaciousness.

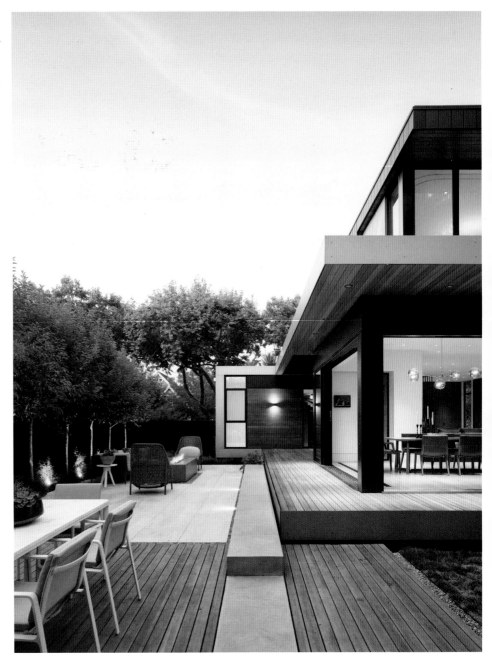

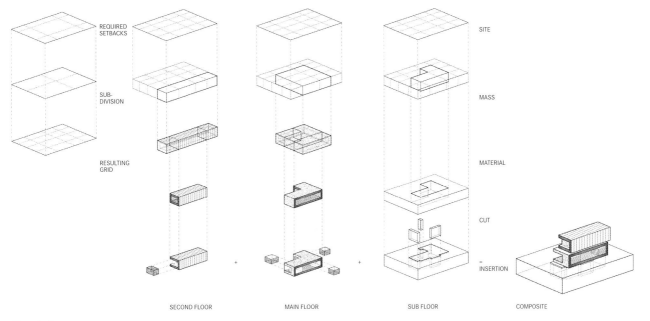

REQUIRED
SETBACKS

SUB-
DIVISION

RESULTING
GRID

SITE

MASS

MATERIAL

CUT

= INSERTION

SECOND FLOOR

MAIN FLOOR

SUB FLOOR

COMPOSITE

Tectonic diagram

The different building volumes shift
and recede from sight as they move up:
concrete for the basement, wood at the
main level, and dark zinc for the top floor.

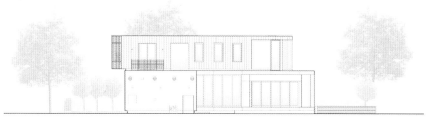

North elevation

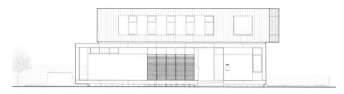

South elevation

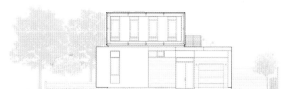

East elevation

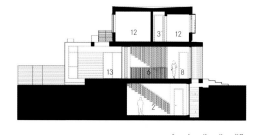

West elevation

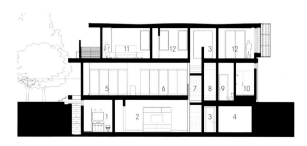

Sections

1. Bathroom
2. Family room
3. Hallway
4. Mechanical room
5. Dining area
6. Great room
7. Staircase
8. Entry
9. Half bathroom
10. Bathroom
11. Master bedroom
12. Bedroom
13. Deck

The main level is lifted slightly above grade, allowing deep light wells to penetrate underground and provide light and air to a full basement.

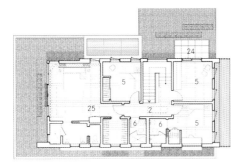

Second floor plan

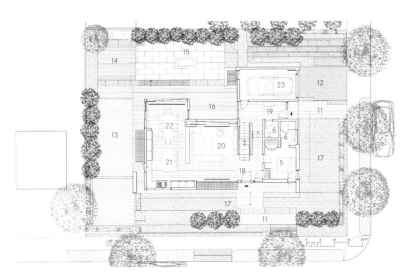

Ground floor plan

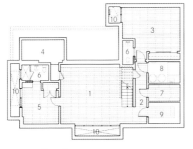

Basement floor plan

1. Family room
2. Hallway
3. Exercise room
4. Crawl space
5. Bedroom
6. Bathroom
7. Wine room
8. Mechanical room
9. Storage
10. Light well
11. Entry path
12. Driveway
13. Play area
14. BBQ and dining patio
15. Fire pit patio
16. Porch
17. Entry garden
18. Entry
19. Foyer
20. Great room
21. Kitchen
22. Dining room
23. Garage
24. Deck
25. Master suite

097

The design incorporates various shading devices such as deep overhangs with metal grilles and louvered screens to control the amount of light that reaches the house interior and maintain a comfortable temperature.

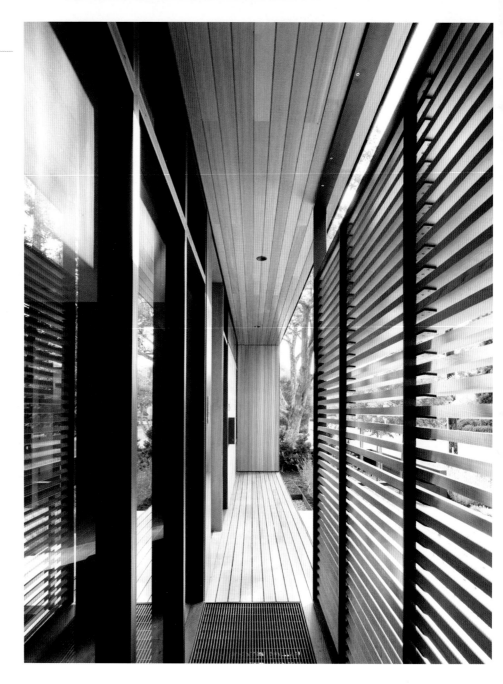

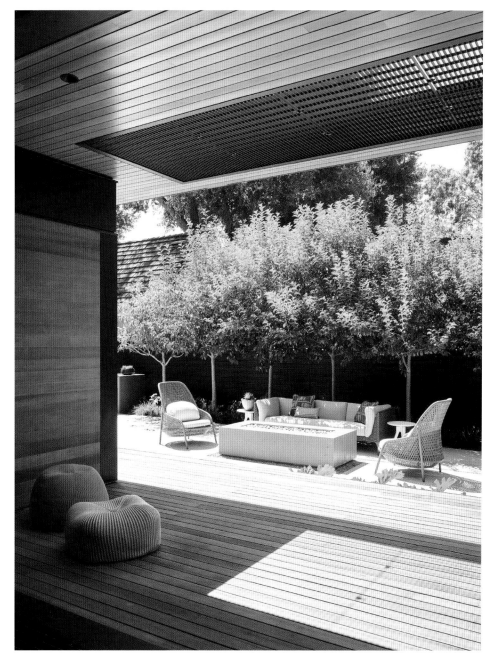

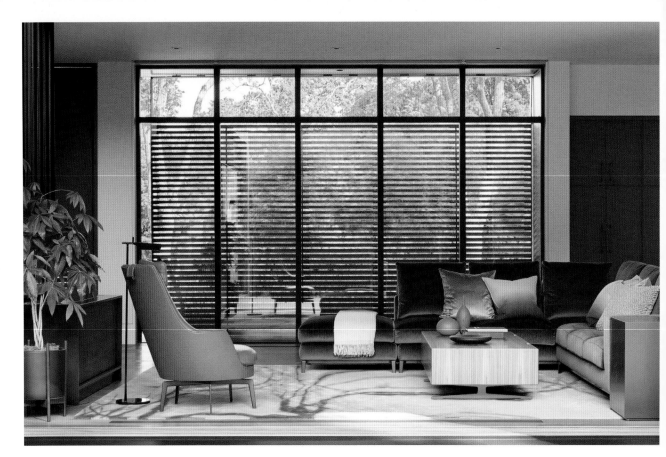

098

Louvers make the most of light
and shade, creating comfortable
environments adapted to different
situations. They filter light to allow
just the right amount for reading,
for instance, and avoid glare or
block light—and views—when
privacy is needed.

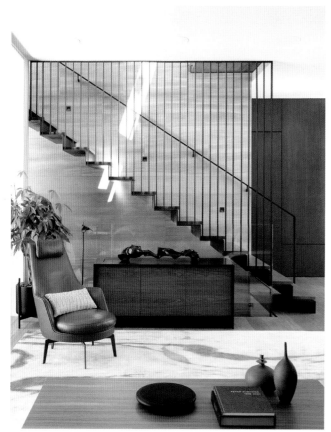

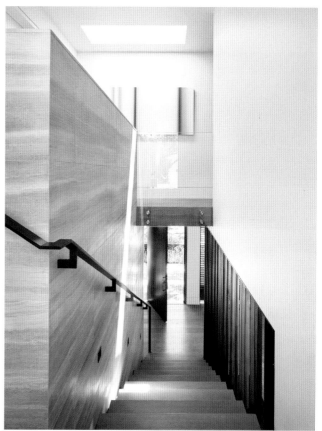

A sculptural steel stair set against a continuous stone-slab wall anchors the entire house and unifies the three levels.

Elegant, carefully considered cabinetry in the kitchen and entertaining areas on the main level ensure that the open plan does not feel loft-like.

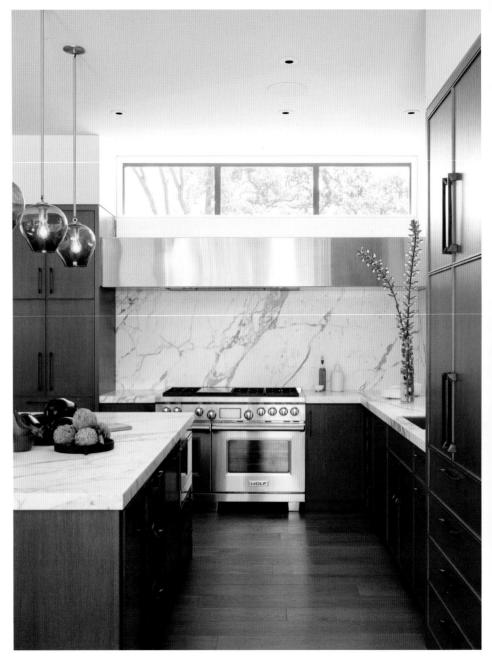

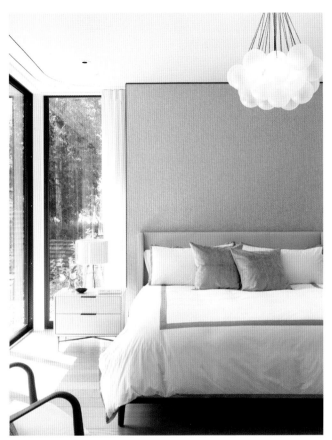

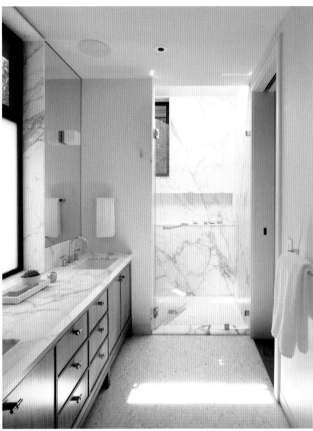

On the upper level, the master suite and bedrooms are strategically organized to ensure privacy and views outside.

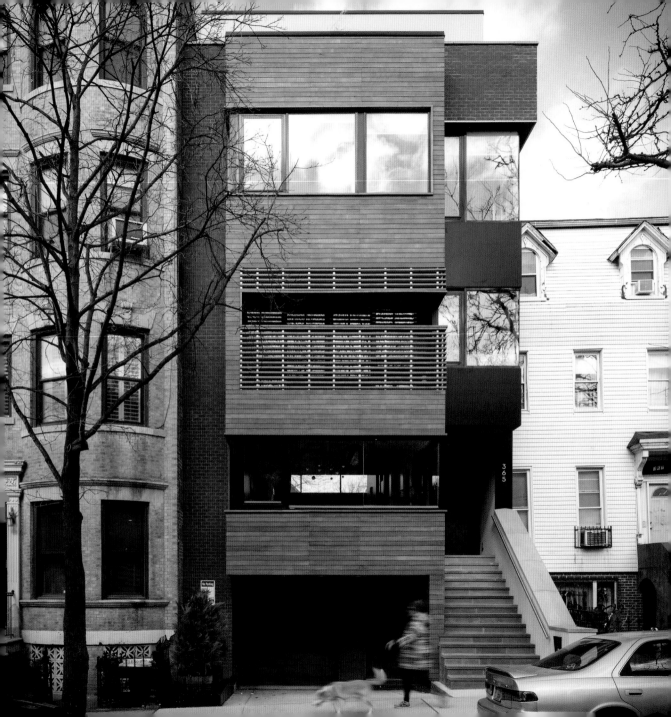

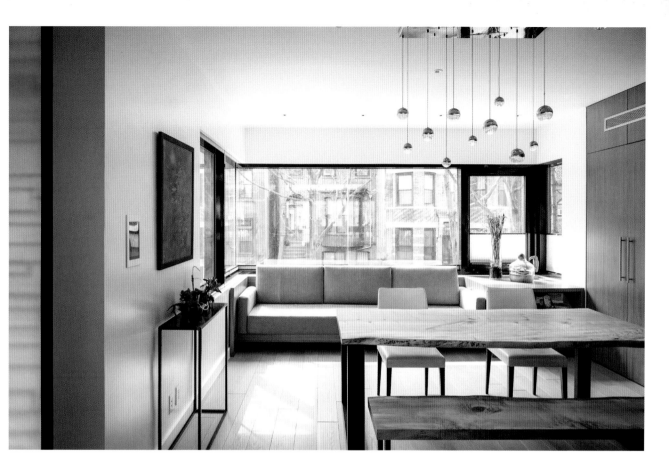

This new construction, a five-story townhouse, is home to a young family of four. The facade, which combines brick, a cedar rainscreen, and black aluminum panels, is respectful to the neighboring buildings' scale, form, and materiality. Maintaining an indoor-outdoor connection throughout was important to the clients, so despite the narrow twenty-five-foot lot, each floor opens to exterior spaces. Concurrently, maintaining a comfortable level of privacy from the street and neighbors was also critical. With sustainability in mind, the design incorporates energy-efficient techniques, including Exterior Insulation and Finish System (EIFS) combined with insulated metal panels to provide continuous insulation at the building envelope, reducing heating and cooling loads. A solar canopy shades the upper roof terrace, while light-colored pavers help minimize the heat island effect.

Park Slope Townhouse

5,000 sq ft

Brooklyn, New York, United States

Resolution: 4 Architecture

© Resolution: 4 Architecture, Eric Soltan Photography

The garden level houses a mudroom, guest bedroom, and playroom that open to the backyard, where turf tiles create a maintenance-free lawn. Weathering-steel bamboo planters provide privacy. Up the exterior stair, the dining terrace opens to the double-height living space on the main level.

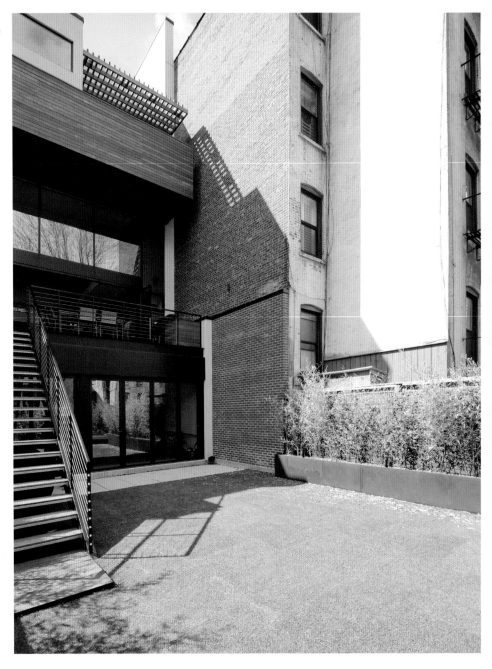

On the top floor, which serves as an art studio, the facade steps back to preserve the street's cornice line. This setback creates terraces on either side of the studio and helps maintain privacy.

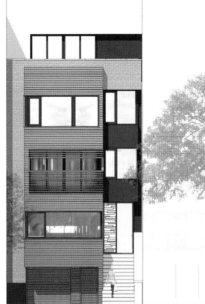

Site plan

⊗

Front elevation

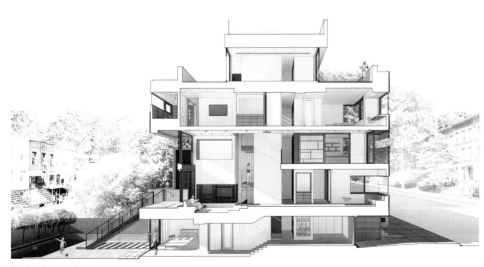

Sectional perspective

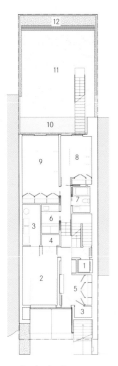

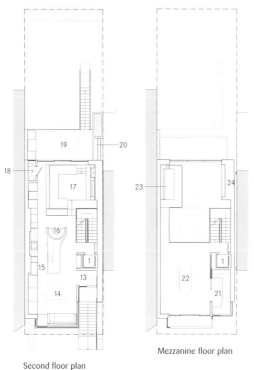

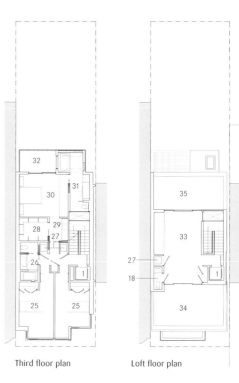

Garden level

Second floor plan

Mezzanine floor plan

Third floor plan

Loft floor plan

1. Elevator
2. Garage
3. Mechanical room
4. Aquarium
 equipment room
5. Mudroom entry
6. Laundry room
7. Guest bathroom
8. Guest bedroom
9. Playroom
10. Rear patio
11. Turf yard

12. Bamboo planters
13. Entry
14. Dining area
15. Kitchen
16. Island banquette
17. Living area
18. Powder room
19. Dining terrace
20. Waterfall feature
21. Office
22. Mezzanine
23. Movie pod

24. Projector screen
25. Kids bedroom
26. Kids bathroom
27. Mechanical closet
28. Master closet
29. Master dresser
30. Master bedroom
31. Master bathroom
32. Master balcony
33. Art studio
34. Front terrace
35. Rear terrace

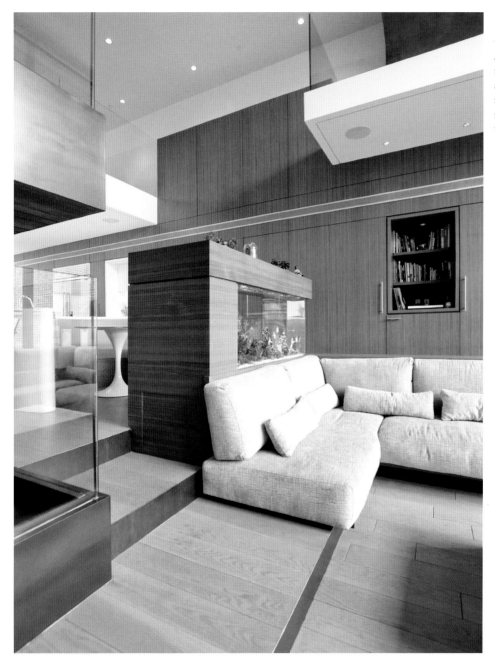

A custom teak sofa defines the sunken living room. On one side, a wall of custom cabinetry of the same material provides generous storage, while stitching together the living spaces.

An open-tread staircase allows for light, air, and sound to pass between floors, while the landings feel like part of the living spaces, enhancing connectivity between levels.

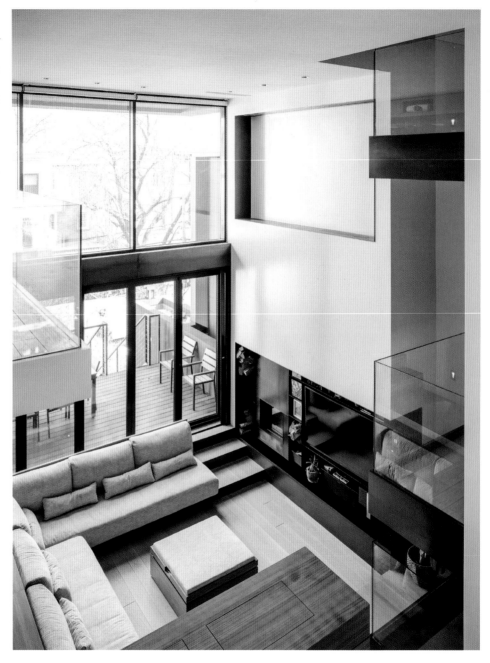

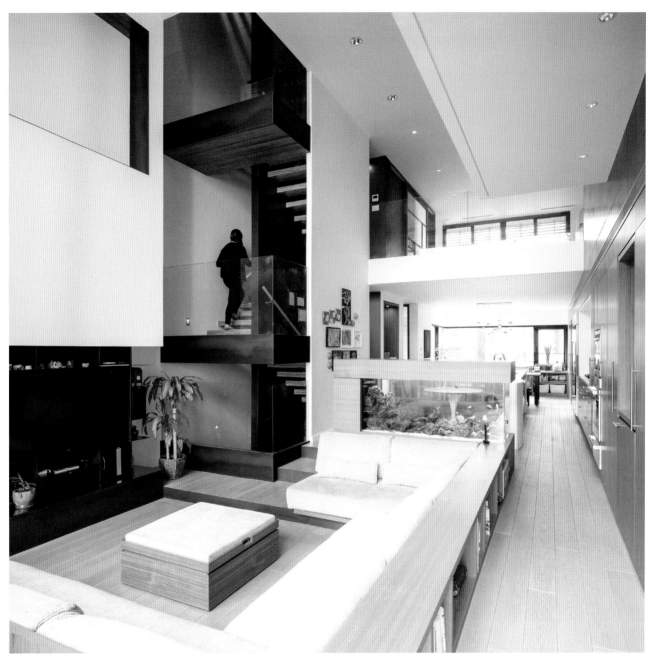

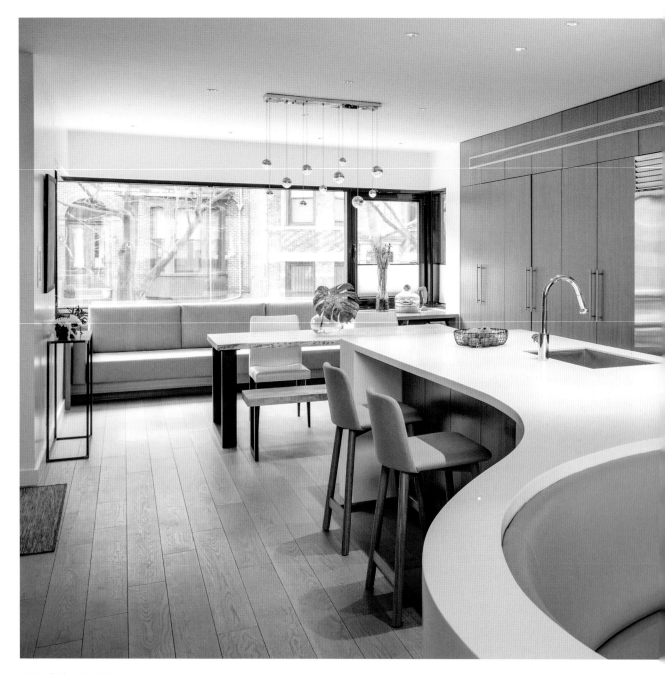

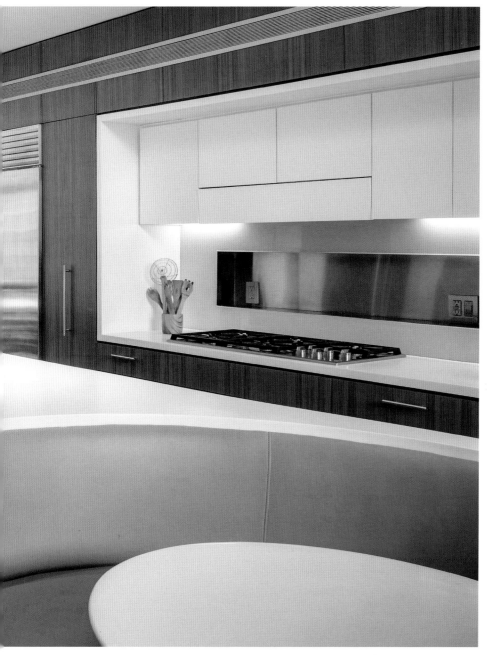

Just like the teak wall cabinetry is used to stitch the living spaces together, the curving, white Corian island grounds the main level and includes a breakfast banquette at one end.

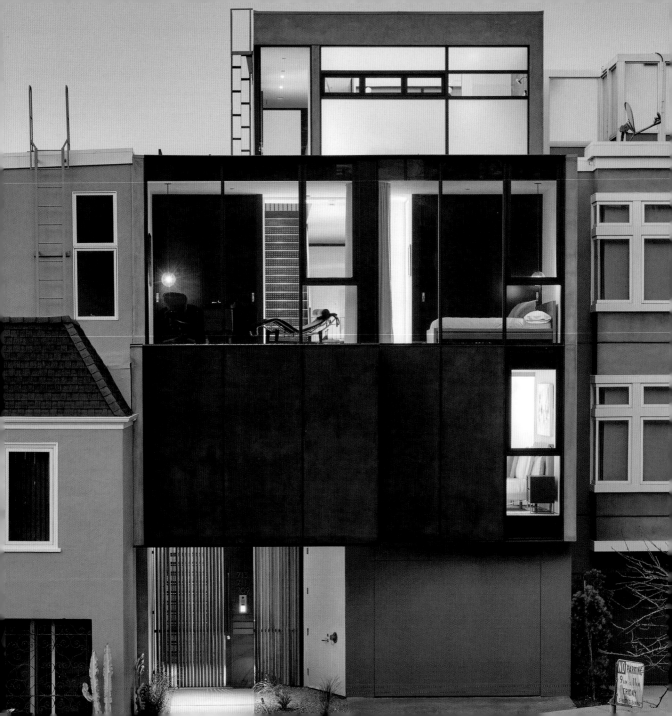

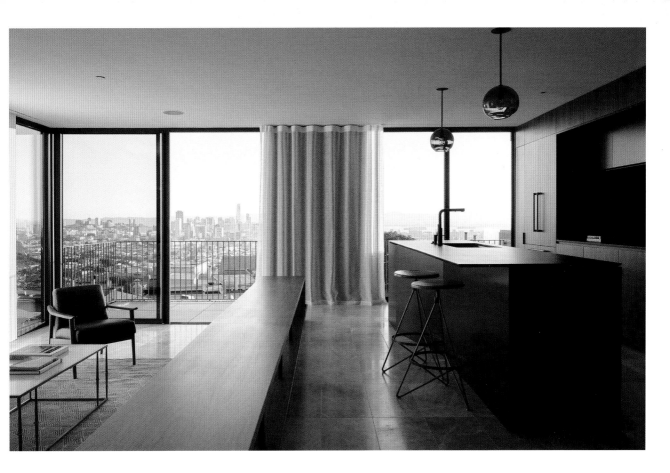

This project converts a neglected single-family residence into a three-unit residential building on the eastern slope of Twin Peaks in San Francisco, allowing for sweeping views of the city from each of the five floors at the rear of the building. The remodel of the building's envelope was inspired by modernist architecture. The movement, which established itself in the US around the 1930s, embraces minimalism, focusing on volume, asymmetrical compositions, and minimal ornamentation. The building is also sensible to the particularities of the site, maximizing light and views. The units vary in size and configuration, but all share common spatial and material qualities. All three units have double-height spaces and a combination of limestone floors and walnut cabinetry.

Twin Peaks Residences

4,121 sq ft

San Francisco, California, United States

Michael Hennessey Architecture

© Adam Rouse Photography

The front elevation is a composition of steel frames with aluminum windows and integrally colored cement plaster infilling the steel framework.

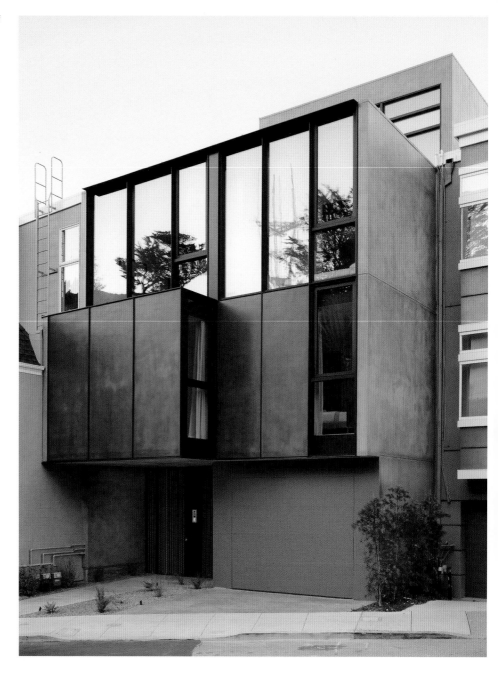

Exploded axonometric of the street facade composition

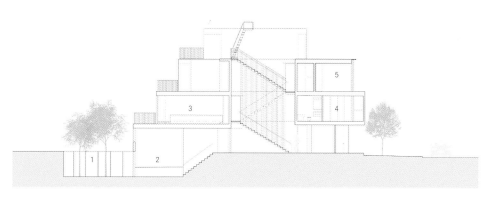

Section

1. Rear yard
2. Lower unit living
3. Middle unit living
4. Middle unit bedroom
5. Upper unit bedroom

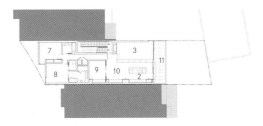

Third floor plan

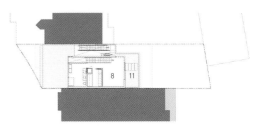

Fifth floor plan

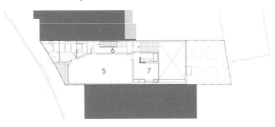

Second floor plan

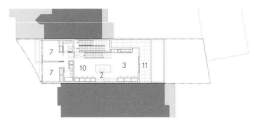

Fourth floor plan

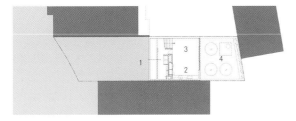

First floor plan

1. Laundry
2. Kitchen
3. Living area
4. Rear yard
5. Garage
6. Common stair
7. Bedroom
8. Master bedroom
9. Office
10. Dining area
11. Deck

The one-bedroom unit occupies the ground floor with its double-height space opening up to a minimalist gravel rear yard sparsely landscaped with grasses.

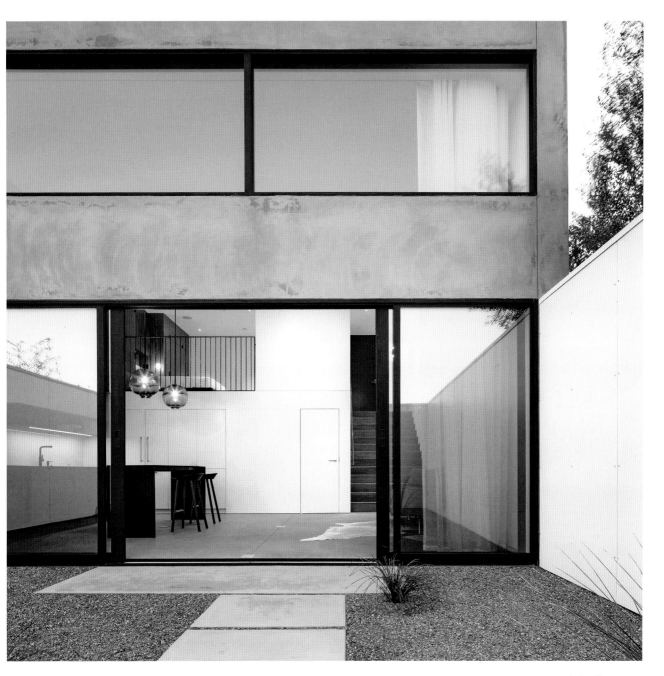

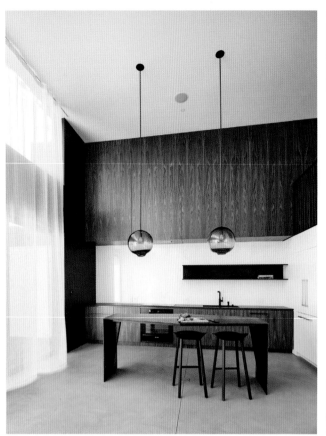
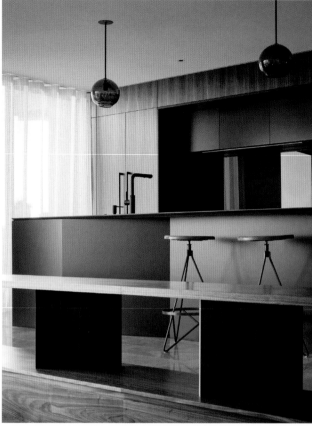

103

The finely crafted wood cabinetry in all three units adds warmth as a counterpoint to the taut overall design. The images above show views of the ground floor and middle unit kitchens. The middle unit has a low bookcase that mediates the floor height difference between the kitchen and the sunken living room.

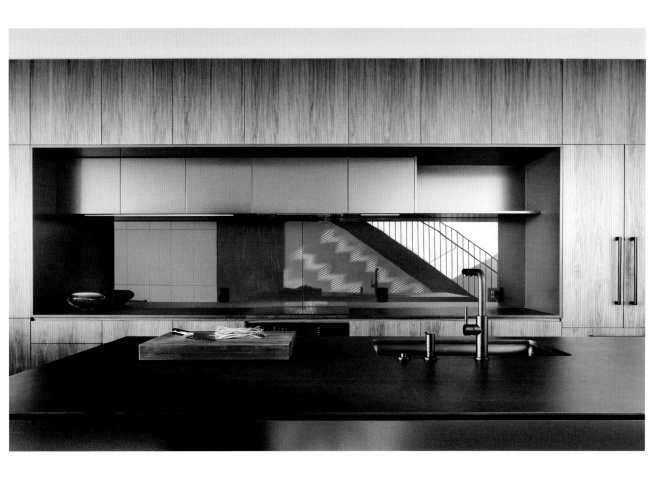

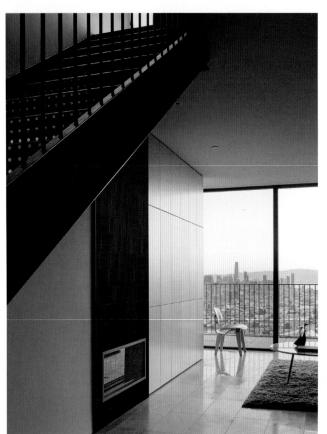

104

Windows and an exterior entry stair opening to the sky amplify the sense of space by allowing light in and opening rooms to views. As a result, indoor spaces feel open and inviting.

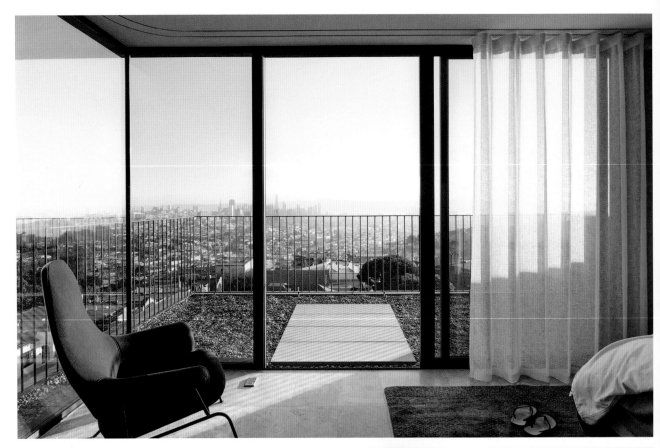

105

Terraces and balconies are precious assets in urban homes. Ideal outdoor spaces to enjoy in the bustling city where land is scarce and its cost is high.

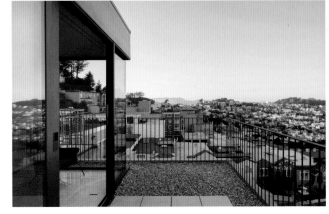

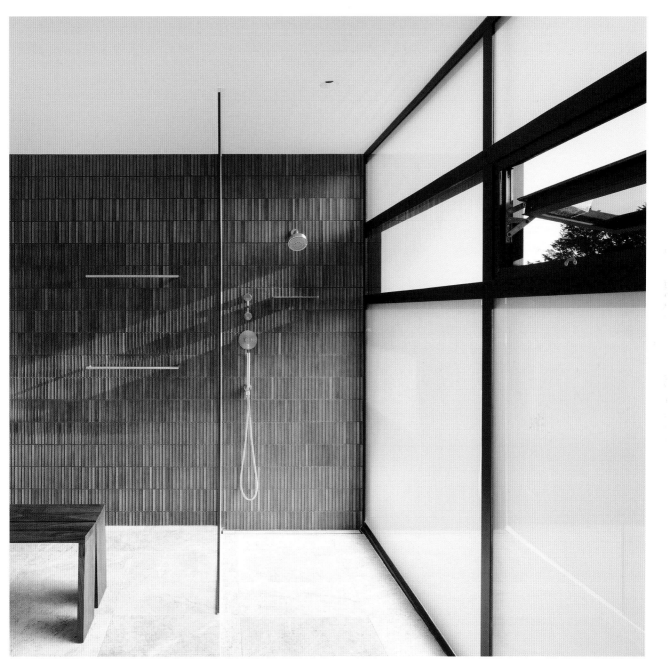

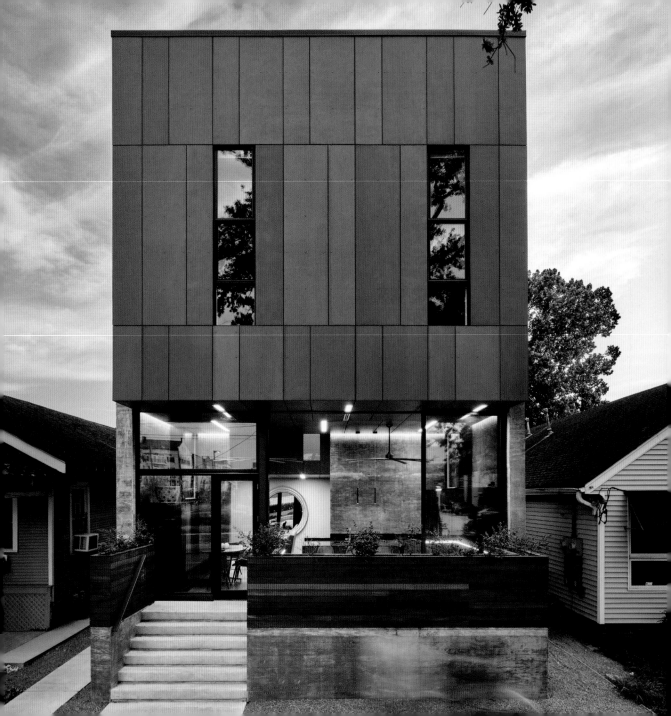

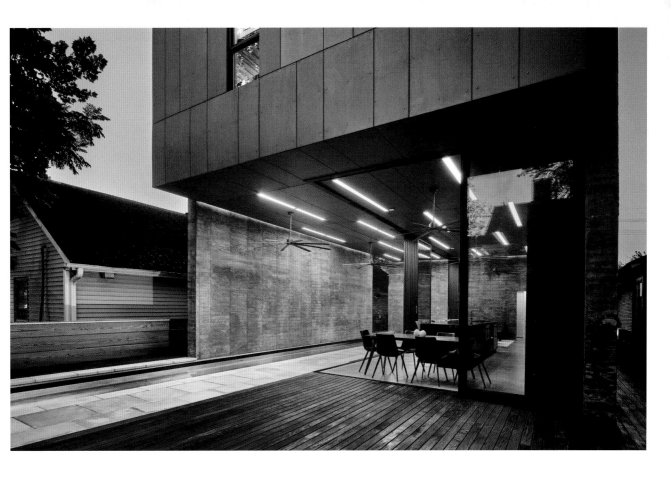

The house is designed as a duplex to maximize a small lot for two units. A major design goal was to configure communal areas to best access outdoor spaces despite the density of required spaces. The layout orients the front unit as its public face while mirroring the position of the primary unit to connect with the rear yard, favoring seclusion. Architectural forms are configured to accentuate the transparency between interior spaces—of the ground floor—and the exterior. The upper floors, containing private spaces, are wrapped by exterior surfaces, forming an echelon of suspended cubic forms legible from multiple viewpoints, including the underside. The static forms juxtapose the more animated interior space as a frame, reinforcing the transparency.

Bienville House

4,000 sq ft

New Orleans, Louisiana, United States

Nathan Fell Architecture

© Justin Cordova

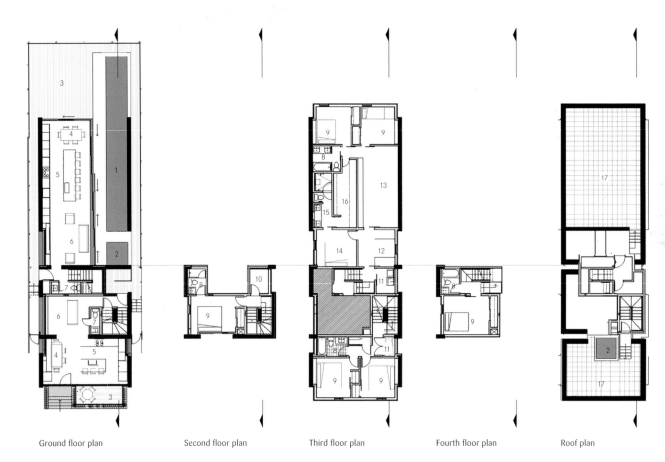

Ground floor plan Second floor plan Third floor plan Fourth floor plan Roof plan

1. Pool
2. Hot tub
3. Outdoor deck
4. Dining area
5. Kitchen
6. Living area
7. Toilet room
8. Bathroom
9. Bedroom
10. Storage
11. Laundry room
12. Study room
13. Playroom
14. Master bedroom
15. Master bathroom
16. Master closet
17. Roof deck

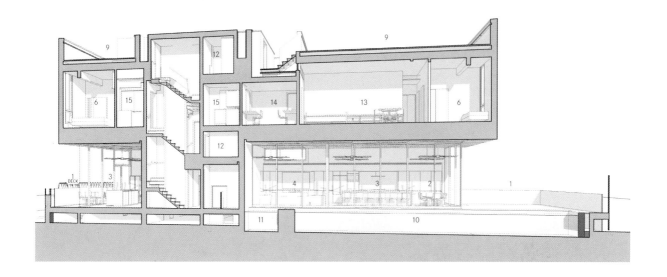

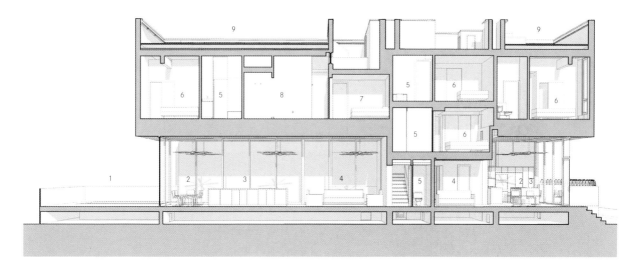

Section perspectives

1. Deck	6. Bedroom	11. Hot tub
2. Dining area	7. Master bedroom	12. Storage
3. Kitchen	8. Master bathroom	13. Playroom
4. Living area	9. Roof deck	14. Study
5. Bathroom	10. Pool	15. Laundry room

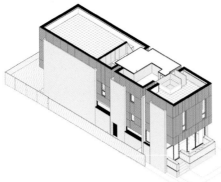

EAST (FRONT-LEFT) CORNER

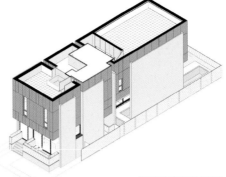

NORTH (FRONT-RIGHT) CORNER

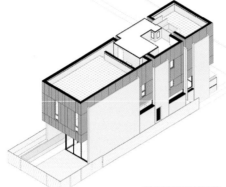

SOUTH (REAR-LEFT) CORNER

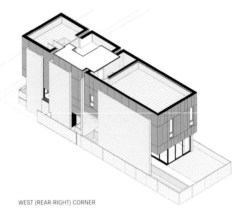

WEST (REAR-RIGHT) CORNER

Axonometric views

The house design turns the table on indoor home life on a small urban lot. The front rental unit engages occupants with the street life. The primary unit at the back, on the other hand, is connected with the backyard, which offers more privacy and seclusion.

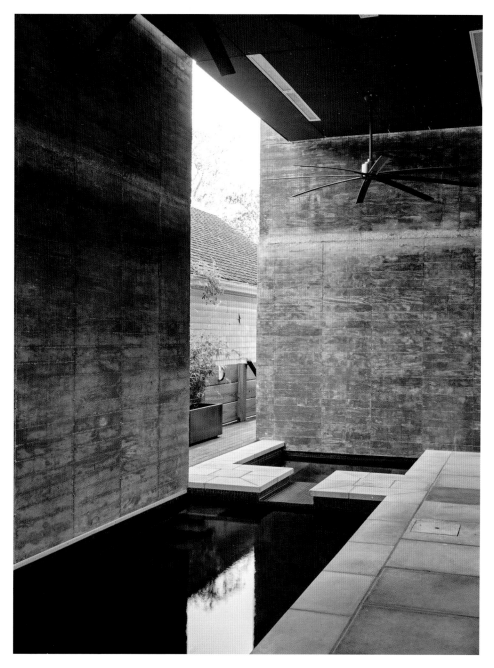

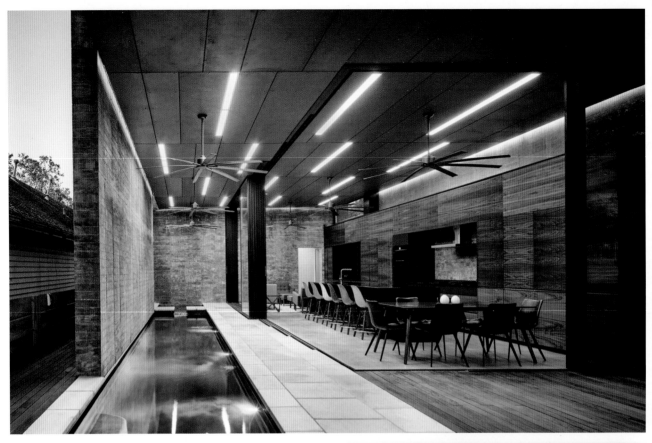

Communal spaces capture natural light and air, while creating a comfortable sense of amplitude despite the density of the spaces.

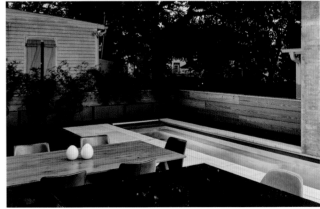

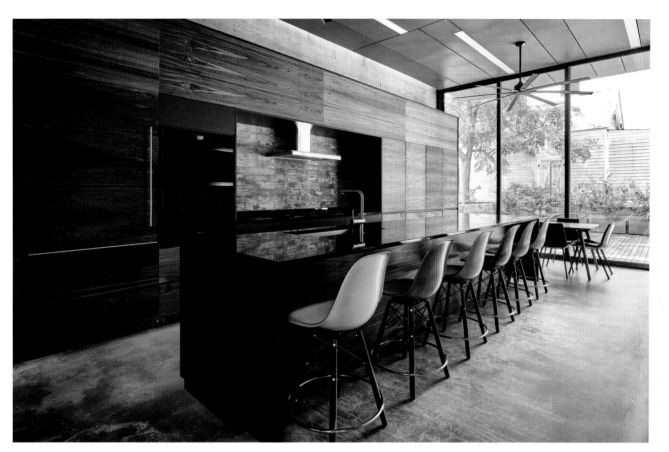

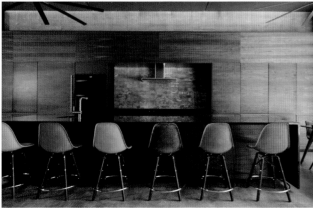

Large glass panels on the ground floor's communal spaces retract to expand the interior to the exterior.

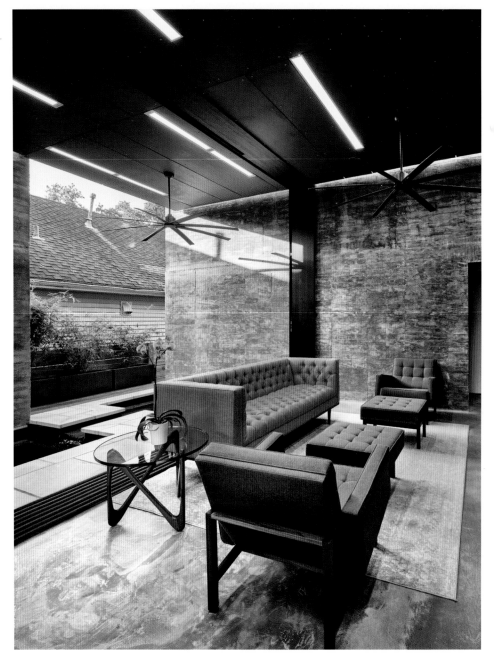

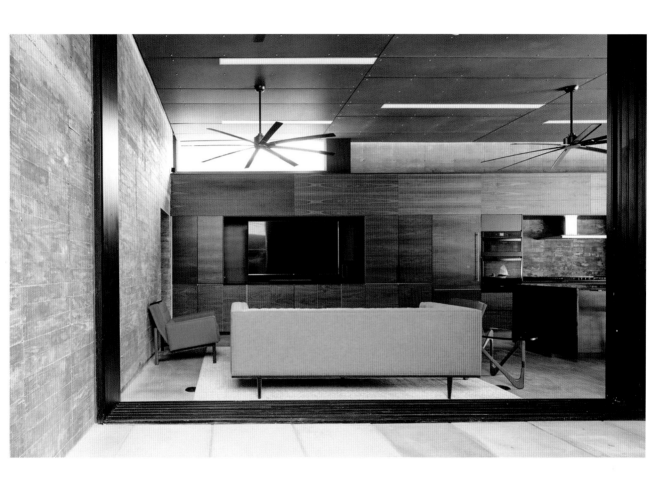

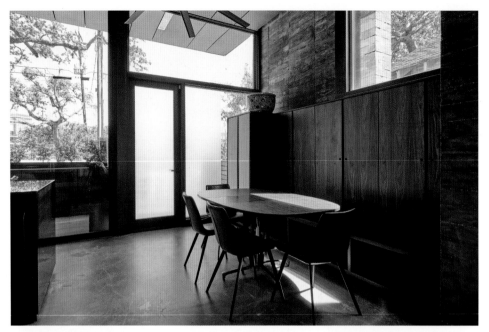

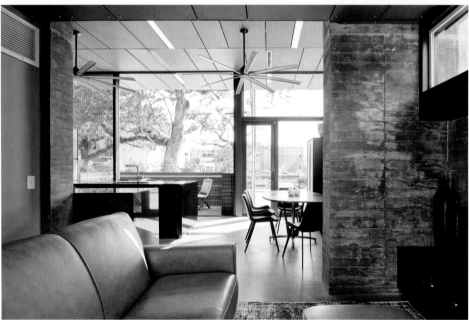

The front unit's living spaces spill out onto an exterior deck facing the street. The wooden guardrail doubles as a planter, which provides a little privacy from passersby.

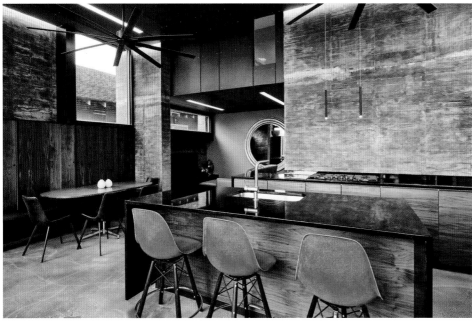

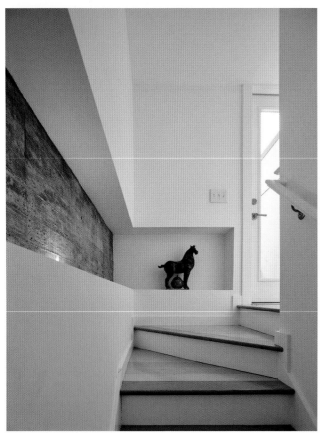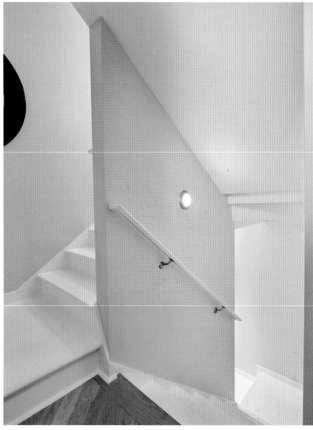

While the ground floor features exposed concrete walls, walnut cabinetry, and furniture that adds pops of color, the upper floors draw attention to a bolder use of color, covering large wall surfaces and doors.

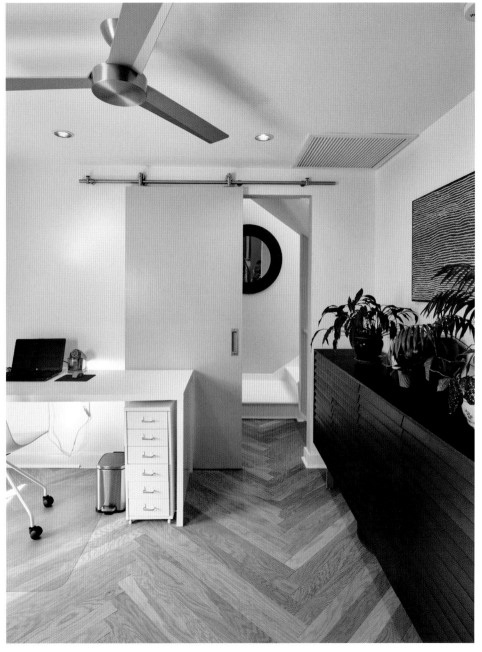

The use of color reflects the outgoing personality of users, while the different colors provide each space with its own identity.

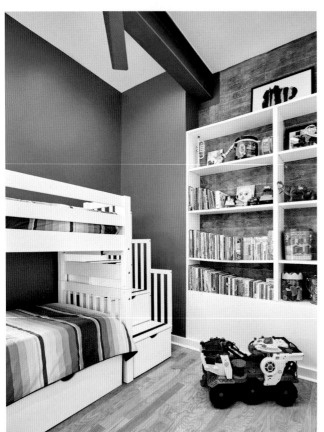
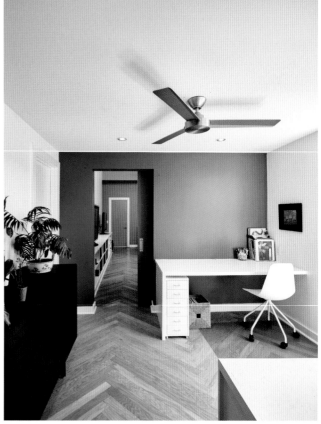

109

While the layout of the ground floor focuses on transparency to facilitate an indoor-outdoor connection, the upper floors are more opaque, allowing for private spaces.

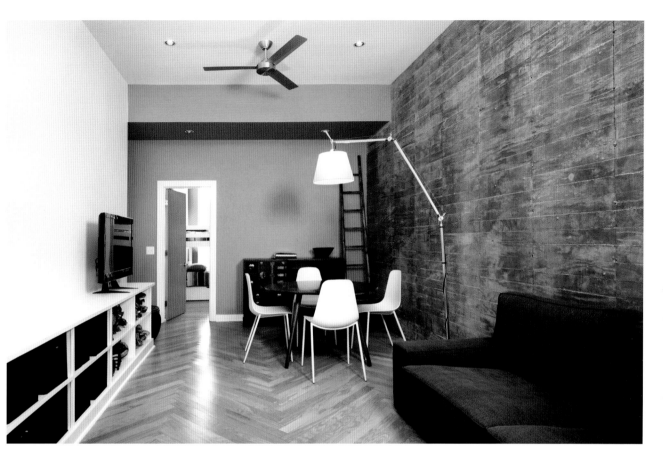

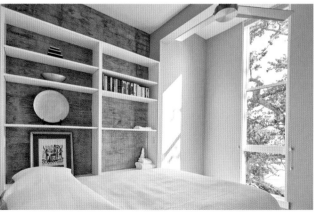

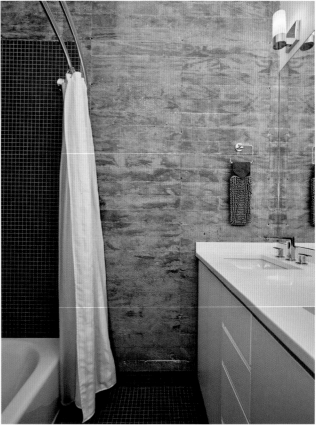

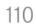

110

Contemporary architecture is rethinking the rooftop as an additional private outdoor space. Up high, the roof terrace offers the extra benefit of long views.

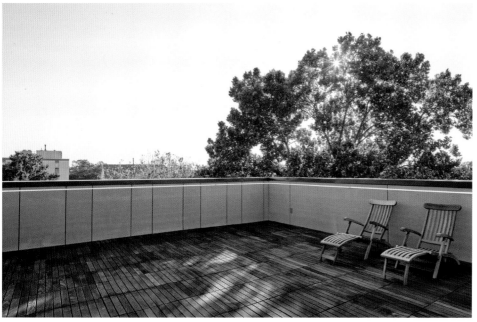

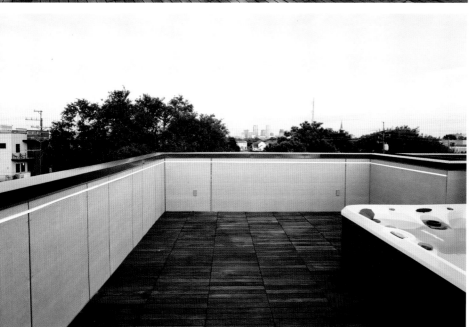

Palm Grove

18,000 sq ft
New Delhi, India

DADA & Partners

© Ranjan Sharma

Palm Grove is the result of a remodel and extension to an
existing one-story house. The design intent emerged from
the existing landscape of striking, fully grown, forty-feet-high
palm trees forming the heart of the design. The approach to
the house is routed through the east face of the building, and
series of spaces unfold as one enters into the house, creating a
dramatic sense of arrival toward this Palm Grove. The house
perfectly blends with the landscape and gives the feeling of
being one with its surroundings, whereby living spaces are
woven together indoors and outdoors.

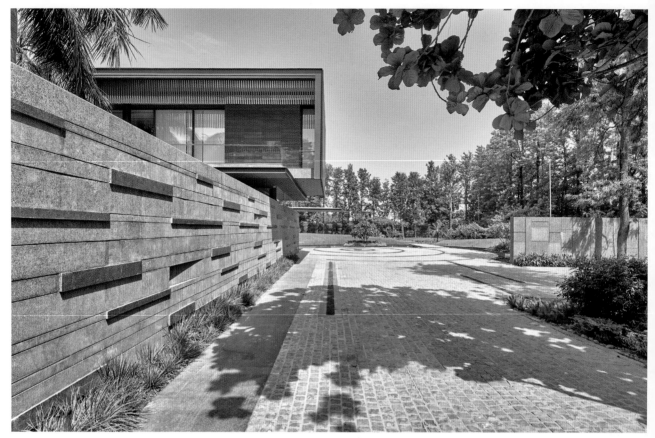

111

A granite-clad wall separates
the driveway from the garden
and enhances the arrival to the
house experience.

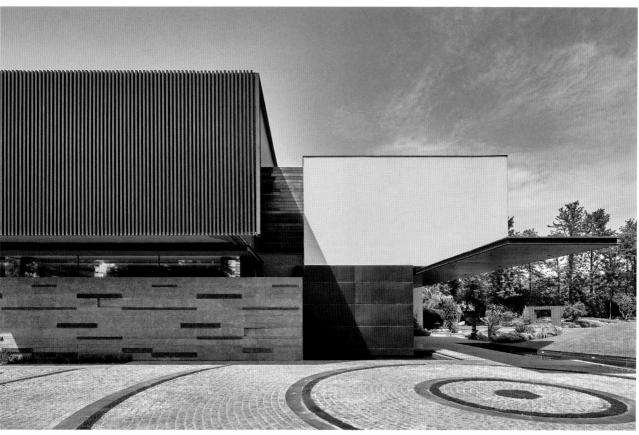

Throughout the house, the texture of the granite stone and natural finishes complements detailed metalwork such as vertical screens, louvers, and canopies.

While the lower-level views are established on the east-west axis, the upper floor extends out from the older block in the south in the north-south direction. This juxtaposition is further accentuated by cantilevering the upper volume onto the drive court on circular columns forming the "legs" of the house with a continuous clerestory glazing on the ground floor.

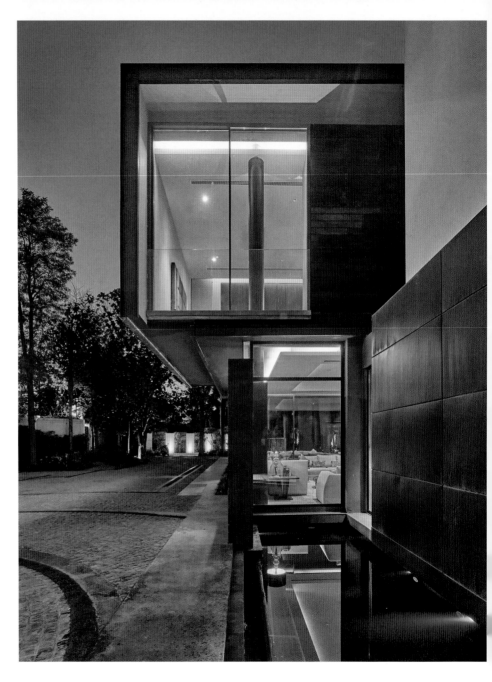

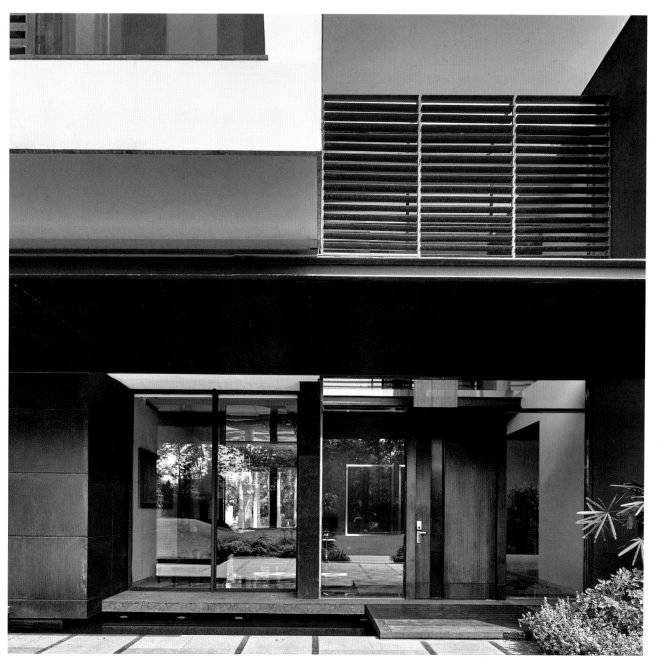

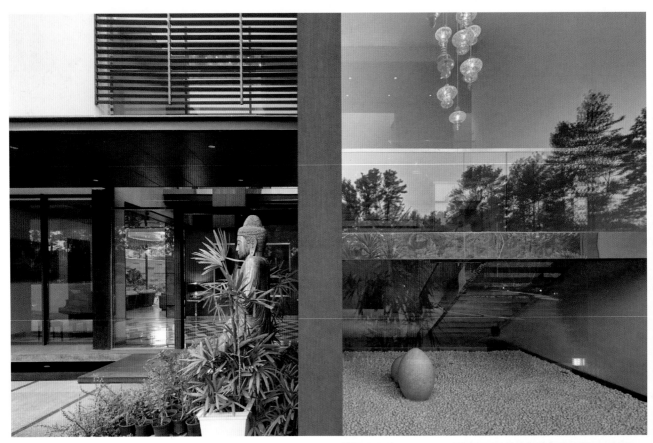

112

Large expanses of glass for views and light allow for a home that is as much part of the surrounding landscape as the landscape is part of the house.

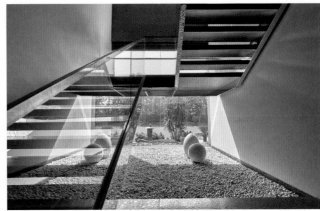

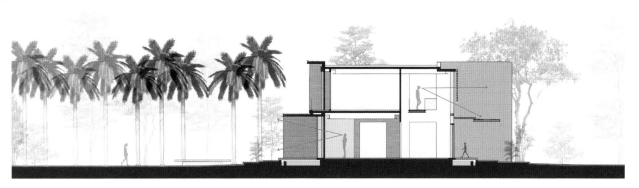

Section A

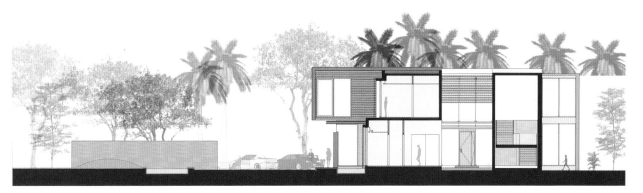

Section B

Key plan

113

The house was designed to enjoy the lush landscape, focusing on a private living environment with generous indoor-outdoor connections.

Preserving existing structure and landscape elements

Introducing a series of walls as a design element

Placing volume and forming outward views

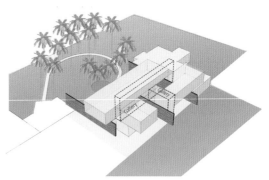

Creating gallery spaces

The new design stems from the existing house with a rectangular footprint. It juxtaposes a palm cluster forming a ring that serves as a backdrop to the extension's social spaces.

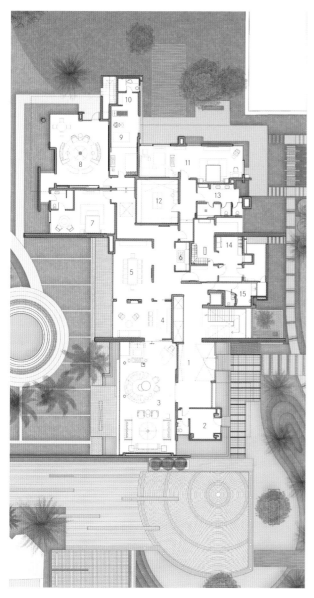

Ground floor plan

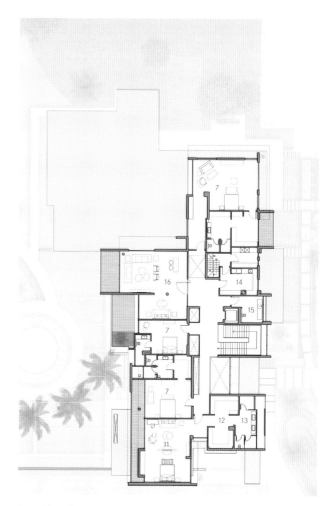

Second floor plan

1. Entrance lobby
2. Office
3. Drawing room
4. Bar
5. Dining area
6. Puja room
7. Bedroom
8. TV lounge
9. Gym
10. Storage
11. Master bedroom
12. Master walk-in dresser
13. Master bathroom
14. Kitchen
15. Powder room
16. Lounge

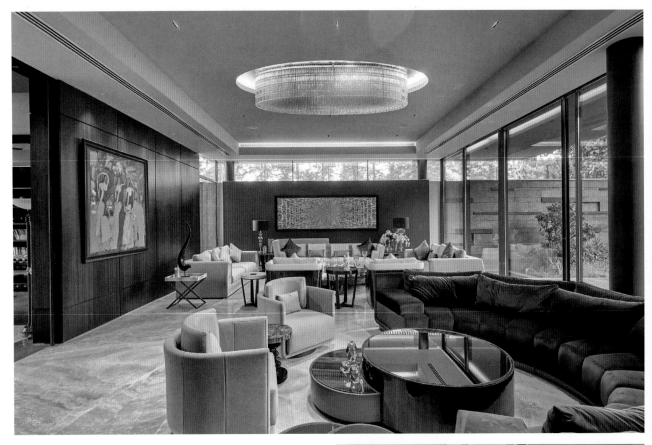

114

High-quality furnishings and finishes round off the overall house design, introducing a sense of understated luxury with a modern take.

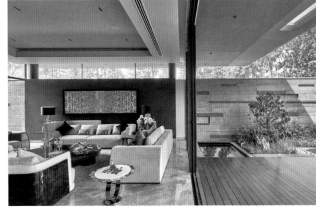

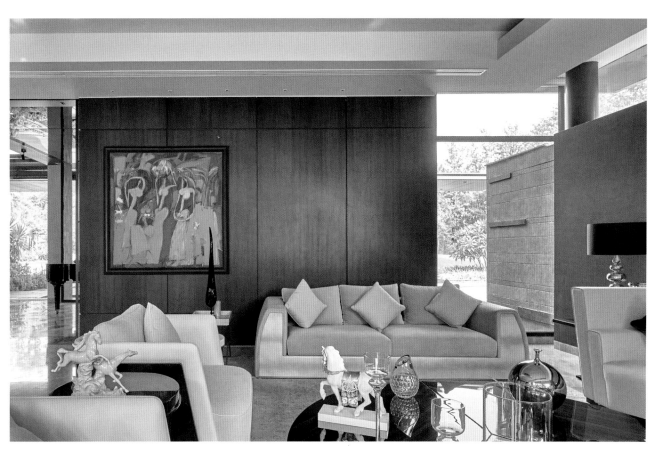

Filtered light casts dynamic
shadows on the interior's surfaces,
creating an ever-changing and
captivating atmosphere.

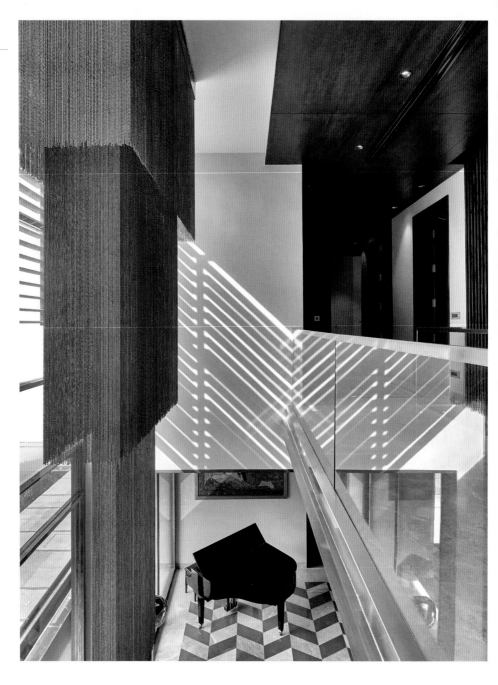

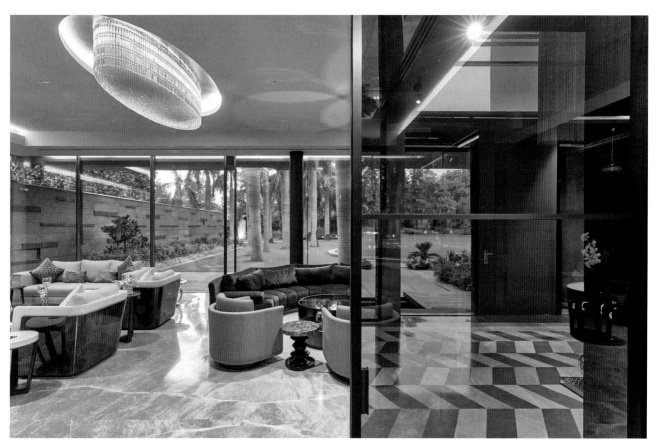

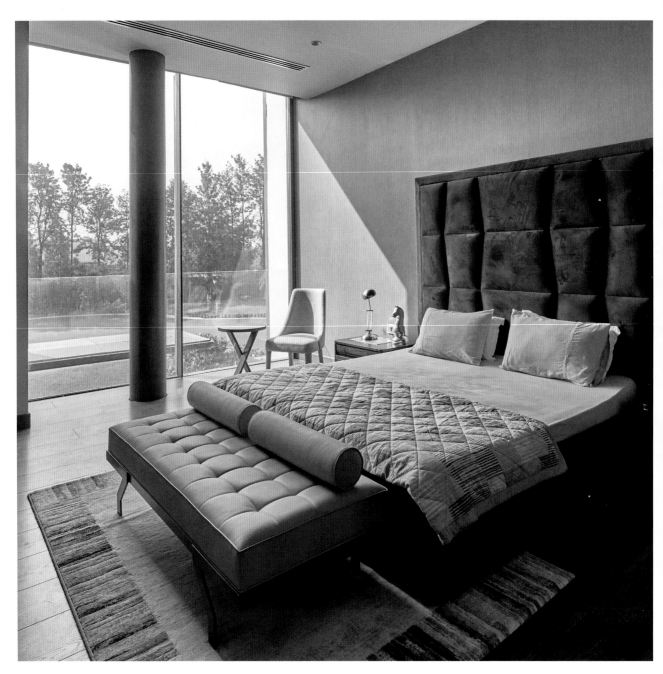

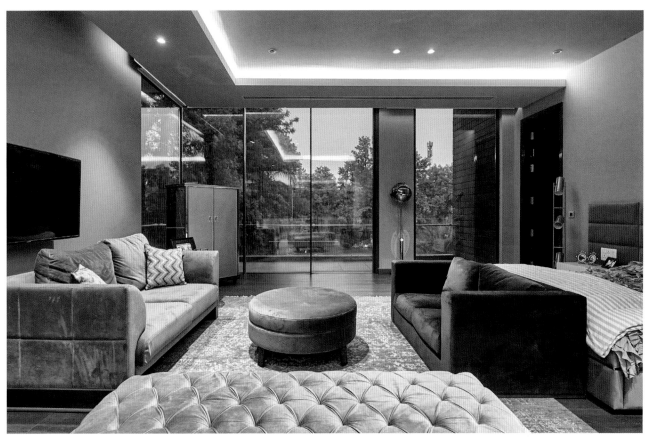

The private areas of the house occupy the remodeled house and the second story of the addition.

116

Lighting can change the atmosphere and character of spaces. While during the day, the landscape around Palm Grove is a pivotal design feature, at dusk, the interior of the house glows to take center stage, flooding with its warm gleam the surrounding landscape.

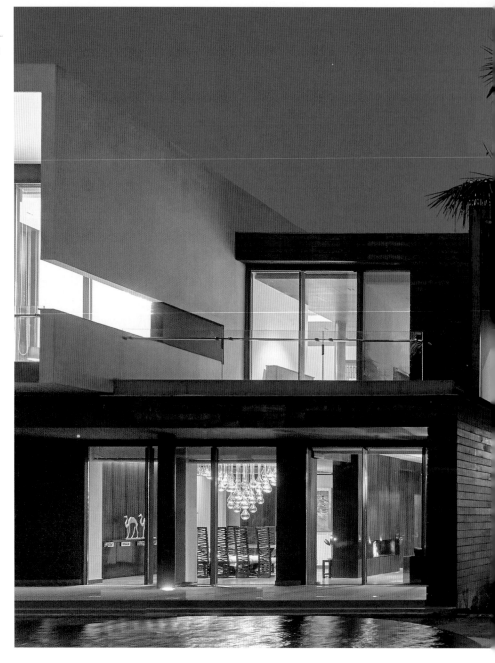

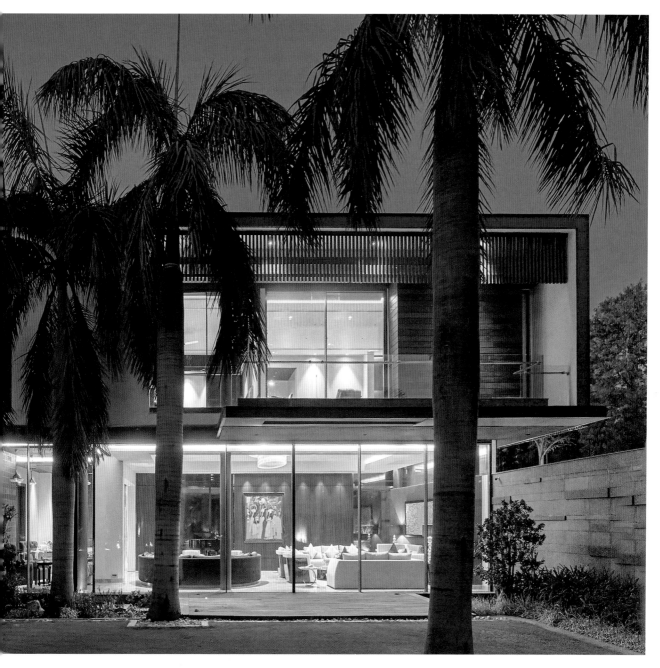

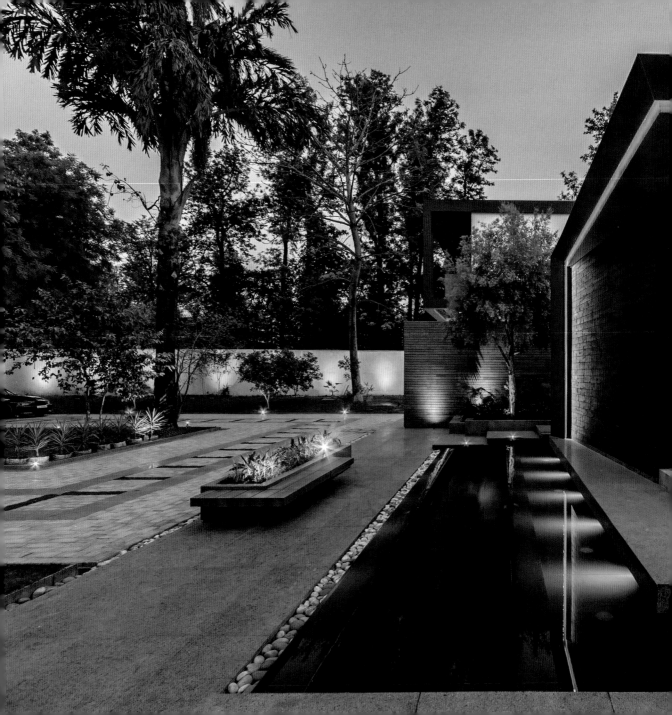

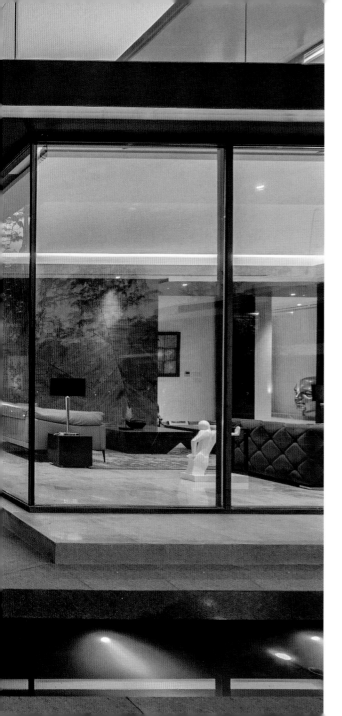

Caryota House

14,000 sq ft
New Delhi, India

DADA & Partners

© Ranjan Sharma

The residence design brief was to provide a home for a family of four with generous comfort and luxury. Positioned within the tranquil landscape of almost three acres, the prime component of the design is a central courtyard with an existing soaring fishtail palm around which the residence is configured. The amalgamation of the white walls, glass, and charcoal gray cladding accentuates the minimalistic architectural vocabulary that the owners aspired for.

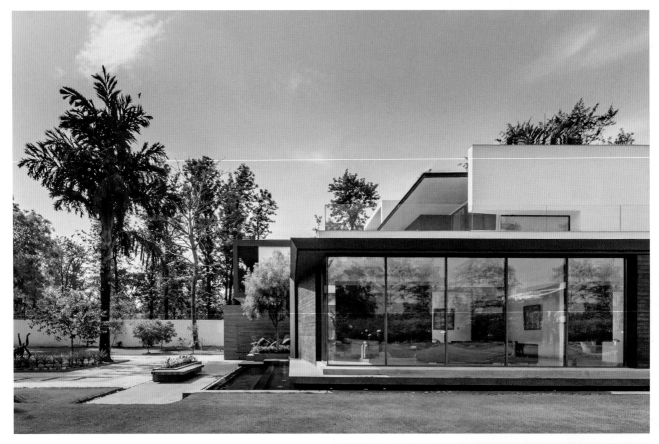

117

A reflective water feature cascades along the stepped entry court and wraps the living room on three sides that sits elevated over an infinity edge, accentuating a floating effect. This configuration further assists in cooling the space when the glazing is open.

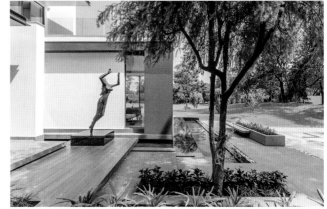

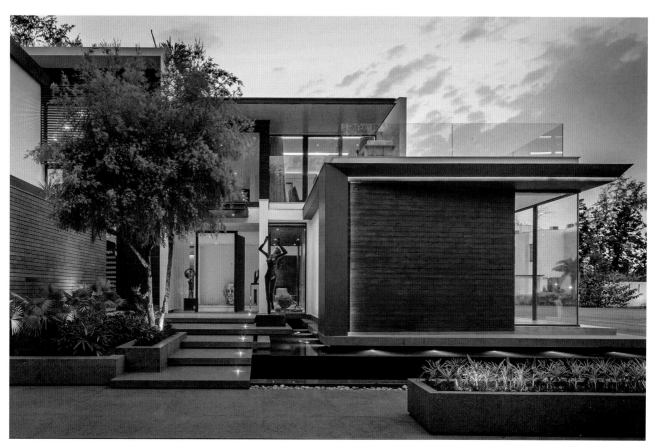

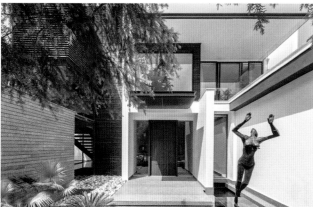

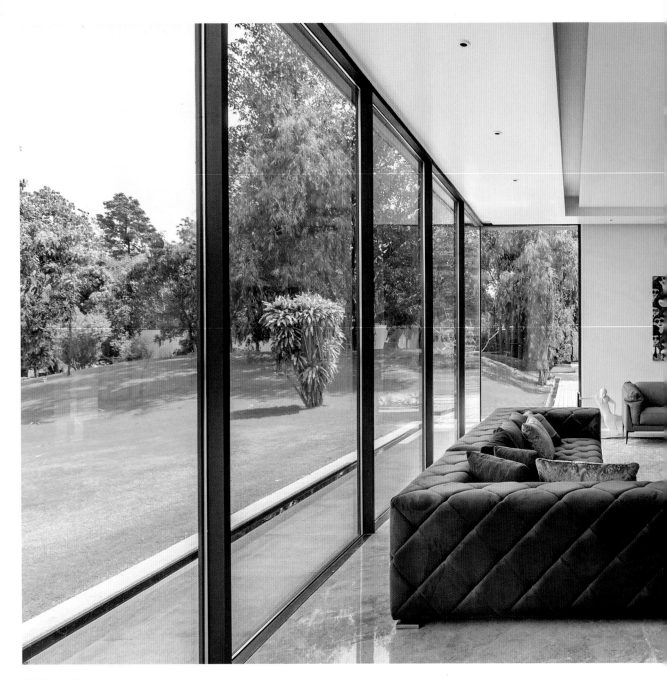

The formal living room, with its glass wall facing the garden, adopts a pavilion-like character, large and airy.

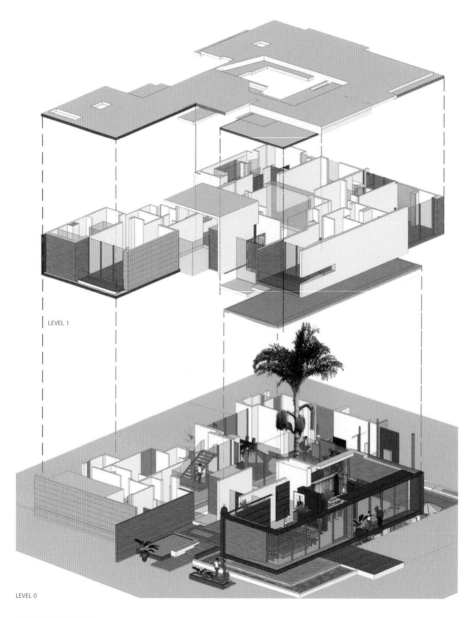

LEVEL 1

LEVEL 0

Exploded axonometric

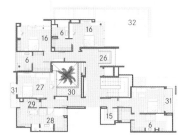

Upper floor plan

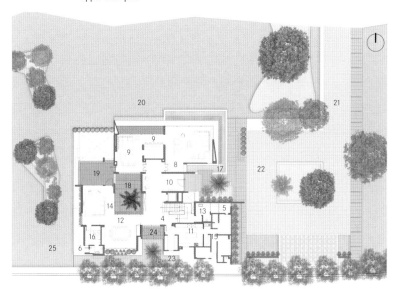

Ground floor plan

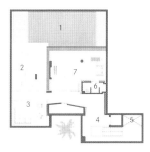

Basement floor plan

1. Swimming pool
2. Pool side deck
3. Entertainment den
4. Stair atrium
5. Bamboo court
6. Bathroom
7. Gymnasium
8. Formal living room
9. Bar
10. Entrance lobby
11. Kitchen
12. Dining room
13. Powder room
14. Lounge
15. Utility
16. Bedroom
17. Reflective pool
18. Palm courtyard
19. Patio
20. Front lawn
21. Driveway
22. Drive court
23. Kitchen garden
24. Winter court
25. Rear lawn
26. Puja room
27. Master bedroom
28. Master bathroom
29. Walk-in dresser
30. Terrace garden
31. Balcony terrace
32. Terrace

ECOLOGICALLY ADAPTIVE

CAVITY WALLS INTRODUCED TOWARD ALL
WALLS FACING WEST TO MINIMIZE HEAT GAIN

ALUMINUM LOUVERS INTRODUCED TOWARD
EAST FACE TO FILTER DIRECT SUNLIGHT

ENTIRE ROOF THERMALLY TREATED TO AVOID
HEAT INGRESS DURING PEAK SUMMERS

WEST

EAST

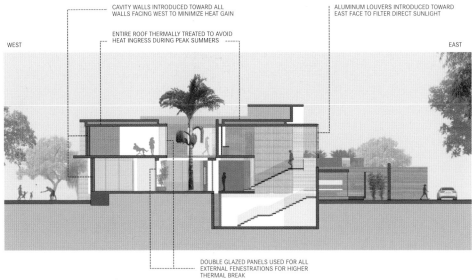

DOUBLE GLAZED PANELS USED FOR ALL
EXTERNAL FENESTRATIONS FOR HIGHER
THERMAL BREAK

Section through palm courtyard

ECOLOGICALLY ADAPTIVE

THE PALM TREE AND OVERHANGS
ENABLE THE COURTYARD TO BE IN
SHADE DURING PEAK SUMMERS;
HENCE CREATING A MICRO CLIMATE

THE BUILDING SECTION MODULATES
SUCH THAT WINTER SUN IS ABLE TO
PENETRATE DEEP INSIDE THROUGH TO
THE LOWER GROUND LEVEL

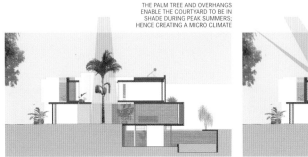

Section through sunken court

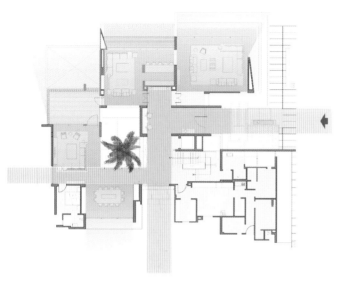

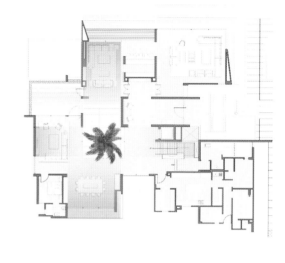

External permeability diagram

All zones of the house have views to the landscape in both north
and south faces. The entry forms toward the east.
The west is kept less porous for privacy while minimizing heat gain.

Internal permeability diagram

All zones of the house have simultaneous views toward the
internal palm courtyard.
Unhindered internal glazed fenestrations wrapping the courtyard
make spaces feel part of the landscape.

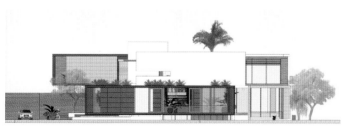

North elevation

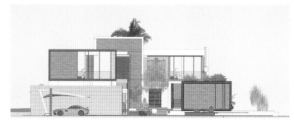

East elevation

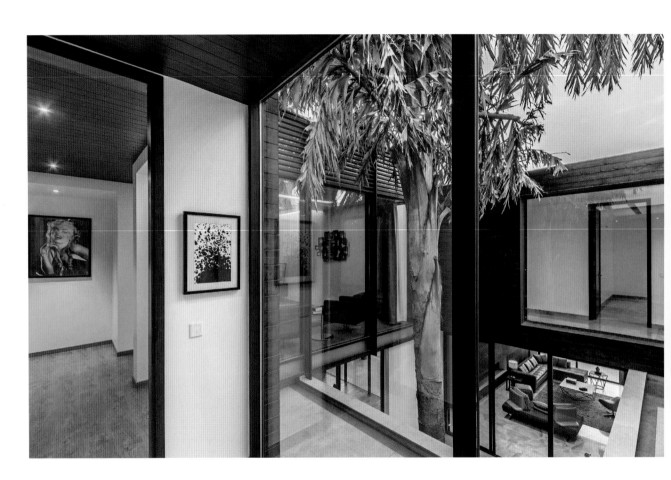

The open to sky central courtyard wrapped with sliding fenestrations create an efficient airflow providing a comfortable micro-climate.

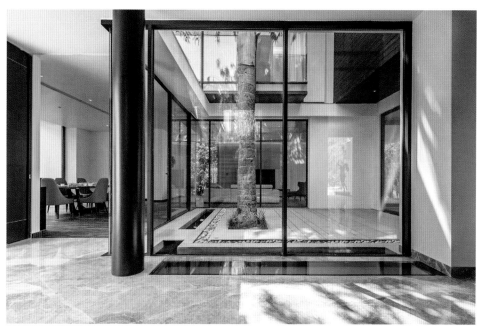

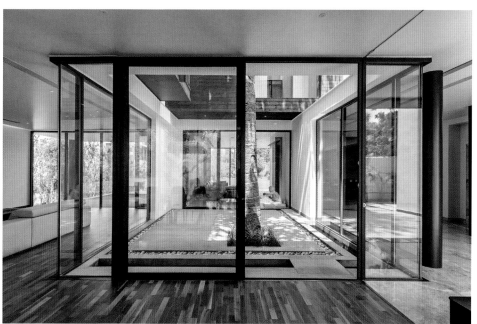

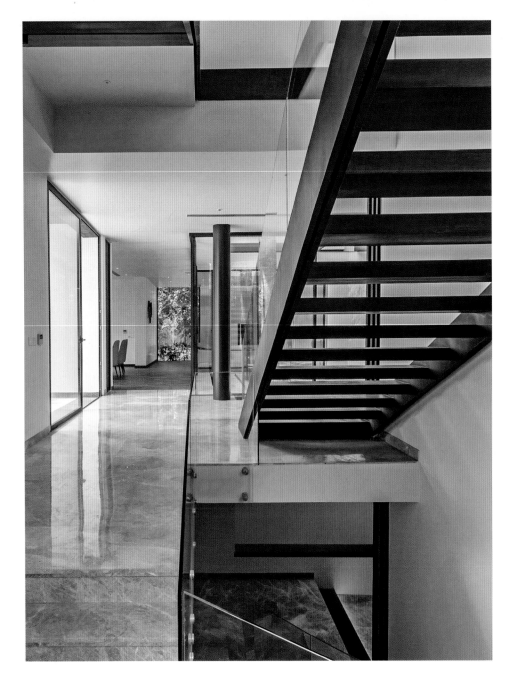

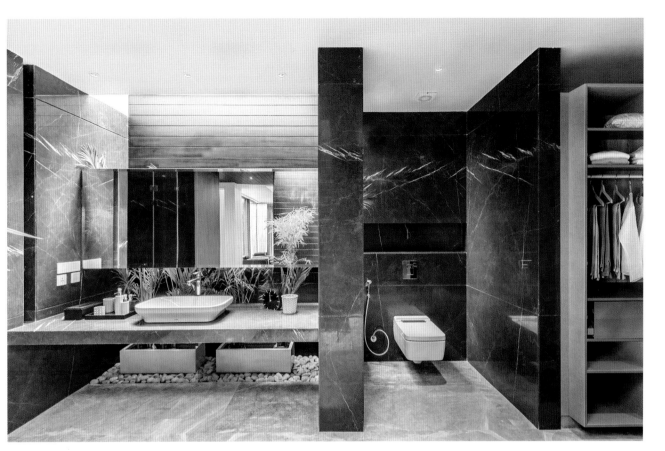

120

Ceiling cut-outs throughout the house provides natural light to all habitable spaces. Wherever required, these combine with landscaped courts to introduce greenery.

121

On the first level the bedrooms are approached through a gallery that circumferences the internal courtyard with views giving a pivotal anchor to the first floor.

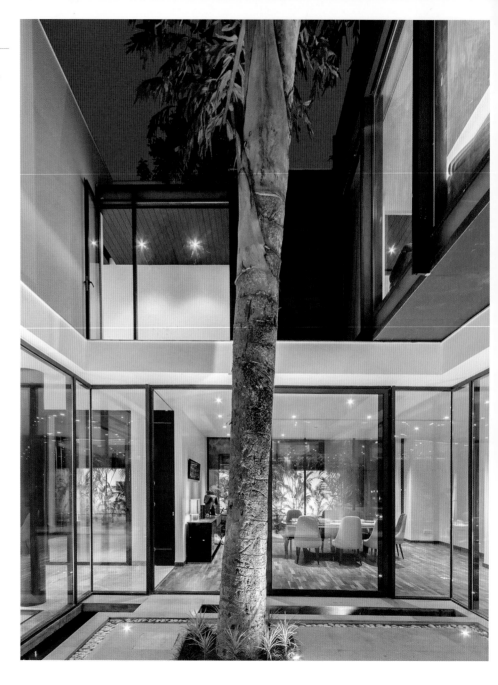

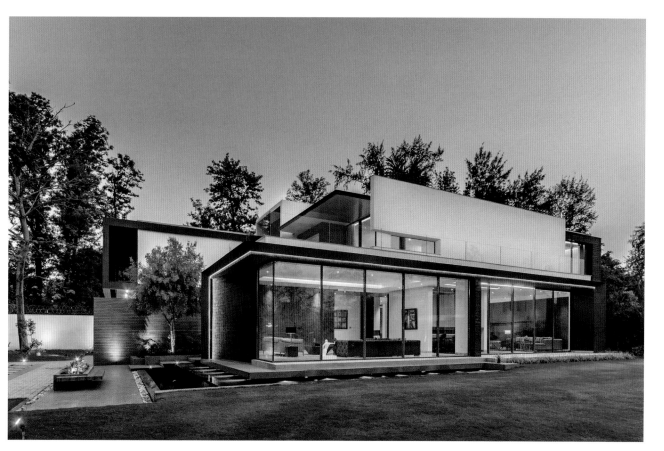

1·22

The lighting reinforces the geometric vocabulary of the residence, enriching the play of reflections through glass over water.

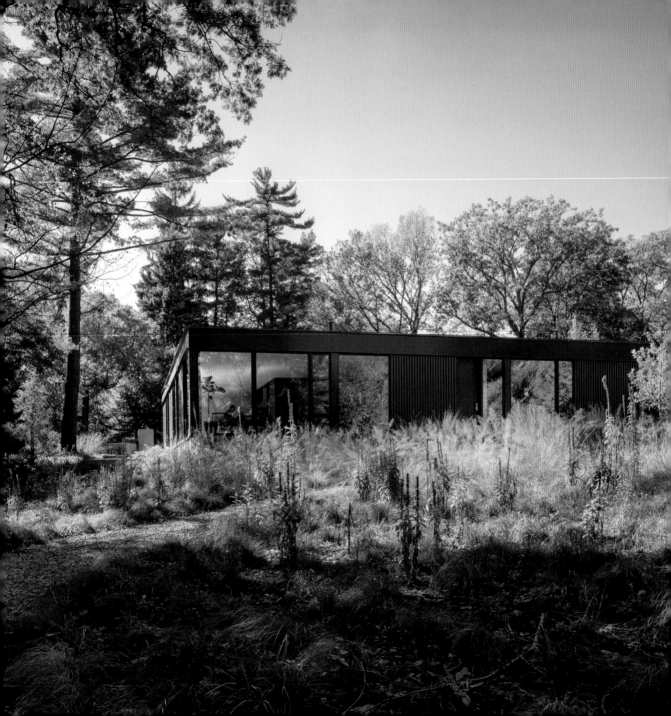

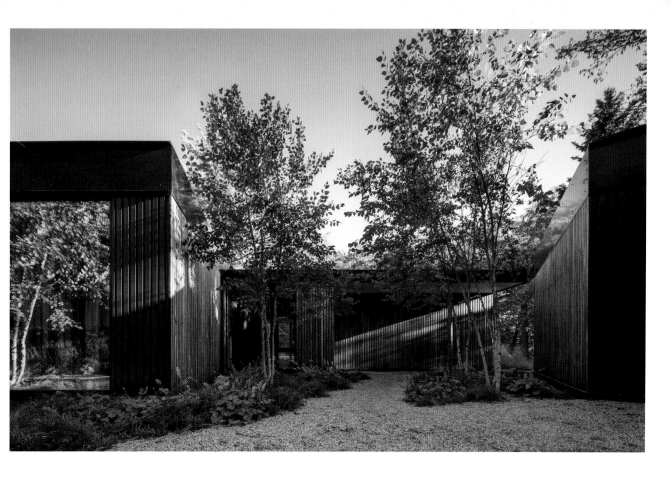

The Ravine House was designed for a couple of empty nesters, who desired a retreat in contact with nature. It was conceptualized as a single dark, rectangular volume with one corner (the garage) broken off to create an entry courtyard. The house and garage are intentionally pulled apart to allow the wild, natural terrain to spill into daily routines. The house has three distinct areas organized around a central utilities core: one area encompasses the master suite and a painting/spinning studio; another contains the living, dining, and kitchen areas; and the third holds two guest bedrooms and an office. Modest in scale and spatial requirements, the house supports the owners' active lifestyle and their different interests while embracing the surrounding natural environment.

Ravine House

House: 3,850 sq ft
Garage: 675 sq ft

Highland Park, Illinois, United States

Wheeler Kearns Architects

© Tom Rossiter

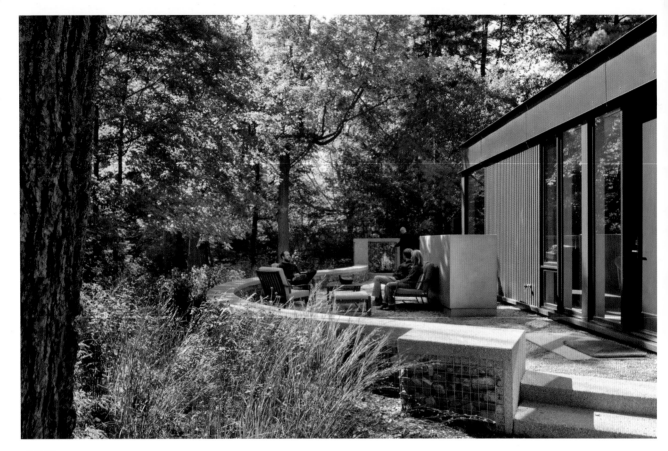

123

Outdoor living has become a house
design trend, one that brings us
closer to nature in the comfort
of the home. So much so that a
backyard, a terrace, or a patio can
become an outdoor extension of
the living spaces.

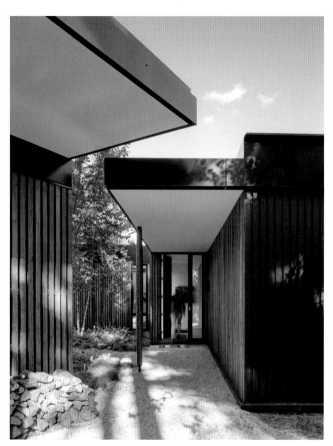
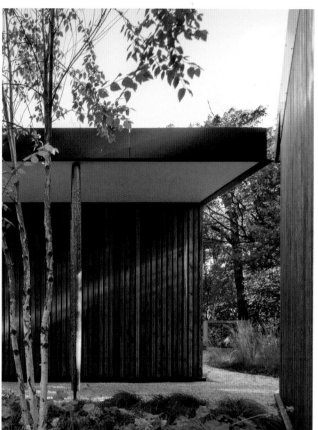

The exterior volume is wrapped in black, square-edged, vertical siding, while a rainscreen of American black locust lines the entry courtyard.

Conceptual diagram

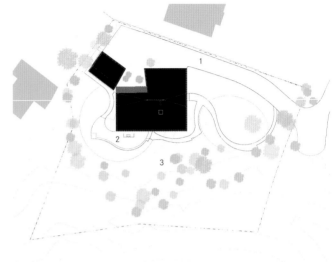

Site plan

1. Driveway
2. Patio
3. Ravine

Conceptual model

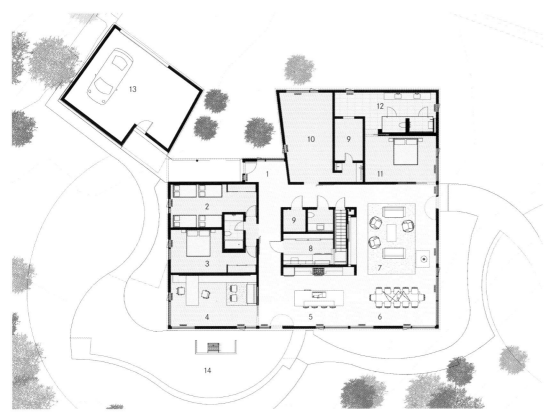

Floor plan

1. Entry
2. Bunk room
3. Guest room
4. Office
5. Kitchen
6. Dining room
7. Living room
8. Pantry
9. Closet
10. Studio
11. Primary bedroom
12. Primary bathroom
13. Garage
14. Patio

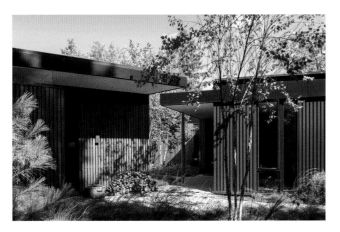

The idea of the garage breaking apart from the singular rectangle has several purposes: to deconstruct the object and create a space where one can breathe fresh air and experience the seasons.

The compression and expansion of interior spaces generate a dynamic spatial experience that takes users through a journey of large and narrow spaces, some revealing views. This experience is further enhanced by the quality of light and the materiality of such spaces.

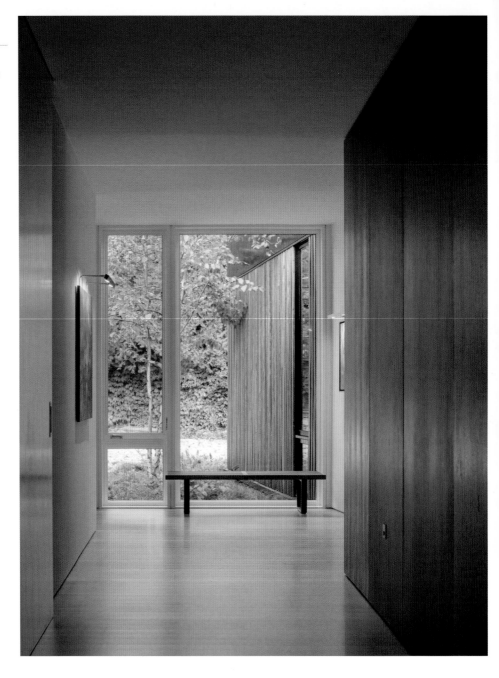

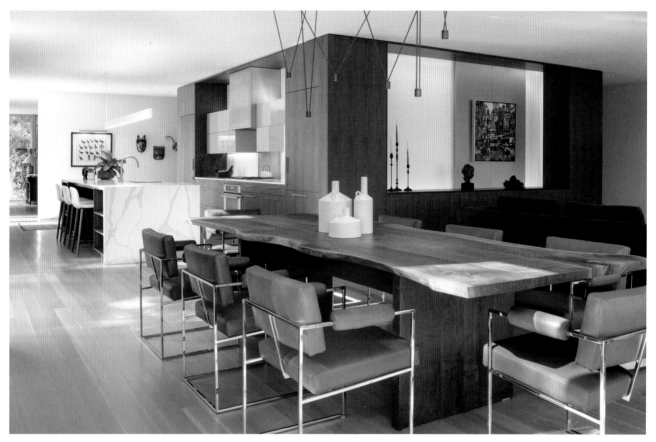

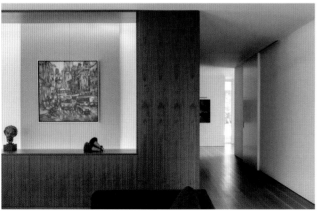

The heart of the home is a central volume of American walnut with all the continuous white-oak-floored living spaces revolving around it.

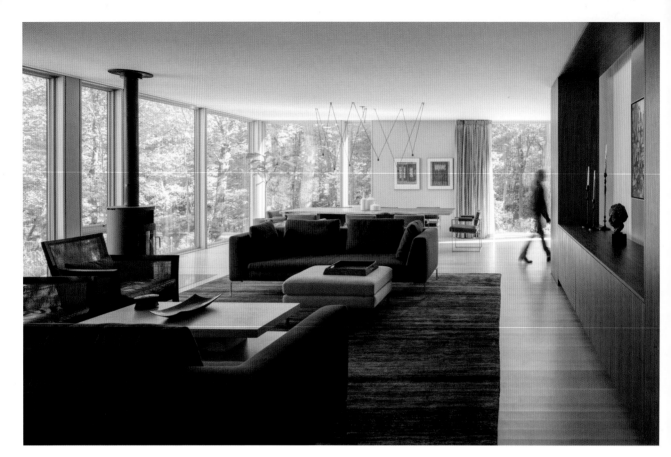

125

Floor-to-ceiling windows invite in the natural surroundings. They allow it to be part of the home environment, linking nature and architecture.

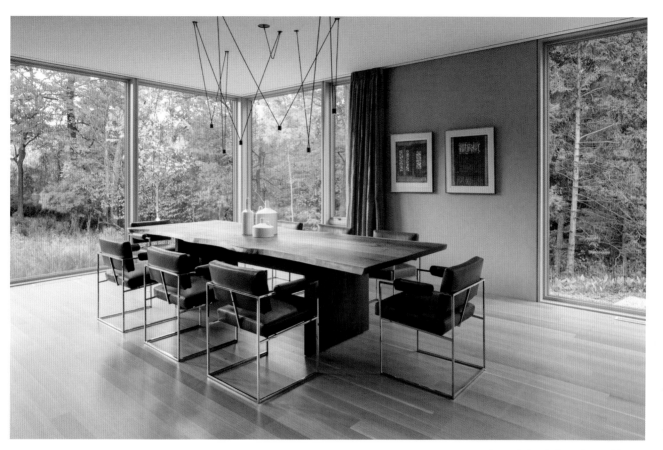

Large windows to the ravine provide
vistas of the cadence of seasons, color
spreading through the fall leaves or
dappled light on the fresh snow.

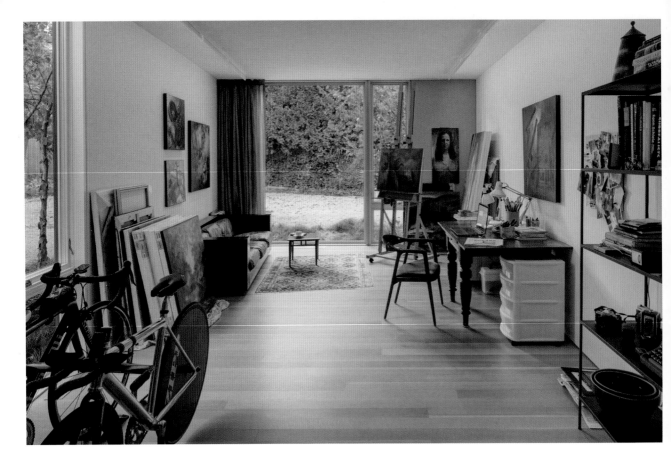

126

According to research, a holistic approach in architectural design supports human health. This approach may integrate natural environments and architecture to improve human well-being while inviting reflection and creation.

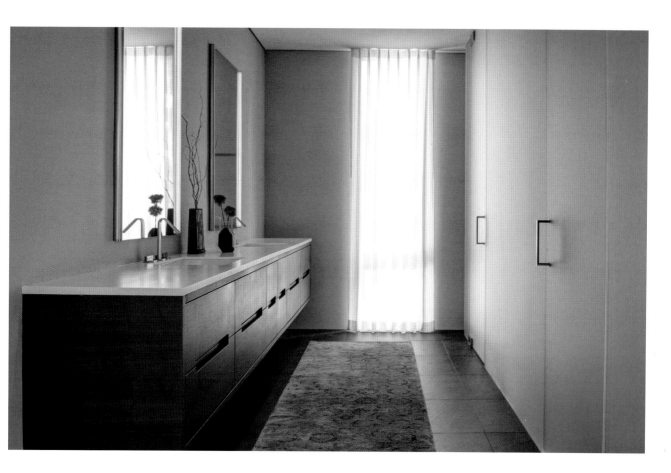

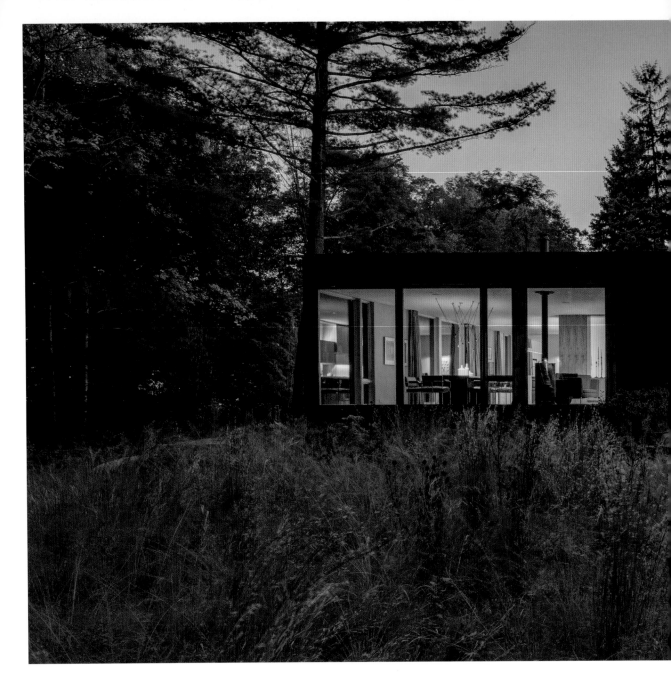

The house sits sensibly on the land, reflecting the architect and the owners' attitude toward nature, a respectful attitude with environmental and aesthetic benefits.

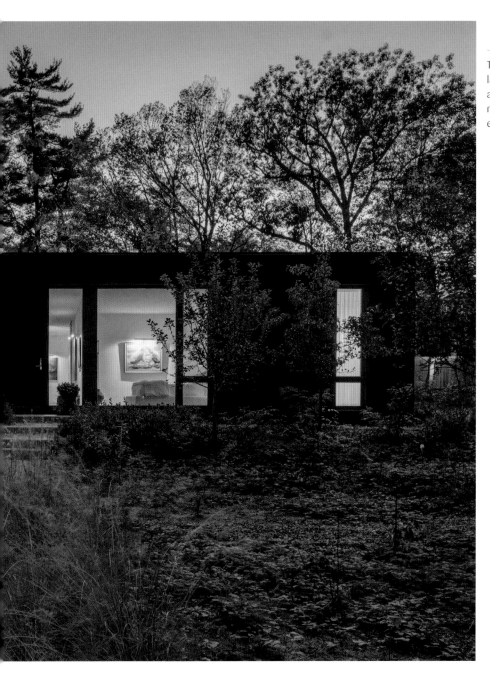

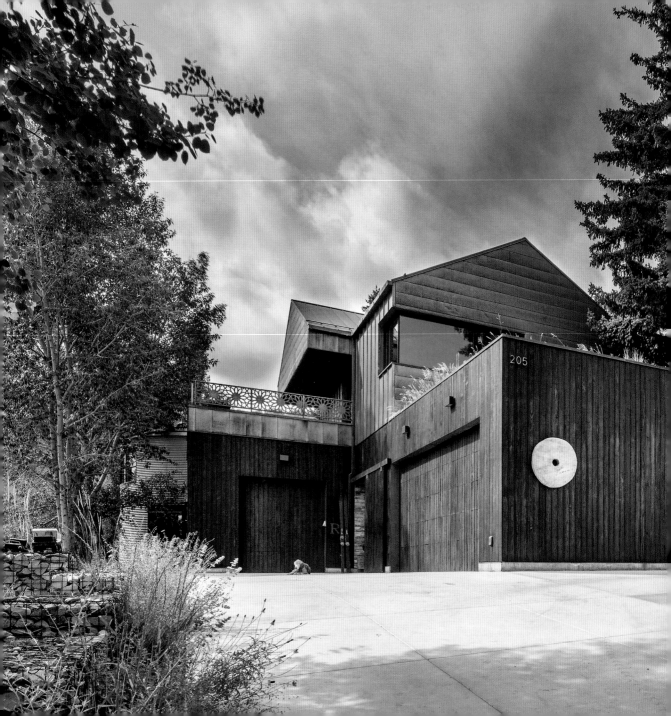

Thaynes Canyon Residence

4,800 sq ft

Park City, Utah, United States

Sparano + Mooney Architecture

© Scot Zimmerman

In an early meeting with clients, the architects were given the direction to design "a work of art that we can live in." This challenge inspired the design team to produce architecture that could stand up to an eclectic art collection and fit within the context of the beautiful mountain site. The clients—she is an artist, and he is a filmmaker and ski touring guide—were the ideal couple to direct the process of remaking their family home. The design responds to the site, taking in views of mature trees and a meadow with a stream while providing optimal solar orientation. Inspired by petrified wood on the site—a material that over time has transformed from wood into stone—this house also retains the memory of its past. The alchemic process of the wood is analogous to the transformation of this turn of the nineteenth-century farmhouse into a contemporary residence.

Historic documents uncovered the original mining era farmhouse circa 1894-1930 with an eroded rubble foundation. This original structure is evident in what emerged as new—the wood structure became stone, occupying the historic footprint of the former structure.

Design sketches

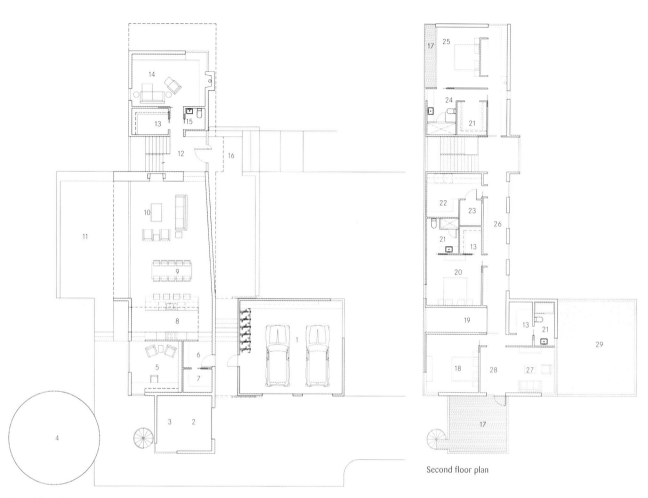

Ground floor plan

Second floor plan

1. Garage
2. Storage
3. Mechanical below
4. Existing silo
5. Workspace/library
6. Mudroom
7. Pantry
8. Kitchen
9. Dining area
10. Living area
11. Patio
12. Entry
13. Closet
14. Media room
15. Powder room
16. Porch
17. Deck
18. Bedroom
19. Open to below
20. Bedroom
21. Bathroom
22. Laundry room/storage
23. Mechanical room
24. Master bathroom
25. Master bedroom
26. Gallery/library
27. Living room
28. Storage (future kitchen)
29. Green roof

Thick, textural stone walls contrast with wood reclaimed from the house. This wood was treated with the shou-sugi-ban process. The architectural form is a pure iconic domestic farmhouse, newly updated.

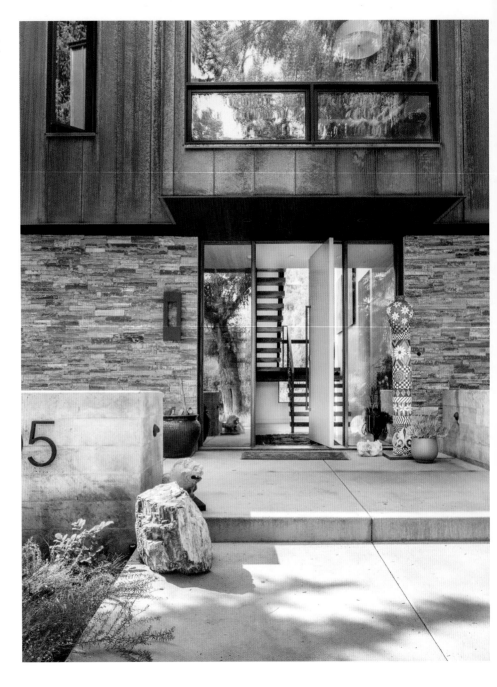

128

The design of the house takes
a cue from the site, both in its
natural and historical context.

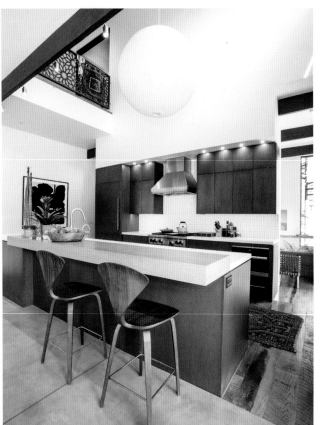
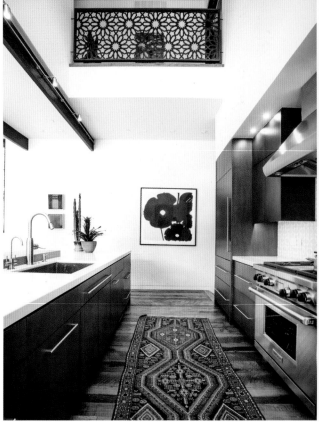

129

The kitchen is a double-height
space, opened to the bedroom floor
above. High clerestory windows
bring light into the space below.

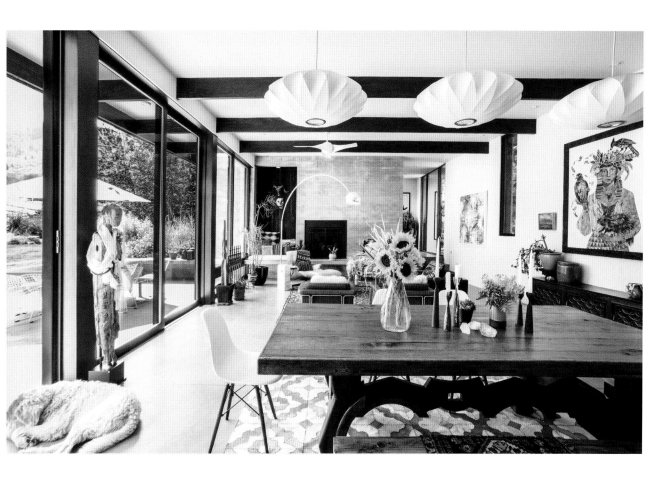

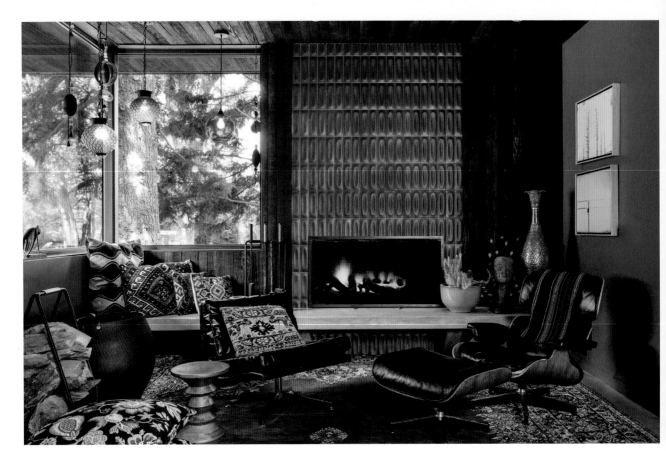

130

An eclectic material selection gives
each space its own identity—from
the stone and wood exterior to
the large window walls and the
perforated metal and wood surfaces.

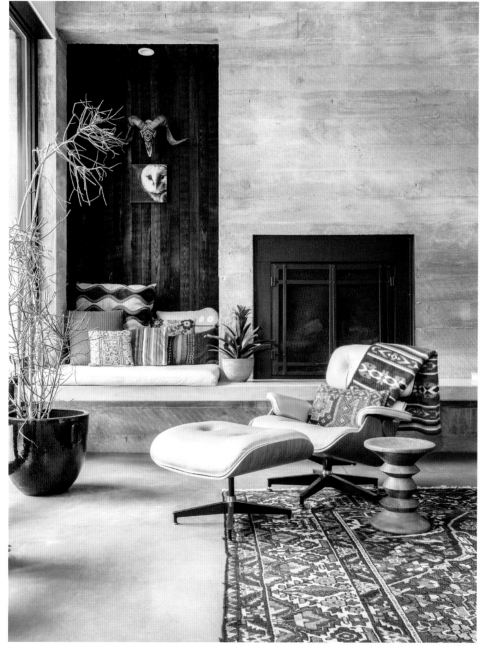

The living room's board-formed fireplace has a bench in the same material that extends outdoors.

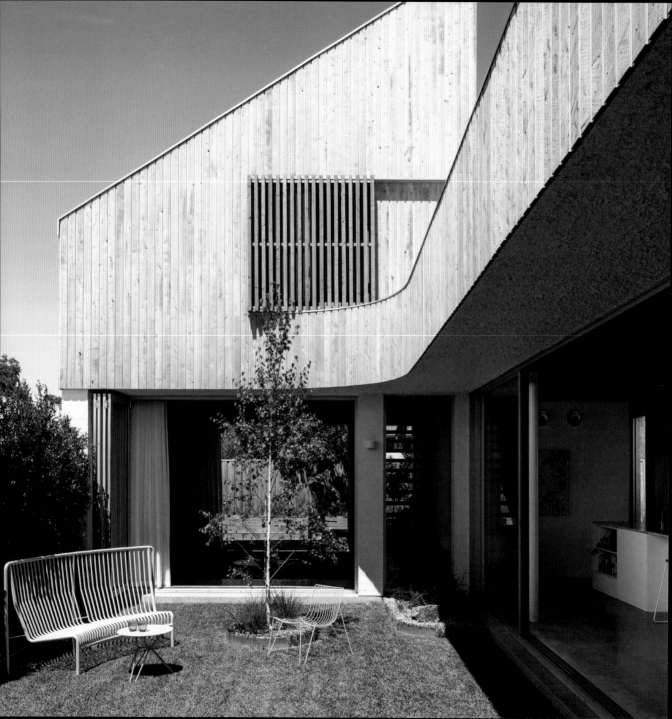

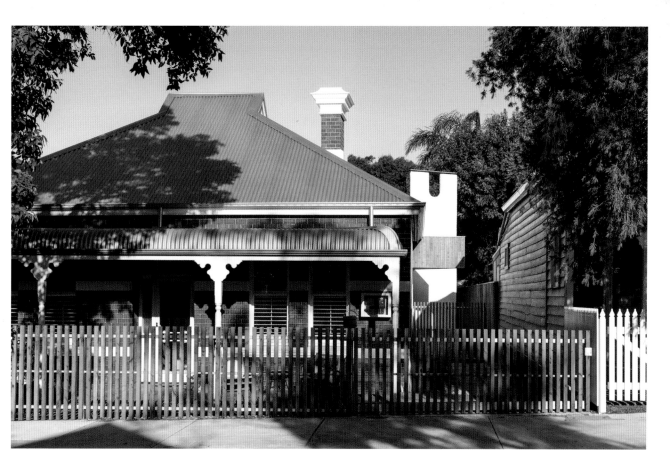

The East Fremantle House is a contextually responsive addition to a heritage cottage in suburban Perth. The most important part of this project is the space that is not built—specifically, a large northern void—a space for sun, light, sky, sound, and breeze to inhabit. The house then traces this edge, creating rooms with an immediate connection to these elemental conditions. Formally, the house is expressed in four parts: the existing brick cottage, an entry link, the ground floor addition, and the first floor addition. The entry link acts as a mediating point between the elements, dark, hard, and solemn. To the left upon entry is the existing cottage, restored and lightly amended. To the right, the garden room and living spaces are bright and open. Above these sits the new wood-clad upper story, forming the articulated eaves and containing the master suite.

East Fremantle House

2,475 sq ft

Perth, Western Australia, Australia

Nic Brunsdon

© Dion Robeson Photography

Second floor plan

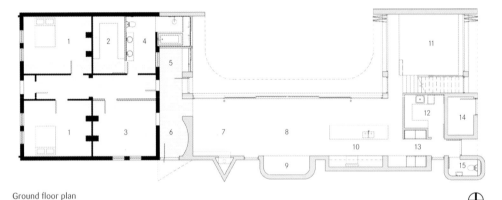

Ground floor plan

1. Existing bedroom
2. Walk-in closet
3. Bedroom
4. Bathroom
5. Study nook
6. Entry
7. Living area
8. Dining area
9. Art wall
10. Kitchen
11. Sunken lounge
12. Laundry room
13. Pantry
14. Outdoor store room
15. Powder room
16. Master bedroom
17. En suite

The ancillary program elements are expressed as "lumps" on the south face of the addition, pushing through the purity of the north-facing living box to create a tall triangular chimney for the fireplace, a curved north-facing shell for an art wall, a low top-lit box for the kitchen, and a high round cylinder for a powder room.

Exploded axonometric

132

Getting the massing, orientation, and subsequent program planning right is the most important thing designers of lived-in environments can do. More so than ever in our current context of shifting work patterns toward the home.

The original cottage is sensibly restored to encompass a kitchen, a dining area, and the staircase up to a second floor where the bedrooms are. The distinction between old and new is achieved through flooring materials: hardwood floors in the restored cottage and polished concrete floors in the extension.

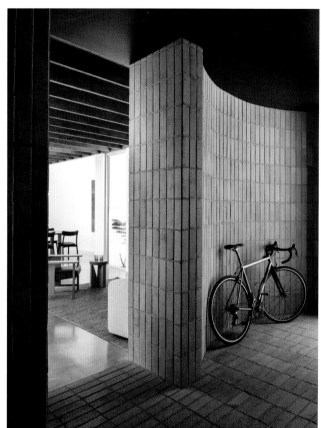

A dimly lit and enclosed curved masonry entry leads to bright and open living areas, amplifying the spatial variety of this modestly sized, yet space-efficient house.

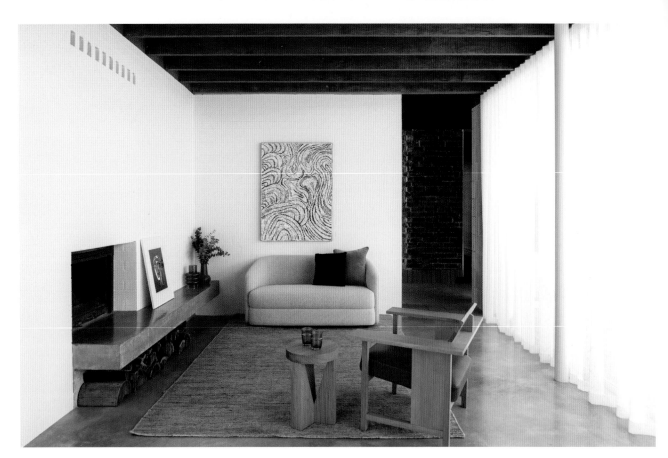

133

This project demonstrates that by placing the northern garden as the first design move on the site, the building then becomes secondary and deferential to this.

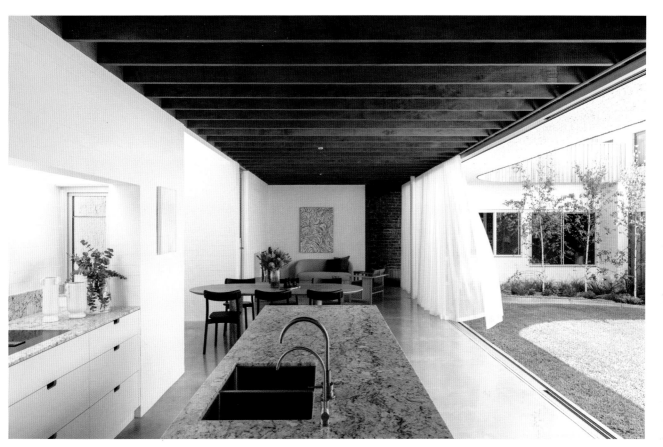

134

The garden, this void of space, gives measurable and appreciable amenity to the project and shows that an understanding of and connection to the space beyond the built can shape the rhythms, patterns, and quality of daily family life.

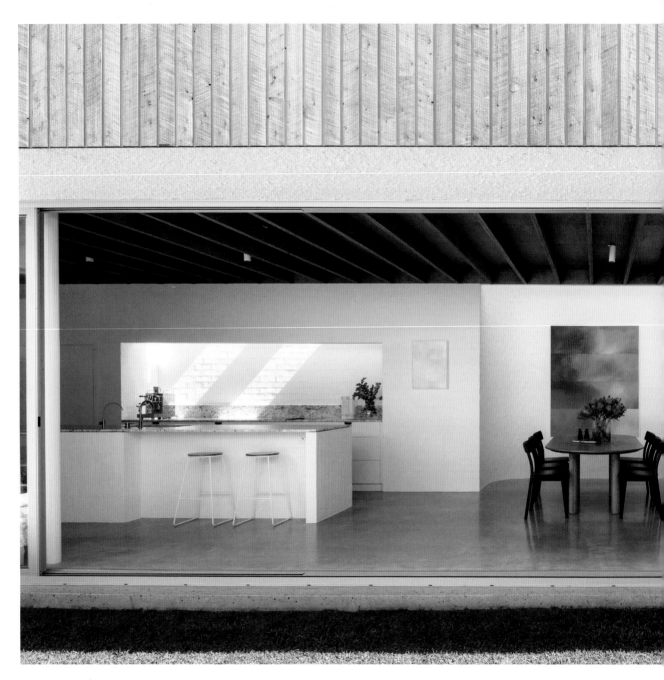

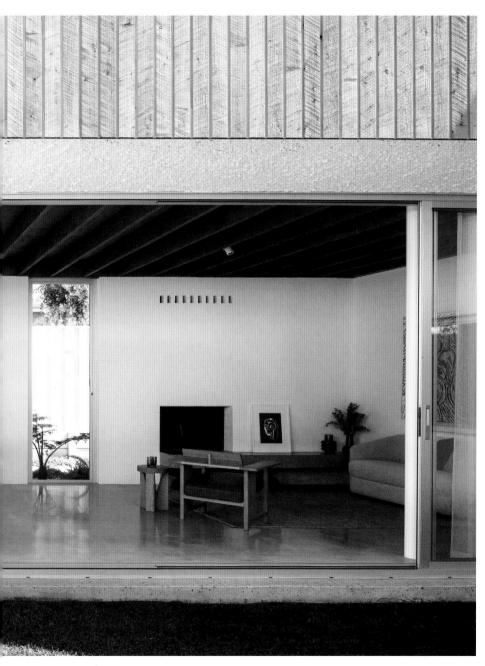

The simple and linear form of the addition is conceived as one long "garden room." Its north face is lined with sliding doors, opening up the house to the exterior and allowing indoor activities to spill out and occupy the full width of the site.

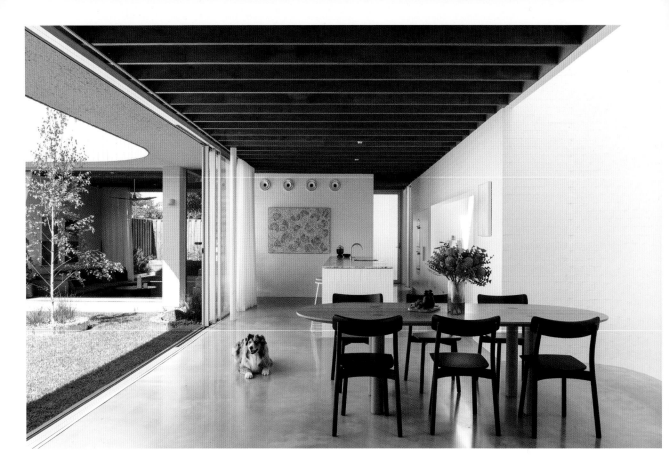

135

A concave wall adds extra space to the dining area, demarcating the space while avoiding walls or other types of space-framing solutions.

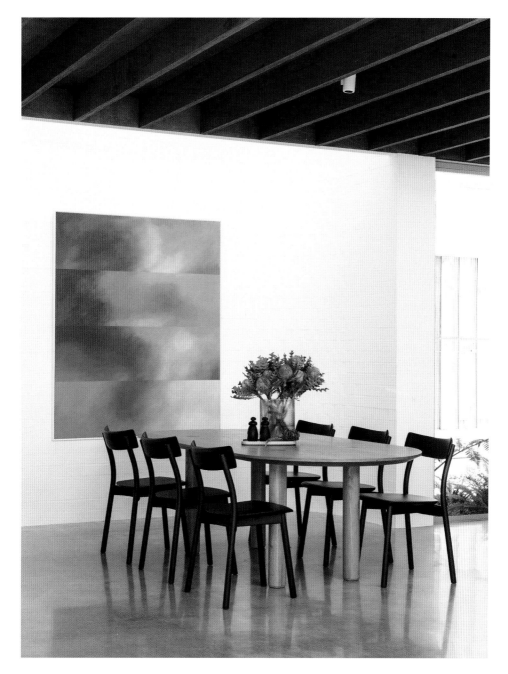

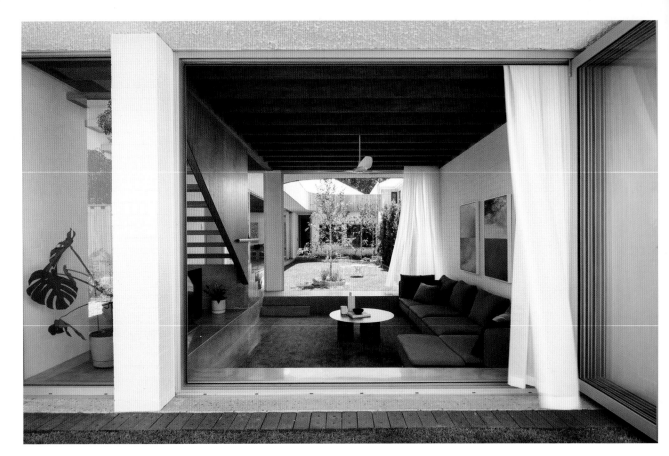

136

A sunken living area is another space-demarcation solution that provide areas with specific functions while maintaining space continuity.

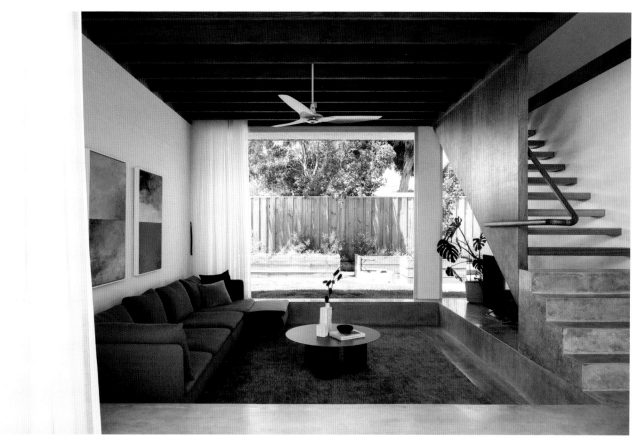

The sunken living area provides comfortable seating with framed views of the garden room.

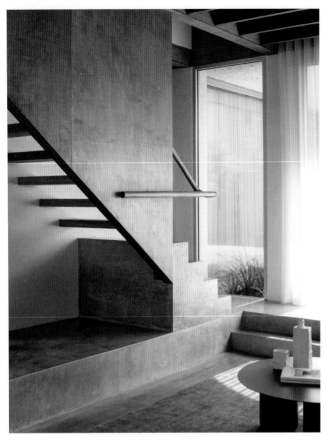

Rich colors complement the alteration and addition strongly shaped by geometric forms, creating a very distinctive aesthetic and architectural language.

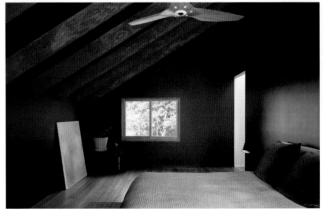

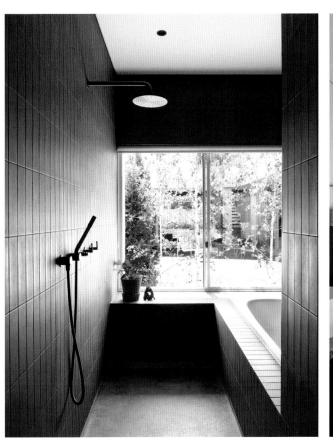
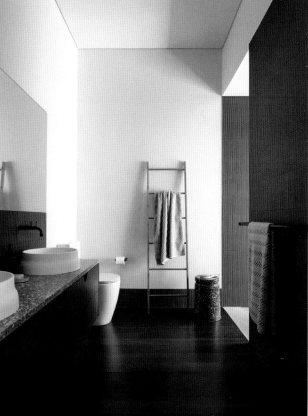

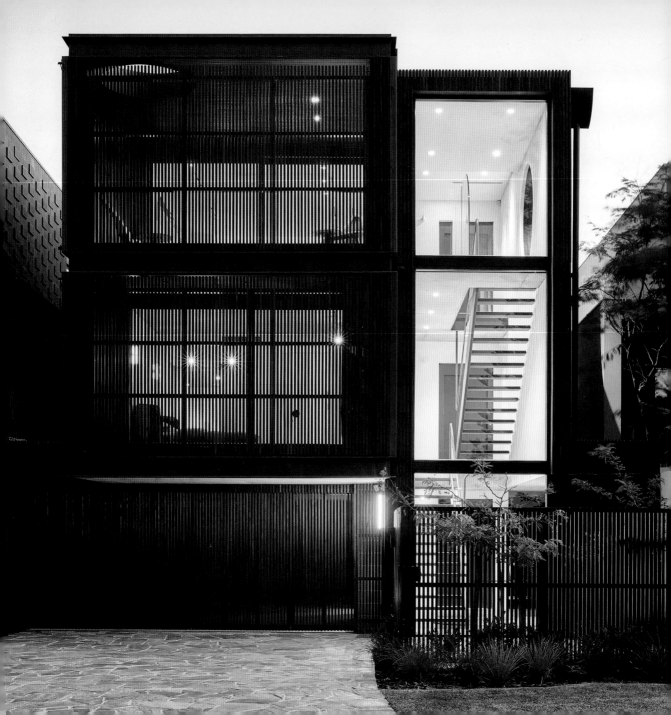

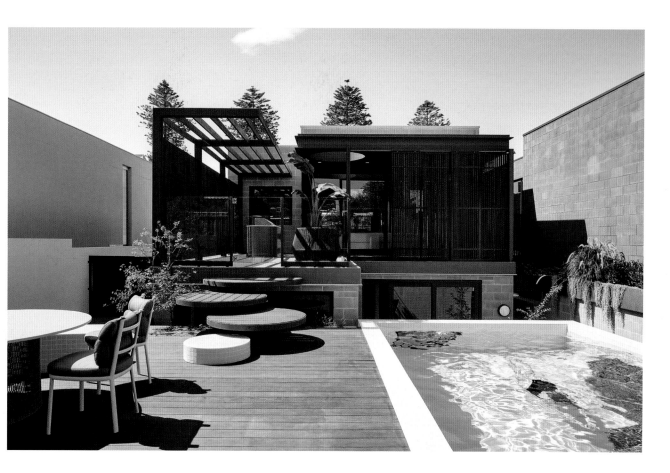

Shutter House is a celebration of vibrant color, rich textures, light, and shadow. It is an experiential space throughout with a balance between powerful and gentle sensations. Strong, rectilinear forms and graphic geometric lines are softened and offset by strategically placed circles and curves. There is a balanced tension in this contrast that is simultaneously stunning and exciting, but also calm and balanced. The vision for the project was to capture views of the lake opposite while maintaining privacy and control of light and shade within. The brief identified the drastically sloping site as an opportunity to work with strategic use of floor levels and the creation of connectivity between spaces across a variety of planes. Vistas are framed with the intention to unite the interior with the exterior, while the height of boundary walls and surrounding buildings create sensations of secluded privacy.

Shutter House

6,760 sq ft

Wembley, Western Australia, Australia

State of Kin

© Jack Lovel, Sophie Pearce

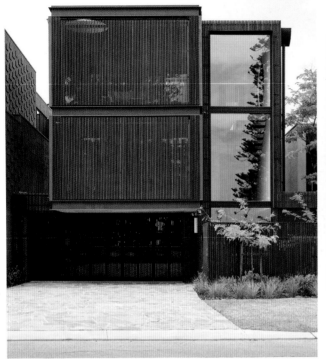
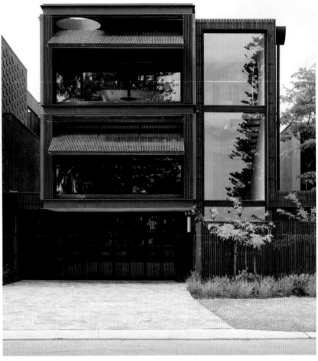

The three-story facade features
mechanical timber shutters, which lift
open and closed as desired to reinforce
a dynamic flow of air, light, and energy
throughout the house.

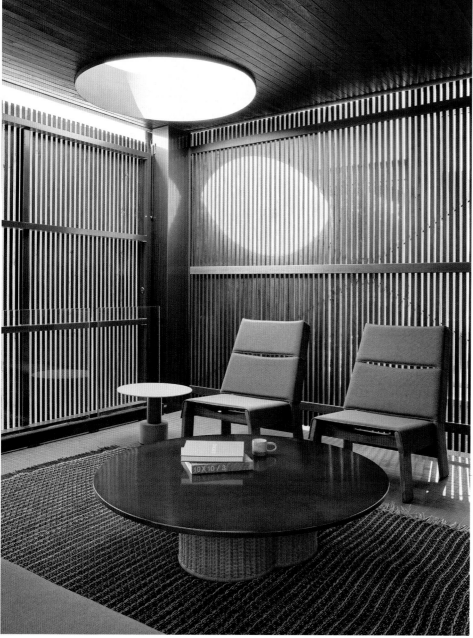

The mechanical shutters can change the house's appearance and atmosphere, both outside and inside. For instance, when the shutters are closed to the street, the facade looks like a resonating timber box with a hint of depth beyond; from the interior, a moody, secluded balcony.

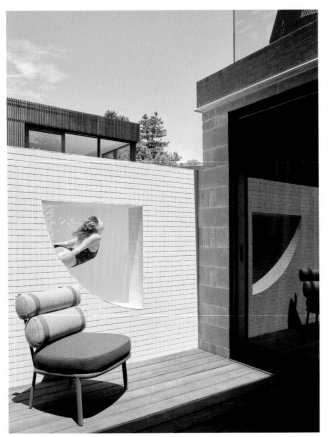
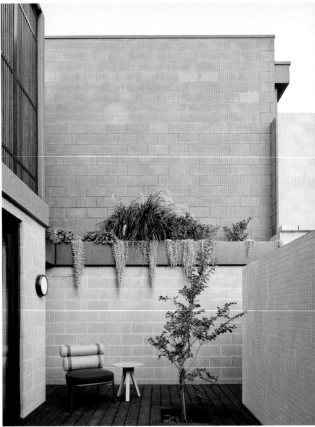

The bedrooms open into a private
courtyard, bound along one side by the
pool, celebrating the changing levels
and connecting spaces. A quarter-round
window in the tiled pool wall looks
into the depths of the pool from the
courtyard, inviting diffused light to flow
through the pool and into the home.

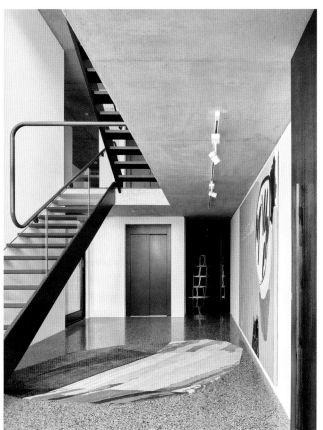

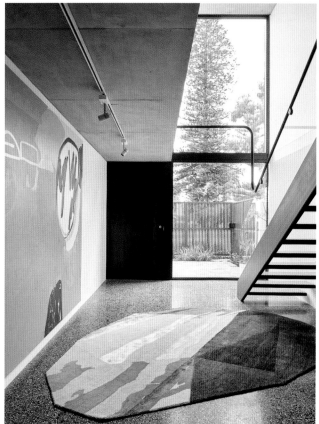

The powerful entry with polished terrazzo floor draws visitors upward and into the space beyond via a sculptural staircase with travertine floating treads and a curved handrail.

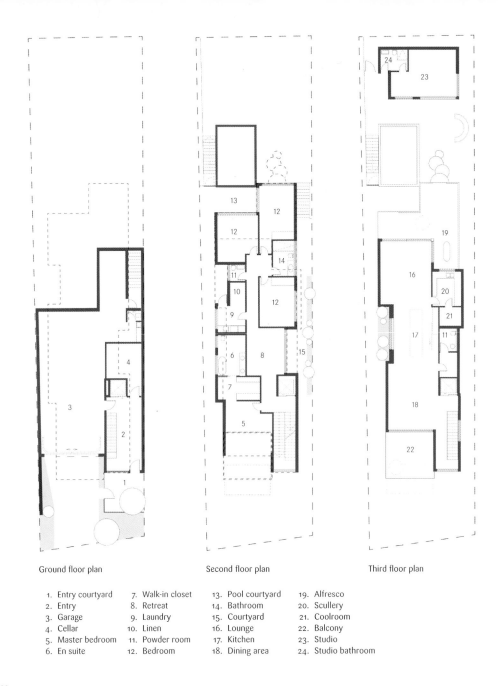

Ground floor plan

Second floor plan

Third floor plan

1. Entry courtyard	7. Walk-in closet	13. Pool courtyard	19. Alfresco
2. Entry	8. Retreat	14. Bathroom	20. Scullery
3. Garage	9. Laundry	15. Courtyard	21. Coolroom
4. Cellar	10. Linen	16. Lounge	22. Balcony
5. Master bedroom	11. Powder room	17. Kitchen	23. Studio
6. En suite	12. Bedroom	18. Dining area	24. Studio bathroom

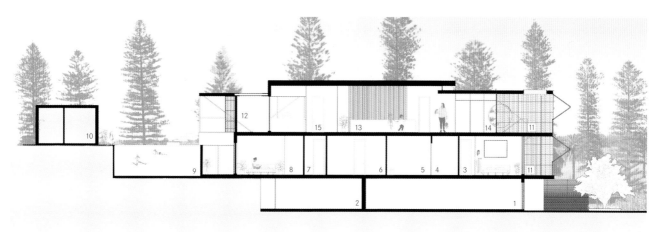

Longitudinal section

1. Garage
2. Storage
3. Master bedroom
4. Master closet
5. Master bathroom

6. Laundry room
7. Powder room
8. Bedroom
9. Pool
10. Studio

11. Balcony
12. Alfresco
13. Kitchen
14. Dining area
15. Lounge

Living and active spaces are connected from the front to the rear, abundant with light, overlooking the lake to the front and the pool to the rear.

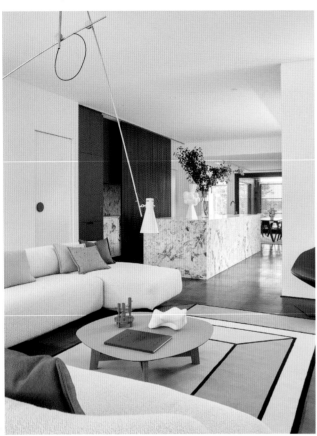

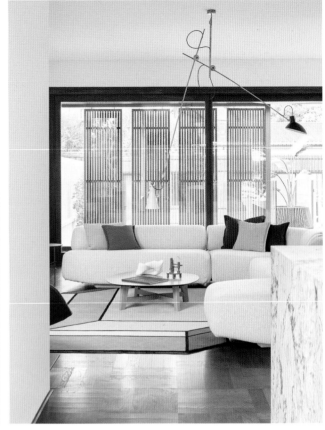

138

Clean white textures create a
crisp, open feeling and the graphic
elements of linear patterns add a
sense of movement and delight.

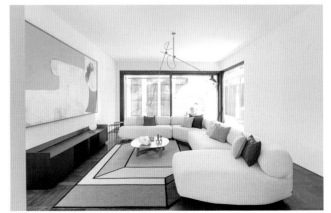

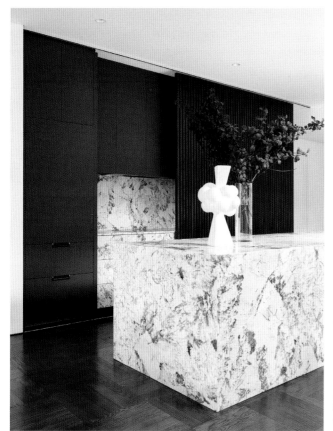

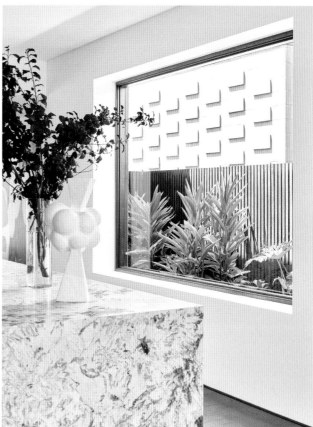

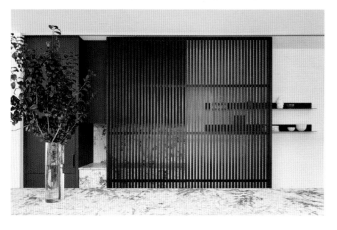

The granite kitchen island is commanding in scale. It looks onto a framed garden bed that visually brings greenery into the room. "Entertaining" kitchen amenities continue in this finish but are concealed beyond a sliding timber batten panel that references the facade. This allows the main open spaces to present as clean and minimalist when not in use while maximizing functionality.

Furniture, artwork, and lighting
elements introduce a mature
selection of forms and refinement,
but with lively and playful finishes
that highlight the polychromatic and
exuberant aesthetic of the home.

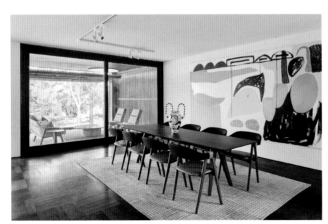

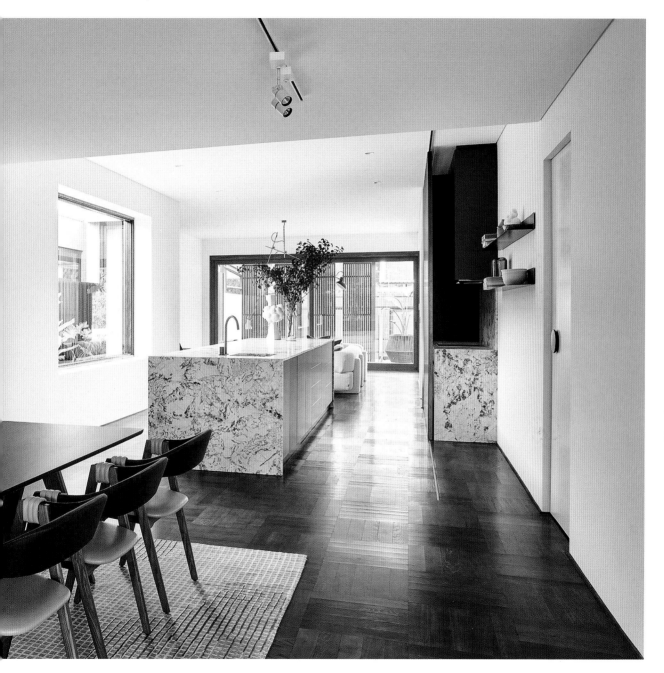

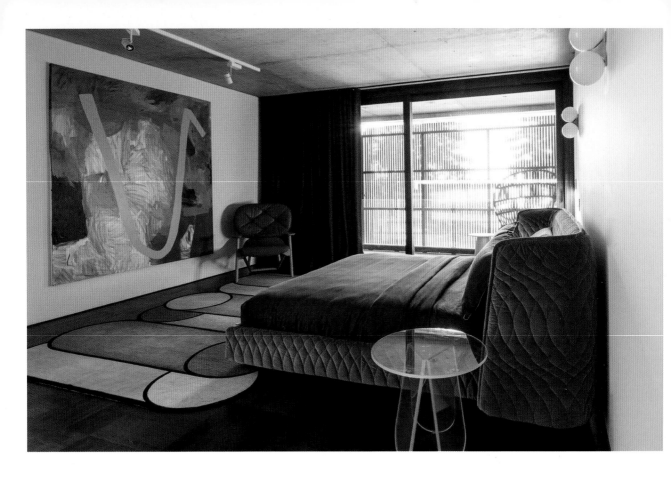

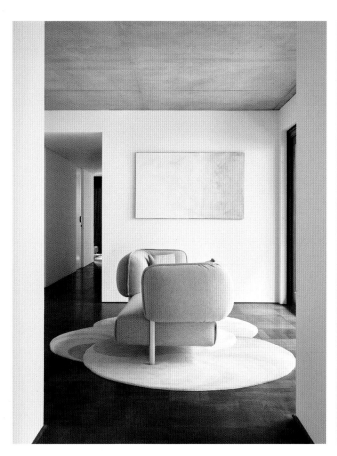

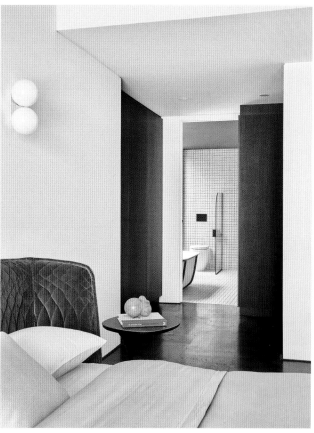

The spaces are warmed by custom timber floors and maintain an ambiance that is at once grand and comfortable.

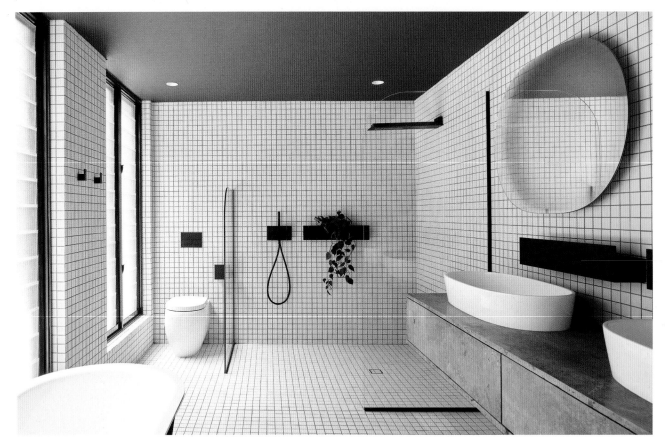

The bathrooms are consistently
appointed with silky travertine sitting
against textured white tile with graphic
colored grout and vibrant ceilings. This
is then paired with linear black Agape
fittings and fixtures and curved glazing,
including iridescent "extralight" mirrors
by Glas Italia (Shimmer range, by Patricia
Urquiola, supplied by Mobilia).

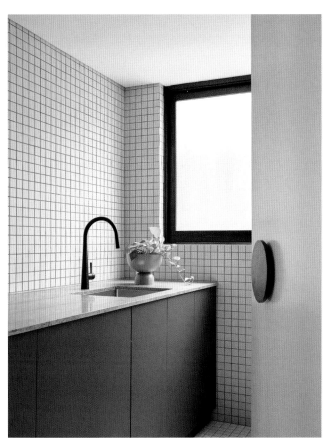
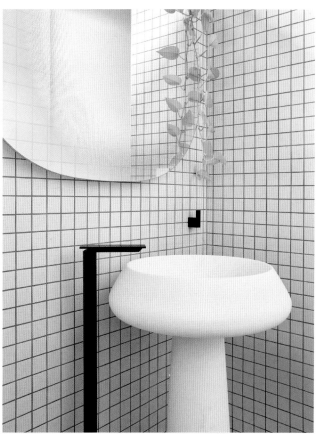

140

Textured louver windows allow
airflow and ventilation without
compromising privacy and diffuse
soft light into rooms.

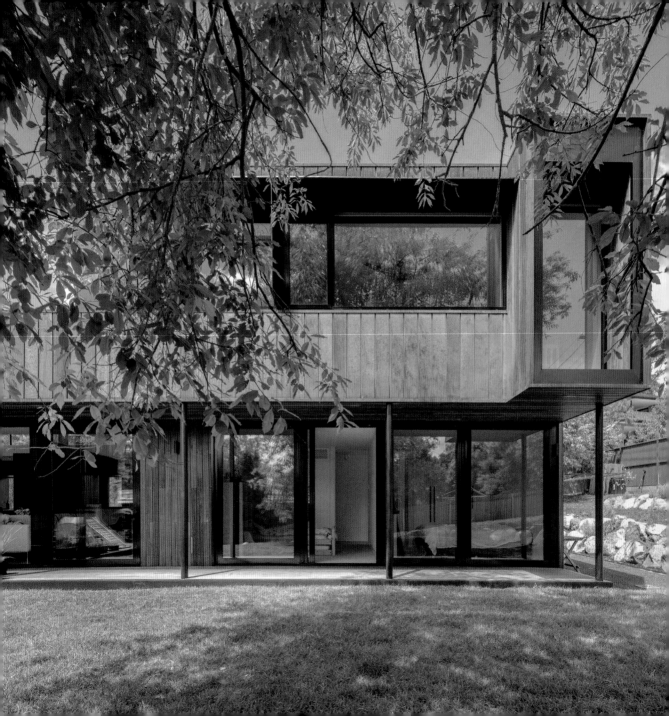

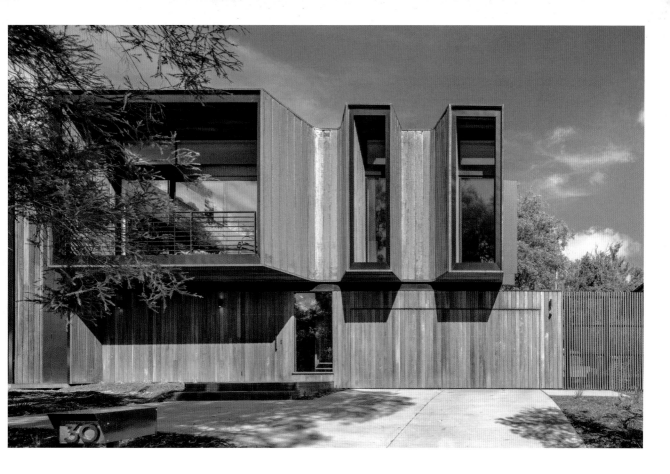

This new house is located in a suburban area with abundant mature native eucalypts and acacias. This setting, with its pronounced topography and local landscape features, dictates the building form. It generates a contemporary visual language of terraced floors/roofs and twisting facades framing particular views. The house responds to its sharp fall from back to front by locating garage access and main building entry at street level. This approach results in elevated living spaces that embrace views and textural qualities offered by the surrounding landscape. The exterior materials—primarily weathering steel cladding and hardwood—were chosen as a mechanism of evoking memories of the vernacular Australian "bush" architecture of rusted sheds and lean-to structures. In contrast, interiors are deliberately light and neutral to contrast the perceived ruggedness of the exterior setting.

SL House

3,207 sq ft

Aranda, Australian Capital Territory, Australia

Ben Walker Architects

© Ben Guthrie

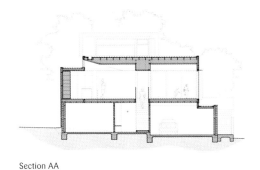

Section AA

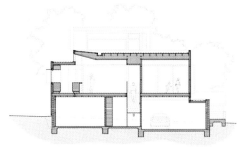

Section BB

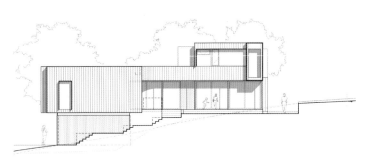

North elevation

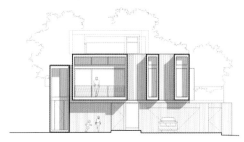

East elevation

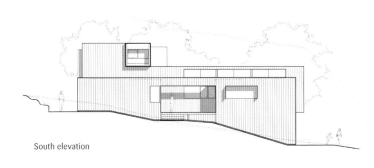

South elevation

West elevation

Third floor plan

The design goal was to establish an internal living environment that embraces the views and textural qualities offered by the strong landscape setting. This strategy drives internal planning decisions and resultant building form.

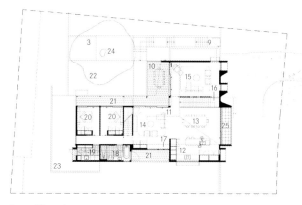

Second floor plan

1. New driveway
2. Entry
3. Seat
4. Staircase to second floor
5. Bag drop
6. Garage
7. Storage
8. Exterior access to second floor
9. Lower entry
10. Outdoor entry terrace
11. Internal entry
12. Kitchen
13. Dining area
14. Living area
15. Living and dining area
16. Void to entry level
17. Reading seat
18. Bathroom
19. Laundry
20. Bedroom
21. Verandah
22. Rear yard
23. Service zone
24. Tree
25. Balcony
26. Landing
27. Study
28. Walk-in closet
29. En suite
30. Reading nook

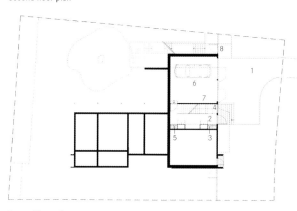

Ground floor plan

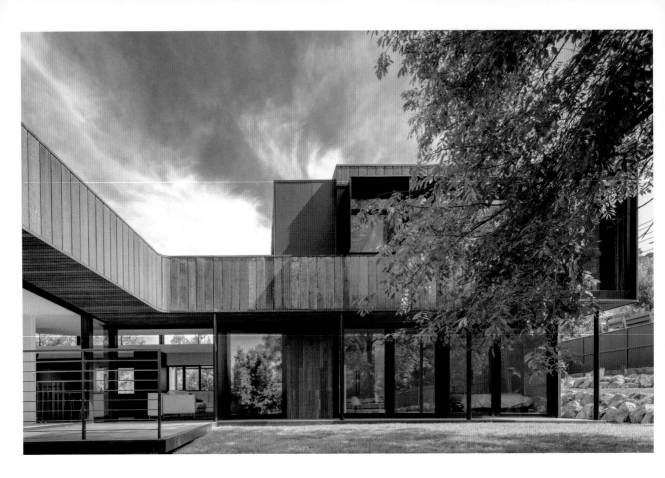

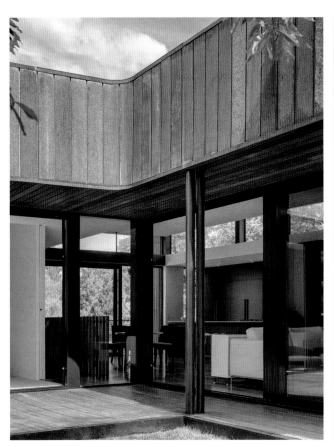

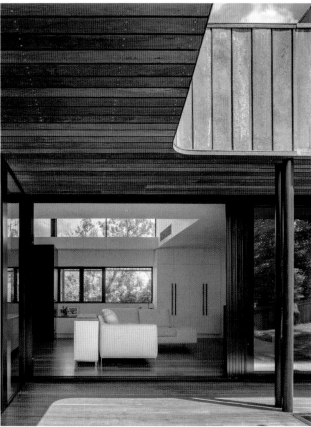

The main social areas of the house—kitchen, living, and dining—face the north and northwest to engage with the rear yard through stacking sliding doors.

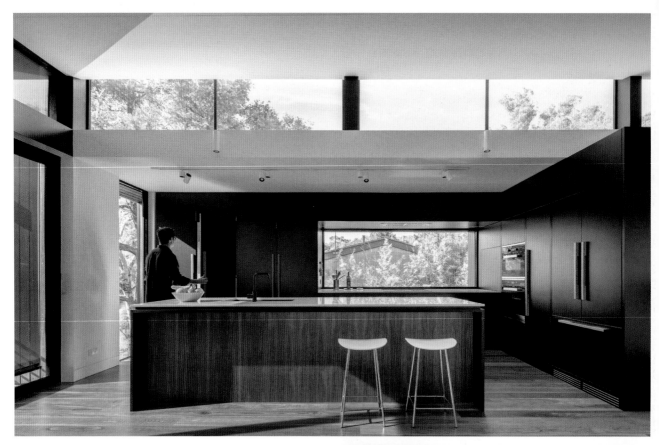

The kitchen, living, and dining spaces have selected and curated views to surrounding trees and hillsides to the east through broad picture windows or thin vertical apertures.

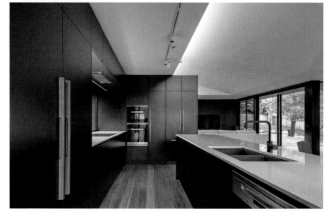

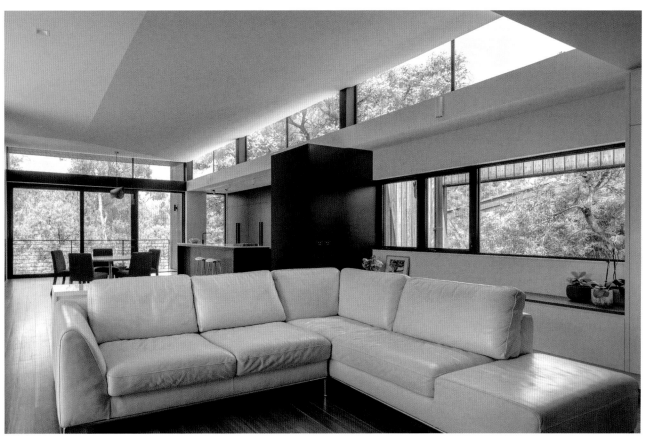

142

The roof form of the living areas
incorporates two raking ceilings that
rise over clerestory windows. The
ceiling profile provides a beautiful
interior volume and graded fall of
light across the ceiling's valley fold.
The clerestory windows bring in
natural light and provide views of
the sky and canopy.

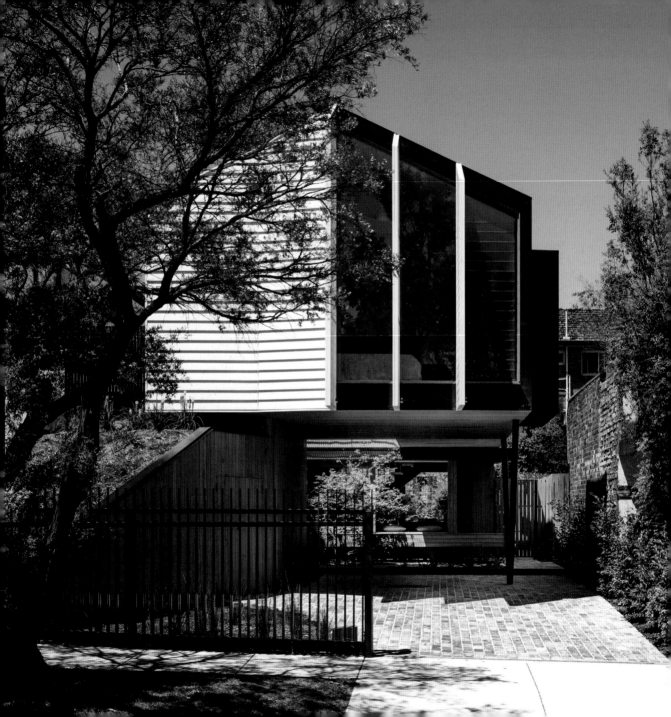

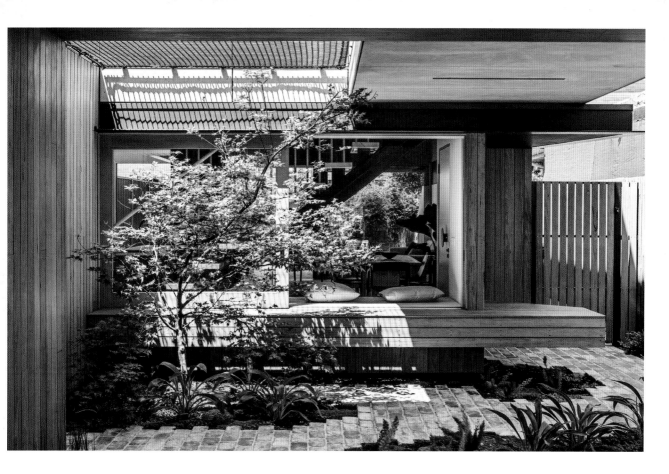

Pop-Up House attempts to counter the status quo of a new family home in a heritage residential setting. Figr created a home that engages with the urban realm by inviting opportunities for interaction between inhabitants, visitors, and neighbors, promoting community engagement. Figr's approach to the domestic container is a simple extrusion of the neighboring vernacular silhouette. The extrusion is elevated and sits atop an arrangement of programs on the ground floor. The envelope is reduced to its simplest form, removing eaves and ornaments. Subtractions in the envelope create openings, and a central courtyard opens the long extrusion to light and program amenity.

Pop-Up House

2,100 sq ft
Essendon, Victoria, Australia

Figr
© Tom Blachford

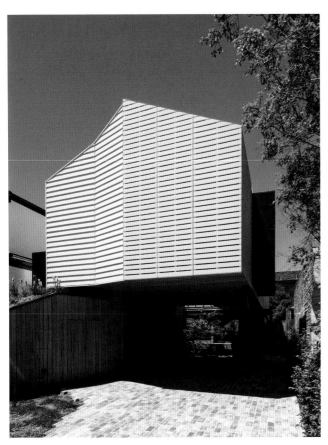
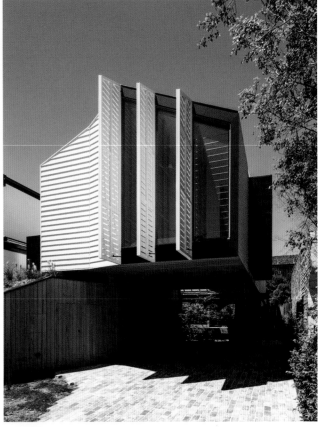

143

Operable shutters enclose the front
face of the second floor to protect
its interior from sunlight while
also providing privacy as needed.
When the shutters are open, the
entire house front engages the
street. The result is a home that is
responsive to its occupants' needs
and to its immediate environment.

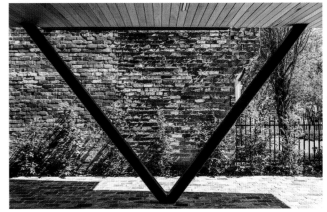

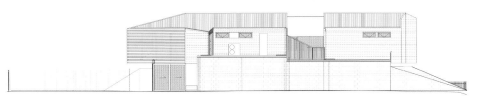

North elevation

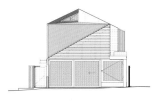

East elevation

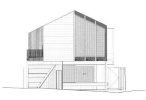

West elevation

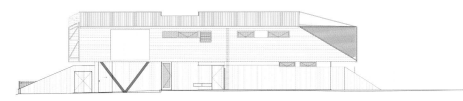

South elevation

The building's upper volume hovers above a landscaped mount that creates the beginning of a journey into the house. Flanked by existing neighboring brick walls, the new house establishes a dialogue between old and new.

Sliding glass doors minimize the indoor-outdoor separation, allowing for indoor activities to spill outdoors and vice versa. This feature is convenient on the occasion of large gatherings.

Roof plan

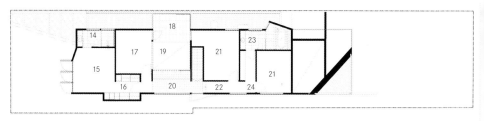

Second floor plan

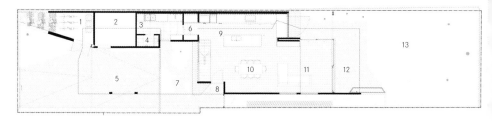

Ground floor plan

1. Storage
2. Workshop
3. Laundry/mudroom
4. Powder room
5. Multipurpose space/carport
6. Pantry
7. Courtyard
8. Entry
9. Kitchen
10. Dining area
11. Living area
12. Covered outdoor area
13. Backyard
14. En suite
15. Main bedroom
16. Walk-in closet
17. Retreat
18. Terrace
19. Net area
20. Study
21. Bedroom
22. Corridor
23. Bathroom
24. Linen

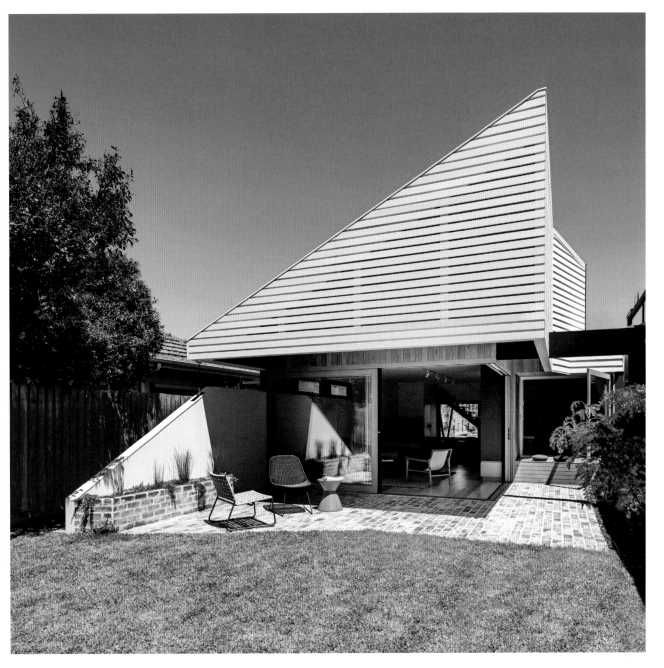

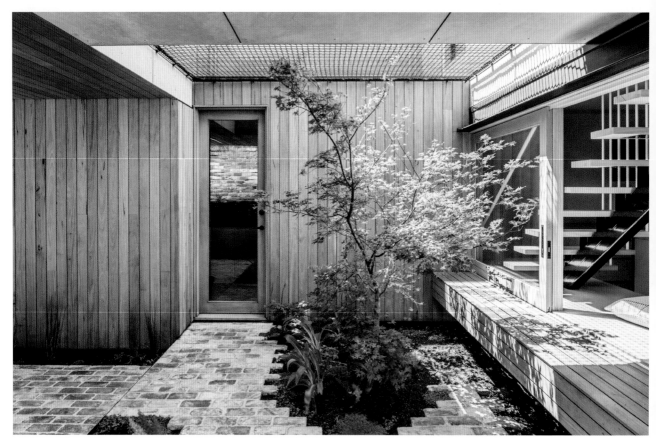

The hovering belly of the house creates
an undercroft that guides guests into the
house through lush, landscaped gardens.
This area becomes a multifaceted space
in the front yard that can adapt and
evolve in program and in use.

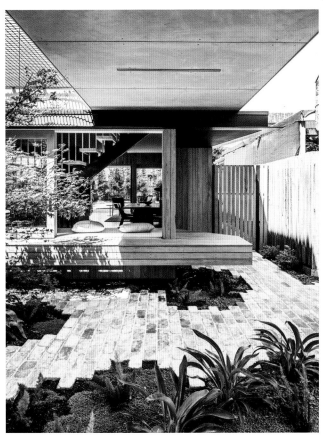
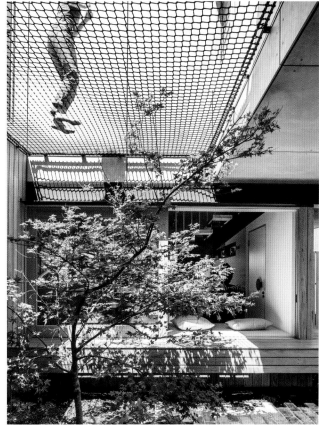

145

A terrace extends into a netted area, utilizing the in-between space to create additional play areas. The underbelly of the dwelling doubles up as a carport, an extension of the workshop, and an informal entertaining area. These moldable areas provide long-term flexibility for use adaption.

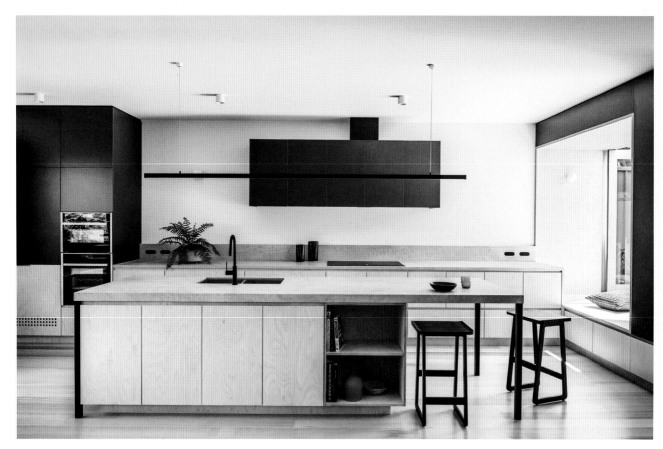

In the kitchen, the Tasmanian oak flooring attunes with the timber fronts of the lower cabinets, creating a unified aesthetic. From counter height upward, the cabinets are finished in a forest green color that adds depth and contrast to the room.

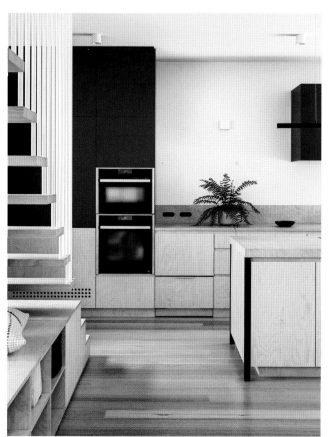

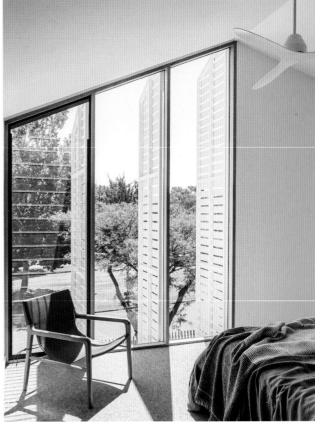

146

The shutters enclose the main
bedroom to create an area with
filtered light for an atmosphere
of retreat or let the light flood the
room to engage with the outdoors.

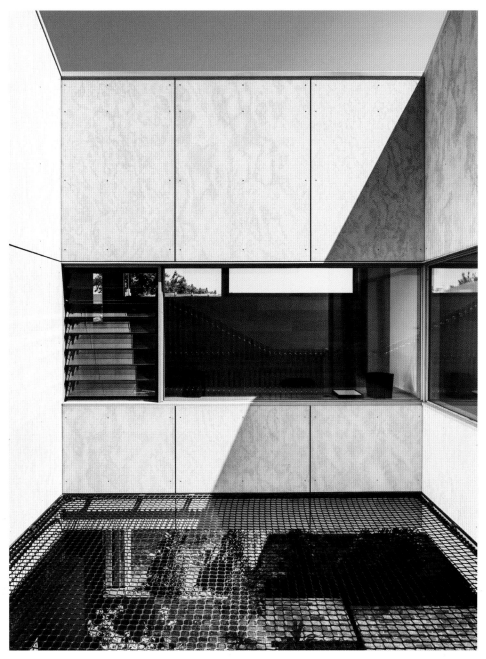

The interior courtyard presents the opportunity for creative use. A jumping net stretches across it at the second level offering extra playground fun.

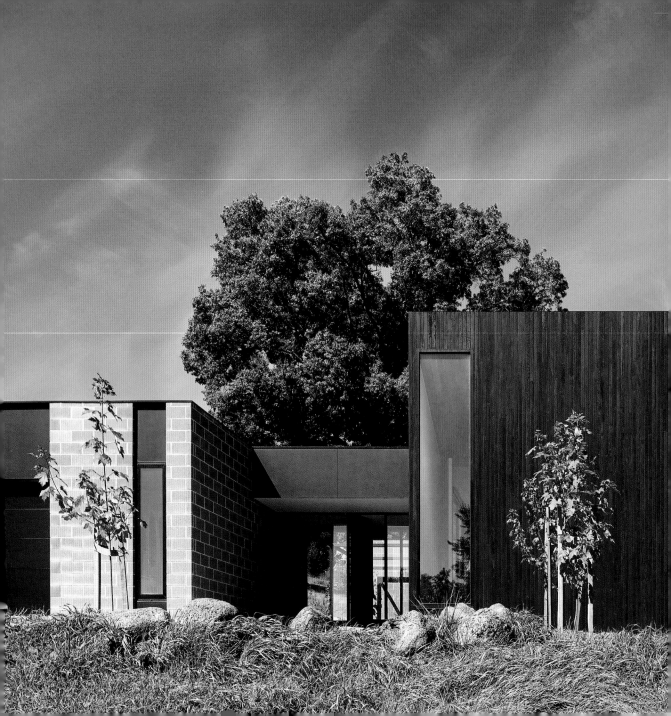

Kyneton House

3,015 sq ft

Kyneton, Victoria, Australia

Moloney Architects

© Dave Kulesza

The pre-leveled site of an unused tennis court created a perfect opportunity for a contemporary home in the historic town of Kyneton. The service and sleeping zones of the house are conceived as separate wings, arranged on-site to maximize light and view access. Both the service and sleeping wings are constructed out of blockwork, anchoring the home to the site. These solid elements bookend a lightweight timber and full-height glass living pavilion, providing privacy and protection where it's needed and a connection to the views and landscape where it's desired. A raw and robust material palette of concrete blocks, black steel, charred timber, natural timber, and burnished concrete are assembled on the hillside, serving as a muted backdrop for the landscape.

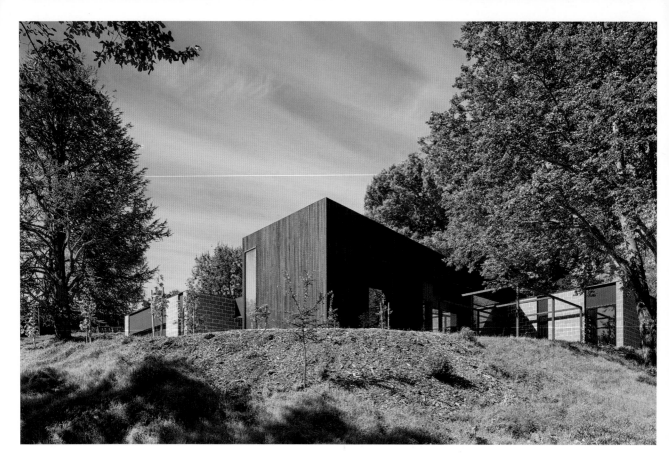

147

An existing cut into the hillside determined the location of the house. Sun exposure and landscape features informed its orientation.

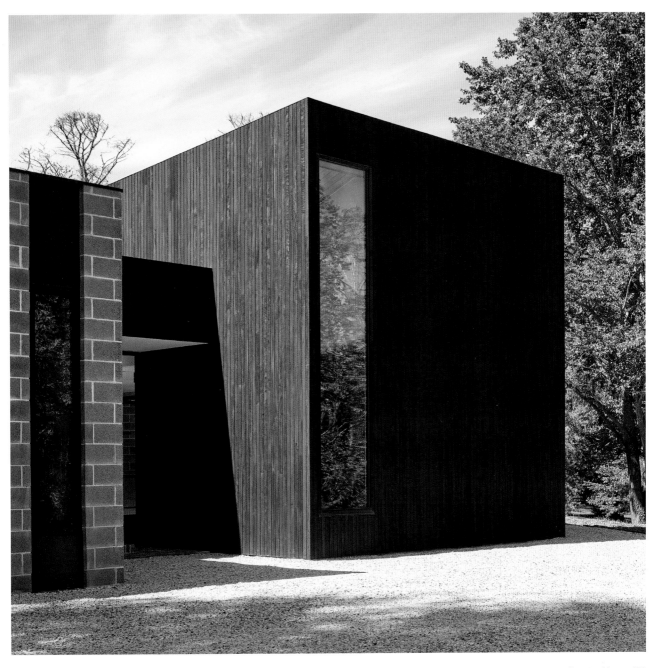

Concrete blockwork bookends a
lightweight timber and glass living
pavilion connected to the views and
landscape. The opaque volumes, instead,
provide privacy and protection where
it's needed.

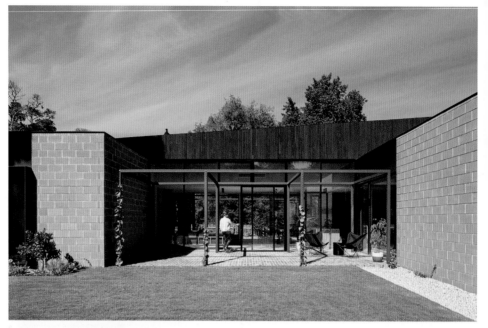

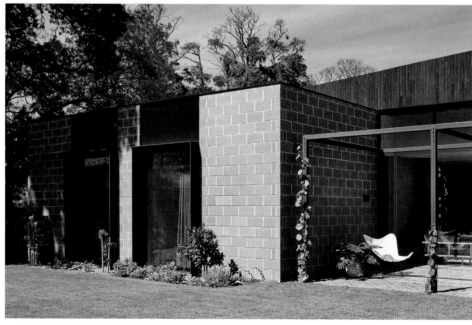

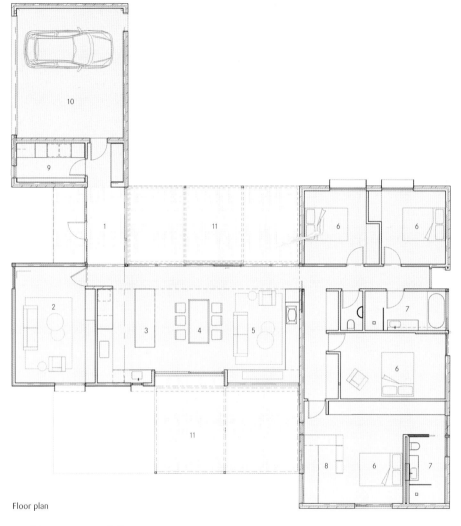

148

The two-wing configuration of
the house, accommodating living
areas in one and sleeping in the
other, maximizes light, ventilation,
and views.

Floor plan

1. Entry
2. Music room
3. Kitchen
4. Dining area
5. Lounge
6. Bedroom

7. Bathroom
8. Study
9. Laundry room
10. Garage
11. Terrace

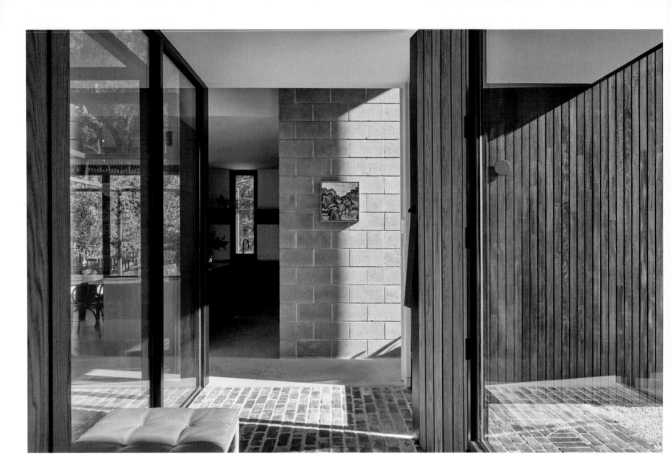

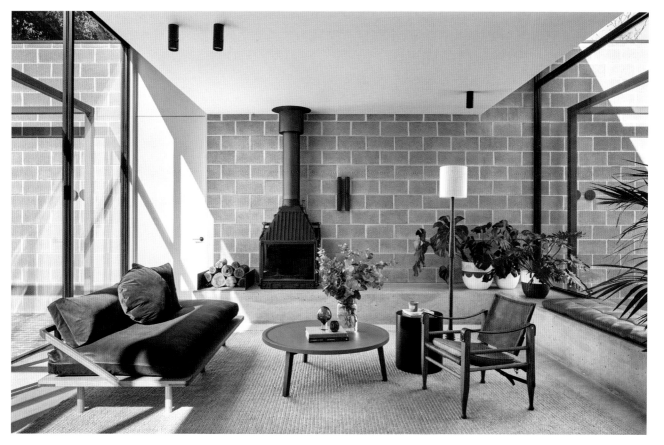

149

Transparency rethinks glass as an enclosure material thanks to technological advances that allow large glazed expanses. This allows to free up architecture from the limitations of conventional windows.

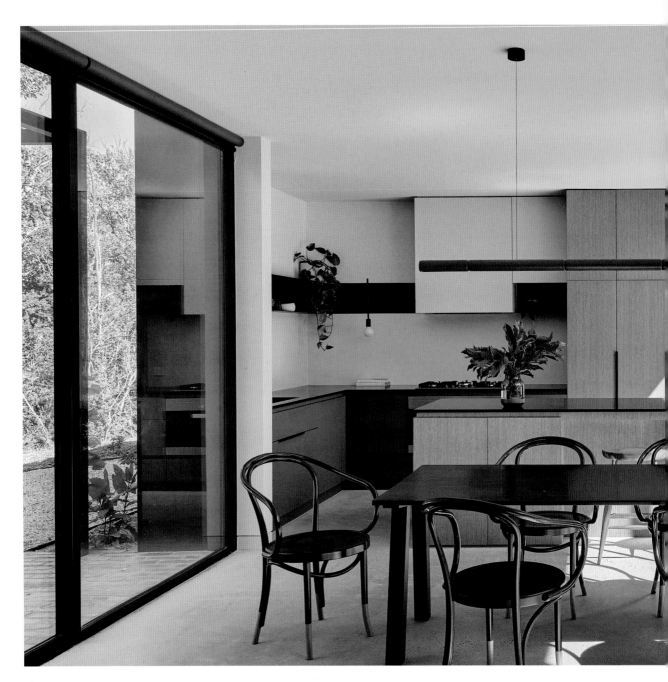

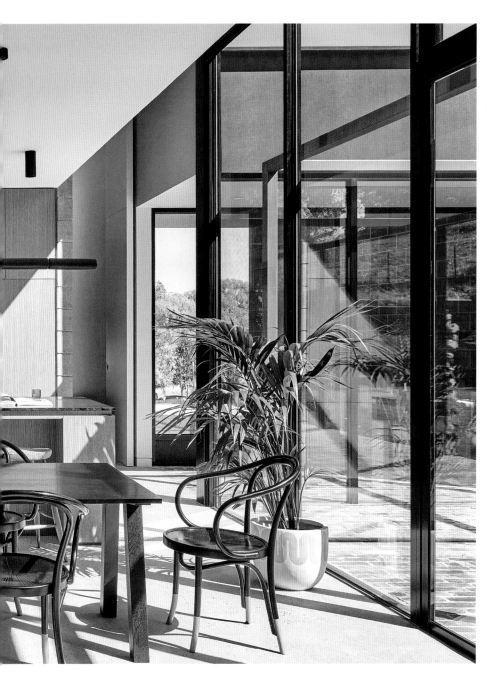

Transparency is a design feature that goes beyond the main idea to bring light into interior spaces. It is a means to create a better interior-exterior flow and integrate the built environment with its immediate surroundings.

DIRECTORY

Bade Stageberg Cox
Brooklyn, New York, United States
www.bscarchitecture.com

Ben Walker Architects
Canberra City, Australian Capital Territory,
Australia
www.benwalkerarchitects.com.au

Chevalier Morales
Montreal, Quebec, Canada
www.chevaliermorales.com

CLB Architects
Jackson, Wyoming, United States
www.clbarchitects.com

DADA & Partners
Haryana, India
www.dadapartners.com

Dake Wells Architecture
Springfield and Kansas City, Missouri,
United States
www.dake-wells.com

Dubbeldam Architecture + Design
Toronto, Ontario, Canada
www.dubbeldam.ca

Ehrlich Yanai Rhee Chaney Architects
Culver City and San Francisco, California,
United States
www.eyrc.com

Figr
Cremorne, Victoria, Australia
www.figr.com.au

**HAUS | Architecture for Modern
Lifestyles**
Indianapolis, Indiana, United States
www.haus-arch.com

Hsu McCullough
Los Angeles, California, United States
www.hm.la

JacobsChang Architecture
New York, New York, United States
www.jacobschang.com

kt814 architecture
Jackson, Wyoming, United States
www.kt814.com

KUBE Architecture
Washington, District of Columbia,
United States
www.kube-arch.com

Malcolm Davis Architecture
San Francisco, California, United States
www.mdarch.net

Mark English Architects
San Francisco, California, United States
www.markenglisharchitects.com

Michael Hennessey Architecture
San Francisco, California, United States
www.hennesseyarchitect.com

Mobilia
Perth, Western Australia, Australia
www.mobilia.com.au

Moloney Architects
Ballarat and Melbourne, Victoria,
Australia
www.moloneyarchitects.com.au

Murdough Design Architects
Concord, Massachusetts, United States
www.murdoughdesign.com

MXMA Architecture & Design
Westmount, Quebec, Canada
www.mxma.ca

Nathan Fell Architecture
New Orleans, Louisiana, United States
www.nathanfellarchitecture.com

Nic Brunsdon
South Fremantle, Western Australia,
Australia
Denpasar, Bali, Indonesia
www.nicbrunsdon.com

Paul Bernier Architecte
Montreal, Quebec, Canada
www.paulbernier.com

Resolution: 4 Architecture
New York, New York, United States
www.re4a.com

Robert M. Gurney Architect
Washington, District of Columbia,
www.robertgurneyarchitect.com

Roger Ferris + Partners
Westport, Connecticut, and
Bridgehampton, New York, United States
www.ferrisarch.com

Sparano + Mooney Architecture
Salt Lake City, Utah, United States
www.sparanomooney.com

State of Kin
Perth, Western Australia, Australia
www.stateofkin.com.au

Storonov Workshop Architects
Montpelier, Vermont, United States
www.stonorovworkshop.com

Strang Design
Sarasota, Coconut Grove,
and Winter Haven, Florida, United States
www.strang.design

Studio Schicketanz
Carmel-by-the-Sea, California,
United States
studioschicketanz.com

Studio VARA
San Francisco, California, United States
www.studiovara.com

Taylor Smyth Architects
Toronto, Ontario, Canada
www.taylorsmyth.com

Wheeler Kearns Architects
Chicago, Illinois, United States
www.wkarch.com